Biological
Museum
Methods
Volume 1

Biological Museum Methods

Volume 1
Vertebrates

George Hangay
Michael Dingley

The Australian Museum, Sydney, Australia

ACADEMIC PRESS
(Harcourt Brace Jovanovich, Publishers)

Sydney • Orlando • San Diego • New York
London • Toronto • Montreal • Tokyo

ACADEMIC PRESS AUSTRALIA
Centrecourt, 25–27 Paul Street North
North Ryde, N.S.W. 2113

United States Edition published by
ACADEMIC PRESS INC.
Orlando, Florida 32887

United Kingdom Edition published by
ACADEMIC PRESS, INC. (LONDON) LTD.
24/28 Oval Road, London NW1 7DX

Printed in Australia

National Library of Australia Cataloguing-in-Publication Data

Hangay, George.
 Biological museum methods. Volume 1.

 Bibliography.
 Includes index.
 ISBN 0 12 323301 1.

 1. Museum conservation methods. 2. Museum techniques.
 3. Natural history—Technique. I. Dingley, Mike.
 II. Title.

069.5'3

Library of Congress Catalog Card Number: 84-73526

*In this book, where drawings are not given a credit in the legend, they are the
work of K. Khoo. The authors are indebted to K. Khoo for his assistance.*

CONTENTS

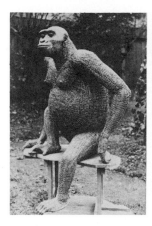 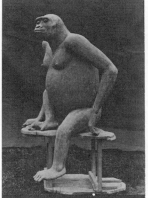 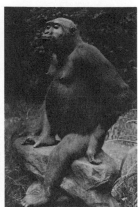

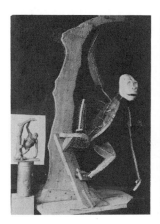 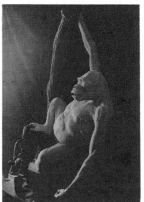

Frontispiece: (top three photographs) Friedrich Kerz developed techniques for sculptured taxidermy as early as in 1877, in Stuttgart, Germany. The finely crafted wood wool or straw model was stitched and bound then covered with clay before the tanned skin was mounted on it. The bottom rare photographs show the work of Herman H. ter Meer, a student of Kerz. The plaster and burlap sculpture is constructed on a timber and metal armature. The prepared skin is mounted directly over this model. The technique is known as the "ter Meer method" and it is practised by most European taxidermists. Photography (reproduction) by H. E. Haehl. Courtesy of the Staatl. Museum für Naturkunde, Stuttgart, Germany.

FOREWORD

NO OTHER class of artisans has ever better served the interests of science and education, or taught the public more about nature in such an exciting and interesting way, than the museum plant and animal preparator. Museum cabinets throughout the world are full of tray after tray of carefully catalogued specimens, that, if put on display that way, would bore the most casual visitor to distraction. No matter how knowledgable or skilled professional scientists or educators happen to be, they have never possessed the skills of the museum artist in preparing specimens for habitat display. Therefore, while scientists were providing the carefully assembled facts, museum artists were just as faithfully presenting them to the public by means of their unique skills.

Yet, though a unique class of artists and craftsmen, museum workers spend entire careers largely unknown and unrecognized. Their numbers are so small that few ever bother to record their skills and techniques for posterity. Consequently, new books on museum display techniques are as rare as annual sightings of endangered species from a single nation. Much of what they learn of technique is passed verbally from generation to generation or gleaned from a small body of out of print books and antiquated classics. It is largely from these books that amateur and commercial taxidermists learn most of what they know about mounting animals, making artificial plants, and constructing habitat exhibits. Without their skills and dedication, our natural history museums would be dry warehouses of cold facts instead of centres of public education and entertainment.

While almost any book on museum preparation techniques is welcomed by everyone interested in the subject, few attempt to cover the subject thoroughly. Many are published for a single discipline, or describe an author's favourite method. So the aspiring artist entering one of the fields of museum work must sort through an already thin literature and experiment for years before discovering what could be learned from a single good book on the topic. Having had the privilege of reading the manuscript for *Biological Museum Methods*, I can truthfully say that this work is one of those stout timbers that bridges the gap between those who know how and those who want to learn; between one generation of classics and another.

I met George Hangay during the period he spent researching in the United States and can testify to his knowledge and experience. He is one of those professional museum workers who enable an Australian to see the flora and

fauna of America in an Australian museum, or an American to see a rare Australian specimen in an American one. On behalf of museum workers everywhere, I would like to thank George and Michael for sharing their knowledge with us.

<div align="right">

JOE KISH

Editor,
Taxidermy Review

</div>

PREFACE

THE PRIMARY AIMS of this book are to highlight the main aspects of the preparator's work, describe as many techniques as practical, and guide the reader to the relevant literature, from which more information can be gained.

To prepare a book of this kind, one must draw heavily on the published and unpublished research of many other workers, present and past. As it is not possible to describe every technique which may be practised in a biological museum, lists of useful publications are provided at the end of the chapters.

In most cases when animal preparation is discussed, the grouping is not governed by any of the accepted scientific systems but rather by preparational requirements.

The preparation of specimens for natural history and building exhibitions has unlimited possibilities. The advances in technology are strongly felt in the museum field. We hope that this book will help the reader to explore ideas, learn techniques and understand the relationship between science and craft involved in the creative process that is the work of the preparator.

ACKNOWLEDGEMENTS

MANY PEOPLE assisted in the preparation of this book. We are grateful to all. First we would like to thank all our major contributors, whose names and institutions are mentioned at the appropriate sections of the text or in the captions of the illustrations. We are indebted to the Director, Dr Des Griffin, and the Trustees of The Australian Museum, Sydney, Australia, for permission to reproduce the many photographs and selections from the writings of museum workers. We are grateful to all those who helped us by giving advice through personal communication, namely (in no particular order): to K. Küng, Naturhistorisches Museum, Bern, Switzerland; D. Oppliger, Naturhistorisches Museum, Basel, Switzerland; H. Inchumuk, Natural History Museum, Denver, U.S.A.; A. James, British Columbia Provincial Museum, Victoria, Canada; R. Séguin, National Museum of Natural Sciences, Ottawa, Canada; R. Hursey, Provincial Museum of Alberta, Edmonton, Canada; E. Parkman, The Cleveland Museum of Natural History, Cleveland, U.S.A.; L. Jensen, Bergen Museum, Bergen, Norway; B. Jensen, Naturhistorisk Museum Aarhus, Denmark; R. Angst, Landessammlungen für Naturkunde, Karlsruhe, Germany; R. Buob, Staatliches Museum für Naturkunde, Stuttgart, Germany; G. Pucka, Niedersachsisches Landesmuseum, Hannover, Germany; K. Wechsler, Übersee Museum, Bremen, Germany; O. Post and H. Hjorta, Zoological Museum, Copenhagen, Denmark; R. Gajeelee, The Mauritius Institute, Port Louis, Mauritius; I. Chisselet and S. Endrödy-Younga, Transvaal Museum, Pretoria, Republic of South Africa; P. Tempest, Natal Museum, Pietermaritzburg, Republic of South Africa; W. Schaefer, Port Elizabeth Museum, Humewood, Republic of South Africa; R. Bullock, University of Sydney, Sydney, Australia; Z. Catalan, University of Los Banos, Republic of the Philippines; E. Diehl, Dolok Merangir, Indonesia; D. Horning, MacLeay Museum, Sydney, Australia; A. Vojnits, Natural History Museum, Budapest, Hungary.

Our special thanks go to the experts who have read parts of the manuscript and, with their constructive criticism, helped to make it better. The readers were: J. Kish, *Taxidermy Review*, Montana, U.S.A.; and L. Vail, F. Rowe, P. Hutchings, J. Paxton, R. Strahan, J. Lowry, R. Springthorpe, M. Gray, C. Smithers, W. Boles, L. Gibson, H. Cogger, O. Keywan and P. Colman (who not only read but also rewrote parts of Volume 1, Chapter 6) all of The Australian Museum, Sydney, Australia.

We are indebted to: K. Khoo for his drawings; J. Fields, Head, Photography Department, The Australian Museum, Sydney, for the photographs; J. Dingley, I. Toohey and K. Hangay for typing and proofreading the manuscript; J. Miller and Ivo Docking for sorting the manuscript; and J. Giffen for translating from Afrikaans to English.

Last but not least we thank Jeremy Fisher, Senior Editor, Academic Press Australia for all his patience and help.

CONTENTS OF VOLUME 2

1
Introduction:
A short history of
taxidermy

O F ALL aspects of the museum preparator's craft, taxidermy is perhaps the most fascinating. In the broader sense it includes most of the allied "arts and crafts" such as sculpting and modelling, moulding, casting, embedding, preserving and so on. In recent times, with more and more complex technology, the preparator's craft has been divided into many different branches. However, taxidermy and its allies still remain the main business of the biological museum preparator.

Taxidermy — the word is derived from ancient Greek words, a literal translation of which signifies "the arrangement of skins" — appears to have been practised ages ago.

Prehistoric humans preserved some of their prey to be used as decoys, charms or trophies. Hundreds of preserved animal bodies were found in the tombs of the ancient Egyptians. These people possessed the skill to arrest decay even in such huge carcasses as those of the hippopotamus, bull, crocodile and other large mammals. However, these preserved bodies had one thing in common: apart from the viscera and brain most other matter of the anatomy was conserved in one piece. The entire body was cured with salts, spices, minerals and other "ingredients" until it was rendered "decay-proof". A lifelike appearance could not be retained with such techniques. The flesh shrank and the skin wrinkled on the dehydrating body until it became dry and hard like a piece of wood. Like human mummies hardly resembling a living person, these animal mummies bore very little resemblance to a live animal.

A *Natural history*, published in Paris by the Royal Academy in 1687, mentions a collection of "stuffed" birds. These birds were collected by the Dutch on their first voyages to the East Indies (now Indonesia) in the early 1500s. The collection was exhibited in Amsterdam and seemingly well remembered 160–170 years later by the French. Unlike the mummies, these specimens were skinned and the spice-preserved skins filled with some material until the birds regained their natural appearance. Thus, these birds could be classified as the first known "taxidermic specimens". From the later years of the sixteenth century more stuffed animal specimens are recorded, including such large ones as the famous rhinoceros of Aldrovandus' Museum in Bologna.

BEGINNINGS

The first major publication to deal with the mounting and collecting of vertebrates was Abbé Manesse's *Treatise on the manner of stuffing and preserving animals and skins*. It was printed in 1786 in Paris. At this time France seemed to be the land of opportunity for taxidermy. Many taxidermists worked there. A number of them published treatises and set up famed collections.

One of them, Monsieur Becoeur of Metz, is certainly worth mentioning. This gentleman, who was the best apothecary of his city, was also the inventor of the taxidermist's arsenical soap. Unlike his predecessors and contemporaries, who employed the preserving qualities of spices, herbs, powdered tobacco, and so on, he treated his skins with a mixture of soap, arsenic, camphor, salt of tartar and powdered lime. This was an ingenious innovation as arsenic does not break down with time and thus the skins treated with it become insectproof practically forever.

Becoeur practised his craft with the greatest precision. He skinned the birds through a single cut of the skin of the belly, and removed all flesh by cutting it away from the bones. While doing this he took great care not to harm the ligaments so that the skeleton stayed as a whole. The carefully cleaned skeleton was then replaced inside the treated skin. Using an elaborately jointed wire armature, the specimen was posed and the flesh replaced with chopped cotton or flax. Once the belly was sewn up the bird was reposed again for absolute lifelikeness and the plumage was painstakingly groomed.

Although the craft of preserving animals was appreciated more and more in Europe, it took a while for appreciation to spread across La Manche. However, the abilities of the French, German and Dutch taxidermists came to be admired by the English. Soon, the first English taxidermists began to show their works — sometimes earning a little less than admiration from their critics.

C. Waterton, who is described by many of his contemporaries as an eccentric genius, had a very sad opinion about his taxidermist colleagues. He writes in his *Wanderings in South America*, published in 1825: "... As the system of preparations is founded in error, nothing but deformity, distortion and disproportion will be the result of the best intentions and utmost exertions of the workman ... This remark will not be thought severe when you reflect that that which was once a bird was probably stretched, stuffed, stiffened and wired by the hand of a common clown. Consider likewise, how the plumage must have been disordered by too much stretching, drying and perhaps sullied, or at least deranged, by the pressure of a coarse and heavy hand ..."

However, he was also criticised by others who did not find his methods too favourable. Yet he invented a technique which permitted him to mount without wires. He also decried the use of arsenic. He must have been a talented and skilled worker and it is known that he had great patience. He could spend days in scraping out the hand and feet of a large ape until he got the skin paper thin. His invention of a kid glove substitute for a peacock's face is also known, and there were many other virtuoso taxidermic achievements.

Many taxidermists tried to match or surpass Waterton's work. Most of the specimens were exhibited, not only in museums but also in private exhibits. Of course, all these works directed the public mind to the contemplation of natural history.

GROTESQUE SCHOOL

The Great Exhibition of 1851 in Paris marks the proper beginning of modern taxidermy. Peculiarly enough, a considerable impetus to the more correct and artistic delineation of animals came from an odd contributor, the so-called 'grotesque school' originating from Germany. This trend in taxidermy was denounced by most serious taxidermists, however, even today the public is often fascinated by its product.

The oldest works from the grotesque school illustrated fables, with appropriately posed and dressed mounted animals in fairy tale settings. Although such exhibits went against the trend in taxidermy by misrepresenting nature, they taught a special lesson for increased care was necessary to prepare them. To render the facial lines of an animal so that they create the proper half-human, seriocomic impression required by the setting is no small task for any taxidermist. To present something unnatural in the most natural way was the main goal for the old masters of the grotesque school. Many examples of the art are still to be seen (Fig. 1.1).

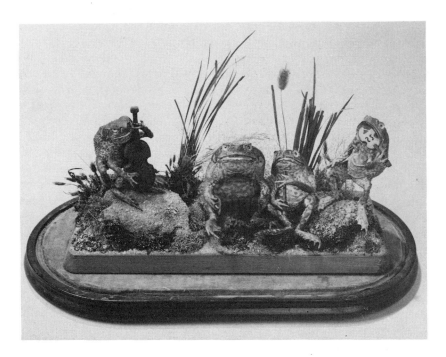

Fig. 1.1. Toad orchestra, an example of the "Grotesque School of Taxidermy". Photo John Fields. Courtesy of the Australian Museum.

Another great achievement of the Great Exhibition was the introduction of mounted animal groups in their natural habitat. Roland Ward's taxidermy studio exhibited a number of these groups and they became famous in their time. One of them was the "lion and tiger struggle". This and some other similarly dramatic group exhibits captivated the public's imagination. Taxidermy became a very popular craft.

Hunting, especially for big game in Africa and India, was popular too. The proud hunters were not satisfied with just a pair of horns or elephant tusks — they wanted to see and show their trophies as lifelike as possible. Roland Ward, whose taxidermy studio was the first on a big commercial scale, employed foreign craftsmen beside his English taxidermists. Under an immense workload the taxidermist had to be fast, but also very efficient, to satisfy the well-paying but fussy customers. England soon was producing high class taxidermy. The public acquired the taste for exquisite, quality work. New exhibits in museums received extensive review in daily newspapers, and private collections of mounted specimens represented huge values in artistic as well as in monetary terms.

MODERN TAXIDERMY

Roland Ward's taxidermists developed a technique which was adhered to until recent times. An artificial body was made of wood wool by wrapping the material around a steel armature. Anatomical detail was worked into the body by forming surface muscles of bundles of wood wool and by stitching through it with long needles and string. The tanned or pickled skin was tried on many times until the body fitted it perfectly. Before the final setting and sewing on, the artificial body was coated with a layer of wet clay or papier mache. The skin was mounted on this wet mouldable surface. Fine detail was achieved by pushing and squeezing the clay under the skin until it retained the living animal's appearance. In this technique, the skills of the sculptor were just as important as the tanner's preparations.

Another innovative taxidermist was Karl Küsthardt, one of the most talented taxidermists in Germany. He worked in the Grand Ducal Museum of Darmstadt from 1891 and prepared a vast number of lifesize mounts for the dioramas. He practised techniques very similar to those which became known as the Akeley method, developed by Carl Ethan Akeley — naturalist, taxidermist, sculptor, artist, inventor, photographer — and probably the most famous taxidermist of all time. Akeley was born in 1884 near Clarendon, New York. At 16, he was a competent bird and small mammal taxidermist. His natural artistic talent helped him to set up his specimens in a most lifelike manner. During his career he worked for Professor Henry J. Ward's studio (no connection with Roland Ward), for the Milwaukee Public Museum, for the Field Museum and for the American Museum of Natural History. He ran a very active commercial studio while working for these museums. His group exhibits, which are all masterpieces of taxidermy, are still part of these museum's exhibits. Many of them were prepared in his private studio.

He pioneered a technique by which he skinned mammals through a dorsal incision, but he was aided in the studio by being able to collect his specimens personally thus securing accurate field notes, body measurements and moulds. In his dorsal incision method the legs were not split open, therefore unsightly seams cannot be seen on his specimens. Once the skins were secured he made small models of the specimens, preferably of the whole group, and then the lifesize sculptures were prepared. To achieve accuracy in stance and appearance he used motion pictures as a record. Hollow casts were made from the life-size models, which were made of modelling clay. Plaster of paris and burlap were used for this purpose, the result was a strong, but lightweight, mannikin. The skin was mounted on this. The hard, anatomically and artistically perfect, mannikin assured good results. The tanned skin was pasted onto it and, since it was held in position by the paste and hundreds of pins, it could not change during the slow process of drying.

Unlike the large mammals mounted before this technique was invented, Akeley's specimens retained their lifelike appearance (Fig. 1.2).

Akeley's most famous successes are in the field of elephant taxidermy. This animal poses a very difficult task for the preparator, not only because of its size but also because of the problems occurring during modelling and handling of the skin. The absence of hair means that even the slightest imperfection in the modelling of the body is noticeable. The many wrinkles and folds of the living skin can disappear fast during the drying process.

Akeley's elephants, still on exhibit, do not show any of these imperfections. They are just as perfect as they were when Akeley collected them more than 70 years ago in the African bush. As modelled taxidermy grew in status many other talented people learned the craft. America seems to have been a very fertile land; most of the more famed taxidermists have been citizens of the United States.

However, not all of them were born there. Coloman Jonas was a Hungarian by birth, and learned his trade in Hungary and Germany. He established his commercial studio in Denver, Colorado, in 1908. With his brothers he soon dominated the taxidermy business in America. They were the first to form a supply house (Jonas Brothers Taxidermy Supply) for other taxidermists. They also contributed greatly to present day taxidermy methods. By the second decade of the 20th century, taxidermy had become so popular in the United States that almost all outdoorsmen, amateur naturalists, and science teachers wanted to learn it. Glass eyes, scalpels, modelling tools and so on were sought after items. Jonas Brothers were able to meet the need.

Leon Pray, another American, was the first to use borax instead of arsenic to preserve and insectproof skins. The use of borax as an efficient preserving agent gave another boost to the popularity of taxidermy. The dangerous substance, arsenic, could be omitted from the taxidermist's workshop. Opinions about this differ; some preparators love "good old arsenic". It is dangerous, but it is reliable, they say. Others will not touch it; they would rather take a chance with the moths and silverfish.

Today, taxidermists are divided into two large groups: the museum men and women; and the commercial operators. In a museum, where quality is the most important point to be observed, the taxidermist has a more interesting and satisfying career than in commerce.

Although there is a marked difference between the methods of the commercial taxidermists and the museum preparators, the gap appears to be closing. It is fair to say that this desirable situation, which promotes a constant improvement of standards, has been largely created by the increased availability of relevant literature. The trailblazer for the immense improvement of standards — both in the commercial and the museum field — has

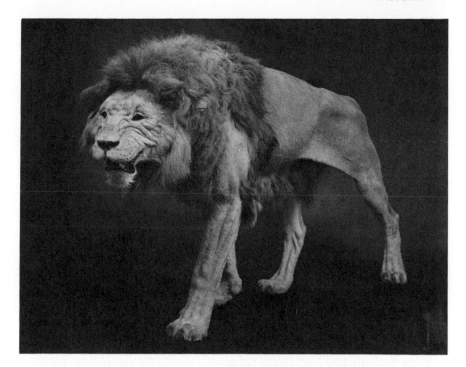

Fig. 1.2. African lion. Akeley has prepared this specimen on a hollow plaster mannikin, early in his career. Photo John Fields. Courtesy of The Australian Museum.

been Joe Kish's *Taxidermy Review.* The devotion of Joe Kish has acted as a catalyst and recognition of the necessity for high standards has become more widespread. Techniques which once were used only by museum preparators are considered today as routine by the commercial studios, and the result has been high quality prepared specimens.

A commercial taxidermist must produce a certain amount of work, otherwise the business cannot survive. In countries like the U.S.A. or Canada, commercial taxidermy is extremely competitive and good technicians are much sought after by the various firms.

In a modern museum, the taxidermist's life can be very gratifying. With enough work on hand, and suitable equipment, materials and information available, a preparator can gain immense knowledge of the subject. Today's techniques are varied and taxidermists choose their own methods for each task they undertake.

Birds are mounted according to the same principles in most museums and in private practice. The body is removed through a vertical incision of the

skin. The main bones of the limbs and the skull are retained, cleaned, preserved and used in the construction of the artificial body. This is often made of wood wool or carved in rigid plastic foam. A wire armature keeps the mount upright and, once the skin is mounted on the artificial body, the plumage is carefully arranged. After a period of drying the faded colours of the fleshy parts are restored.

The preparation of small mammals is very similar to that of birds. Being a little thicker, the skin of these animals often requires more attention. In many instances the cleaned hides are pickled, or even tanned, before mounting.

Large mammal mounting is the most complicated and most difficult aspect of taxidermy. To practise this, the taxidermist must have a sufficient knowledge of anatomy as well as extensive knowledge of the animal's behaviour. The most common technique is based on Akeley's method. However, with the advancement of technology, more and more plastics and other modern materials are being used by museum preparators and commercial taxidermists.

TANNING AND MODELLING

Tanning methods also have improved greatly during the last few decades and the up-to-date taxidermist employs tanning agents which give a better tannage for hides than the old material.

The initial modelling of the animal's body also has been improved by the use of new techniques. In many instances, the mould taken from the skinned carcass can be used as a basis for modelling. This was perfected in the Jonas studio. Henry W. Inchumuk of the Denver Museum of Natural History practises this technique and, through his generosity, we are able to describe it here.

Despite all the advancement of the craft, taxidermists often meet some tough opponents in their practice. Some species of birds or mammals are extremely difficult to handle. Problems start on the skinning table. To mention just a few examples, pigeons and some small passerines have extremely thin skins, while others have very loose feathers. The slightest mistake, a little more pressure on the skin, or a little nick of the scalpel, and the delicate specimen can be damaged, sometimes beyond repair. The skin of a cuscus is also very delicate, just like the skin of the American cotton-tail rabbit. Some species, many frogs, for instance, change colour after death, so that restoration is almost, or sometimes outright, impossible. The translucency of the nose of a sugarglider, for example, is a battle the taxidermist has lost.

Again, modern technology is invaluable. In the course of preparing specimens for the Mammal Gallery of the Australian Museum a technique was developed for the preparation of rats. Normally, the mounting of rats does not cause problems for a skilled taxidermist, although it could not be considered as one of the easiest tasks. However, the museum wanted perfectly preserved detail around the nose and mouth as well as around the eyes and ears. The specimens are too small for conventional large mammal mounting technique where all fleshy parts are split and filled with modelling material to prevent shrinkage. Therefore the rats were mounted in the regular manner, but lips, noses, ears were left intact. Before the skins could dry they were placed in the freeze-drying machine where they were slowly cured in vacuum on a low temperature. Shrinkage and distortion were avoided with this method, something which could not have been done before the invention of the freeze dryer.

With ever changing, ever advancing technology, the art of taxidermy is advancing too. The present day preparator can make use of the knowledge of the preparators of past generations, but is also in the fortunate position of being able to improve the old methods with the aid of modern technology.

SOURCE MATERIAL

Abels, A.: Moderne Tierpräparation um 1910. *Der Präparator* 28/4 1982: 345–348.
Anonymous: Carl E. Akeley 1864–1926. *American Taxidermist* 12/6 1979.
Anonymous: Henry S. Wichers Inchumuk. *Taxidermy Review* 8/2 1979.
Arndt, W.: Dermoplastik einst und jetzt. *Museumskunde N.F.* 6/1934: 15–18.
Ballard, L. D.: A giant step forward. *Taxidermy Review.* 7/5 1979.
Behrmann, G.: Ein Beitrag zur Geschichte der Präparation. *Der Präparator,* 3/4 1972.
Berry, B.: Drawing. *Taxidermy Review* 5/3 1976.
Breiner, Ernst: Alles schon mal dagewesen. *Der Präparator* 14/4 1968.
Browne, N.: *Artistic and scientific taxidermy.* London 1896.
Ceram, C. W.: *Gods graves and scholars.* rev. ed., Knopf, New York 1967.
Eger, L.: *Der Naturaliensammler.* 5th ed., Vienna 1882.
Ennenbach, W.: Uber ein Bildinventar und Präparationsmethoden einer zoologischen Sammlung um 1700. *Der Präparator* 27/4 1981: 161–167.
Faller, A.: Die Entwicklung der makroskopisch-anatomischen Präparierkunst von Galen bis zur Neuzeit. *Acta anatomica* 1948 Suppl.
Hangay, G.: Stuffed with life. *Australian Natural History* 20/3 1980: 79–82.
——. Historical taxidermy specimens in the Australian Museum. Conference of Museum Preparators, Sydney 1980.
Hughes, H.: Preparators, an insight. Conference of Museum Preparators, Sydney 1980.
Kelly, T.: Schools of taxidermy. *American Taxidermist* 17/1 1983.
Kish, J.: Knowledge and pride. *Taxidermy Review* 5/6 1977.
——. So, you're a taxidermist! *Taxidermy Review* 8/2 1979.
Koch, G. V.: *Die Aufstellung der tiere im neuen Museum zu Darmstadt.* Leipzig 1899.
——. Uber die Modellierung künstlicher Körper für die dermoplastiche Darstellung von Wirbeltieren. *Museumskunde* 1/1 1905: 43–53.

———. Die Zoologischen Sammlungen des Landesmuseums in Darmstadt. 3. Tiergeographische Gruppen. *Museumskunde* 4/2 1910: 92–113.

Martin, Ph. L.: *Die Taxidermie oder die Lehre vom Präparieren. Konservieren der Thiere und ihrer Theile, vom Natursammeln auf Reisen usw.* Weimar 1869.

Reed, V.: The commercialization of taxidermy. *Taxidermy Review* 6/4 1978.

Reichert, R.: Tierpräparation gestern und heute. Von der Mumie zur Dermoplastik. *Der Präparator* 1 1955: 65–71.

Robinson, J.: A future for taxidermy. Conference of Museum Preparators, Sydney, 1980.

Volkel, H.: Der Museum Präparator — ein Berufsbild im Wandel der Zeiten. *Der Präparator* 28/4 1982.

VERTEBRATES

2
Fishes

FISHES generate a lot of interest amongst the general public. This large group in the animal kingdom is also frequently studied by zoologists and other workers in natural history. It is very important that a museum which houses zoological collections has a fish section. An extensive and well kept collection of preserved fishes is an invaluable source of information. Exhibitions displaying well made reproductions, prepared fishes and the relevant information have enormous education value.

COLLECTING

There are many different, and often very complex, methods of collecting fishes. Some require expensive, highly sophisticated equipment (for example, deep sea collecting instruments). Those which are beyond the finances and means of most collectors or smaller institutes are omitted from this description. More information on the subject can be gained from the relevant literature, of which examples are listed at the end of this chapter.

The most practical scientific collection methods are netting (including trawling), poisoning and anaesthetizing. Spearfishing and angling are not considered serious collecting methods by scientists; however, one must recognize that a great many interesting specimens are captured by these popular means. Large specimens of many species can only be caught by

chance, mostly by rod and reel. Others, especially those species which frequent rocky underwater crevices, coral reefs and so on where netting is impractical, can be taken by speargun. There is much written about angling and spearfishing in the appropriate periodicals and manuals and, since these subjects belong in the realm of sport than museum methods, they are not discussed at length.

Most mass collecting methods, such as netting or poisoning, must be authorized by local government agencies. The laws concerning these methods of capture vary from one area to another; therefore it is most advisable to obtain sufficient information about the subject before embarking on a collecting trip.

DIP NET

This is fine netting suspended on a circular hoop which in turn is attached to a long handle (Fig. 2.1). Very small fishes up to 70 mm are caught using this net so the mesh size must be small enough to contain smaller fish. Sweeping the net quickly under water is difficult even with a mesh size of 10 mm, and smaller mesh sizes will make the task even slower. Therefore a compromise must be made between certain sizes of mesh before starting out on a collecting trip.

The quiet waters of rivers and streams and rock pools are the most likely places to find small fishes and, being quiet waters, it is easier for the collector to see them. The dip net is slowly submerged and gradually moved to a position under the fish, trying to avoid making underwater currents which will frighten the fish. When the net is close to the underside of the fish it is quickly moved upwards and out of the water. Only practice will enable the collector to become proficient in capture, so, if specimens are not captured the first time, keep repeating the procedure until the prize is caught. Use of a dip net at night with a torch is often productive, as many surface fishes are not as active at night.

Fig. 2.1. A dip net.

Experienced skindivers can use a dip net under water more or less in the same fashion as a butterfly collector uses a net. The captured fish is kept in a plastic bag or in a smaller, bag-like carry net.

SEINES

These nets are very useful in catching fishes and are used with a boat or, just as easily, from the shore. Shore use naturally brings in those fishes which frequently live near the surface and close to land, whereas boats can venture out into deeper waters, still catching surface fishes, but those which like open seas.

Small seines for small fishing areas are generally 1 m deep by 2 m–6 m long and are made of nylon with a mesh size of 3 mm^2 or 6 mm^2. The larger beach seines, useful for teaching students techniques in capture and also good for catches, are 2 m deep and have a length of up to 100 m. The top of the seine has floats mounted every 2 m or so and the bottom has lead weights to prevent the net from floating (Fig. 2.2). Students are an excellent source of help in using a seine, and this also gives them first hand knowledge of fishing. With a group of several students, each student holds the top cord of the net at a 90° angle to the shoreline until the first student reaches water that is too deep for walking. The first student then moves to the left or right in a wide arc until the first and last students are opposite each other parallel to the shore. The two ends are then pulled slowly towards the shore causing the net to bag outwards in an arc shape. Pulling the seine slowly keeps the fishes moving in front of the netting without causing them too much stress until very shallow water is reached, by which time the first and last students are on the beach

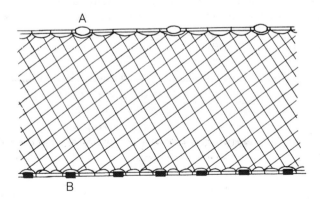

Fig. 2.2. Seine net. A. Floats B. Weights.

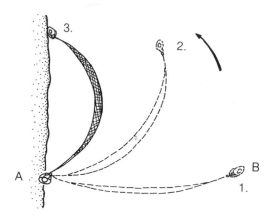

Fig. 2.3. The method of using a seine net. Person A remains stationary during the operation, while person B moves one end of the net first to station 1, then to 2 and finally to 3.

cutting off any escape route. The seine is pulled in until such time as only a small volume of water remains within the net confines and the fishes can be removed by hand and placed into buckets or similar containers (Fig. 2.3).

Trawling is one of the most effective collecting methods, especially for ocean fishes. Unfortunately, expensive equipment, including a good seagoing boat, is essential and, of course, skilful staff to handle it effectively. Institutes which cannot afford to have such costly equipment often charter trawlers to perform scientific collecting with research staff on board.

It is also often possible to purchase specimens from commercial fishermen. It is of paramount importance to obtain the appropriate date, locality and other important facts.

FISH POISONS

Rotenone (available from suppliers of rural chemicals) comes in liquid and powdered forms, and needs to be diluted before use. Tidal pools at low tide, or small bodies of water, are best suited for collecting fishes as large waves, incoming tides or currents will eventually dilute the poison into concentrations which are no longer lethal.

ANAESTHETIC CAPTURE

Many fishes, especially those that live on reefs, quickly swim into rock crevices if disturbed, which makes it hard for the collector to capture them.

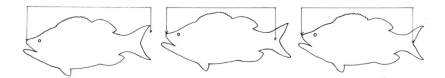

Fig. 2.4. The three ways of measuring the length of a fish. Drawing by G. Hangay.

The answer lies in a substance called Quinaldine (manufactured by Kodak), which, when squirted into these hiding places, anaesthetizes the fish causing it to leave the crevice so it can be scooped up using a dip net or picked up by hand. Fish quickly recover from the effects of the anaesthetic and are then placed in plastic bags before being transferred to buckets on land. For use, the Quinaldine is diluted with alcohol or acetone in the ratio of one part Quinaldine to 10 parts dilutent.

PREPARATION OF SCIENTIFIC SPECIMENS

The best way to kill fishes is to place them into a plastic bag containing just enough water to cover them and then put them into a freezer. If a freezer is unavailable, fishes are placed into a container holding 10% formalin until death occurs.

If the collecting is carried out for the sake of increasing a fish collection the only anatomical record taken in the field is the length of the specimen. There are three methods of measuring the length of a fish. One measurement is called the "total length", which means the shortest distance between the snout and the end of the caudal fin; another is the "standard length" which is measured from the snout to the end of the hypural bone (plate); and the last one is the "fork length" which spans the distance between the snout and the deepest point of the caudal fin's fork (Fig. 2.4). Depending on the policies of the collecting agency, usually one method is selected and employed as standard practice on a permanent basis.

There are many more measurements which can be taken from a fish. The nature and number of the measurements taken from a specimen depends on the specific interest of the scientist. Unlike birds and mammal specimens which must be measured as soon as possible after capture, fishes can be preserved first and measured later when it becomes practical or necessary.

However, the recording of other data is absolutely essential. Without the appropriate data, a fish, like any other scientific specimen, is completely useless for research. A typical data sheet (Fig. 2.5) is filled out for each

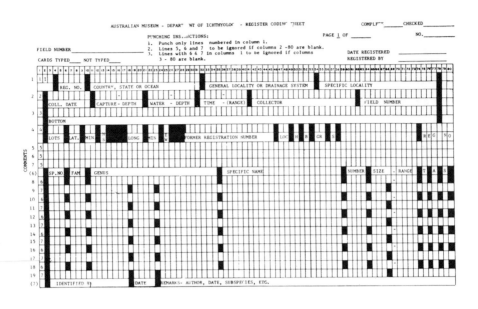

AUSTRALIAN MUSEUM - DEPARTMENT OF ICHTHYOLOGY - REGISTER CODING SHEET

PUNCHING INSTRUCTIONS:
1. Punch only lines numbered in column 1.
2. Lines 5, 6 and 7 to be ignored if columns 2 -80 are blank.
3. Lines with 6 & 7 in columns 1 to be ignored if columns 3 - 80 are blank.

GENERAL INSTRUCTIONS:

1. All numbers must be written to the right side of the field, ie. ending on last column of field.
2. All alphabetic information must begin in first column of field.
3. Where a range is available (depths, time, and size), if only one record is available write to the right of the dash (-).
4. Date in collection record must be Day, Month, Year, with no slashes or dashes. ex. 08121977.
5. Comments cards must be numbered 5 for collection records. No comments should go on line 4.

LOCALITY CODES (LOC) CARD 4

0 or blank - no data
1 - Queensland
2 - Lizard Island
3 - One Tree Island
4 - NSW (Including ACT)
5 - Sydney Harbour
6 - Victoria
7 - Tasmania
8 - South Australia
9 - Western Australia
10 - Northern Territory
11 - Lord Howe Island
12 - Norfolk Island
13 - Kermadec Is.
14 - New Zealand
15 - Macquarie Island
16 - Antarctic
17 - New Guinea
18 - Solomon I., New Britain, New Ireland
19 - New Hebrides
20 - Fiji
21 - New Caledonia
22 - Indonesia
23 - 69 See other sheet

HABITAT CODES (H)
Card 4

blank - unspecified
F - Freshwater
E - Estuarine
M - Marine
C - Combined

BOTTOM CODE (B)
Card 4 (dominant)

blank - unspecified
C - coral
R - rock
G - gravel
S - sand
M - mud
V - vegetation
W - water
I - invertebrate assoc.
O - other (wood, etc.)

SOURCE CODES (S) CARD 4

Blank - public donation
M - museum collection
E - exchange
F - state fisheries
U - professional
C - commonwealth
A - museum associates
P - purchased

COLLECTION METHOD
CODE (GR) - CARD 4

blank - unspecified
RO - rotenone
EX - explosive
SN - seine
GN - gill net
BT - bottom trawl
MT - midwater trawl or plankton net
SE - selective, spear, quinaldine or hand net
HL - hook & line
FM - fish market
NL - night light
OT - other (beach washup, hand, etc.)
SH - shocker
TR - trap
CM - combined methods

FIELD DATA
COMMENTS

CARDS 5
Gear
Additional locality detail
Water temp. °C
Salinity - ppt
O$_2$ ml/l
Elevation in m
Tide
Wire out
Time at depth
Vegetation
Shore
Stream width
Any other

SPECIES REMARKS CARD 7
subspecies
Author(s) of types
Date of description
Destroyed or exchanged details
Publication records
Other

SPECIES CARDS 6

TYPE CODE (T)

H - holotype
P - paratype
S - syntype
L - lectotype
R - paralectotype
N - neotype

SPECIMEN CODES (A)

blank - specimens
S - skeleton
C - cleared & stained
O - otoliths
K - skin
J - jaws
A - specimen + cleared & stained
B - specimen + otoliths
E - jaws + skin
D - drum
T - tank
F - drum + otoliths
G - tank + otoliths
H - skeleton + otoliths
P - parts, egg cases, etc.

STATUS CODES (S)

E - exchanged
P - part exchanged
D - destroyed
L - lost

Fig. 2.5. An example of a fish data sheet. Courtesy of The Australian Museum.

specimen or for each batch of specimens. Individual specimens, collected one by one at different localities, each receive a number and a data sheet. If a number of specimens is collected from the same locality at the same time all individual specimens receive the same number and only one data sheet.

Photographic recording of freshly caught or live specimens is becoming standard procedure.

Fishes designated for the scientific collection which are longer than 15 cm are slit between the pectoral and pelvic fin bases on the right side to enable the formalin to preserve the internal organs. Specimens will harden after only a few hours but should be kept in this formalin solution for four days after which they are washed in tap water for three to five hours and then stored in 75% ethyl alcohol. If specimens arc to be stored in formalin for longer than six months the formaldehyde should be neutralized before diluting, as this will prevent the skeleton from dissolving.

Specimens which are to be photographed are removed from the initial formalin fixative and placed onto a soft board such as polystyrene foam sheeting. The fins are spread, using pins to hold the first spine of each fin outstretched. The fins are then painted with formaldehyde (40%) which will harden the membrane very quickly.

Fishes that are too long to be stored in a straight position are not bent or coiled but are cut either in half or through nine tenths of the body and then placed vertically into a storage container. The reason for this is to allow more precise measurements to be taken, as bent specimens are very difficult to straighten. Needless to say, specimens treated in such a way are not suitable for display purposes.

Many workers consider it beneficial to remove the slime adhering to the scales before preservation; it can be rubbed off using a dry cloth or a cloth soaked in a dilute solution of borax or alum in tap water.

COLOUR PRESERVATION

Waller and Eschmeyer (1965) suggest a chemical antioxidant, butylated hydroxytoluene (BHT), in a liquid emulsifiable concentrate to preserve colour in fishes. Orange and red coloured fishes used to test the BHT with a concentration of 20 cm^3 of BHT per 4500 cm^3 of 10% formalin retained their colour after 18 months. Red, orange, yellow, brown and black coloured fishes, when tested, did not lose their colour, but a blue damsel fish faded, as did fishes with iridescent lustres. Similar results were obtained when 40% isopropyl alcohol was used as the fixative with BHT.

This colour preservation only works when the storage containers are filled completely with the solutions to exclude air as oxidation will occur if air is allowed to contact the specimen, and this will cause the colours to fade.

PREPARATION FOR DISPLAY PURPOSES

One of the most difficult tasks in the course of the preparator's work is to produce a lifelike reproduction of a fish. According to some fish experts, true to life reproductions or taxidermied fishes do not exist. While acknowledging such statements, it must be noted that no prepared specimen of any species of the animal kingdom is "true to life" since they all lack one very important thing: life! A prepared specimen, or a reproduction, can only reflect the physical presence of the animal. If this specimen is well prepared it should have a lifelike appearance, creating an illusion of life, but no more. Fishes, as we see them most of the time, are very lively creatures. Observed through the glass of an aquarium, or during a diving expedition, most species are always on the move, or, if they are stationary, their fins, mouths, eyes are moving. Pull a fish out of the water and it will struggle and flap around in order to get back into its life supporting element, and it will look very much alive while doing so. But wait until it lies still, even for a brief second, and it will appear dead immediately. Fishes lack changeable facial expressions, unlike mammals, and the presence of life in their bodies is indicated by movement.

Another typical characteristic of a live, or at least freshly killed, fish is translucency. In many species, not only the fins, tail and facial sections can be translucent, but also their entire colouring. The iridescent, shimmering and reflecting, yet still translucent, colours of some species are practically impossible to reproduce by human efforts. Taking all these into consideration one can understand the difficulties which the preparator faces in the course of fish preparation.

FIELD PREPARATION

In order to produce an acceptable, good quality fish reproduction or taxidermied fish, a perfect specimen is needed. Regardless how the fish was captured, it must be handled with great care from the beginning. Since colours typical of the live fish fade and change very quickly after death, the specimen must be photographed immediately.

Using a good quality camera (preferably 35 mm or larger), several colour transparencies are made of the fish. By using a polarising filter and taking photographs from various angles, reflections and glare are eliminated. By bracketing the aperture for each shot, the colours are captured on film with certainty. A standard colour chart should be included in each shot. A sketch of the fish with colour notes will help when the colours of the specimens are restored. If possible, the specimen should be photographed live. It is often possible to obtain underwater photographs of individual specimens of similar

species. These are very handy during the painting process. It is also often possible (especially with some smaller species) to place the live fish in a small aquarium and photograph it that way.

The photographed specimen is placed in a cloth bag and kept moist. Wet grass or leaves can also be used to keep the fish moist. The specimen must be kept in a cool, shady spot until further preparation.

Unless preparation can begin within a short period after capture the fish must be saved from spoilage. This can be achieved by two methods: freezing, or formalin preparation. Of the two methods freezing is the better one. The fish is wrapped in wet, brown or white paper (not newspaper). The name of the species and other important data are written on a card and attached to the specimen, which is then sealed in a transparent plastic bag. When it is placed in the freezer care is taken that it lies in an outstretched position on its side. If the specimen has a better side (perfect and uninjured) it should be laid on its injured side with the good side up. To prevent unnatural bending and disfiguration of the body, the fish should be laid on a piece of timber. Nothing should be placed on top of the fish which would indent its body.

If no freezer is available the fish can be preserved with formalin. The specimen is laid out in the manner it is supposed to look when finished. This sometimes has to be done on a bed of wet sand which can support an upcurved tail or head. The body is then thoroughly injected with 10% formalin. Care should be taken that the formalin is distributed equally throughout the body and does not form bulging lumps under the skin. Fins are fastened, if necessary, with pins through their bases in order to remain in a lifelike pose. The sunken abdomens of smaller specimens, and eyes, are injected with formalin until they regain their original fullness. The entire surface of the fish is swabbed with 10% formalin and the specimen is covered with a cloth saturated with the same liquid. After a few hours the fish becomes "fixed" by the formalin. It can now be placed in a container filled with 10% formalin.

Specimens which are to be reproduced in an outstretched position can be fixed in a flat bottomed, shallow dish and covered with formalin immediately after they have been posed.

MOULDING AND CASTING

The best method of preparing a fish specimen for display is by moulding and casting. There are several alternative techniques which yield good results.

WITCHARD (1980) described the technique which is practised in the Australian Museum, Sydney, and we are pleased to have permission to reprint his work here.

Cleaning the fish

When considering the casting of a fresh fish specimen, the first step to take is to clean the entire surface of the fish of all matter that will be detrimental to the plaster mould. Most often this will consist of a layer of slime which is continually produced by the skin. Some fish, like trout, may need to be soaked for a short period in alum or formalin solution because the slime is produced so readily. Formalin cannot be used for any fish which are to be eaten afterwards, so the mucus can only be wiped off with a wet sponge, but beware of vigorous scrubbing. The skin or scales of such fish as garfish or ribbon fish can scarcely be touched roughly, let alone scrubbed. Cleaning chemicals should be well rinsed off the specimen afterwards.

The mouth and gill-chamber should be thoroughly rinsed out, and if the mouth is required to be shown open, a plug of cotton wood should be pushed into the gullet. Fish which have been preserved for any length of time in formalin generally give a good impression if they are not crushed into an unnatural shape, but they must be well washed and dried, as formalin retards the set of plaster. So, too, do specimens that have been kept deep frozen for a few weeks – the slime-producing potential of the skin is mostly destroyed. But where dehydration has been long or severe, all the good qualities of shape the fish ever had will also be destroyed.

Although the fish may have been thoroughly prepared as outlined, further precautions can be taken by ensuring that the plaster is as quick setting as is convenient to use. It stands to reason that the quicker the plaster reaches a solid set, the less time the mucus has to interfere with it. If it can be spread over the fish in 60 seconds, one will get a much more satisfactory impression than if the plaster stands for about 10 minutes before beginning to thicken. Mixing plaster to a rich creamy texture is an art that comes with experience; fluff the dry powder up with the scoop before picking it up and sprinkling over the entire surface of the water; generally enough dry powder to leave practically no free water is a good guide. When mixing quick setting plaster, use a dish that is much wider than it is deep rather than a bucket.

Making a plaster mould

The simplest and quickest type of cast to make is that which shows somewhat more than half the surface of the fish. To make it, support the ventral, caudal and dorsal fins on blocks of potter's clay as big in area as the fins, and with slightly sloping sides in the manner of truncated pyramids. Place a clay wall around the fish to retain the plaster. A narrow perimeter piece is poured first, up to the midline of the fish and the height of the clay pyramids. When nearly set, a few dimples can be made with the fingertips in the top surface to serve

as locating keys later on. When completely set, give the surface a coat of separator grease to ensure that the mould will come apart neatly at the proper place. For the second pouring, sufficient plaster should be mixed to cover the fish to a depth of 1 cm or so. It is wrong to just up end the bowl and allow the plaster to submerge the specimen with a sudden rush in an attempt to beat the setting deadline. Fins can be lifted and become trapped and lost, and every crevice will hold air bubbles of one size or another. The plaster should be ladled quickly into the mould, in small quantities to begin with, and spread thinly in an advancing wave from one end of the fish to the other. In many instances it will be helpful to work a well-loaded, soft brush ahead of the wave of plaster, filling in awkward and backward-facing undercuts with it. Once the surface of the specimen is entirely covered, plaster can be added more rapidly and, if practicable, gently poured in and spread with the brush. Even if the plaster has begun to thicken by this time, it can still be used to back up the plaster already on the specimen.

When the last plaster has become quite hard, invert the mould and remove all the clay, and also the fish. The narrow ring section may come away and break up while you are doing this, but that does not matter. Where it sticks fast, give a few taps with a mallet and chisel along the parting line. The pitch of the note given by the tapping will drop a little just when the separation is occurring. The detail surfaces of a wet mould should not be touched or brushed, as they mark very easily. Consequently, the specimen should be lifted straight off a mould and not dragged across the surface of it. Chips of the mould, broken off in this operation, which show some of the detail of the mould should be saved without too much handling, and kept for replacement later. If large sections of the mould have to be carved away for any reason, it is better to do it now while the mould is wet, rather than later. The mould should be thoroughly dried. A plaster cast can be taken from this type of mould while it is quite fresh, but, in general, nothing is to be gained from working on a wet mould.

Preparing the mould for casting is a time when many of the defects that existed in the specimen can be got rid of, and its appearance therefore improved. On the mould, surfaces that make contact, bruised sections caused by the hammer and chisel work in opening it, must be cut away; likewise, any knobs or acute ridges which are likely to hinder the perfect reassembly of the mould. Any punctures in the fish can be carved back, and the scale pattern replaced — torn fish membranes can be smoothed and lost spines engraved. The mould is now sealed with shellac. Once the powdery surface of the plaster is sealed, missing parts can be built up with Plasticine — parts such as those deep crevices around the mouth. But there is no point in defining structures to the extent that there will be no strength in their plaster replicas (raised gill cover, for instance). In taking plaster casts from this type of mould, the thin

edges of such structures will nearly always break off and remain in the mould. Consequently, this method is definitely not suited to a spiny fish. With all repair work done, a second coat of shellac can be applied to the mould, brushing well to prevent flow marks forming, and taking it well out onto the contact surfaces. Shellac should always be mixed with sufficient alcohol to allow a generous amount of brushing time, and not be lumpy or treacly.

Many different kinds of greases and waxes are suitable for use as separators between plaster and plaster, but they should be prepared in a form that allows easy brushing onto the mould. One which can be easily made is a solution of candle wax in olive oil, such that sufficient wax is melted in the oil so the whole sets to a soft white mass at room temperature. This has one big advantage in that it is non-poisonous and pleasant to handle, and, although there are any number of proprietary mould releases available, there is much merit in being able to prepare your own. If the mould has been fully sealed, very little separator will be needed to provide an efficient parting — enough to provide a palpable waxiness on the mould will do. If it can be seen and felt, as ridged brushmarks, then both the amount and texture of it are at fault, and the cast will reproduce more of brushwork than of scale pattern. The separator should also be carried onto the contact surfaces of the mould.

Making a plaster cast

The mould can now be assembled ready for pouring. Throughout the whole process of preparation, neatness and care are desirable, and this simple operation of putting the mould together could almost be considered a fair index of a preparator's skilfulness. When the parts are clamped together, their fit should be not far short of the original, as a mould of this type does not warp much. The method of attaching the finished cast to its support should be settled before the casting is done. A block of wood embedded in the back of the fish is a universal method, giving purchase to screws from behind; but it may not do for a small fish because once the piece of wood is over a certain size in proportion to the size of the fish, it can be relied upon to crack the cast. It must be heavily sealed to prevent water absorption, and studded with a few nails driven partly in, on all but one large side, to key it into the plaster. If any but iron nails are available, they ought to be used, because iron and plaster are not good permanent companions.

For small fish it is convenient to substitute a brass nut, ungreased, threaded on a well greased bolt and suspended so that the nut becomes embedded about the centre of the cast. Two or more nuts soldered on to a piece of brass pipe will make a fitting suitable for fish up to a fair size, without any risk of the cast cracking. Pour the plaster slowly, working with a soft brush again to eliminate air bubbles and getting all corners filled. When the cast is very

firm, but still able to be cut with a knife, remove all stays from the block and screed off the back with a steel straight edge.

It is necessary to use a harder plaster for the casting operation, because, if any point sticks when knocking the cast from the mould, it will then be more likely to be the mould that suffers. A hard plaster is less powdery when dry, and the cast is more durable.

Should the fish be a rather heavy one — 8 kg and up — it would be prudent to make a fibre reinforced plaster shell instead of a solid cast. The fibre is thoroughly wetted by the handful in the plaster, and laid in the mould without trapping air bubbles. Small scraps of hessian can be used instead of fibre. In such a cast, the block of wood can be quite large without any risk, as it can be tied into the frame of the fish only at the corners, and not allowed to absorb much water. The reinforced plaster shell of the cast need not be very thick to have sufficient strength for self-support. Be careful not to place unsoaked patches of fibre against the mould, and therefore on the surface of the cast; gentle pressure when laying the fibre will avoid this. Cover the whole mould in a continuous operation for, if the working edge sets, it will lift, and the next work will then produce a flow-mark. Slow setting plaster is necessary, as the whole job need not then be done with one batch. A good rule is for all blocks for solid casts to be tied around with a strong band of fibre soaked in plaster, before being placed flush in the freshly poured casts. Wooden blocks will have to be weighted and pinned to keep them in position when pouring, and brass bolts will have to be firmly stayed to keep them perpendicular.

The question of durability leads to a further refinement with the use of artificial stone. This material may be a bit too expensive to use for the whole cast, but delicate edges will be gained from its use. If a small quantity is prepared in a separate bowl at the same time as the plaster, the procedure is as follows: the sections requiring strength, such as the leading edge of the pectoral fin, mouth parts, gill covers etc., are filled with a spoonful of stone, and this is retained in place by a piece of hessian soaked in plaster and laid over it. The main plaster is then added, a task which will have to be done very carefully indeed. In a mould where such a step is deemed necessary, it is unlikely that the cast will separate easily, and to force it would be dangerous. If the position of these undercuts is marked previously on the back of the mould, it can be cut away at these points by careful use of a mallet and small chisel until the undercut is freed. The whole cast should be laid on a bag partly filled with wood wool packing while this is done, as greater control can then be kept over the chisel work.

Then, a cast from a one piece mould should have been produced. For fish having the general shape of flounders and some rays, it is quite a good method. For most fish, apart from giving a record of size and shape, it is far from satisfactory as it stands. It can be improved by cutting away most of

the block of plaster behind each fin, either with a knife or a dental burr. This rids the cast of its bas-relief look, and makes it a lot more convincing. It allows the ventral fin to be extended and, with care, the pectoral can be lifted a little way off the body. If the technique is intended for a cast reinforced with fibre, the fibre must be kept out of the parts that have to be carved away.

If the fibre gets in the way it can be burnt away with a red hot iron. However, little can be done to remove that "stiff as a board" look, for to bend the body, open the mouth, and full extend the paired fins is to pose problems which are insoluble with this technique.

Making a plaster mould for plastic casting

The advent of cold pouring plastics, particularly polyester resin, has now made it possible to cast the fins of most fish in actual thickness without removing them from the fish and making cumbersome moulds of each of them.

When the choice has been made as to which side of the fish is required for exhibition, it is laid flat on a glass slab which is covered with a few sheets of newspaper, the wanted side uppermost. In this description, the body of the fish is considered as being straight, but various curvatures can be embodied without any alteration to the method.

Potter's clay of freely workable consistency is packed around the fish to leave only the top side exposed. The neatest method is to beat pads of clay to the right thickness as judged by sight, and, with one side trimmed to fit against the fish, slide them down under the fins (dorsals, caudal and ventral) leaving a generous margin of 2 cm or more. Pins behind the spines may be needed to retain the fin in the position required, because it should not be pressed too deeply into the clay. The clay should be soft enough when so pressed to rise between the spines, stretch the membranes and exclude pockets of trapped air. Beware of completely burying the tips of spines. Cotton wool, moistened and laid over the fins, will keep them from drying out while the work continues, or if the job has to be left for some little time. Strips of clay, trimmed square on one side, are used to finish outlining the fish. It is difficult to pack up the pelvic fin with a solid block of clay, and an easier method is to use a thin slice and chock it up from underneath with odd bits of clay while holding it against the fin. If the mouth is open, the clay wall should not cross it, but should go back along each lip and meet at the corner of the mouth on the underside.

The pectoral fin can be given a variety of treatments as a result of the variety of forms in which it comes. Lack of time provides the only justifiable reason for cutting this fin off the fish. This might be the case when casting a large black marlin. Here, where it is permanently erect, it will also mean

a considerable saving in plaster on a job that one operator may be unable to complete in one day. So, every time saving device available should be used. For example: lay the pelvic fins at different angles and treat them as one fin; or, if the mouth is to be open, start packing clay at the head and pour the mouthfill to set while completing the packing around the tail. Before starting, remove the pectoral fin on the underside also to prevent distorting the pectoral girdle area of the fish.

A simple method of moulding pectoral fins is to build a wall of clay across the fish and lay the fin against it. This will give you the side of the fish in two pieces, with the fin between them. It works well on fish that are firm-fleshed, but on soft-bodied fish, the weight of clay leaves an unsightly depression. This is a disadvantage which cannot be lightly dismissed. An alternative method has been worked out which does not require clay walls. This is detailed in the continuation of the general procedure.

When the clay packing is complete, smooth the surface with some appropriate tool to remove all holes and sharp angles likely to form undercuts, and dibble a series of shallow pits right around to form keys. As a rule, the irregularity of the clay surface will be sufficient key in itself, but it is better to be sure. Hold the pectoral fin fully erect with a guy-string clipped under the leading edge halfway along. It is wise to scrape a shallow undercut along the leading edge of all fins to help hold the fish in the mould when it is turned over. If a 2 cm margin is not marked with a faint line around the fish, it is as well, when pouring the plaster, to go around and see that this margin is secured. Unlikely as it seems, it is easy to leave the corner of a fin sticking out or covered with just a thin splash of plaster. The two halves of the mould have to be clamped with G-clamps when casting, so fashion the plaster to form a thick, level area at the edge, particularly over the fins. Achieving this without the need to build a wall to enclose the pour is one advantage of quick-setting plaster.

Flow the plaster up to the base of the pectoral fin all around, and leave it rising from the bottom of a depression. Now the fin can be unpinned and laid back against the wall of this depression, at the same time piling more plaster under it to lengthen the slope accommodating the fin. It should be laid down and brushed carefully to avoid covering the fine edge (Fig. 2.6). On the open front face of the fin, the edge of plaster should on no account be allowed to encroach up the fin — it is better that some of the body be left uncovered. The edge of the plaster around the fin should not be drawn out to a fine angle; that is to say, the plaster slope should rise at a steep angle to the skin of the fish. Also, be careful not to get an undercut on the slope of this depression, or the point of the fin cap will break off. This fin cap is the next piece of the mould to be poured, covering the fin, and filling the depression. Make some point on the main mould higher than the pectoral fin, because when the

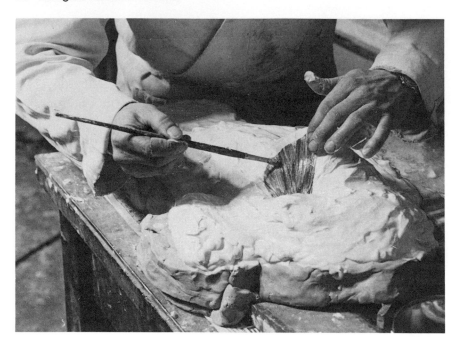

Fig. 2.6. Positioning the fin. Photo H. Hughes. Courtesy of The Australian Museum.

mould is empty and inverted, it must not rest on the fin detail. When all the plaster is quite hard, the mould is turned.

Circumstances will determine how best to do this. If the glass slab and fish are not heavy, press them together and turn the lot, then slide the glass off. The fish must not sag out of the mould as it is lifted. A lot can be done to prevent this if the clay packing around the fish is not brought quite to the halfway line or midline. This will form a slight undercut all around the first peice, so gripping the fish, but there cannot be too much of it.

When working on a fish that is completely thawed out, and especially if it is like a trout, with a large, soft belly, any placing of clay packing against this belly will cause a depression along it. If it does not come at once, it will surely come when the fish is turned over and the viscera flop across to the other side. With a one sided cast, it is a big advantage to terminate the clay packing at the anus and around the chin, and so mould all the soft belly that will be shown in one piece. The pelvic fins present a difficulty if there is much soft area on both sides of them. Where they are extended, a block of clay suitably shaped to fill the space between them, and yet not be trapped when the mould is poured, can be used to support them. In effect, this gives them the same treatment that is described above for the pectoral fin. Some care

should be taken to avoid trapping air under the lower fin when pouring the body mould, although this surface will not be seen in the cast. Tilt the glass slab to pour the pectoral and pelvic fin caps together; then, after turning and removing the clay, tilt the glass again until the soft belly contacts the edge of the mould and so establishes a correct continuity of the surfaces.

Returning to the general method, after the fish is turned, the clay should be stripped off carefully, leaving only the pieces where it dips to hide the pelvic fin. Put it aside, and wash under a running tap later to remove all chips of plaster. Using fresh clay, build up the other pelvic fin in a similar manner to the first. An important point to keep in mind at this stage is how the fish is required to be shown. If the back side has to be flat against the wall, the extended pelvic fin may interfere with the fixing. The second side, in a wall mount, is poured in the same manner as the first, except that no provision is made for the pectoral fin, and a large hole may be left in the centre through which to pour the cast. On the other hand, if the specimen is to be viewed from all angles, treat the pectoral fin in the same manner as before and do not leave any holes. Such a cast can be mounted on a post screwed into a fitting embedded in the fish.

Before pouring the second side, it is important to remove all the scraps of clay and thin flowthroughs from the first side to give a clean edge. Fins that are pulled loose by the clay can be stuck down again with the separator grease or pinned in place. Pins which are going to be buried beyond recall should have the heads nipped off.

Then, only the small piece between the pelvic fins remains. If the two main side pieces are likely to fall apart, clamp them firmly together before turning the fish onto its dorsal edge. It does not matter if the pectoral fin caps fall off. When the clay is removed from the space between the pelvic fins, the surface greased and the fins stuck down, a quantity of water should be poured in and allowed to remain there. The surplus water should be mopped out only immediately before pouring the plaster. The purpose is to prevent air bubbles rising in the new plaster and leaving large holes. This is advisable whenever a second pouring of plaster is made on top of one which has had any time to dry, because, in these circumstances, the already set plaster rapidly extracts water from the new lot. The second pouring is made easier and less hazardous when it is a thinner mix with more free water. If you consider the mould too weighty to be turned on edge, a clay wall can be built around the section and the piece poured sideways. There is a greater risk of trapping air bubbles in this method, and the heads must be cut off any pins used.

All separation lines should be parted by a tap with a chisel before the mould is dismantled and the fish removed. If the cast is important, the specimen rare, or your confidence wanting, put the fish back in deep freeze until the job is finished.

Casting in polyester resin

Casting in polyester resin requires a thoroughly dry plaster mould. Water causes a severe surface inhibition of the resin which may prevent final hardening altogether on thin members such as fin membranes.

Some characteristics of these plastics can be mentioned here, and a little experiment should be made to determine setting time because it varies a little with resin from batch to batch, and also depends on the age of the ingredients.

Polymerization is a reaction helped by mass. A casting with approximately three equal dimensions will need less hardener to effect the same set as would the same volume of resin poured into a mould like a fin, with only two appreciable dimensions. So it can be seen that a very fast mix, although essential for success in a long tenuous fin, would be disastrous if left to set in bulk, due to exothermic heat and its accelerating effect. In a cast as thin as some fins will be, surface inhibition of the resin must be absolutely prevented. A strong or fast mix is only half the remedy. The separator used must be hard enough at room temperature not to mix with the resin. For this reason, the oil and wax separator used for plaster casting is not suitable for plastic. Again, a multitude of commercial separators is available, but a saturated solution of beeswax in trichlorethane has been found to be equal to the best commonly available.

So far these refer only to polyester resin and not to epoxy resin. There is a vast difference between the behaviour of the two. The field for epoxy resin is limited when using plaster moulds because of its negligible shrinkage on setting and its penetrating powers in such a porous mould since it does not go through a gel stage. The shrinkage of the polyester, which can be greatly overcome when not needed, turns out to be a valuable asset and an assistance in separation.

Consider first a plaster cast incorporating plastic fins for a wall mount. As before, the mould is cleared of blemishes as far as possible, and shellacked. The back half is then sawn to allow access to the fins. Take the tail off straight across, then, with a longitudinal cut, separate the dorsals from the ventrals. This cut should turn aside just in front of the pelvic fins to keep the head in one piece. Saw only about three quarters of the way through the mould from the outside and then break it. In this way, a better join is produced, although it regulates the order in which the parts can be assembled. Put several coats of beeswax separator on the fins and some candlewax separator on the body. Have a really wide margin waxed around the fins, or there is a danger that they may be torn while extracting them. All fins are cast by the same procedure, and the back of the mould can be cut up even further to allow making them one at a time.

It is a very lax practice to simply paint resin on each side of the mould and fold them together, for, if there is not more than enough resin in there, all the air will not be forced out, or the periphery of the fin may leak away. To overcome these troubles, fold a layer of absorbent paper into the fin. Facial tissues have been found to be the best because they are only 0.005 cm thick, rather open and loose textured, and affect the transparency of fins little. A denser material would leave almost no room for resin in very thin fins, thereby adversely affecting setting. Very thin glass felting can be used instead. Although it does add strength, it is not a matter of strengthening the fin — the paper mainly acts as a spreading and holding agent for the resin. Any bubbles that are trapped in the fin will not produce a shothole effect, and will be much easier to repair. The addition of 2%–3% of a polyester resin flexibilizer (such as Benzoflex) will prevent a great deal of trouble later by removing the glass-like brittleness of the plain resin; addition of a higher percentage will tend to allow long fins to droop.

Under the influence of the slippery resin, the two halves of the mould at the tail may not go together exactly straight even when clamped tight. An immeasurable deflection in the tail at the beginning will cause a despairing divergence at the head end later, and a failure of the mould to close properly. Prevent this by clamping the dorsal piece securely as a temporary guide.

Chock up the mould pieces until the fin detail surfaces are as near level as can be obtained. Take a piece of facial tissue that more than covers the fin and separate the plys, one for each side. Some device to key the fin into the future plaster body is needed. Wedge-shaped pieces of set plastic are much better than wire loops. Select a piece for this that is long and narrow to get a firm key into the fish past the narrow section of the tail. It must be kept from touching the sides with wedges of some material that can be removed later.

Mix a sufficient quantity of resin to set in about 10 minutes. For small fins it is easy enough to spread it with the stirring stick, but, for big jobs, a brush is essential to get the coverage in time. The resin must cover a margin around the fin, and fill to the brim any grooves representing spines. Lay the tissue on each side and allow it to wet through, pressing it down as little as possible. To put more resin on top of dry paper will only trap bubbles under it, and these are very difficult to remove. Have the paper extend enough to give a wide margin on all sides except that where the keys will be. Here it should be flush, otherwise it is a nuisance. A little more resin can be put on top of the paper after it is wet to make sure there will be sufficient in the mould (Fig. 2.7). Then close the two sides of the fin together, after the manner of the covers of a book. This must be successful at the first attempt, and, where necessary to ensure this, mark corresponding points earlier for guidance.

Clamp firmly, with the clamp pressure coming over the contact surfaces around the fin, otherwise the mould will be cracked. Prop it up with the open top level, and place the key pieces in position. Now fill with resin until these keys are gripped well, and all narrow places filled up. Try not to get resin on the body of the mould which will give the plaster its impression. At times this may be impossible because the resin has to be run in, in a stream across the surface of the mould, to get it there at all. Where such smears of resin have occurred, wait until it is rubbery before peeling it off, when it should come away cleanly. If the mould leaks, the holes can be plugged with Plasticine (oil based modelling clay), but a properly prepared mould should not leak. This outline of procedure for the tail applies exactly to all the other fins. The pectoral fins can be done together, and if the piece between the pelvic fins is sawn in half longitudinally, they too can be done together. In any case, for one-at-a-time technique, the back half of the mould will have to be sawn up until there is only one fin impression on each piece. This is to avoid pulling the mould pieces apart between casting the fins and casting the body, which is a rather undesirable practice. It can lead to complications, if the fin, although formed in the mould, cures without its support. With a little dexterity, more than one fin can be made at a time.

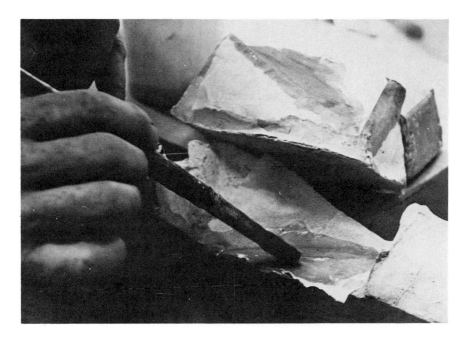

Fig. 2.7. Applying the resin. Photo H. Hughes. Courtesy of The Australian Museum.

If no hole can be made in the back piece to work through, then it is better to saw off the head with no fin attached. The problem that will arise immediately is that when the ventral fin is level, the pelvic fins are aslant. As such cases arise, put only enough resin on the mould so that little excess is squeezed out to the top, and close the mould when the resin has passed into the treacly stage. Now each fin can be topped up individually and supplied with keys. Provided no grease gets onto it, one layer of resin will bond perfectly with any subsequent layer. The same method will apply for the production of long, curved fins such as the dorsal in bream and luderick. The fin, of course, could be filled in one pouring, but resin is prohibitively expensive compared with plaster, and the shrinkage of such a volume of resin would leave a gap into which the plaster could flow and give a double impression.

Any prominent spine or delicate feature of the fish that would be risky to recreate even in artificial stone can be made in plastic by placing a small circular dam of Plasticine around it, filling this with resin, and removing the dam when the resin is at the jelly stage. An important example of this is the fleshy processes that exist on some fish; some of these, such as the whiskers of catfish, may be large enough to warrant a separate mould piece. With these, there is rapid dehydration of the member between the pouring of the two pieces of plaster enclosing it. The result is that the cast will be only a rather shrivelled replica of the original unless its fullness is replaced by scraping when the mould is prepared. If the fish is very spiny, a casting method described further on in this chapter will be more suitable.

Before pouring the plaster body, a cupful of water should be poured into the mould and swilled about. If there is any doubt about the security of any pieces of the mould, the clamps must be left on, though usually the resin will have effectively glued them together. The ultimate support of the cast must be considered, too, and the wooden block becomes a bit outmoded at this stage. Brass nuts soldered to a bar are a vast improvement here, and two holes are drilled through the back piece to take the bolts that hold the fixture in place in the mould. The body of it will have to be introduced before the head piece is clamped on.

Tip out the excess water and pour the plaster in in small quantities, swilling it slowly back and forth between each pour, to get it around all the fin keys. It takes a tricky bit of manipulating to get the last bubbles out, and, as the plaster sets, it will subside in the hole and must be topped up. Also, as the plaster reaches its final set, the swelling will probably crack the mould. It is better that this happen than the mould be so strong in resisting that the layer of separator grease be obliterated and the surfaces of cast and mould tightly stuck together. If the specimen is a big fish, the body can still be made as a plaster shell reinforced with fibre, as described earlier. In this case, as before, the wooden block is still the best fixing method.

A fixture suitable for attaching casts to upright, flat surfaces, where no access to the back is possible, is the keyhole plate. Attached right way up on a wall, or upside down on a fish, the hole is slipped over a protruding bolt-head and gravity does the rest.

There is a second method for a two-sided cast which allows presentation in any direction. It will be seen clearly, from a look at the back side of a cast made by the preceding method, that, even if it were complete, it would be unfit for any sort of presentation. This is because as the mould has been kept upright during pouring, all air bubbles and excess water have collected at the top and ruined the surface. As all air and excess water cannot be entirely removed from fluid plaster, it must be kept to the interior, and a good surface established all over.

If there is no existing hole in the mould to work through, a small opening should be made where the surface detail is not very pronounced or complicated, and a piece of dowel rod made as a plug. The mould is completely assembled from how ever many pieces it has been divided into and preferably tied with cords tightened with wedges, as G-clamps are unwieldy here. With a small quantity of plaster poured inside, the mould is tumbled until a thin film of plaster is spread over the entire inside surface of the mould. The superfluous plaster is then poured out, and the casting allowed to set awhile. This procedure is repeated with a series of slips until a fair thickness of plaster is built up, and then the casting allowed to fully set (Fig. 2.8). This method is not advisable for use with a fine-grained plaster where the layers are liable to separate.

Fish casts made as just described have two disadvantages. First, the cast will nearly always turn out with one flat side giving it a lopsided appearance. Second, the cast is heavy. Merely being heavy is not so objectionable unless it is coupled with an awkward shape and delicate fins.

The flat-sidedness is a fundamental fault of the moulding technique — the fish's body receives no proper support while the first side is poured. If the body is flaccid, the flatness is automatic with the placing of the fish on a hard, flat surface. Shaping the clay packing to give more support is a frustrating job because of its difficulty. It is better to freeze the fish with the body properly supported in a sand tray. Carefully done, this will give as nearly correct a shape as is possible with a dead fish, but it imposes a strict time schedule. Moulding cannot begin until ice no longer forms on the outside of the fish, as water in the plaster will form ice crystals on the skin of the fish and destroy the surface detail. Also, as the fish thaws and the ice in the body melts, it will shrink, and this will cause a slump when the mould is turned over, with consequent discontinuity of the surface at the join in the mould. This is a common and serious trouble, and if there is any doubt about finishing the moulding in time, the fish had better not be completely frozen.

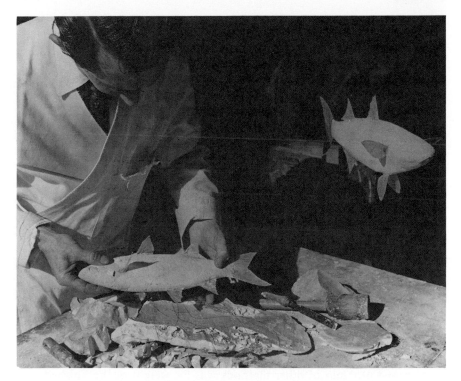

Fig. 2.8. A plaster fish with polyester fins. Courtesy of The Australian Museum.

The essential point is to evenly distribute support while preserving the normal curvature of the fish's body.

This desired support can be achieved, and moulding speeded up, by pouring a quantity of quick plaster within a low-walled dam, in area somewhat bigger than the fish. When this is just starting to thicken, the fish is pressed into it to a depth of the midline. If depth is insufficient and the plaster level not up to the midline, it can be quickly remedied by adding more where necessary. Some ladling of plaster is bound to be necessary in most cases, and care should be taken to keep the plaster line on the fish as neat as possible. Tools needed are a pair of tweezers, a wooden modeller's knife with a sharp tip, a small soft brush, pins, swabs of cotton wool, teaspoons and tablespoons, and a penknife.

Care should be taken to avoid a tendency to push the unpaired fins out of the horizontal plane and into rather windswept angles, and also to avoid burying the ends of long isolated rays. A considerable amount of difficulty will be met with if the fins are crumpled and will not stay out in a relaxed state, in which case they will have to be pinned or tied. A generous amount

of plaster has to be scooped away to allow the lower pelvic fin to be extended properly; if this is left until last, the plaster should be firm enough to permit such manipulation. Splashes of plaster on the fish can either be left to set and flicked off, or washed off immediately with a soft brush loaded with clean water. It is difficult not to get plaster on top of the fins, so a fair amount of brushing is inevitable.

After this piece of the mould has been completed, treat the small bit between the pelvic fins, and then treat the top side as detailed above. An obvious advantage of this method, where no clay is used, is the avoidance of the annoying double impression given when a fin comes loose from the first side. This, however, only applies to casts intended for wall mounts. Where a two sided cast is required, the leading edge of fins should be undercut in the pressing operation, as if the plaster were clay. In many instances, this first piece will show large and alarming bubbles of air, so it is useless as a final mould. The fish is therefore turned as usual and the first pouring discarded so that the underneath side can be moulded similarly to the top. If the pectoral fin is elaborate or expansive it must be covered with a piece of paper, smaller than the side of the fish, before it is pressed into the plaster, otherwise it will become hopelessly trapped and make a two sided mould impossible. Throughout this method there are no forces, bar its own weight, exerting any crushing effect on the fish. The reason for freezing or hardening it up is to eliminate even this factor as much as possible.

A second problem of other methods was the weight of the finished cast. This has been more than satisfactorily overcome by creating the whole cast in plastic; for example, a 2 m marlin cast can weigh less than 4 kg. This technique was developed to enable casts to be hung by a single, fine strand of nylon. The two halves of the mould are now easier to handle when they are entire; and there is no necessity to have any openings left to work through, a fact that brings us at last within reach of a perfect cast. The mould should be prepared with meticulous care and given at least two coats of the beeswax separator. If the mould has been made in at least more than two pieces, by reason of the position of the fins, it should be reduced to two pieces, by casting the pectorals and one pelvic fin.

A thin film of quick setting resin is brushed on to the mould, up to the contact surfaces but not onto them — any that spills there must be carefully removed after it has gelled. Neither should the resin be put on the fins unless they are thick and fleshy. This generally means that it will go on the fins only on big fish such as marlin and groper. But even here, if the fin has some thin membranous parts, they should not be coated. While applying this film all over, the opportunity to fill any small spines, the edge of the operculum, and so on should be taken. The resin will also tend to drain down and lie in a pool

in the middle of the mould. It should be prevented from doing this by collecting it and spreading it elsewhere. Do not scrape the mould with any hard tool. The resin must be allowed to set completely before proceeding, and any attempt to work on it beforehand will risk tearing it and pulling it loose. If it has to be left for periods of days or weeks, precautions should be taken to prevent airborne grease from contacting it. This film secures all the surface texture of the mould and prevents any bubbles trapped in the reinforcing layer from opening onto the surface. Provided it is kept thin, it will not be affected by the usual contraction of setting, and will remain firmly in contact with the mould. If it is left with a thick edge, or allowed to set in pools, contraction will cause a separation, and the edge of the thick section will be lifted. The next application of resin will then fill this gap, giving a second impression and flowmarks.

A thick layer incorporating fibreglass mat or a woven fibreglass cloth is now spread on top of the first layer. The mat is the most satisfactory, both because of its behaviour after wetting with resin, and its ability to hold the resin within its structure on a curved mould. It is advantageous with big fish to turn the mould on its long axis when doing this part, and lay the glass in separate dorsal and ventral strips; perhaps even three strips if the tendency of the resin to drain around the curve is too great. For easier wetting, and the best exclusion of air bubbles, spread some resin on the mould first, and press the glass into it, adding more resin on top. Small bubbles trapped in this layer are no disadvantage, but large ones should be removed.

What was said above about contraction lifting the edges applies even more to this layer of the work because of the greater bulk. The glass should be brought up almost to the contact edges all around, but feathered off without soiling the contact faces. The practice of taking the glass beyond the edge, then cutting it back, is an amateurish one and will result in an ugly join because the mould is softer than cured resin. Fibrous materials other than glass can be used for this reinforcing work; hessian, for example.

The addition of fillers to the resin to alter its physical properties is standard practice, and a wide selection of fillers is available. Inert fillers have no effect on the setting of the resin unless used in massive quantities. In powder form fillers will continue to pour at all good spreading consistencies, and long fibred fillers such as chopped glass tend to ball on the stirrer and not spread at all.

The addition of a mixture of equal parts talc, glass wool and Aerosil (SiO_2) until the required stiffness is reached will make a resin paste which will stay exactly where it is put. The method here is for the filled resin to be arranged around the contact faces so that the closing of the mould extrudes it back into the interior cavity of the mould, and effectively seals the joint. As this joint

may contain the impression of up to five separate fins, all fins will have to be done simultaneously, and, depending on circumstances, they may have to be done differently. The filled resin may be unsuitable for casting the fins because it is opaque, or because it contains too many hard lumps. The filled resin also contains myriads of small air bubbles which make it unsuitable for any part of the mould that has not already got the surface film on it. Small or thin fins will have to be formed by the established technique with plain resin and paper and, as there is nothing to stop this from draining away under gravity and ruining the job, judgment of the right moment to close the mould must be dead accurate. After closing, as a further precaution keep what fins there are horizontal or pointing downwards, with the main exhibition side underneath.

Mix a quantity of resin (moderately catalysed) and add filler mixture by the spoonful until it remains in place when pulled up the side of the container. Spread this with a palette knife or brush right around the edges of both halves of the mould, overlapping the finished glass work, and a little onto the contact faces (Fig. 2.9). Build up and strengthen the area where the supporting cord will enter the fish. Carry this thick mixture across the base of the fins to dam up what is placed on them later. Then, mix enough resin for the fins, more heavily catalysed, and quickly apply it as described earlier. When this is passing through its treacly stage (the filled mix should not yet have gelled), it is the right moment to close the mould (Fig. 2.10). With a series of G-clamps apply all the pressure that the mould will safely take. Remnants of resin squeezed out into the air can give a false idea of setting conditions, so do not open up the mould too hurriedly.

Uneven depressions in the mould can be levelled out with this filled resin before the glass is laid in. This is often a great help where the pliability of the glass is not enough to let it follow the surface closely. Small fish can be done entirely in filled resin without using glass at all, as it becomes difficult to manage over small and tight curves.

To support such a cast by a nylon thread, find the centre of gravity and drill a small hole through the casting. Tie one end of a thread around a short length of strong fine wire, bent like a boomerang. Insert this toggle into the fish and pull taut. Always allow a generous margin of safety over the breaking strain of the thread.

Prepare a site for the lens by building a smooth low mound of Plasticine on the eye of the fish mould, thus forming a concavity in the cast. Grind a lens shape from a section of already set, clear polyester so that it will neatly fit the cavity of the eye socket. Paint the required colouring on the cast and, when dry, set the lens into it with a quantity of slow setting resin. Fast setting resin used to glue in a lens will cause mirroring, and lenses ground out of acrylic will craze in the resin before it sets.

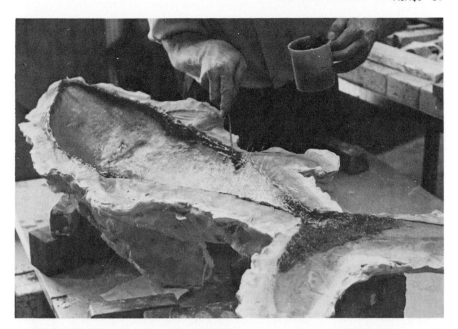

Fig. 2.9. Filled resin is applied to the edges of the cast. Photo H. Hughes. Courtesy of The Australian Museum.

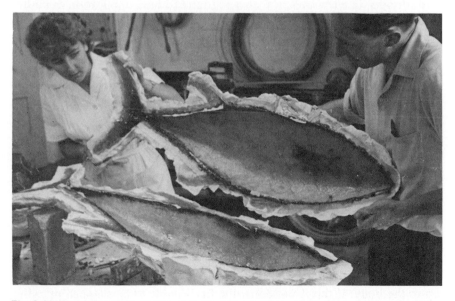

Fig. 2.10. The two halves of the cast are joined. Photo H. Hughes. Courtesy of The Australian Museum.

Demoulding the cast

Whichever method is used to construct the cast, and whatever type of cast it is, the same basic plan is followed for removal of the mould. In the first place, these can only be considered as waste moulds, and that is why a soft, fine plaster in the minimum quantity, and unstrengthened with fibre as far as possible, is demanded. Do not try to take advantage of the rubbery state of the resin and remove the mould intact. The filled resin offers little resistance to tear and parts of the cast may be setting more slowly than others. Very small sections, or small fish, should be allowed to completely cure for several days before any attempt is made to chip away the mould. None of the preceding methods is intended as a quantity production technique, and, in the event of duplicates being necessary, it is more satisfactory to prepare a separate mould for each. A convincing fish cast can hardly be conceived without undercuts, so any thought of quantity production will entail the use of a flexible mould.

Only general pointers can be given as to how to attack a mould with a mallet and chisel as each job will have its special features. In the first place, the chisel should be sharp but not too acutely angled, and at least 1 cm wide. A narrow chisel tends to dig too deep before the plaster fractures and the flake comes loose, although they are essential for narrow places. Longhandled screwdrivers, in a few sizes, will also be found to have application as plaster chisels.

Always consider the way the force of each blow spreads fanwise from the point of the chisel, and place it so that most will be gained by getting the largest and easiest chip. When searching for the tips of hidden spines, the course of flaking fractures should not be directed at right angles across the spine. The same applies for other delicate features and the edge of fins, though here you have the waste margin around the fin as a guide.

As an example, take a two-sided cast with all the fins spread. Begin by removing the small pieces, the pectoral fin caps and the bit between the pelvic fins. Chip away as much of the bulk of the piece as is possible while still leaving as much as possible of the surfaces that contact the cast, and hold it firmly. Then, when removing this remaining part, work from the edge of the fins back to the body so that no large lump of plaster is left hanging by the thin fin should it shake loose. As each fin is fully uncovered on its first side, slide a thin knife blade under the edge and gently lever it loose from the supporting plaster. The edge of even the thickest fins will have sufficient elasticity to allow this, and the separation does not have to be brought right up to the body. If this is not done, the fin is liable to be snapped off when the other side of the plaster mould is being removed. It takes extremely careful chiselling to get the plaster from under the pectoral fin.

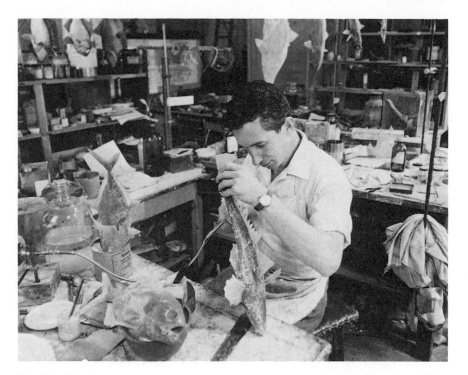

Fig. 2.11. The dental drill is a useful tool for cleaning up the cast. Courtesy of The Australian Museum.

When one side of the body is clear, turn the cast over and support it on padded, parallel bars to do the other side. Undercuts which form the main anchoring points holding the mould should be released after the fins. In most cases, by the time this is done, the vibration will have so loosened the mould that it can be simply lifted off.

Accidents will always happen and pieces will be broken off. Fins can be glued back using a quick setting resin mix, and a suitable support to hold them straight. Do not allow Plasticine, or other greasy substances including perspiration, to get into the broken surfaces.

If the pieces that are broken off are lost, the gap will have to be built up to make good the loss. Lay a piece of tissue dipped in resin against one side, and after this has set, turn the fish over and build up the gap until it is overfull. Grind off the excess with a dental burr when everything has set, replacing the detail of the fin rays. Bubbles and other cavities which may open onto the surface should be treated in the same way (Fig. 2.11).

If the cast is extracted soon enough, the waste margin around the fins may be cut off with scissors. Even after curing, it can still be trimmed with scissors

if the heat of a Bunsen burner is applied momentarily to soften the resin. Once the resin is cured, another method is to saw the waste off with a cross-cut fissure type dental burr. The seams on the body of the cast can be trimmed away with a round-headed burr or file. If any thin skin of plaster is left sticking to an all-resin cast, it can be removed by playing a flame from a Bunsen burner over it, and gently scraping at the same time, or it can be soaked with sodium acetate and scrubbed off with a stiff brush. The presence of any remnant of the mould indicates either insufficient catalysing of the gel coat, or, more likely, an insufficient application of wax separator.

Moulding very large fishes

Handling large specimens creates special problems. Because of its weight, a large fish can be too heavy and bulky for one person to handle; it is often necessary to recruit one or two assistants for the work. In many instances it is practical to do the work out of doors, especially on the beach. Wet sand is an ideal base for the fish to be laid out on. If a one-sided cast will suffice as the final product, the procedure of preparation is as follows:

The specimen is laid out on the sand with the better side showing. The surface of the skin is cleaned with alum water. Sand is built under the fins (Fig. 2.12) and the sand is smoothed all around the fish. The pectoral fin and ventral fins are cut off in order to save time. If the specimen is to be moulded with its mouth open a mould is made from the mouth's interior first. The throat is plugged with wet newspaper or some other suitable matter and a splash coat of plaster is applied to the interior of the mouth. This is done by splashing a thin plaster mix into the mouth by hand, covering only the surface of the interior but not filling it up. This is followed up immediately with a thicker mix and the thickness of the plaster coating is built up. Finally the whole interior is filled with plaster, forming a solid plug (this can be seen in Fig. 2.12). Once the plaster has set, the surface which is showing is painted with oil.

Now, the entire fish is coated with a thin plaster mix which is worked into all details of the surface. A good working speed is necessary and this first layer of plaster must be followed up by another batch of somewhat thicker mix. While this is applied to the fish, the assistants should prepare a further batch, a little thinner this time, and handfuls of prewetted sisal should be dipped into it. The plastery sisal is laid on the fish as evenly as possible, increasing the thickness of the mould until it becomes thick enough; how thick the mould should be depends on the quality of the plaster and the size of the specimen. Finally, lengths of steel are embedded with bundles of plastery sisal on top of the mould. These serve as additional reinforcement to the mould and also as handy grips when the mould is to be shifted.

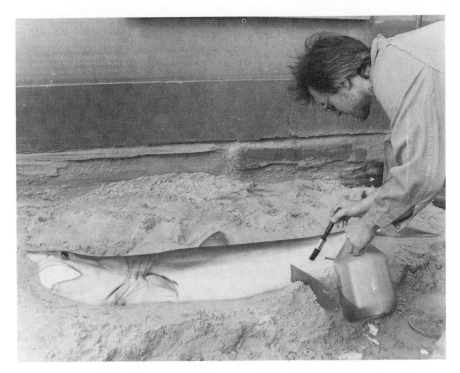

Fig. 2.12. The fish is laid on a bed of sand prior to moulding. Photo Kate Lowe. Courtesy of The Australian Museum.

After a suitable period the mould is removed. The cut off fins can be moulded later, or if there is time, at the same time. The further treatment of the mould and casting procedure (large fishes are always made in fibreglass) is the same as described above.

However, as the cast shows only one side of the fish its reverse side will be hollow. It has to be reinforced with wooden struts horizontally and vertically. The struts are fibreglassed into the cast and fittings for hanging (if the cast is to be hung on the wall) can be fastened to them.

If a full reproduction, showing both sides of the fish, is needed, the other side also has to be moulded. In order to do this the fish has to be turned over. This can prove to be a very difficult manoeuvre if the specimen is large. However, it is better to do it on the soft sand of the beach than on hard ground where the mould could break more easily. The mould must be strong enough to withstand such a test of strength!

Once the fish has been turned over, the surface is cleaned of sand. The best method is to use a dry brush first, then water. The surrounding plaster surface is also brushed clean and oiled thoroughly. If there are any holes, protrusions

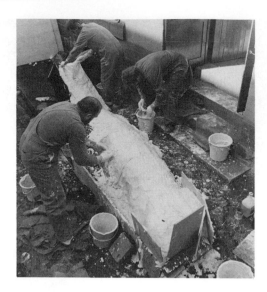

Fig. 2.13. A large shark is being moulded. Photo J. Fields. Courtesy of The Australian Museum.

or any other undercuts on the plaster they must be eliminated, either by filling with wet sand or clay or by carving. The pectoral fin on this side is also cut off. The entire surface of this side is moulded in the same way as the other side. This piece of mould is also reinforced with sisal and steel, then the plaster is allowed to harden (Fig. 2.13). Once hardened, the mould is opened and the fish is removed.

Large moulds must be treated with chemicals to prevent fungal and bacterial growth in the plaster. Carbolic acid solution is best for the purpose. It can be sprayed on the inside surfaces from an atomizer. Vapours must not be breathed in.

It is also possible to use polyester resin and fibreglass mat or cloth to make a fish mould. The fibreglass mould is lighter, stronger and also cheaper, especially if it is made of a very large specimen.

Incorporating fish parts in the cast

Sometimes it proves to be too difficult to reproduce an intricate part of the specimen's anatomy. For example, the mouths of some fishes have very complicated formations and, if these are bony, the preparation of a rigid mould is impossible. The most practical way to handle such problematic specimens is to incorporate these complicated parts in the reproduction.

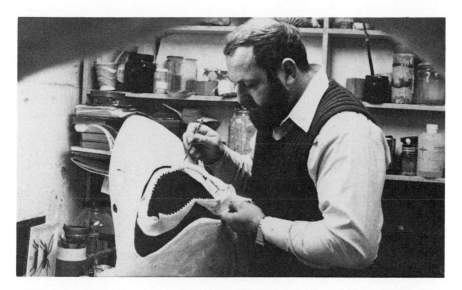

Fig. 2.14. The preserved jaw of the shark is being fitted in the fibreglass cast. Photo J. Fields. Courtesy of The Australian Museum.

The specimen is prepared as described above by moulding and casting. The part intended to be incorporated is cut out of the fish after it has been moulded and cleaned of all flesh and fat. If the part in question is the jaws of a shark, care is taken not to injure the cartilaginous tissues. The whole object is immersed in 10% formalin for a few days in order to preserve it.

After it has been preserved, it is taken out of the formalin and briefly dried on the surface. It is also rinsed with acetone to remove all fat from the surface. The cast of the specimen is now prepared to receive the preserved part. The section is carved with a dental drill and, after some test fitting, it should accommodate the preserved part. It is first wired in securely and then it is puttied in, using an epoxy compound which is compatible with water-wet substances. If this compound is unavailable, the object is wired in the required position and left to dry. After drying, polyester resin is filled with a filler until it becomes putty-like, catalysed and then is used to cement the preserved part to the rest of the cast (Fig. 2.14).

Parts of large fishes (for example, marlin bills) could contain large quantities of fat which cannot be preserved and therefore must be removed physically. The marrow-like fat is simply scooped out from the interior of the bill, together with fragments of bone tissue. The bill is soaked in a degreaser solvent for a few days and occasionally agitated. After it becomes relatively fat free it is preserved in 10% formalin, as mentioned above. Once preserved,

it is left to dry in a well ventilated, dry room. Sudden drying must be prevented, otherwise the bill may warp. The cavity is filled with the polyester filler compound and a suitable metal rod is embedded into it. As the resin sets hard the rod becomes solidly attached to the bill. The protruding end of the rod serves as a fixing point by which it can be attached to the cast. The same polyester putty can be used to cement the rod to the cast. Where the bill joins the cast gaps could occur. These are also filled with polyester putty and the filling is sanded smooth after setting hard.

Making artificial eyes for fish

Excellent quality glass eyes are available for most animal species and many manufacturers are willing to take special orders for out of stock items. Fish eyes are also available in just about all sizes but they are not made with the same perfection as those meant for warm blooded animals. The colouring and pupil shape is so varied in fishes that no manufacturer could possibly gear up to mass produce eyes for all species. At most times, glass fish eyes with clear, uncoloured irises can be purchased in many sizes. However, the pupil shape is always the same, roughly resembling a tear drop (Fig. 2.15). If one desires a perfectly shaped pupil and the correct coloured iris, consideration should be given to making the eyes in the house. To make artificial eyes in polyester resin is not so difficult, although it is somewhat time consuming.

A selection of glass fish-eyes is laid out on a bed of oil-based modelling clay (Plasticine or Plastiline). The flat backs of the eyes are gently pressed into the clay, but only a "hair breadth" deep. A ribbon of clay is put around the bed and catalysed silicone rubber is poured on the eyes. Some silicone rubbers do not set if poured on oil-based clay. To counteract this undesirable characteristic of the rubber, the clay surfaces have to be painted with shellac before moulding. Once the rubber sets it is peeled off; the eye mould is made and it is ready for casting.

Fig. 2.15. The typical shape of a pupil in a fish eye. Drawing by G. Hangay.

A small amount of embedding resin (crystal clear polyester resin) is poured in the impressions of the mould and left to set. Using black paper, the appropriate shape of the pupils are marked on and cut out. These paper pupils are glued on the set resin with small amounts of the same freshly catalysed resin. Care should be taken to avoid small bubbles under the paper.

The colour of the eyes is also created on this side. The technique employed depends on the nature of the eye to be made. If the iris of the fish's eye is coloured with many small specks of colour, or the pigmentation if grainy, coloured chalk is scraped on the still tacky flat back of the polyester eye. Silvery or gold effect is achieved by sprinkling silver or gold dust. Solid, even colours simply can be painted on the flat back of the eye, or a more intricate pattern can be painted with a fine brush, or sprayed with an airbrush. Once the required colour is achieved the eye is left to dry. After drying, the eye is ready to be installed in the specimen.

TAXIDERMY OF FISHES

Most authors dealing with this subject agree that a skin mount cannot be as lifelike as a good quality plastic reproduction. However, fish taxidermy is considered as a known method of preparing display specimens and therefore it should be discussed here, if only in a condensed form.

There are many different ways of mounting fish skins; techniques range from the most primitive to the most elaborate. The results vary but the outcome of the work depends on the method used as well as on the dexterity of the worker. The nature of the species plays a great role also. Some fishes are relatively easy to prepare, some are impossible.

SKINNING

The specimen is collected and data are recorded as described above. In addition, a contact drawing is made. The fish is laid on a sheet of paper and its silhouette is traced. If there is any danger that the specimen may spoil, the surface is swabbed with 2% formalin. If formalin is used on the specimen, rubber gloves should be worn during skinning.

The fish is examined for faults (for example, wounds or scars) and the better side, which will be the "show" side of the finished specimen, is selected. With this side down, the fish is placed on a few layers of newspaper on the table. The initial cuts (Fig. 2.16) are made with a sharp scalpel or knife and the skin is carefully peeled away from the flesh. This is best done by thrusting the handle of the scalpel (or the handle of a tablespoon) between the skin and flesh and gently prying them apart. Care should be taken to avoid losing too

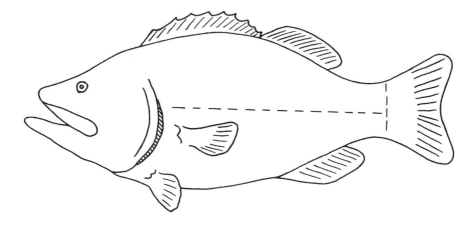

Fig. 2.16. The opening incisions on a fish to be skinned.

many of the scales. If excessive loss of scales occurs (especially on the show side) the specimen becomes worthless for taxidermy purposes.

Once the base of the dorsal fins and the ventral and anal fins are reached, these are cut through and the skinning continues to the other side of the fish. The base of the pectoral fin is cut through as well. While peeling the skin off the body an attempt is made to lift the body then pull the skin off it. The base of the caudal fin is also cut through, thus freeing the tail. While holding the tail in one hand, and pressing the skin to the table with the other, it is possible to separate the skin by gently lifting the tail upward. The base of the pectoral fin on the other side is also cut from the body. At the other end of the body, the spinal column is also cut just behind the skull. It is now possible to lift out the whole body from the skin.

If the fish was preserved in formalin in the field it still can be skinned. It is very unpleasant and unhealthy to work on a formalin specimen. To counteract the strong odour of formalin, the specimen is thoroughly washed in running water, then soaked in a solution of sodium bisulphite and sodium sulphite. This soaking can only be brief enough to diminish the strong smell of formalin. Rubber gloves should always be used when working with such specimens.

Once the fish has been skinned, the skin's flesh side is cleaned very thoroughly of all flesh and fat. The bases of the fins are cleaned with a small wire brush or with a taxidermist's metal comb. The head is hollowed out as much as possible, using strong sidecutters or tinsnips to cut away all the flesh

and bone. Care is taken to avoid damaging the outer bones of the skull and face, which give the shape of the head. The flesh of the cheeks is removed through a hole cut in the bones of the preoperculum and operculum. The eyes are removed and the eyesockets are also cleaned out.

It is easier to clean a specimen preserved in formalin than a fresh one. Some taxidermists prefer to pickle the uncleaned skins to "firm up" the tissues; they clean the flesh side only afterwards. The simplest pickle is 75% alcohol (ethanol or methanol); an immersion of from 15 to 30 minutes firms the flesh and prevents spoiling the skin. The skin may harden a little, but this can be counteracted after flesh removal by washing and cleaning it in cold water with a little detergent. At this stage formalin is unsuitable for pickling, since it fixes the skin. Once the skin has been treated with formalin its shape also becomes "fixed" and cannot be manipulated at will any more. If an unskinned specimen is treated with formalin the skin is fixed in the right shape but a skin without the body is not in the proper configuration.

If the skin is clean of all flesh, but appears to be too fatty or oily, it must be degreased. Any of the commonly used degreasers would do the job; chloroform, acetone, trichloroethylene or trichloroethane (Genklene) can be used. The skin is immersed in the degreaser fluid and gently agitated for a few minutes. After this brief period it is removed from the fluid, rinsed in cold water and preserved.

If the skin has been already pickled or the specimen was preserved with formalin prior to skinning no further preservation is needed. Untreated skins can now be preseved by an immersion in 75% alcohol for 15 to 30 minutes, followed by immersion in a saturated borax solution for another 15 to 30 minutes. The latter not only insectproofs the skin but also relaxes it after the alcohol bath. After this treatment the skin is ready to be mounted.

Using the skinned body and the contact drawing as reference, the contours of the fish's body are transferred to a slab of rigid foam (preferably on 64 kg m^{-3} density polyurethane foam). The contour is cut from the slab and an accurate duplicate of the body is shaped using a rough wood rasp and various grades of sandpaper.

After test fitting the skin, the artificial body is marked where the fins join the body. Small depressions are carved into the foam body at these places to accommodate the bases of the fins. The side where the skinning incision was made on the original body is fitted with a piece of flat timber. The timber must be strong enough to accommodate two timber screws later on.

MOUNTING THE SKIN ON THE ARTIFICIAL BODY

A stiff modelling compound is made (as described in Formulae). The skin is checked once more for cleanliness. The head must also be cleaned of all flesh,

Fig. 2.17. The fins are "sandwiched" between pieces of cardboard while drying.

fat, and so on. If it is impossible to clean the head completely, the inside is brushed with 10% formalin. Soon after application of the formalin the head is filled with the modelling compound. The compound seals in most of the unpleasant smell of formalin. It is also practical to use an electric fan to drive the fumes away from the worktable.

The flesh side of the skin is painted with a thick coat of body paste (*see* Formulae) and the artificial body is inserted. If the skin seems to be a little too loose at the bases of the fins it can be remedied by careful filling with modelling compound. Filling must be done very carefully; the skin must not be overfilled and the shape of the body, which was copied from the natural body, should not be altered by it. The slippery body paste assists the moving of the skin over the artificial body. Once it is in position the incisions can be sewn up, using a surgical needle and waxed thread.

The fish is turned over now with the display side up. The fins are posed in the required manner. Their positions are fixed by pins which are inserted at their bases, and pushed through the skin into the body. The fins themselves are sandwiched between pieces of cardboard held together by pins, paper clips or small alligator clips (Fig. 2.17).

The eye socket is filled with modelling compound and the artificial eye is set. In most cases, skin mounts are displayed on the wall, showing only one side of the fish. Such specimens do not need to have both eyes installed, since the eye on the wall side is not visible to the viewer. The eyesocket on the wall side is simply filled with modelling compound. To prevent curling of the edges

Fig. 2.18. A simple drying rack for taxidermied fish.

at the preoperculum, operculum and the branchiostegal area, these are pinned to the head and the body with fine insect pins.

The fish is laid on a drying rack (Fig. 2.18) and left to dry in a well ventilated, dry room. Slow, even drying is best. The drying process should be checked from time to time and distortions due to shrinkage, warping and so on should be corrected immediately.

FINISHING THE SPECIMEN

The completely dried fish is freed from all the pins, cards and other supporting matter. Damaged fins can be repaired first by replacing the missing membrane. The membrane is replaced by placing a piece of fibreglass surfacing mat on the wall side of the fin. The mat is trimmed to the right shape and a small amount of catalysed polyester resin is painted on it. Once the resin has set the mat is bonded to the fin. Missing rays are replaced in the following manner: small lengths of thread of appropriate colour are cut. The repaired patch on the show side of the fin is painted with a small amount of catalysed polyester resin and, before the resin sets, the pieces of thread are laid on it in a fashion which resembles the formation of the rays of the fins. After the resin has set, another fine coat of catalysed resin is painted on the show side of the entire fin, giving it a uniform surface. This surface will appear more glossy than the rest of the fish, but, after the specimen's colours are restored by spray painting and a final high gloss top coat is applied to it, this difference will disappear.

Shrinkage and distortions on the head can only be remedied by modelling. An epoxy compound which is slightly translucent is ideal for this work. Once

set, this compound (*see* Formulae) resembles unpigmented wax, but is more permanent. It can be worked like a water based modelling compound and if it needs to be thickened it can be filled with any of the usual fillers (kaolin, talc, or whiting). The interior of the mouth can also be modelled with this compound.

The same compound can be used to model over the seams on the wall side. Although this part of the specimen is not visible, it is a good idea to seal it completely. This minimizes the opportunity for insects to penetrate the interior of the mount. Once all the repairs and filling have been completed, the specimen is ready to receive the paint and lacquer.

The above technique is just one of many practised by taxidermists all around the world. Information on these can be gained from the literature listed at the end of this chapter.

COLOUR RESTORATION

There is no known method, apart from painting, which can be used with certainty to preserve the colours of all fish species. The colour preservation technique mentioned previously works well on some wet preserved specimens, but proves to be ineffective on a dry mounted fish.

The most efficient way of restoring colours on a fish (a reproduction or a skin mount) is to apply a variety of dyes, stains, paints and lacquers to the specimen. The methods of application could vary a great deal. The colours could be simply wiped on, painted on by brush, or sprayed with spraygun or airbrush. In some cases pigments, dyes, and pearl essence are incorporated in the casting resin to give the cast an initial colour or special effect.

Some skin mounts can be coloured effectively by wiping the colours on them. This technique is used by amateurs who lack sufficient equipment to carry out more efficient and elaborate colouring methods. Also it can be employed by smaller provincial museums, or those with limited funds. The technique is as follows: the dried mount is painted with a coat of clear varnish. This usually brings up some of the original colours in some species, but, if the skin has intricate patterns of dark pigmentation (for example, various freshwater trout species), these will certainly show up more vividly. The hues of colours which have disappeared after the curing of the skin are simply wiped on once the varnish has dried. A ball is formed from a lint free cloth (often old nylon garments are used) and dipped in thinned oilpaints. The paint has to be thinned to the consistency of a wash and it is applied very subtly. The pattern of the natural colouration of the skin, or the remains of it, must not be obscured by the paint and the fine surface detail of the skin should not be clogged. Wipe marks are eliminated by dabbing the surface with the ball of cloth where necessary. The colours are applied one by one,

starting with the lightest one and gradually proceeding to the darkest. Although this technique sounds crude and primitive the results can be astonishingly good when the technique is executed with sufficient experience and expertise.

Once the required colour effect is achieved, a top coat of high gloss varnish or lacquer is applied, either by brush or sprayed. If spraying equipment is not available, pressure packed paint or lacquer can be used for top coating fish.

In order to colour a skin mount or a fish cast to the closest possible resemblance to a live specimen sufficient reference material must be kept at hand.

Reference books with detailed descriptions of the fish are of great help since more can be learned about the species than by looking at the specimen or pictures alone. Colour photographs and artists' impressions of the fish are also of enormous value. A number of photographs show the fish in a variety of angles, light and position. Artists' paintings and drawings highlight the aesthetics of the species. This, of course, must be judged and followed with caution, since artistic licence should not play a great part in true to nature colour restoration.

Good quality colour transparencies are the most practical aids for the preparator during the colour restoring process. The transparencies are too small to be used directly. A conventional projector needs a darkened room; therefore, it is not practical to display the transparencies this way during the colouring process.

A slide projector still can be used if a light box attachment is added to it. This can be made of plywood and a piece of translucent white glass or acrylic (Fig. 2.19). This latter acts as the screen on which the transparency is projected.

Fig. 2.19. Slide projector fitted for back projecting. A. Projector. B. Plywood or cardboard box. C. Translucent screen. Drawing by G. Hangay.

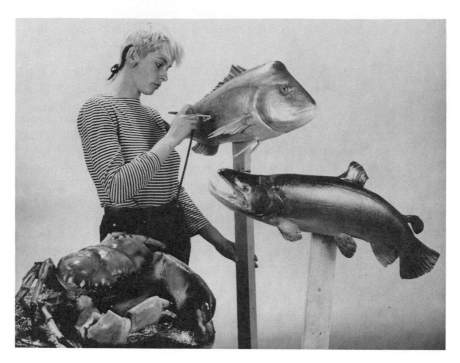

Fig. 2.20. Restoring lifelike colours on mounted fish specimens requires skill and artistic ability. Photo J. Fields. Courtesy of The Australian Taxidermy Studio.

Spray painting the specimens is more effective, and, when high quality is the chief goal of the preparator, this is the only painting method which should be considered. Spraying, of course, can be combined with brush painting and wiping (Fig. 2.20).

A method widely practised by most fish taxidermists is as follows: the specimen's surface is degreased by washing with a solvent. The entire surface, except the fins, is sprayed with a white undercoat. This undercoat is sprayed on sparingly in order to avoid the clogging up the fine surface detail of the specimen. Automotive lacquers are best to use, since they dry immediately. The next coat contains pearl essence. This substance is derived from the scales of commercially caught fishes. Natural pearl essence is far superior to the artificial varieties which are cheaper and used for blending fingernail polish, automotive lacquers and so on. The essence readily dissolves in a number of solvents, therefore it can be mixed in nitrocellulose or acrylic based lacquers as well as into turpentine based paint.

The essence is mixed into a clear lacquer (only a very small amount of essence is used) and this is sprayed on the fish.

Next, the dark spots, stripes and other markings (if there are any on the fish) are sprayed on with a fine airbrush. Sometimes it is necessary to put

Fig. 2.21. An outstanding example of fish casting; a specimen from the Ubersee-Museum in Bremen, Germany, prepared by Klaus Wechsler. Polyester resin cast from silicone rubber mould. Courtesy of Klaus Wechsler.

these often intricate patterns on with a fine brush, or even with a felt tipped pen. Follow this up with a light coat of white on the ventral surfaces.

It is practical to mix some pearl into the white, too, since it is an opaque paint and would cover the previous coat's pearly effect. After this, only translucent and transparent paints are used. The colours are applied one by one, starting with the light ones and gradually progressing to the darkest ones. The translucency of the paints allows the preparator to blend the colours to the required shade on the fish, rather than in the mixing jars. The fine coats of translucent paints do not obscure the patterns painted on at the beginning. As the darker colours are reached the pigmented paints are mixed with clear paints and applied thus.

If translucent or transparent paints are not available, clear lacquer is used as a base and small amounts of opaque paints of the same solvent base are mixed into it. Clear nitrocellulose based lacquer can also be coloured with aniline dyes. Oil paints can also be mixed into some lacquers.

There are many different types of lacquers on the market, and trade names differ from country to country. The best practical approach to fish painting is to experiment with a number of lacquers. A consultation with local experts is also very valuable since certain lacquers behave differently under different climates.

The final coat is almost always a clear, high gloss one. This gives a "wet look" appearance to the fish. If the specimen is to be displayed in a diorama depicting an underwater scene, a glossy top coat is incorrect. Fishes appear matt underwater. For a realistic effect even the gloss of the colour coats should be neutralized by spraying the specimen with a matting agent, or matt clear lacquer (Fig. 2.21).

REFERENCE

Waller, R. A., and W. N. Eschmeyer: A method of preserving color in biological specimens. *Bioscience* 1965: 36.

SOURCE MATERIAL

Adam, H., H. Schirner and F. Walvig: Versuche zur Narkose und Relaxation von Myxine glutinosa L. (Cyclostomata, Vertebrata). *Zool. Anz.* 168/1962: 216–228.

Anonymous: Painting the large mouth bass. *Taxidermy Review* 5/6 1977.

Auerbach, M.: Fischmodellen für die Schausammlung naturwissenschaftlicher Museen. *Zool. Anz.* 71/1927: 281–287.

Bauch, G.: *Die einheimischen Süsswasserfische,* 3rd ed. Radebeul, 1955.

Behrmann, G.: Tiefseefische im Nordseemuseum Bremerhavens. *Der Präparator* 22/2 1976.

Behrmann, G.: Versuche zur Erhaltung von Form und Farbe bei Museums-präparaten von Fischen. *Veroff. Inst. Meeresforsch. Bremerh.* 10/1966: 137–139.

Berry, B.: Painting the brown trout. *Taxidermy Review* 5/3 1976.

——. A judge's observation — what constitutes a good fish mount. *Taxidermy Review* 6/1 1977.

——. The eyes have it. *Taxidermy Review* 6/3 1977.

——. Painting the dolphin. *Taxidermy Review* 6/6 1978.

——. Painting a catfish. *American Taxidermist* 7/6 1979.

——. Painting the lake trout. *Taxidermy Review* 8/1 1979.

——. Painting the walleye. *Taxidermy Review* 8/2 1979.

——. Painting the long eared sunfish. *Taxidermy Review* 9/2 1980.

——. Painting the arctic char. *Taxidermy Review* 9/1 1980.

——. Painting the American shad. *Taxidermy Review* 9/4 1981.

Berube, L.: Neue Verfahren zur Fischkonservierung durch Kälte. *Mh. f. Fischerei* 7/1939: 1–5.

Borodin, N.S.: Effective method of preserving fishes in natural colour. *Museum News* 8/1930: 11–12.

Brandt, A. v.: Fischfanggerate und Fangmethoden. *Prot. z. Fischereitechn. Hamburg* 9/1953.

——. *Fish catching methods of the world,* London 1964.

Brimley, H. H.: Modelling a nurse shark from an embalmed specimen. *Museum News* 10/1932: 7.

Browne, T.: *The taxidermist's manual.* A. Fullarton and Co., London 1853.

Browne, M.: *Practical taxidermy.* London 1884.

Brunn, M. v.: Ein Beitrag zur Museumstechnik. *Abh. Naturwiss. V. Hamburg* 13/1895: 3–9.

Cappel, L. J.: *A guide to modelmaking and taxidermy.* A. H. & A. W. Reed, Sydney 1973.

Cullingworth, A. W.: Methods employed in sealing glass display jars containing specimens in spirit; and of displaying fishes with their natural colours in spirit. *Sama,* Natal (1939) 261–267.

Gilbert, P. W., and F. G. Wood: Method of anesthetizing large sharks and rays safely and rapidly. *Science* 126/1957: 212–213.

Grafe, M.: Sammelexkursion vor Grönlands Küste. *Der Präparator* 26/2 1980.

Grantz, G. J.: *Home book of taxidermy and tanning.* Stackpole Books. Harrisburg, PA 1969.

Hall, J.: Shrinkage. *Taxidermy Review* 6/4 1978.

——. Fish taxidermy (Pro's corner). *Taxidermy Review* 7/1 1978.

Hansen, O. J. W.: Mount your own fish trophies. *Popular Mechanics* 48/1927: 138–144.

Hill, R. R.: Habitat fish groups. *Nature* Sept./1934: 127–128.

Hjortaa, H.: Duplit zum Abguss von Fischen. *Der Präparator* 6/1960: 46–50.

——. Riesenscholle aus glasfaserarmierten Polyesterharz. *Der Präparator* 7/1961: 193–194.

——. PVA dispersion glue as casting medium. *Taxidermy Review* 10/4 1982.

Hope, J. W.: Mounting sharks and large fishes. *Museum News* 9/1931 6–8.

Kaden, J.: Fische in Schwarmen. Eine Abteilung einheimischer Fische im Zoologischen Museum der Humboldt-Universitat Berlin. *Der Präparator* 11/1965: 253–254.

Kaden, J.: Mimoplastik eines Segelfisches, Istiophorus gladius. *Der Präparator* 22/2 1976.

Kish, J.: Points on fish anatomy. *Taxidermy Review* 8/3 1979.

Knaack, J.: Beitrage zur Kenntnis der mitteleuropäischen Cobitiden. *I. Geographische Verbreitung, Biotope und Fang. Aquar. Terrar. Z.* 18/1965: 10–13.

Kolber, M. A.: Embedding fish and other mucus-covered animals. *Aquarium* 21/1952: 6–8.

Kotthaus, A.: Fischforschung im Indischen Ozean. Meteor Expedition 1964/65. *Umschau* 66/1966: 118–123.

Kusahabe, D.: On collection and staining of young fish. *Bulletin of the Japanese Society of Scientific Fishing* 19/1953: 382–383.

Logier, E. B. S.: A method of colouring replicas of silvery fish. *Museum News* 12/1934: 7–8.

Martin, T. R.: *Taxidermy techniques.* Indian Oaks Education Media, Shabbona, Ill. n.d.

Meacham, C. Painting the bluegill. *Taxidermy Review* 8/4 1980.

——. Painting the northern pike. *Taxidermy Review* 8/5 1980.

Merill, L. F.: Improved way to mount a fish. *Popular Science* Aug./1932: 83–84.

Migdalski, E. C.: *How to make fish mounts and other fish trophies.* Ronald, New York 1960.

Moyen, J. W.: *Practical taxidermy.* Somerset, NJ. 1979.

Obata, Y., and K. Matano: A new method to make specimens of fishes. *Bulletin of the Japanese Society for Scientific Fishing* 18/1953: 651–652.

Paclt, J.: *Farbenbestimmung in der Biologie.* Jena 1958.

Pape, H.: Die Herstellung von Fischmodellen für die Schausammlung. *Der Präparator* 9/1963: 193–199.

Phillips, A.: Elevate the lowly cat. *American Taxidermist* 11/1 1977.

——. *Fish painting and identification manual.* Archie Phillips, Fairfield, Ala. 1979.

Piechocki, R.: *Makroskopische Präparationstechnik.* Akademische Geest u. Portig, Leipzig 1967.

Pohl, J.: Untersuchungen über die Totenstarre an Süsswasserfischen. *Z. f. Fischerei N. F.* 2/1953: 421–449.

Porkert, J., Novak, J., and Grosseova, M.: Ein kombiniertes Hautkonservirungsmedium fur dermoplastische Fischpräparate. *Der Präparator* 29/2 1983.

Pray, L. L.: *Taxidermy.* Macmillan, New York 1943.

——. *The fish mounting book.* Modern Taxidermist Greenfield Center, NY 1965.

——. *Modern taxidermy tips.* Modern Taxidermist Greenfield Center, NY 1981.

Reichert, R., and K. Syeffarth: Fischnachbildungen und ihre Darstellung. *Neue Museumskde.* 1/1958: 193–197.

Richter, W.: Präparation von Fischen. *Der Deutscher Sportangler* 3/1935: 199–200; 223–224.

Rotarides, M.: Konzerválástechnikai vizsgálatok halakon. *Állatt. Közlem.* 34/1937: 109–121.

Samter, M.: Das Messen toter und lebender Fische für systematische und biologische Untersuchungen. *Arch. Hydrobiol.* 2/1907: 143.

Schnäkenbeck, W.: Fischereibiologie, in Grimpe, G., and E. Wagler: *Die Tierwelt der Nordund Ostsee*, vol. 1, Leipzig 1940: 1–48.

Schultz, L. P.: Directions for collecting, pressing and shipping fishes. *Atoll Research Bulletin* 17/1953: 90–95.

Shein, M.: Colour restoration and preservation of gross museum specimens. *Bulletin of the International Association of Medical Museums* 32/1950: 117–123.

Sprungmann, O. J.: Papier-maché bodies for fish. *National Taxidermist Magazine* 1/1933: 4–5.

Steedman, H. F.: Preservation of dogfish. *Nature* 175/1955: 352.

Sterda, G.: *Die Neunaugen.* Die Neue Brehm-Bücherei, Leipzig 1952.

Taborsky, K.: Osteologische Präparation von Fischen. *Neue Museumskde.* 6/1963: 218–224.

Tack, E.: die Urethan-Betaubung von Forellen bei wissenschaftlichen Untersuchungen. *Fischwirt* 3/1953: 417–423.

Taning, A.: A method for cutting sections of otoliths of cod and other fish. *J. Cons. Int. Expl.* 13/1938: 213–216.

Toyama, K., and Miyoshi, G.: Prevention from colour fading of aquatic animals under preservation I. Test on preservatives to retain red colour in fish and crustacean specimens. *J. Tokyo Univ. Fish.* 50/1 1963: 43–48.

Verheijen, F. J.: On a method for collecting and keeping clupeids. *Pubbl. Staz. zool. Napoli* 28/ 1956: 225–229.

Wechsler, K.: Eine Methode zur Herstellung von Kunststoff-Abgussen unter Verwendung bedingt elastischen Fasermaterials am Beispiel eines Korallenfisches. *Der Präparator* 25/ 4 1979.

Whitley, G. P.: Conservation of freshwater fishes and shoreline fauna. *Australian Museum Magazine* 11/1955: 359–364.

Witchard, R.: Fish casting. Conference of Museum Preparators. Sydney 1980.

Yoshida, Y.: A way of making fish specimens with their original body — colours kept. *Bull. Misaki Mar. Biol. Inst.,* Kyoto Univ. 3/1962: 67–68.

Zymny, E.: Neue Wege der Konservierung in der Aquaristik. *Aquarien und Terrarien* 2/1955: 8–11.

3
Amphibians

THIS CLASS of the animal kingdom is very rich in species. The amphibian fauna of many parts of the world have not yet been thoroughly researched. There is a lot more to learn about these fascinating animals and by studying them we may gain a better insight into our own past and the origins of life on dry land. It is very important that a museum has a collection of amphibians to aid studies in systematics, and other research in zoology and allied sciences. Amphibians are excellent for exhibition purposes. The various stages of vertebral metamorphosis can be beautifully illustrated. By displaying the various forms and showing students, or the general public, how the gills of the larva develop into the lung of the adult, a condensed story of evolution can be presented. A systematic display of amphibians can also be very educational; the richness of form, colour and adaptation of the many species make an interesting study, even for those who are only superficially interested in zoology.

COLLECTING

Most amphibians prefer a wet environment. Water is necessary for them to breed, go through the various stages of larval existence, and function as adults.

Members of the order Apoda (legless amphibians) are difficult to collect, since they live in the soil of tropical areas. The best opportunity to collect them occurs when roadbuilding and other earthmoving activities are being carried out. By visiting such sites it is possible to collect the odd specimen, but success depends on luck.

Urodelas (newts and salamanders) live mostly in the Northern Hemisphere. Salamanders prefer hilly, forested areas where occasionally they occur in large numbers. In the summertime, shortly before or after a warm cloudburst, they appear on the forest floor foraging for food. Normally nocturnal, the animals can be seen during the day on such occasions. Otherwise, they spend most of their life under bark, stones or rotting wood, coming out only at night to feed. It is possible to collect them at night by walking through the woods with a torch.

It pays to wear "sneakers" and to walk very quietly, halting and listening frequently. Salamanders are clumsy animals and make considerable noise as they clamber through the leaf litter of the forest floor. In dense forests, for example, birch, the undergrowth is normally sparse and the animals can be detected quickly. They can also be collected by pit traps (see below).

Newts are best collected at mating time when the animals seek permanent bodies of water and wear a vividly coloured breeding coat. In shallow water they can be caught with a small dip net. In waters where predator fish live, newts cannot survive.

The order Anura (frogs and toads) is the largest of the three orders of the amphibians. These animals are mainly nocturnal in their habits and can be located using torch beams aimed in the direction of their calls. A headlamp connected to a battery strapped to the waist enables the collector to have both hands free in order to catch the specimen.

At night, collecting is best carried out with two people as the wet and swampy areas visited can prove dangerous for one person to traverse. Two people working together with torches will also find it easier to track down and locate specimens. Ponds, lakes, streams and even temporary water are likely sources of specimens. During the day, debris, such as fallen trees, stones and dense moist foliage, should be checked for specimens. Whenever such debris is moved it should be lifted so that it lifts off the ground furthest away from you. If there are snakes under the debris they will not be able to attack you.

Frogs frequent a great variety of habitats. As an example, some members of the genus *Litoria* are found on the bark or under leaves of trees which grow near rivers and streams. Others can be found in or around sheds and other buildings, especially if water tanks are nearby.

The collector's own methods of collecting frogs and toads will arise with experience, but the easiest method of capture is to grasp specimens in the hand. Calico bags are used to contain specimens after capture. The bags

should be dampened with a little water. They are not bulky to carry and can contain many specimens.

Calico bags which are used mainly for transporting reptiles are acceptable for transporting frogs if the bag is first soaked in water to keep the specimens damp and cool. Plastic bags are becoming more acceptable among collectors. They are regarded as superior to calico bags.

Amphibians need little oxygen and can survive in the bags for a few days. Some leaf litter should be included with the specimens or some other vegetation so that they do not contact each other very much. Plastic bags can be blown up to allow breathing space for the specimens. Also, they do not dry out, leaving the specimens moist at all times, but a disadvantage is that plastic bags do not allow air to circulate, thereby increasing humidity, which can cause premature death.

Frogs' eggs are to be found in clumps, and toads' eggs in ribbons, at the bottom of ponds, or clinging to aquatic vegetation. Using two hands, as the eggs are very slippery, transfer the egg mass into a plastic bag or bottle. Fill the container with water to allow only a very small air space. This small air space prevents the water from too much movement during transportation, which, if too severe, can kill the eggs.

Tadpoles are caught easily using a small dip net on a long handle and scooping through the water. If the water is clear, it makes the task of locating tadpoles easier.

FIELD AND LABORATORY PREPARATION

In most cases it is possible to keep the specimens alive until the collector returns to the laboratory. However, on longer expeditions the specimens can be prepared in the field as in the laboratory, since relatively few instruments and equipment are needed for the preservation of amphibians.

Place live specimens into a 0.5% solution of chlorobutanol until death occurs. Do not leave specimens in this solution for extended periods as they become rigid. (Another method is to place specimens into a 0.5% solution of trisodium metasulphonate [MS 222]. This allows them to be left longer without the risk of becoming rigid. This compound is unstable in light, expensive and very difficult to obtain, as in certain places supply is restricted.)

Lignocaine can also be used for killing larval and adult forms of amphibians; larvae are killed in a 1% to 4% water solution, and adults in a 10% water solution. The animals are dropped into a container with the solution in it. They die in a completely relaxed state, which is most desirable if they have to be set and fixed in a particular position. Lignocaine is sold under various trade names. It is used mostly as a pain killer in human and veterinary medicine.

RECORDING DATA

Amphibians are not measured in the field routinely. It depends on the specific interest of the researcher how many, if any at all, measurements are taken from a specimen immediately after it is collected. Body weight also is seldom recorded if the animal is collected for a systematic collection. However, locality, date of collecting, name of the collector and other remarks regarding the specimen are recorded. A numbered tag is attached to one of the hind legs of the specimen soon after it is killed and this number is entered in the book containing the relevant data.

Colour notes also should be recorded, since the colours of amphibians fade or change rapidly. The best method of recording colours is to photograph the specimens while they are alive. A colour chart should be included in the photograph. Colour transparencies are the most practical photographic method since they are the most colourfast. These photographs are of great help when a specimen is prepared for display purposes and has to be recoloured.

SETTING AND FIXING

A solution of 10% neutral formalin may be injected into the abdominal cavities and the large muscular areas in the fore and hind limbs of dead frogs (Fig. 3.1). The specimens are then positioned so that they will be fixed in that position. After injection, they are placed in a deep tray lined with paper towelling which has been soaked with a 10% solution of formalin. The specimens are set in the desired position, then are covered with a layer of paper towelling. More 10% formalin solution is poured until the paper is thoroughly wet. The tray is covered to prevent evaporation.

Another method of fixation is to float specimens in the fixative for 15 minutes. This enables the abdomen to set in a full rounded form. A flat form

Fig. 3.1. The position in which frogs and toads are fixed. Dots indicate injection points.

results from setting in a pinning tray. The frogs are then placed into storage containers.

Tadpoles and frogs' eggs do not go through this setting stage. Directly after death they are placed into the final preservative and storage containers.

STORAGE

Some workers prefer final storage in a 7% to 10% solution of formalin, but most store specimens in a 65% alcohol solution. Frogs' eggs and tadpoles should not be stored in alcohol, but in a 5% formalin solution. Glass containers, with tight fitting lids, should be used to house specimens. Labels should be heavy rag base paper. Relevant data should be written with a HB pencil, or waterproof India ink. The label should have a thread fixed to it. This should be sewn through the muscle of the hind leg and tied around the femur to prevent the thread pulling away from the specimen and becoming lost. Some workers prefer to tie the label around the abdomen. As the abdomen is narrower than the outstretched limbs, this prevents dislodgement.

COLOUR PRESERVATION

There are several formulae for the colour preservation of amphibians. None of them is absolutely effective. Some species keep their colour better than others and, in some, the colours are impossible to preserve. All of the colour preserving formulae are for wet preserved specimens. Papparitz (1933) recommends a formula which is injected into the specimen. This formula consists of 100 parts water, 5 parts chloral hydrate, 5 parts magnesium sulphate and 5-10 parts 40% formalin. The specimen remains in the same liquid for six hours. After this the specimen is thoroughly rinsed and placed in a storage liquid which consists of 100 parts glycerine, 20 parts potassium chloride, and 200-300 parts water. Koeppen (1958) suggests using one litre of distilled water mixed with 10 g-20 g of 40% formol alcohol. The specimens are killed by immersion in formol alcohol and placed in the above mentioned solution. If they shrink, the body cavity should be injectted with the same liquid. The specimens are stored in this formula.

Further research by Koeppen (1961) proved that the colour of toads and frogs can be successfully preserved with the following method: The specimen is killed by immersion in 2 parts 40% formalin, 40 parts 96% alcohol, and 60 parts water and stored in 550 mL glycerine, 150 mL water, and 20 mL tanning solution. Large newts are treated in 100 mL glycerine, 250 mL water, 100 mL 95% alcohol and 40 mL tanning solution. Smaller newts are treated in the glycerine/water/tanning solution mixture. It is recommended that the jars

containing the storage liquid and the specimens should not be sealed permanently for four to six days. The condition of the liquid and the specimen are closely monitored during this period. If clouding occurs, the specimen is thoroughly rinsed and the storage liquid is replaced. If shrinking occurs, the same storage liquid is injected into the body until the original shape and size have been regained.

The retention of colour is normally quite good if the specimen is freeze dried. The freeze drying of amphibians is described in Chapter 9.

PREPARATION OF DISPLAY SPECIMENS

A series containing eggs, various tadpole stages and adult forms is best displayed embedded in clear plastic. The techniques concerning this work are described in Volume 2, Chapter 12. If specimens are in close proximity to each other, the size relationships and clear anatomical features essential for the studies of biological students will be clearly seen. Stained skeletal mounts can also be embedded in plastic. The technique for staining cleared specimens can be found in Volume 1, Chapter 10.

Amphibians can be displayed in a storage liquid, preferably formalin based or the abovementioned colour preserving liquids, in clear acrylic wet boxes.

For display, the specimen is fixed as described above. After fixing it is fastened to a sheet of acrylic and fitted into the wet box. This aspect of preparatorial work is described in Volume 2, Chapter 10. Freeze dried adult forms of amphibians make the best display specimens (Fig. 3.2). Their form and colour retention is better than any other preparations.

Another successful method of preparing amphibians for display purposes is "paraffining". The technique, although it seems to be cumbersome, gives very good results. It is time and labour consuming and has been superseded by freeze drying. However, freeze dryers are expensive and those who have no access to such equipment may find paraffining a handy alternative. The technique is described in Volume 1, Chapter 8.

Conventional taxidermy procedures are not suitable for amphibians and smaller reptiles, although very large toads and frogs may be exceptions. These can be mounted successfully using the same technique as described for small mammals. The skins of amphibians may shrink in a pickle containing alum. However, a 75% alcohol pickle has been used by the author (Hangay) to preserve freshly skinned *Bufo marinus* specimens for taxidermy with success.

SKINNING TOADS AND FROGS

The specimens are killed in chlorobutonal, or by immersion in alcohol, and skinned. There are three basic methods of skinning toads and frogs (Fig. 3.3).

Fig. 3.2. Most freeze dried specimens show good colour retention. Freeze drying by G. Hangay. Photo by Adrian Pitman. Courtesy of The Australian Museum.

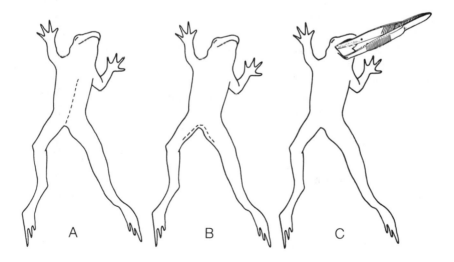

Fig. 3.3. The three methods of skinning frogs and toads. The dotted lines indicate the opening cuts. A. Ventral incision. B. Thigh incision. C. Skinning through the mouth.

Ventral incision

The animal is laid on its back and an incision is made from the sternum to the vent (Fig. 3.3A). The body is removed through this cut using a technique similar to that practised on small mammals. The legs are left in the skin while the body is taken out, severed at the neck. The skin is turned back on each of the legs as far towards the feet as possible. All muscles are carved off the bones, but the ligaments are not cut.

The feet should also be cleaned of as much flesh as possible, but they are not skinned normally. All the legbones are left attached to the feet.

The neck is removed completely and the head is skinned as far as possible without risking cuts and tears to the head skin. The interior of the mouth, including the tongue, is cleaned of all flesh; the jaw muscles are removed. The brain is scooped or wiped out through the enlarged foramen magnum and the eyes are removed from the outside. Pairs of strong, surgical scissors and forceps, and a small scalpel, are useful tools to carry out this work. The slipperiness of the specimens can be minimized by sprinkling plenty of powdered borax on the sections which are being worked on. After skinning, the skin is soaked in 75% alcohol for approximately 25 minutes.

The entire surface of the flesh side of the skin is thoroughly cleaned of all flesh and fat and the skin is rinsed in clear, cold water. The skin and the attached bones are insectproofed by either of the techniques described in Volume 1, Chapter 5.

The actual taxidermy, the mounting of the specimen, is carried out in a similar manner to small mammals. The leg bones are wired and wrapped with fine taw or cotton wool and fine thread (Fig. 3.4). Once wrapped to the required shape the legs are coated with a body paste (see Formulae), thickened a little with plaster, and the skin is turned back on them.

An artificial body is made from fine wood wool and thread, using the natural body as reference. A piece of wire is embedded in the brain cavity with a fast setting epoxy compound or plaster. The artificial body is coated with thickened paste and inserted in the skin. The head and leg wires are anchored to it.

The specimen is checked for anatomical correctness. If necessary, alterations can be made at this point. The face, if necessary, can be filled now with little wads of cotton wool dipped in paste and the leg muscles corrected. Once a satisfactory appearance is achieved the incision is sewn up with fine stitches, using a surgical (intestinal) needle and very fine thread.

Thigh incision

The specimen is skinned out through a cut as illustrated in Fig. 3.3B. The treatment of the skin and the mounting procedure is the same as described above.

Fig. 3.4. The taxidermy of a large frog or toad. A indicates the wrapped legs. B shows an "X-ray" view of the assembled specimen.

Skinning through the mouth

This method of skinning (Fig. 3.3C) is a little slower than the first two, but mounting is simpler. It is ideal as a practice exercise for students.

The neck vertebrae are grasped with a strong pair of forceps and forcefully pulled out through the mouth. As they fragment, the pieces of bone and flesh are removed. Viscera are removed the same way so that, gradually, the entire body is taken out through the mouth. Except for the skull, the bones are removed from the skin. Once the skin has been hollowed out it can be turned inside out and properly cleaned. The skin is fixed in alcohol and insect-proofed as mentioned above.

Wires of appropriate length and thickness are cut and one inserted in each leg. The skull is also wired as described above. An artificial body is carved from cork or balsawood. It must be small enough to fit through the mouth. The skin of the legs is filled with a modelling compound (*see* Formulae). The compound can be squeezed in from a syringe fitted with a very large gauge needle. The compound must be thin enough to go through the needle, but thick enough to be used as a soft modelling agent.

Once the legs are filled, the artificial body is inserted and the wires are anchored into it. The slackness of the body skin is removed with more filling. At this stage it is possible to mix sawdust in the compound to give it more

body and reduce weight. A small packing tool can be made to get the compound in evenly.

The throat and the face are filled with compound and, perhaps, little wads of cotton wool dipped in the compound. Once the specimen is filled, it can be fastened to its base and shaped. Overfilling must be avoided; natural wrinkles and folds in the skin must be reproduced by arranging the skin while the compound is still soft.

FINISHING THE MOUNTED SPECIMEN

After a sufficient drying period during which the specimen is kept in a well ventilated, dry room away from direct sources of heat and sunlight the specimen can be finished. If the skin is sewn the stitches can be waxed over, using small amounts of beeswax. Colours can be restored by painting (Fig. 3.5). Fine detail is normally applied with a small handbrush or a felt tipped pen. Inks are good to use as they do not distort surface detail. If paint is used, it should be thinned as much as possible to avoid a heavy appearance. Once the colours are restored, a top coat is applied to the specimen. If it is desired that the specimen appear wet, it is best to spray on a high gloss clear lacquer. Semi-gloss or matt finishes are applied if it is desired to show the specimen in a dry or damp environment, under logs or stones and so on.

Fig. 3.5. The cast of a frog is tediously painted. This work requires artistic ability, skill and patience. Cast by A. Bowman. Photo by Adrian Pitman. Courtesy of The Australian Museum.

MOULDING AND CASTING

There are various methods of reproducing an amphibian. Some are relatively simple, and therefore suitable for a museum with limited finances, or for a student class as an example of display preparation.

One of the simplest methods is to reproduce a large frog or toad in plaster. The specimen is killed and, while it is in a relaxed state, posed in a lifelike manner. For the sake of easy moulding it should be posed in a crouched position with head down and legs tucked in. It is posed on a natural base which can be as simple as a bed of sand or soil.

A batch of plaster is mixed, and the specimen is covered with it. The first coat must be thin, otherwise the weight of the plaster could deform the specimen. Once the first coat of plaster has set another batch is mixed and poured on. Here again, only a thin layer is added as too much plaster will crack the first layer. After the second batch has set, the thickness is built up to approximately 25 mm. After sufficient time for setting the specimen can be demoulded. The mould is painted with oil and filled with a freshly mixed batch of plaster.

It is practical to tint this batch with some colour, preferably one which matches the basic colour of the specimen. Once this coloured batch has set the mould can be carefully chipped away. As the plaster is being removed, little by little, it reveals the coloured plaster of the cast, thus indicating to the preparator where to chip. Once all the mould has been chipped away the cast of the specimen is cleaned; breakage, if there is any, is repaired and the colours are restored.

Instead of plaster, molten wax (hard paraffin wax) can be used as a casting medium. The plaster mould must be wet before the wax is poured in. As the wax solidifies it shrinks; the mould must be topped up with more wax.

Wax is easy to work with and only a few tools are needed to clean the cast; therefore it is suitable for student work. Wax also produces a nice translucent cast which can be coloured gently with translucent paints. It is more lifelike than a plaster replica. The colours can be put on with aniline dyes dissolved in alcohol. Where a more opaque effect is needed, artists' oil paints can be employed; finally, the cast is sprayed with a clear top coat of lacquer.

Polyester resin can also be used to produce the cast. If resin is chosen as a casting medium the plaster mould should be left to dry first. After it has dried properly, the inner surface should be painted with three thin coats of shellac. The dried shellac is painted with a release agent and, after this has also dried, the catalysed resin can be poured in.

It is not practical to make a solid resin cast of a large frog or toad. It is better first to pour in enough resin to coat the inner surface of the mould and let it set. After it has set, apply another batch of resin and let that set too. Now a small quantity of resin can be catalysed and filled with whiting or talc

or any other suitable filler to form a thick paste. This is applied to the interior of the cast, making sure that no air bubbles are embedded in it. This application should be approximately 4 mm–6 mm thick. After it has set, the cast is ready to be demoulded by chipping the plaster mould away.

Polyester resin gives a translucent cast like wax, but is much more durable. The cast should be washed with a degreaser before colouring.

Very small amphibians can be reproduced by a more sophisticated method using silicone rubber as a moulding agent. The specimen should be posed in an easily mouldable position, that is, one with a minimal amount of undercuts. A small amount of silicone rubber is catalysed and poured on the specimen. A quick setting rubber is recommended in order to produce a "rubber glove" like mould with one pour. After the rubber has set, it is sprayed or painted with a silicone rubber separator. It is sometimes necessary to cut the specimen out of the mould, using a fine, sharp scalpel to make neat incisions in the rubber.

Catalysed polyester resin can now be poured into the thin mould first. The mould is gently rolled between the fingers until the resin is squeezed into all the tiny details. Once this is achieved the mould is inserted into its jacket and filled completely, using a syringe, with more catalysed resin. After the resin has set the cast is carefully demoulded and coloured.

REFERENCES

Koeppen, E.: Erfahrungen bei der Präparation von Lurchen und Kriechtieren für die wissenschaftliche Belegsammlung. *Neue Museumskunde* 1/1958: 68–70.
——. Ergangzung der Konservierungsmethoden von Fischen, Lurchen und Kriechtieren. *Neue Museumskunde* 4/1961: 76–78.
Papparitz, G.: Note in *Blätter fur Aqu. und Terr. Kunde* 34/1933: 417.

SOURCE MATERIAL

Cogger, H. G.: *Reptiles and amphibians of Australia*. A. H. & A. W. Reed, Sydney 1984.
Gordon, F. G.: Preservation of small amphibia in gelatin. *Science* 80/1934: 475.
Hoefke, R.: Anleitung zum Sammeln und Konservieren von Laich und jungen Entwicklungsstadien unserer einhcimischen Amphibien. *Mikrokosmos* 43/1953: 133–136.
Juszczyk, W.: The preservation of natural colours in skin preparations of certain amphibia. *Copeia* 1952: 33–38.
Logier, E. B. S.: *The frogs, toads and salamanders of eastern Canada*. Toronto 1952.
(Further source material can be found at the end of Chapter 4.)

4
Reptiles

REPTILES form an extremely interesting class in the animal kingdom. The study of this group of animals is very important; therefore, it is essential for the preparator to possess sufficient knowledge to prepare reptile specimens in an efficient manner. There are still many species of these animals unknown to science. Since most reptiles live in warmer climates where collecting is often difficult, it is more than likely that many years will pass before the entire reptile fauna of the world has been thoroughly researched.

COLLECTING

In most countries of the world, reptiles, like many other animal classes, are protected by law. It is essential for the collector to check these regulations before commencing any field work.

SQUAMATA

Lizards and Snakes

The most frequently seen reptiles belong to the order Squamata (lizards and snakes). They live in the most varied habitats, ranging from the steaming tropical rainforests to the most arid deserts.

In arid areas, pit traps, especially if combined with a drift fence, yield good catches. It is recommended by Banta (1957) that the traps be protected from strong sunlight by placing a few small rocks around the opening and a piece of cardboard on top of these, thus forming a roof. To prevent the cardboard blowing away, it should be weighted down with other stones. The setting of a line of pit traps and drift fence is described in Volume 1, Chapter 6.

In areas where the night temperature falls to between 15°C–25°C, snakes and lizards often seek warm road surfaces after dark. If a car is driven at low speed, the animals can be spotted easily in the headlights. In Australia, it is also a known collecting method to drive on rural roads during the day keeping a lookout for sunbasking reptiles either on, or at the side of, the road. Some of these species, especially members of the genus *Varanus*, are very fast moving, alert animals. One must be equally fast and nimble to catch them on the run. A hand net is a practical piece of equipment in this operation.

Small lizards can be pounced on if one is agile enough. Some collectors use a pistol loaded with rat shot or .22 dust shot to stun or kill specimens if they are in inaccessible areas such as rocky terrain. Rubber strips, such as bicycle inner tubes cut into strips, make good weapons. One end of the rubber strip is held between the thumb and forefinger of one hand and the other end is pulled back, stretching it to the fullest extent. When the strip is released, it shoots forward, stunning the unwary victim and sometimes killing it. It requires good aim to use the rubber strip, so practice is needed to master the technique.

Rifles are cumbersome to carry and use in the field, but they can bring down large arboreal snakes and lizards if loaded with .22 bullets. Shotguns (.410, 20g) also can be used for the same purpose.

Nooses of various shapes and sizes can be used deftly, according to the situation. The easiest noose to make is one with a piece of nylon or cotton thread which has one end tied into a loop and the other end passed through the loop and tied to the end of a long stick. A small lizard, if sunning itself, can be caught by placing the noose over and around its head and lifting the stick quickly, which in turn closes the noose. Larger lizards require a heavy duty noose (Fig. 4.1).

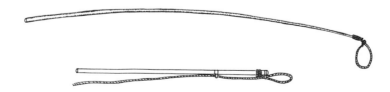

Fig. 4.1. Two examples of nooses used to capture reptiles.

Piechocki (1967) recommends the use of a pair of large anatomical forceps, 30 cm long. Lizards seeking refuge in narrow rock crevices can be extracted using these forceps. Since it is easy to lose any instrument in the field, the forceps should be fitted with a string which can be attached to the collector.

Geckoes and other small lizards can be captured at night near lights which attract insects. During the day these reptiles hide under stones, the bark of trees, loose timber planking on buildings and so on. They can be collected from these sites.

Snakes should be approached with caution, especially in the tropics where species with potent venom are common. Caution cannot be overemphasized. Even the most experienced workers can be bitten by snakes. On extended field trips in remote areas antivenom (antivenene) should be essential addition to the first aid kit. Knowledge of the first aid procedures for snake bite victims is also essential.

It is often difficult to locate snakes, yet they can appear at the most unlikely moments and in the most unlikely places during a field trip. They can be found under rocks, bark, old timber boards and sheets of iron left on the ground.

Snake sticks are easy tools to use and they may be made in different shapes and sizes. The simplest is an L-shaped stick which is useful for pinning down snakes, lifting them up and also for pulling loose bark from trees and moving small rocks. A T-shaped stick can be used also, as can a noose. The noose is useful for 'quiet' snakes, or those in captivity, whereas snake sticks are better for capturing wild snakes on the move. (Fig. 4.2).

Snakes should be placed in strong cloth bags; the collector must be very careful not to get bitten. All snakes are best held behind the head and placed head first into the bag; then the head can be held with the other hand outside the bag through the material. The first hand is withdrawn and the bag is closed. At the same time as the second hand is removed from the snake the bag is twisted and tied, using twine or heavy canvas strips.

Large lizards also are placed into strong cloth bags using the same method. Small lizards, geckos and skinks are placed into small calico bags which are tied to prevent escape.

Fig. 4.2. Snake sticks.

Crocodiles

Crocodiles are sometimes easy to collect, providing the appropriate location has been found. During the day the animals are usually very alert and difficult to approach. If the collector tries to stalk them on dry land they must be approached with the greatest of caution, as they are easily alarmed and head for the water. Although the authors have collected some very large specimens of *Crocodilus porosus* on dry land using the usual big game hunting methods, the technique is not recommended.

It is more practical to collect the various species from a boat at night. A good stable boat and three people are needed; one to row the boat, one to handle a searchlight and the harpoon, and one to shoot. It is best to quietly launch the boat at a likely spot after dark. The surface of the water should be swept with the searchlight (a hand-held spotlight powered by a 6 volt battery is ideal); the eyes of crocodiles will soon be noticed. It is possible to get very close to the animal (1.5 m–2 m) providing the boat is rowed slowly and quietly. While the light is kept on the animal, a shot is fired between the eyes (a 44 magnum rifle is ideal, or, if a very large specimen is anticipated, a 45/70), and the harpoon (or gaff) is immediately driven into the neck. It is vital that the animal is harpooned immediately, otherwise it sinks. People engaged in such activity must be experienced and physically fit. An under-estimation of the specimen's size, coupled with bad shooting, could lead to tragic consequences.

Medium sized crocodiles are caught by catching them in a noose while they are floating in water.

Very small specimens can be collected by hand either in the water or on land, but one must not let them bite as they can inflict a serious wound. If they are grasped firmly behind the head they are prevented from biting. They should quickly be placed into a strong canvas bag. Before placing them in the bag, the mouth should be tied, using a rubber band, string, tape or other suitable material to stop them biting when being handled in the future. Rubber bands should not be wrapped too tightly as they can damage the snout.

Crocodiles can also be snared on dry land using some carcass as bait. Nets can be used to catch smaller specimens.

CHELONIA: TURTLES AND TORTOISES

Being mainly aquatic, these reptiles are generally collected using a drum net made from wire baited with meat and submerged in a river or lake. The trap must be inspected frequently as the specimens can drown, but, importantly, also to prevent the drowning of captured water rats (*Hydromys chrysogaster*)

and other animals that make their homes near water. In clear, shallow waters specimens can be seen sometimes and pounced on. People who fish inland river systems sometimes catch turtles on the end of their lines, but this method does not guarantee success every time. Marine turtles are caught in the open sea using a harpoon or speargun. It is practical to engage local fishermen to obtain such specimens as it is almost impossible for the inexperienced collector to capture a marine turtle in its own element. Smaller turtles may be caught in drag nets accidentally. Here, again, an arrangement with local catchers is more profitable than the mounting of a fishing expedition specifically to capture turtles.

Tortoises are also mostly caught by chance. Local help is of great value and, in tropical areas, children are often eager to help the collector catch some tortoises.

FIELD AND LABORATORY PREPARATION

Since most reptiles keep well in captivity for a short while, it is not often necessary to process the specimens in the field. The live specimens can be kept in canvas or calico bags. Wetting the bags in order to prevent dehydration is wrong, as the animals cannot breathe through the wet cloth and suffocate. Instead of wetting the cloth, the animals should be wetted occasionally. Some collectors even place lizards in a shallow dish of water for a few minutes every two or three days if they are travelling in arid country.

RECORDING DATA

Measurements of the reptile specimens are usually not recorded. As with amphibians, it is up to the individual researcher to decide what sort of information should be recorded in the field.

Locality, date of capture, and the name of the collector are always recorded. The specimens should also be photographed, preferably live, to record the colours of the skin, the interior of the mouth and the eyes (Fig. 4.3).

KILLING

Reptiles react to variations of outside temperature changes and require a source of heat to increase their metabolic rate in order to hunt for food. If the temperature drops, so does their metabolism, and, if the temperature reaches a certain low level, they become torpid. Therefore, the most humane way of killing them is to place them in a freezing chamber until death occurs.

Fig. 4.3. Photographs of live specimens are useful references for the preparator. Photo John Fields. Courtesy of The Australian Museum.

A second method of killing is to inject a lethal dose of sodium pentobarbitone intraperitoneally or into the heart. A third option is to employ chloroform vapour. The specimen is placed in a large glass jar and a rag or cotton wool moistened with chloroform is dropped in. The time taken for death to eventuate differs with each specimen; snakes are the most troublesome.

Be very cautious before handling a supposedly dead snake. Allow plenty of time before removing it from the container to ensure death has in fact occurred. Sometimes, chloroform causes the specimens to have severe muscle contractions, causing twisting and bending. If this occurs, the animal has to be straightened out and placed into position before fixation and subsequent preservation.

SETTING AND FIXING

For general museum collections, dead specimens are injected with a 10% solution of formalin in the abdominal cavity, the thoracic cavity, the tail (if it has one), and, in very large specimens, the brain through the foramen magnum. Do not over inject as this causes localized distortions. It may be necessary to make many small injections rather than a few large ones. Snakes require a small injection about every 3 cm along their entire length.

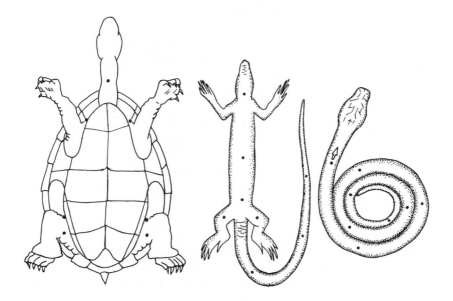

Fig. 4.4. Positions in which reptile specimens are fixed. The dots indicate injection points.

Turtles and tortoises should have their fore and hind limbs, head and neck pulled out from under their shell and injected, whilst those specimens which have special oral characteristics (Scincidae and Cheloniidae) necessary for taxonomic identification usually have their mouths prepared in an open position during fixation (Fig. 4.4). This is easily done by opening the mouth and filling it with a rubber bung, ice lolly stick, wad of cotton wool, or paper. Setting reptiles depends on the method or the size of storage container.

Small skinks (Scincidae) can be set out straight; dragons (Agamidae) have their tails curved to bring the tip of the tail in line with the snout. Snakes and many limbless lizards are usually coiled in a spiral. They are laid in a tray containing paper towelling saturated with a 10% solution of formalin and covered with another piece of paper wet with fixative. A lid is placed on top to prevent evaporation and they are left for three or four days.

PRESERVATION AND STORAGE

After fixing, geckos are placed into 70% alcohol and all other reptiles are placed into 75% alcohol. Small specimens should be stored in glass containers with tight fitting lids and very large specimens (crocodiles and large snakes) are stored in plastic tubes with lids. As lids do not fit tight, evaporation will occur. Periodic replenishing of the solution is advisable.

PREPARATION OF LARGE REPTILES

If circumstances permit, large specimens of reptiles collected for scientific purposes, for example, crocodiles and varanides, are injected and stored in liquids, as described above. However, in the field it is often impossible to handle these large specimens in this way. In order to preserve the specimens of such size and render them useful for science and display, they can be treated as large mammals. The recording of data is carried out in the same manner; body measurements are taken prior to skinning and, if possible, the weight of the freshly killed specimen is also recorded. The importance of photographic records cannot be emphasized enough. A series of good quality colour transparencies is of paramount importance. These are used not only as scientific records, but also to assist the taxidermist in modelling the artificial body or mannikin, if the animal is to be mounted in a lifelike manner for display purposes.

If the specimen is meant to be displayed, it must not be preserved in formalin and it is most desirable that most of the bones are retained and/or a full body mould is taken from the skinned carcass. The treatment of skeletal material in the field is described Volume 1, Chapter 10, and the preparation of a body mould for a four legged animal in Volume 1, Chapter 6.

The four legged reptiles are skinned as large mammals (Volume 1, Chapter 6). After an incision on the ventral surface of the body and limbs, the body is separated from the skin. Specimens up to the length of 1.5 metres can be skinned as small mammals, which means that the under side of the legs is not cut open.

Members of the genus *Caiman* are especially difficult to skin. These reptiles have armour like plates on their ventral surfaces which cannot be cut easily. It is more practical to make the initial incision on the skin of their abdomen and to lead the cut up towards the axilla. From here, skirting the armour, continue cutting towards the neck between the plates. The tail and the limbs can also be cut open in a similar fashion (Fig. 4.5).

The skinning of reptile heads creates a special problem. The most cases, skinning is practically impossible. The skull is normally left in the skin and the specimen is treated more or less in the same manner as a fish (Volume 1, Chapter 2). The interior of the skull is cleaned through the enlarged foramen magnum and all flesh and fat is excavated from the head. This work has to be carried out with care if the specimen is designated for the scientific collection where the skull may be used for study. Display specimens can be cleaned more vigorously and the bony parts may be chopped away during the process. Care should be taken not to damage the external shell of the skull which could cause the head to cave in.

Fig. 4.5. Starting incisions for skinning a *Caiman*.

The tongue and the interior of the mouth are also cleaned out, and all flesh and fat are cut away. The eyes are removed and the eye sockets are cleaned. Sawdust or borax, or both mixed together, can be used to soak up blood and body juices during the skinning and fleshing process.

The toes, if large, are also cut open on the under side and all flesh, sinews and fat removed. The entire surface of the flesh side is worked over after skinning is completed and all bits and pieces of flesh and fat are removed.

The epidermis of a reptile is very sensitive. If the specimen is, or is near, moulting, the uppermost layer of its skin peels off after it is skinned, no matter how carefully executed the skinning has been. In many cases, specimens which are seemingly far from moulting lose their epidermis during the time which elapses between collecting and thorough preservation. Often this is not detrimental to the appearance of the animal, since the peeling skin reveals another layer of freshly formed epidermis. The colours are normally more vivid on this layer of skin and the danger of peeling is remote, providing the skin is preserved properly.

Field preservation of the skin is relatively simple. The skin is salted very thoroughly, resalted the next day, and left to dry in a shady, well ventilated place. Heads containing flesh should be injected with full strength alcohol.

The rest of the skin preparation is the same as that for large mammal skins. The best tanning agent for large reptile skins is Luten F (see tanning procedure in Volume 1, Chapter 6). The skins can be finished off as flat skins and placed in the scientific collection as such.

PREPARATION OF SPECIMENS FOR DISPLAY PURPOSES

The wet preserved reptile specimens, if they are of practical sizes, can be displayed in acrylic wet boxes filled with a formalin based storage liquid. If the specimens were in contact with alcohol earlier, they must be washed very thoroughly for 24 hours in tap water. After this, they are injected with 10% formalin and can be displayed in a container filled with the same liquid.

The specimens are attached to a sheet of acrylic with fine fishing line and placed in the display container.

Smaller specimens can be prepared to show their stained skeleton. These can be embedded in clear plastic, and this renders them very durable. Such preparations can be handled by students without any risk of damage.

Lifelike effects can only be achieved with dry preserved specimens or replicas. Freeze drying is an excellent method for preparing reptiles. A description of the technique is given in Volume 1, Chapter 9.

Paraffining is another method by which excellent dry preserved specimens can be made. As mentioned in Volume 1, Chapter 3, this method, although it gives excellent results, has been superseded by the freeze dryer. However, the technique is described in Volume 1, Chapter 8.

TAXIDERMY OF REPTILES

Large reptiles, except snakes over 1.5 m body length, should be mounted on sculpted mannikins, in the same way as large mammals. Under this size, they are mounted like small mammals.

It is often said that reptiles should not be mounted because they never look lifelike, and well mounted reptile specimens are rare. The reason for this is that field preparation, and the recording of sufficient data are often neglected by collectors. The taxidermist has no adequate guides when constructing the mount. The skinned carcass of a reptile always looks too small, but this is also how the mannikin should look. The skin can be mounted with the appropriate amount of wrinkles on the correctly sized artificial body, and this makes it lifelike. Most mounted reptiles lack the wrinkles which are so typical of most species.

These folds can be made on the mount only if the artificial body is not too big. The simplest way to make wrinkles is to coat the artificial body with a heavy paste (body paste [see Formulae], thickened a little with plaster) and, after the skin has been sewn on, the folds are formed by manipulating the skin with the hands and modelling tools. The deep sections of the wrinkles are pinned to the body with stainless steel pins (insect pins) which can be removed once the skin and the underlying paste have dried.

Smaller specimens are mounted like small mammals. The wrapped artificial body is placed in sections (limbs, torso and so on). These specimens can be treated almost the same way as above. Here, the artificial body is not coated with paste, but the entire surface of the skin's flesh side is, prior to the insertion of the artificial body parts.

The specimen, after a sufficient drying period, is ready to be finished. The interior of the mouth, the gaps at the eyelids and similar parts may need modelling or filling. This can be done by the same means as used with a fish (Volume 1, Chapter 2). Seams are also sealed with the same compound. Once the modelling compound has set, the interior of the mouth can be coloured to the appropriate colours with artist's oil paints, or, in the case of a larger specimen (for example, a crocodile) with an airbrush. It is appropriate to put a high gloss top coat over the coloured interior of the mouth to indicate moisture, but one should refrain from spraying or painting gloss over the entire specimen, unless it should appear wet. A semi-gloss or matt clear top coat is more appropriate for most reptiles, and if it is not sprayed on too heavily, it can improve their lifelike appearance. It also seals the skin, making its cleaning easier, and helps to prevent insect damage.

TAXIDERMY OF TURTLES AND TORTOISES

These animals are skinned in a special way. First the caraplace is separated from the plastron. Smaller specimens, which can be held in a vice, are handled as illustrated on Fig. 4.6. String tied to the feet serves to keep the limbs out of the way of the saw. Larger shells can be cut with a bone or hack saw. The limbs, tail, and neck are separated from the shell and skinned. In most cases the skin can be rolled off the limbs, tail and neck (with the help of a sharp scalpel or knife) like a finger of a glove. Accurate measurements of the skinned members and contact drawings are essential for successful taxidermy. The limbs and neck of large turtles should be moulded to assist in the making of an accurate reproduction.

Limb bones should be retained. Those species which have soft or semi soft shells, such as most marine species, require special attention. The shells, and only the shells, of these animals must be preserved with 10% formalin soon after skinning. Ideally, the shell should be immersed in formalin for at least three to four days and slowly dried in the shade. If there is no suitable vessel available to accommodate the large shell, it should be packed in formalin saturated rags or flexible foam and sealed in sheet plastic. It should remain sealed for five to six days, then slowly dried.

The interior of the formalin preserved shell is degreased and cleaned of all remaining traces of dried flesh. The skin of the limbs, tail and neck, together with the attached skull, are tanned (or at least pickled) with Luten F or 75% alcohol. The skin is insectproofed, oiled and kept moist until it is mounted.

Fig. 4.6. The method of cutting a tortoise's shell. The specimen is held in a vice, the legs are pulled downward and the shell is cut with a jigsaw. After Piechocki (1967).

Artificial limbs, tail and neck are made of wrapped wood wool on a strong wire armature. Very large specimens may need threaded rods in the legs. The ends of the wires or rods are cemented into the plastron using either an epoxy compound or polyester putty (Fig 4.7). One member at a time, the skin's flesh side is coated with a heavy body paste (*see* Formulae) and this slipped over the artificial member.

The edges of the skin can be tacked to the plastron. The neck skin is treated the same way, and the skull is firmly anchored on the artificial neck. This is best achieved if the neck is contructed so that the sharpened end of the metal armature protrudes from the wrapped section (Fig. 4.8), which is jammed into the skull. It is also practical to fill the skull with modelling compound prior to mounting. The hardening compound fixes the head in the required pose.

Finally, the tail is mounted in the same manner and the specimen can be erected. A bed of epoxy compound (*see* Formulae) is laid on the sawcut surfaces of the shells and the two pieces are gently pressed together. The compound which has been squeezed out is wiped off before it sets.

After setting, the shells are wired together very strongly. The skin of the front legs and the skin of the neck are tacked to the carapace. A small amount of two part polyurethane foam is mixed and poured in through the hole of one of the hind legs. The specimen is tilted and occasionally rocked from side to side to allow the forming foam to fill the areas where the front legs and the neck are jointed to the shell. Once this batch of foam has set the rest of

Fig. 4.7. The installation of neck and leg rods for a turtle. The rods are cemented to the plastron by plastic putty. Drawing by G. Hangay.

Fig. 4.8. Side view of the wrapped neck of a turtle. The sharpened neck rod is protruding to accommodate the skull. Drawing by G. Hangay.

the body cavity is filled. It is wise to pour several small batches of foam. Overfilling, especially if it is done with one large batch, will burst the shell and cause a great deal of extra work!

Finally, the skins of the tail and hind legs are tacked on the shell. The eyes are set as described in Volume 1, Chapter 2 and the specimen is allowed to dry slowly. It can be finished the same way as any other reptile specimen.

MOULDING AND CASTING OF AMPHIBIANS AND REPTILES

A well made reproduction of a reptile or amphibian is often more suitable for exhibition purposes than a taxidermic specimen. The cast, being made of plastic or some other casting medim, is impervious to insects and often more lifelike than a "stuffed" skin. There is a great variety of techniques and materials which can be employed in order to prepare a reproduction. Some of the techniques and materials become somewhat obsolete as new techniques are invented and new materials appear on the market. Some substances have proved to be dangerous to health and are not used any more.

The following selection of techniques was composed from those which are most frequently used and which have proved to be sound, workable methods for making a reproduction.

PREPARING THE SPECIMEN

The preparation of the specimen is of paramount importance. The appearance of the specimen at the time the mould is made governs the look of the finished reproduction. Therefore, it is important that the animal to be moulded is in good condition.

As a rule, several colour photographs, preferably transparencies, are taken of the animal. If it is possible, the specimen should be photographed alive, or at least immediately after it is killed. Close up shots of the eyes are also necessary in order to record the colour of the iris and the shape of the pupils. Venomous snakes are placed in a closed terrarium and photographed through the glass. A standard colour chart should be included in each photograph.

Reptiles are killed with an injection of veterinary Nembutal (pentobarbital sodium) (approximately 0.05 body weight) or a 10% water solution of lignocaine (approximately 0.05 body weight). These substances are injected into the body cavity near the heart, and, if they are administered slowly using a fine needle, the animal dies relaxed.

Chlorotone (chlorobutanol) is mixed in water (0.5%) and is used to kill frogs and other amphibians in a completely relaxed state. Lignocaine can be

used the same way and with the same effect. It is very important that the specimen is relaxed and not distorted by rigor mortis.

Before posing, the body is checked for shrinkage caused by dehydration or starvation. If necessary, water can be injected into the sunken areas with a hypodermic syringe and a very fine needle. Sunken eyes can also be filled with water. All dirt and slime must be wiped off with a wet sponge.

POSING

The specimen can now be posed. For small amphibians and lizards, micro-balloons form an ideal moulding base. In small quantities, these microscopic glass balls can be worked like wet sand. With larger specimens, wet sand or clay can be used.

The specimen — for example, a medium sized lizard — could be posed in a walking position. If it should have its abdomen slightly raised, a small amount of wet sand is pushed under this area. If the head is to be raised, more sand is pushed under the neck and chin until the required pose is achieved. The legs are arranged in a natural stance and the tail gently pushed into the sand. The severest undercuts are eliminated by filling them with sand (behind the legs, at the base of the tail, and so on). The surface of the sand around the specimen is smoothed with a modelling tool.

MAKING A PLASTER MOULD

A thin mix of plaster is prepared and a splash coat applied to the entire surface of the specimen. The plaster must cover every part of the animal and, if necessary, it should be worked into the fine surface detail of the skin with a fine brush. Before the first batch sets, another (this time a little thicker) mix is prepared and applied to the specimen. This layer is allowed to set, but, as soon as it is hard enough to support the next layer without cracking, a new batch is made and poured. Once the mould is approximately 25 mm–30 mm thick, it is allowed to set hard. After sufficient setting time, the mould, with the specimen in it, is turned over. The sand is brushed off the plaster and the animal. The parts of the plaster which have touched the sand are painted with oil. It is possible that the abdomen of the lizard has become a little flattened. This may be caused by the weight of the animal itself and the plaster laid on it. It can be remedied with an injection of water.

Now, the ventral surface of the specimen is moulded in the same way as the first piece was made. After the plaster has thoroughly hardened, the two pieces of the mould are separated. The specimen is removed and can now be prepared for the scientific collection or for any other purpose. The two pieces are tied together to prevent warping and allowed to dry.

CASTING

After drying, the mould is treated as described in Volume 1, Chapter 2, and a polyester, fibreglass cast is prepared from it, following the same principles as described in Chapter 2.

Instead of polyester, epoxy resins can also be used. Epoxy is a very versatile plastic, and casting resins can be formulated to suit almost any purpose. The flexibility of these resins can also be regulated and, by choosing the correct formulation, flexible or semiflexible casts can be made. Flexibility is desirable on many occasions. A finely detailed, delicate cast of a lizard is very vulnerable if it is made of rigid resin. The toes, spines, and tips of the tail can break very easily, even with the most delicate handling. If the cast is made of a flexible compound, the danger of breakage is minimal. Rubber latex is cheap and easy to work with. It is simple to make rubber casts from plaster moulds.

The dry mould is not shellacked, but left natural. A pouring hole is drilled into it, preferably on the ventral surface. The mould is tied together and rubber latex is poured in until the mould is full: After a few seconds, the latex is poured out and the mould is placed in a drying cabinet. As soon as the latex coating the interior of the mould has dried, the mould is filled again. The latex is poured out into its container, and a little sawdust is sprinkled into the mould. The mould is rotated in order to distribute the sawdust evenly on the interior surface. The presence of sawdust speeds up the drying of the latex. The procedure is repeated until a suitable thickness is built up. Once the cast is strong enough, it is demoulded.

To add strength to the cast it can be filled with a hard wax. After the wax has been heated, it can be poured through the drill hole. If necessary, the pose of the cast can be changed while the wax is warm and pliable.

If the cast has been made thick enough, it supports itself. However, it is practical to install sharpened wires into the legs, neck and tail. These wires allow the cast to be fastened to its base or in a diorama setting. Repositioning is also possible with the help of the wires.

This technique is highly recommended if congregations of reptiles are to be demonstrated. As an example, the Denver Museum of Natural History displays a diorama depicting a scene on the Galapagos Islands. The numerous land iguanas in the diorama are made from two or three moulds, but clever repositioning gives the viewer the illusion that many specimens were prepared for the exhibit.

There are a number of other flexible casting compounds.

Pereira's technique

This very interesting method was contributed by Mr A. PEREIRA from the McGregor Museum, Kimberly, Republic of South Africa:

"The carapace of a tortoise (the upper shell) is made of calcium and the scales are made of keratin protein. Separation of the scales from the carapace is the result of shrinkage when the animal dies. This has always been a problem when mounting tortoises because the shrinkage cannot be controlled. Eventually all the scales either peel off or flake, spoiling the appearance of a specimen intended for display. If the entire specimen is cast in fibreglass, much valuable time is spent in detailed and accurate hand painting the shell patterns. My method of casting a tortoise in glass fibre eliminates any possibility of the scales flaking off. Since the actual scales are used in the cast, there is no need for meticulous hand painting, either.

"A live tortoise can be killed by injecting sodium pentabarbitone into the heart and kept frozen until you are ready to work on it. In an unfrozen state it is first relaxed by manipulating the extremities, then washed in cold water.

"It is set up for moulding by inserting four wires into the body, one through each leg. A fifth wire is run through the length of the body and into the head. The head wire should not protrude from the body. The real eyes are replaced with glass eyes bedded into the sockets with putty to give the casting a lifelike appearance. A 4% formalin solution is injected into the fleshy parts to keep the body rigid for the moulding process.

"The prepared tortoise is placed on a board with Plasticine clay under the body to raise it to a natural position. The leg wires are pulled through holes in the board and fastened underneath.

"While waiting for the formalin to stiffen the flesh, a retaining wall of Plasticine is built around the bottom of the carapace. Registration keys are pressed or added to this wall. The exposed shell is given a thin coat of grease separator. Then a plaster mould is made over the entire upper shell. By the time the plaster mould has set the formalin will have stiffened the body so the fleshy parts may be moulded in turn (Fig. 4.9).

Fig. 4.9. The tortoise is posed for moulding. Shaded area indicates clay retaining wall around the carapace, supported by pillars of clay. Drawing by G. Hangay.

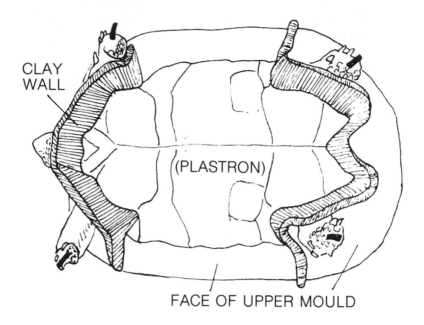

CLAY
WALL

(PLASTRON)

FACE OF UPPER MOULD

Fig. 4.10. Clay retaining walls are formed in order to make the second piece of the mould. Drawing courtesy of A. Pereira.

"With the plaster mould still in place, the tortoise is inverted onto its back and another wall of Plasticine is made around the front and rear edges of the lower shell, the plastron. Separator is painted on the plastron and the exposed faces of the upper mould. Then the lower section is moulded in plaster as was the upper shell (Fig. 4.10). When the plaster has set the clay walls are removed. Without separating the mould sections, the front legs and head, and the hind legs are moulded separately in latex rubber. The leg wires are left in for continued support but cut off flush with the bottom of the feet.

"The fleshy parts are moulded by painting on three or four coats of latex moulding rubber. Do not reinforce the latex between coats since you will want these sections of the mould to be flexible when the parts are cast in them. Allow sufficient drying time between coats before applying the next (Fig. 4.11). When the latex is dry, a two-part sectional plaster jacket is made over each part to support them during subsequent casting. When the plaster has set a knife blade forced between the seams will cause the sections to part easily. The latex moulds are simply peeled from the legs and head.

"The body of the tortoise is then soaked in water for a few days until the scales separate easily from the shell. Alternatively, the tortoise can be dipped

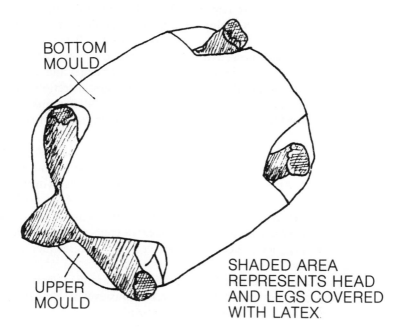

BOTTOM
MOULD

UPPER
MOULD

SHADED AREA
REPRESENTS HEAD
AND LEGS COVERED
WITH LATEX.

Fig. 4.11. The plaster encased tortoise. Shaded area represents head and legs covered with latex. Drawing courtesy of A. Pereira.

in hot water until the scales release enough to be flaked off with a blunt knife. This is quicker than the first method, but the soaking method is less trouble.

"While the tortoise is soaking you can go ahead and cast the legs and head sections in polyester resin. The latex moulds can be held securely in their plaster jackets with glue. The gel-coat can be coloured with pigment to the general shade of the tortoise skin. When the gel-coat has set, the casting is thickened with more resin and reinforced with chopped fibreglass.

"When the tortoise has soaked long enough, the scales are gently pried from the carapace and washed in warm water and detergent to clean them of residual dirt and grease. The individual scales are then fitted into the shell moulds much the same way a jigsaw puzzle is fitted together. A spot of clear adhesive will keep each scale in position in the moulds. If distortion has occurred in any of the scales this can be remedied by heating it with a blow dryer. This will make the scale flexible and easier to position as well as accelerate the setting of the adhesive.

"Thick resin, pigmented to the proper colour, is painted on the inside of both shells. When set the resin will support the shell in the same way as did the discarded carapace.

"The cast head and legs are removed from their moulds and positioned inside the top shell which is still supported by its plaster mould. The bottom shell, also in its supporting jacket to prevent distortion, is fitted onto the top shell and the head and legs checked for alignment and position. The two shells are separated and thickened resin is painted around the edges and in the areas of contact between the upper shell and the leg. The mould sections are then brought together again until the resin has set and locked all sections together. Allow sufficient time for the resin to cure before attempting to remove the plaster moulds.

"The plaster moulds are best removed by saturating a paint brush with thinners and applying it to the edges of the plaster a little at a time. This will penetrate between the plaster and the outside of the scales dissolving the glue. This way you will prevent damaging the scales or shell. The small joints between the scales are now cleverly painted where necessary as are the head and legs. The cast eyes are painted and given extra coats of lacquer for more shine. The whole specimen is then lightly sprayed with clear lacquer to reflect light like the real specimen.

"The original tortoise has now become a fibreglass replica, guaranteed to resist the ravages of time, climate, and the over enthusiasm of school children. It looks as good as the real thing in any situation".

FLEXIBLE MOULDS

Specimens with intricate skin texture, spines or delicate long toes are reproduced more successfully if flexible moulds are made.

Silicone rubbers are the most practical and versatile moulding materials. These are expensive synthetics, but they always give superior results when compared with any of the other flexible moulding compounds ("Vinamould", polysulphite rubber, and rubber latex).

In this procedure, the specimen is posed as described above, but sand or microballoons cannot be used as a base. The specimen has to be posed on a bed of oil based clay. (Check with the technical information on the rubber to ensure the silicone rubber sets on oil based clay. If it does not, the clay can be painted with shellac and allowed to dry).

The posed specimen is coated with a batch of catalysed silicon rubber. To avoid wasting the rubber, carefully pour it on and, if necessary, evenly distribute it with a brush. The rubber can be restricted by a low walled dam built around the specimen. A characteristic of the rubber is a very persistent flow. This means that, if it is a slow setting formulation, it may run from the highest point of the specimen and form pools at the lowest.

The progress of setting should be closely monitored so that the rubber can be scooped back onto the higher sections of the specimen. With some experience, one can learn when to catch it just when it thickens enough to

stay in place. After the first coat has set, another two or three layers are poured and painted on. If the specimen is large (over 20 cm in length), small pieces of bandage are laminated on with more rubber after the second coat. Although this is a little more work, it saves a lot of rubber and makes a stronger mould.

Once the mould is thick enough (for a 20 cm long specimen the mould should be approximately 2 mm–3 mm thick), plaster is poured on it. The thickness of the plaster jacket is built up to approximately 25 mm–30 mm thickness and allowed to set and harden. Now the mould can be turned over carefully. Be careful that the rubber coated specimen does not fall out of the plaster as it is turned over.

The clay is cleaned away, exposing the ventral surface of the specimen and the surrounding rubber. The rubber must be painted with a silicone mould separator. Another rubber mould and plaster jacket is prepared of the ventral side. After the second plaster jacket has set and hardened the mould is dismantled and the specimen removed.

The mould can be used as it is, without any release agent, to produce casts from a great variety of materials. Polyester, epoxy, and plaster can all be used. If the mould has been made strong enough, it can withstand the wear and tear of repeated castings.

REFERENCES

Banta, B. H.: A simple trap for collecting desert reptiles. *Herpetology* 13/1957: 174–176.
Pereira, A.: Preparing a tortoise for display. *Sama* (South African Museum Association) 8/1983.
Piechocki, R.: *Makroskopische Präparationstechnik: Wirbeltiere.* Akademische Verlagsgesellschaft Geest u. Portig, Leipzig 1967.

SOURCE MATERIAL

Anderson, R. M.: Methods of collecting and preserving vertebrate animals. *National Museum of Canada Bulletin* 69/1948: Biology Series 18.
Anonymous: Alcohol and alcoholometers. British Museum (Natural History). *Instructions for Collectors Number 13.* 1938.
——. *Präparieren von Amphibien und Reptilien,* Zoologische Staatssammlung München (n.d.).
——. Reptiles, amphibians and fishes. British Museum (Natural History). *Instructions for Collectors Number 3,* 6th ed. 1953: 1–28.
Barker, D.: Reptile replicas in rubber. Conference of Museum Preparators, Sydney 1980.
Cassidy, M. W.: Reinforced plastics: Casting and laying up in latex rubber molds. *Curator* 7/1 1965: 63–78.
Clarke, C. D.: *Moulding and casting. U.S.A.* The Standard Arts Press, Maryland 1946.
Cogger, H. G.: *Reptiles and amphibians of Australia.* A. H. & A. W. Reed, Sydney 1984.
Cyren, O.: Aufstellung von Reptiliensammlungen und dergleichen zu Demonstrationszwecken, *Blätter Fur Aqu. und Terr. Kunde* 44/1933: 349–351.
Duncker, G.: Herstellung und Aufbewahrung tierischer Spiritus-Präparate. *Naturforsch.* 3/1926/1927: 546–550.
Gilmore, C. G.: *Reptile reconstruction in the United States.* National Museum, Washington 1920.

92 Biological Museum Methods

Gloyd, H. K.: Methods of preserving and labelling amphibians and reptiles for scientific study. *Turtox News* 16/3 1938: 49–53; 66–67.

Gunning, G. E., and W. M. Lewis: An electrical shocker for the collection of amphibians and reptiles in the aquatic environment. *Copeia* 1957: 52.

Kolligs, J. D. Silikonkautschuk "Gurisil 575" bei der Herstellung von Schlangenabgusse. *Der Präparator* 19/1 1973.

Kopsch, F.: Nipasol Natrium zum Betauben von Amphibienlarven und erwachsenen Fröschen. *Anat. Anz.* 97/1949: 158–161.

Laybourne, E. G.: A detailed account of reproducing a water snake. *Museum News* 12/1935: 7–8.

Lemberger, F.: Uber eine zu Kurszwecken verwendbare Alkoholnarkose von Fröschen. *Zeitung für biol. Techn. und Methodik Bd.* 3, H. 2/1913.

Livezey, R. L.: Procaine hydrochloride as a killing agent for reptiles and amphibians. *Herpetology* 13/1957: 280.

Loveridge, A.: Towards reducing cost in mailing reptiles. *Copeia* 1952: 280.

Lowe, C. H.: Nembutal as a killing agent for amphibians and reptiles. *Copeia* 1956: 126.

MacMahon, J. A.: A technique for the preparation of turtle shells. *Herpetology* 17/1961: 138–139.

McCoy, C. J.: A technique for collecting in urban areas. *Journal of the Ohio Herpetological Society* 3/1961: 4.

Moyer, J. W.: *Practical taxidermy.* The Ronald Press Co., New York 1953.

Müller-Gehring, R.: Eine Methode, lebende Amphibien und Reptilien abzugiessen. *Der Präparator* 1/1955: 27–28.

Myers, G. S.: Brief directions for preserving and shipping specimens of fishes, amphibians and reptiles. *Circular of the Natural History Museum, Stanford University* 5 (2nd ed.)/1956: 1–3.

Neill, W. T.: Another device for collecting lizards. *Copeia* 1956: 123–124.

Pape, H.: Anwendbarkeit von Latex-Gummi für zoologische Präparate. *Natur Volk* 85/1955: 326.

——. Erfahrungen über Abgüsse technisch anspruchsvoller oder schwieriger Modelle. *Natur Volk* 88/1958: 390–392.

Petzold, H. G.: Schlangenfang und Schlangenverwertung in Nord-Vietnam. *Natur Volk* 91/1961: 421–429.

Porkert, T. J.: Saisonmassige Unterschiede in der Autotomie und Präparationschwierigkeit der Schwanze der Eidechsen. *Der Präparator* 20/1974: 1–2.

Quinn, J. H.: Rubber moulds and plaster casts in the paleontological laboratory. *Technique Series* no. 6. Field Museum of Natural History, Chicago 1926.

Racek, M.: Erfahrung mit Praffinierung von Schlangen. *Der Präparator* 19/1973: 3–4.

Rau, R.: Abformen von Naturkörpern mit Latex-Gummi. *Natur Volk* 85/1955: 321–326.

——. Naturgetreue Abgüsse durch elastische Formen. *Umschau* 58/1958: 440.

Reinhard, W.: Uber Konservierung von Schlangen. *Blätter fur Aqu. und Terr. Kunde* 49/1938: 121–124.

Riebe, C.: *Anleitung zum Sammeln in tropischen Ländern.* Stuttgart 1931.

Schreiber, E.: Uber das Sammeln, Präparieren und Aufbewahren von Amphibien und Reptilien. In: *Herpetologia europaea,* 2nd ed. Jena 1912, 845–880.

Silis, B., and S. Couzyn: The embedding of cleared biological specimens. *Curator* 1/1958: 87–91.

Slevin, J. R.: The making of a scientific collection of reptiles and amphibians. *Proceedings of the Californian Academy of Science* 16/1927: 231–259.

Smith, H. M.: *Handbook of amphibians and reptiles of Kansas.* Miscellaneous Publications of the Museum of Natural History, University of Kansas 9 (2nd ed.)/1956: 1–356.

Waller, R. A., and W. N. Eschmeyer: A method for preserving color in biological specimens. *Bioscience* 1965: 36.

Walters, L. L.: New uses of celluloid and similar material in taxidermy. *Technique Series* No. 2. Field Museum of Natural History, Chicago 1925.

Wolterstorff, W.: Kurze Konservierungsvorschriften fur Tropenreisende. *Blätter für Aqu. und Terr. Kunde* 37/1926: 275.

——. Versand und Konservierung von Tritonen und anderen Urodelen. *Blätter für Aqu. und Terr. Kune* 44/1933: 164-165.

Zweifel, R. G.: Guidelines for the care of a herpetological collection. *Curator* 9/1 1967: 24-35.

5
Birds

PRESERVED ornithological material of different kinds serve as very important sources of information for students of natural history. Lifelike mounted bird specimens can have a major role in museum exhibits.

COLLECTING

The laws concerning the collecting of birds vary considerably from one country to another; therefore, it is most advisable that the appropriate permits, licences and so on are sought well in advance of a planned collecting trip.

The equipment for general collecting work can be very extensive. However, since most collectors rely on shooting or mist netting as means of securing their specimens, only the basic and most practical items of collecting equipment are discussed here. Apart from guns and/or mist nets, the following accessories are desirable: haversack; fishcreel; notebook and pencil; specimen scale; ruler; tags and labels; pocket knife; cotton wool; camera; plastic bottle with dusting powder; paper for making cones and wrapping material; small bottle of chloroform; assortment of plastic bags and rubber rings; surgical scalpel with detachable blades; small pair of scissors; forceps for dissecting; insect repellant; and fieldglasses.

The ideal collecting gun would be a .22 calibre rifle and a 20 gauge shotgun under and over combination with a 410 calibre auxiliary barrel, equipped with a four times magnifying power quality rifle telescopic sight. Unless it is custom built such a gun could be hard to find; a compromise could be either a 12 gauge double barrel shotgun with a 410 calibre adaptor in one of the barrels, or a .22 calibre rifle and 410 shotgun under and over combination. With these three different guns almost any bird species can be collected.

If very small birds are being collected they can be shot with the .22 rifle armed with either rat or dust shot, where the bullet is subsidized with very fine shot. The delicate specimen will not be damaged beyond repair if the collector uses the gun in the proper manner.

If a new or unworn .22 rifle with undamaged rifling in the barrel is being used, a special shooting technique is called for if rat shot is the ammunition. The rifling spirals the fine shot into an open centre circular pattern. At close range this could mean a clear miss, even if the shooter is an excellent marksman. To avoid this, one should become well acquainted with the gun and shot before embarking on a collecting trip. When aiming, one must compensate for this open centre shot pattern and shoot slightly off target in order to hit the specimen with an adequate number of rat shot pellets. If the .22 rifle's barrel is well worn, it will act as any other smooth bore shotgun and the pellets will form an even pattern. Such a rifle, of course, is not suitable for precision shooting with regular rifle ammunition.

A good .22 rifle, if equipped with a good telescopic sight, is an excellent collecting gun in the hands of the marksman. Larger birds, such as birds of prey, big waterfowl or those species which are difficult to approach within shotgun range, can be successfully hunted with a .22 rifle. Avoid hollow point bullets and for preference, use only quality supersonic ammunition. For close range work "shorts" can be used; these have less charge than the regular long rifle ammunition.

It is a personal matter which calibre or make of shotgun one prefers to shoot with. As a general rule, the smaller the bird one wants to collect the smaller the calibre and size of the shotgun pellets should be. Still, the variations are practically limitless, as a large 12 gauge shotgun with large no. 4 shots can be used, but with hand loaded, reduced power loads which will disperse the pellets in a completely different manner to the way a regular, factory load would do. On the other hand, using a small, 410 calibre shotgun with a special high power load and small or medium pellets, the shooter can bag a large duck flying overhead. As a guide, follow the chart recommended for a 12 gauge shotgun of any make and medium choke. The choice of chokes may be unnerving to the novice, but in reality only the expert shooter can benefit from this knowledge. Full or medium chokes, like the chokes most factory made "run of the mill" shotguns are made with, are the most suitable for general collecting or hunting.

Table 5.1: Recommended shot for collecting birds

Size of bird	Shot sizes	Comments
Duck	4, 5, 6	No. 4 for long range or pass shooting; No. 5 or 6 at normal range
Geese	BB, 2, 4	Big loads with big shots to bag these big birds; Use No. 4 for close range, over decoys
Pheasants	5, 6	For long shots No. 5; Close range over dogs and all around shooting No. 6
Grouse or partridge	5, 6, 7½, 8	Smaller species take smaller shots like 7½, 8; larger ones 5, 6
Quail	7½, 8, 9	Early season birds take No. 9 shots since they are lightly feathered; later in the season 8 or 9 are more practical
Doves, pigeons	6, 7½, 8	No. 8 or 7½ for normal range
Smaller birds	10, 12	No close range shooting for these; at least 40–50 metres in order to hit the birds with only a few pellets.

A shoulder strap or sling on the rifle or shotgun is very practical; it will allow collectors to use both their hands for other tasks without lying the gun on the ground or propping it against a tree.

A selection of ammunition should be carried in the field for the shotgun, ranging from no. 4 to no. 12. Game loads and recommendations (12 gauge shotgun) are shown in Table 5.1.

It is best to use a 20 gauge or 410 gun on smaller birds (under the size of quail), and a .22 rifle armed with ratshot on smaller Passerines.

ACCESSORIES

Haversack

This should be as capacious as possible and divided into compartments to keep the various items of equipment separate from the freshly collected birds.

Fishcreel

This item is necessary if more than five or six specimens are collected within one short collecting trip. The haversack would not be suitable for carrying the birds without damage; therefore a more rigid container, such as a fishcreel, should be used. The birds can be stored and carried in a neat way until the collector returns to the camp and can proceed with the preparation of the specimens.

Notebook and pencil

The notebook should have a hard, preferably waterproof, cover with a pencil attached to it. It is a good idea to carry it wrapped in a plastic bag.

Other equipment

Tags or labels made of parchment paper or other similar card type paper can be attached to the specimen with a short length of thread. These tags should be tied to the bird's leg immediately after the data concerning it are recorded in the notebook. The tag should show the number under which the data are entered in the book. Use a pencil or waterproof pen.

A pocket knife with various accessories is a good companion on any outdoors expedition and can be used for many jobs.

Cotton wool of the absorbant kind is used to plug the bill and vent of the bird, as well as for wiping blood and excreta from the plumage. Small, delicate specimens should be wrapped in smooth layers of cotton wool before being placed in the fishcreel for temporary storage.

The plastic bottle filled with dusting powder can be any medium sized container with a screw top. For the dusting power, use borax mixed with whiting for light coloured specimens only. Crows, ravens or other black birds are best treated with sawdust. The dust is used to dry freshly spilled blood on the plumage.

Paper cones are handy to prevent the bird's plumage from ruffling and unnatural squashing. Do not use newspaper as it can soil light coloured specimens.

Chloroform may be used to kill wounded birds quickly and humanely.

Plastic bags may be useful for many purposes: food plants, bird droppings, or any other material for research can be temporarily stored in them.

A surgical scalpel with detachable blades provides the collector with a sharp cutting edge which can be used for quick field jobs, such as eviscerating larger birds.

Forceps may also be used for many field jobs. They are especially handy when small wads of cotton wool need to be placed into shot holes or into the bill or vent of the specimen.

Insect repellant is often necessary to keep flies away from specimens, or to keep other unpleasant insects and leeches from the collector. It is often necessary to sit motionless for extended periods of time in order to obtain some birds. Mosquitoes, sandflies, and similar pests can turn an otherwise pleasant collecting trip into a painful ordeal if insect repellant is not available.

A specimen scale is a specially designed lightweight scale as shown in Fig. 5.1. An ordinary, engineer's scale can be used.

A ruler can also be of any type; a metal tape measure may be substituted.

For the camera, it is practical to use a 35 mm camera and make transparencies to build up a reference collection. The colour reproduction of transparencies is normally better than that of photographic prints on paper. If a camera is being used to record the colours of the specimen, always carry a standard colour chart. This chart must be included in the record photographs.

Fig. 5.1. Specimen scale for field use. A. Clip to hold specimen. B. Dial showing the weight of the specimen. Drawing by G. Hangay.

Fieldglasses should be lightweight and well made; it is best if they have 7 x 35 or 7 x 50 power. A central focusing screw is essential for fast focusing.

METHOD OF COLLECTING

Most bird collectors rely on shooting as the main method of obtaining specimens. Bird collecting can be carried out at any time of the day, although in most parts of the world the early hours of the morning, or the late afternoon, are the best as these hours are when the birds are active. The bird should be observed before shooting to prevent the killing of an unwanted specimen. Breeding seasons should also be taken note of and, in countries where these are regulated by rainfall or other irregular natural phenomena, the collector must observe the bird long enough to identify whether it is feeding its young or not. It is anticonservational to kill a bird which is still breeding, or feeding nestlings.

If a bird is wounded, but captured, it should be killed in the fastest and most humane way possible. Most collectors use pressure to achieve this; the

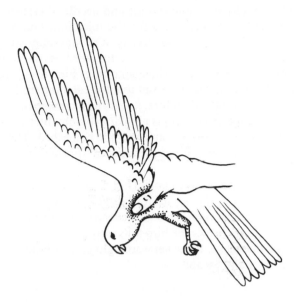

Fig. 5.2. A wounded bird is held this way.

sides of the body of the bird just below the posterior to the shoulder joints may be compressed, thus retarding the lung action. Small birds can be despatched quickly by this method but larger birds require more pressure (Fig. 5.2). It may be necessary to hold them down on the ground and apply the pressure with one knee. The pressure must be firm and even to avoid causing damage to the plumage.

If it is difficult to handle birds in these manners, it is better to use chloroform. A small wad of cotton wool, having been dipped in chloroform, should be held over the bill of the wounded bird to cover the nostrils. The cotton wool must be held firmly, and the bill should be kept shut until the bird loses consciousness (which happens within seconds). However, the bird will need to be exposed to chloroform for some time before it dies; therefore, a small plastic bag should be placed over the bird's head with the cotton wool inside and sealed by means of a rubber ring around the neck. This is a very quick and efficient way of killing wounded birds, or even those specimens which may have been bought from a breeder for study purposes (such as domestic pigeons, chickens, ornamental pheasants and so on). Another way to kill birds painlessly and rapidly is to use a pentobarbitone solution. This substance is sold under a variety of names and is used by veterinarians to "put down" animals. A few millilitres of this solution will kill a large bird within seconds. The disadvantage of using pentobarbitone is that it has to be

administered with a hypodermic syringe and needle; therefore, the operator spends considerable time preparing for the injection. During this time the bird suffers a great deal of pain and anxiety; it may perhaps struggle or flutter until the plumage becomes soiled or even damaged beyond repair.

Another popular collecting method is netting. Fine nets, called mist nets, made of synthetic netting are most suitable for catching birds. The synthetic netting is very fine and soft; therefore, it does not damage the captured birds. This type of net, properly erected, is almost invisible. Birds flying into it fall into pockets formed by "shelves" and become enmeshed. The standard mist net is 2.7 metres high and comes in lengths of approximately 7, 10, 13 and 20 metres.

The mist net is erected between poles (Fig. 5.3). The "shelf strings" are tight between these poles, but the net itself is vertically slack, thus forming loose pockets at each "shelf string". This is necessary to trap birds which fly into the net. Upon striking the net the bird falls into one of these pockets and gets entangled in the fine mesh. If the net were tight and without pockets, the bird could bounce off it and escape.

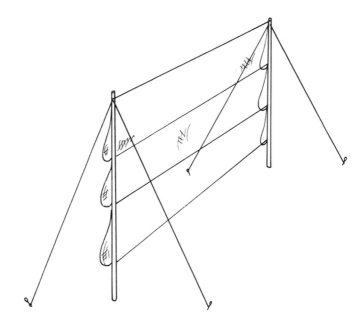

Fig. 5.3. A mist net. The horizontal lines are representing the shelf strings. The horizontal slack forms pockets in the net. Drawing by G. Hangay.

The 13 and 10 metre size nets are the most practical to use in most habitats. The 7 metre net is a little short unless it is used in confined sites, for example, in a garden or in dense rainforest. The 20 metre net is too large for one person to erect and also is too long for many netting sites. However, if there is more than one collector to handle the net and the site is suitable, the 20 metre net is most effective. Most of the time, one net is not enough for successful collecting. The ability of the operator will determine how many of them can be used at the same time. As a rule, every net should be inspected each half hour. Although most birds do not appear to be distressed by being netted, some will struggle endlessly in the net, while others seem to suffer from shock (for example, treecreepers and honeyeaters can suffer from the combination of shock and cold). The wanted specimens should be killed humanely and rapidly and removed from the net; unwanted birds should be freed without delay.

It is very important that the nets are erected in a locality with a fairly dense bird population. A little time spent watching the birds will show the collector where the birds are compelled to fly low. Bear in mind that the effective height of mist nets will be no more than about 2.4 metres from the gound. There is no general rule which can be applied to the selection of netting sites. Creeks, river banks, and waterholes can provide excellent catches in most areas. Edge country (where various habitats meet) is usually very attractive for birds and the population can be rich in various species.

This form of collecting requires additional equipment. The main item, of course, is the mist net itself and the poles which keep it erect. A hammer is also necessary to drive the poles into the ground, a pair of secateurs or a bushknife (machete) is needed to clear vegetation from the immediate vicinity of the net, and, perhaps, a light rake to clear plant debris from the site before the net is erected.

Birds can be attracted to the nets by various means. Some skilful collectors can imitate birdcalls by using homemade or commercially manufactured devices, or simply by whistling or calling. A tape recorder can also be employed for the same purpose. Sometimes bait may be used to lure the birds in the vicinity of the nets. Baiting, however, may have to be repeated for several days or even longer before it brings good results.

Once the bird is in the net it should be removed firmly, but gently, and fairly rapidly. Unwanted specimens should be released immediately. If this is not desired for some reason, the specimens should be kept in small canvas bags in the shade, and out of the wind or rain. It is appropriate to work in conjunction with bird banders, who can band every specimen before release.

The desired specimens should be killed using any of the methods described for wounded birds. One must be careful with the larger waders, as they can be dangerous if handled in a haphazard way. Their long and pointed bills can

be formidable weapons and, if they use them in self defence, the stabs are generally aimed at the eye. Large parrots can also inflict painful wounds on the hand. Raptors may also use their sharp bills and talons in an effective way. The use of leather gloves is recommended when handling such birds.

Birds can also be trapped by using the mist net as a clap net. Wilson, Lane and McKean (1965) of the Commonwealth Scientific and Industrial Research Organization, Australia, use this device to trap silver gulls *(Larus novaehollandiae)*. The technique of rigging is illustrated in Fig. 5.4. Most gulls have very sensitive, snow white breast feathers which could be ruined beyond repair if bloodied by shots. Trapping them live secures some beautiful specimens for the collector.

The mist net can also be set horizontally over water. This technique was designed to catch a North American wader, Wilson's phalarope *(Steganopus tricolour)* according to Johns (1963). It can be used with success for catching some species of marsh and water birds, such as crakes and rails.

Many forms of bird traps have been devised ever since humans began to hunt. It would not be practical to list all or even some of these sometimes simple but at other times extremely complicated instruments.

Decoys can also be used to attract birds into either traps or nets, or within shotgun or rifle range of the hidden hunter. One of the most ancient decoys is a live or preserved owl. The owl is taken into the field and placed on a perch (with one foot tied to it) in a clearing. There need to be some trees in the vicinity. The shooter retires to the hide and waits. A number of species will soon appear and perch on the nearby trees, and can be easily shot down.

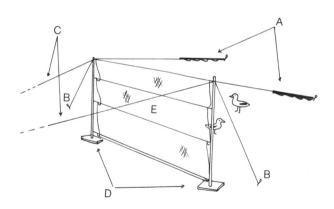

Fig. 5.4. The rigging of a mist net for capturing birds on the ground. A. Looped bands cut from motor tube. B. Light peg in line or slightly forward of net. C. Release cords, which are operated from a hide. D. Base plates. E. Mist net. As the release cords are released, the rubber bands pull the net forward, capturing the birds. Drawing by G. Hangay.

Small and medium birds of prey, such as crows, ravens, and magpies, will gather around the owl and make mock or real attacks on it. Once this was a very popular method amongst the foresters of Europe for keeping "harmful" bird populations down. Fortunately, the practice has been discouraged by authorities; however the method is still practical for the scientific collector.

Often, artificial decoys are also used in bird collecting (or sport), especially to attract waterfowl. Here again, even the most simple decoys are sometimes very useful. There are great numbers of commercially manufactured decoys on the market, all designed for game bird shooters.

Another collecting method is poison baiting. This is a very dangerous form of collecting birds and can cause extreme damage to the entire environment if not done expertly. After careful observation, the collector should settle on a site where no outside interference could cause any tragedies (there should be no access to the site for wandering livestock, household pets or small children). It is also necessary to decide which species of birds will be baited and in what number. Once this has been decided the bait should be prepared. If seed eaters are to be baited, wheat or similar seeds should be soaked in any full strength organophosphate (even those used in animal husbandry are suitable without dilution) and spread in a suitable spot. The collector must remain in the near vicinity (preferably in a hide) and observe the birds as they approach the bait. The poison will act very quickly and, as soon as the required birds are taken, the remaining bait must be gathered and burnt.

Carrion eating birds are just as easy to bait; a suitable cadaver must be injected in several spots with full strength organophosphate and left out in the open. Here, even more caution must be exercised as dogs, cats and carrion eating wild animals will also be attracted to the bait. The collector must remain near the bait and observe the activity around it. Again, once the required specimens are taken the bait must be burnt to avoid further killing of wildlife. Poison baiting is extremely dangerous and should be carried out only by responsible, qualified persons.

RECORDING DATA

As soon as the specimen is collected it must be labelled in the manner described earlier. Essential data, such as date of capture, location, the name of the species, and the sex of the specimen, should be indicated if possible. The two latter specifications can be omitted if determination is not possible immediately, but they must be recorded at a later date. Once these records are written and attached to the specimen it can be wrapped and temporarily stored.

The specimens should be checked for ectoparasites, which should be collected as their scientific significance could be great. The individual specimens can be collected with a pair of Leonhardt forceps, or, if these are not

available, a pair of dissecting forceps, and placed in a small glass vial containing a 75% solution of alcohol (ethanol), together with a data label. The label should show the host bird's name, the locality, the date, the name of the collector, and, preferably, the reference number of the specimen, thus enabling researchers to find the bird's data sheet later on and receive full information about the host animal.

Later on (preferably at the time preparation begins), more detailed information should be recorded. Serious collectors, especially those who work for scientific institutions, use a standard data sheet and, by filling one out for each specimen, record all the necessary information concerning the bird. A sample of such a data sheet is shown in Fig. 5.5. All records must be accurately taken. The specimen's scientific value depends wholly on a properly completed data sheet.

If the bird is meant for display, even more records must be taken, but the scientific records should not be neglected just because the specimen will not be entered into a scientific or "study" collection. A mounted bird with appropriate data can be just as valuable a specimen for an ornithological collection as it is for a display. However, if data were not taken in the regular, orthodox manner, the mounted bird, no matter how "pretty" or "interesting" it looks, is worthless for the scientific collection.

In addition to the scientific records, the collector must make notes on the birds colouring, especially the colour of the eyes, bill, all naked parts (wattles, combs, exposed skin, feet and so on), before death changes them.

It is of paramount importance to record accurate colour description of the live or freshly killed specimens for display purposes. The most obvious method is to employ colour photography. However, to safeguard against the slight colour distortion commonly experienced even with the best colour films, a colour chart should be placed next to the specimen. This colour chart can be compared with the photograph at the time of the painting of the finished specimen and adjustments, if needed, can be made. Several photographs of each specimen, taken with varied aperture openings and speed, will provide the taxidermist with a more or less accurate colour record.

The colour chart can also be used for immediate colour identification of the specimen. By comparing the colours of the bird's naked parts with the colours of the chart a reasonably accurate record can be taken. Internationally accepted charts such as the Munsell System should be used. At least, the colours will be named according to the names used on the chart, making colouring of the prepared specimen a little easier. Collectors often mistakenly use various trade names or one of the many synonyms for the same colour when recording data. The fact that a large proportion of people are slightly colour blind does not help, either.

A colour photograph, especially a print, is not sufficient reference for restoring colours on a mounted bird specimen. Many factors, such as light,

AUSTRALIAN MUSEUM

S.O. 223 D. West, Government Printer

A

Species Name	Serial No.	Data Sheet No.
Scientific name	Band No.	Reg. No.

Date	Locality		Weather	
Time	Lat	Long	Fat	Skull
Weight	Total length	Wing span	Wing	Tail
Age	Sex	How determined	Culmen	
How determined			Tarsus	

Iris	Bare eye skin
Eye ring	Cere
Bill, upper	Gape
Lower	Inside bill
Legs	Claws
Soles	Nostril

WING	1	2	3	4	5	6	7	8	9	10	TAIL (from outside)	1	2	3	4	5	6
Primaries																	
Secondaries																	
Tertials																	

0 - Old feathers 1 - missing or pin 2 - ⅓ grown 3 - ⅔ grown 4 - nearly full grown 5 - new feather

WING COVERTS	Mlt.	Plumage	UPPER PARTS	Mlt.	Plumage	UNDER PARTS	Mlt.	Plumage	HEAD	Mlt.	Plumage
Primary			Nape			Throat			Crown		
Secondary			Mantle			Breast			Forehead		
Medium			Rump			Belly			Ear coverts		
Lesser			Scapulars			Flanks			Malar region		
Under wing			Upper tail coverts			Under tail coverts			Chin		
Bastard wing											

MOULT KEY X - active moult ✓ completed moult S - slight moult

Ecto parasites	Endo parasites

Stomach contents

Habitat	Testes
	Oviduct
	Ovary

Remarks

Hours after death record made	Collector	Recorder

B

AUST. MUS. No.	Date
Name	
Locality	
Collector	Sex
Food	Gonads

Fig. 5.5. An example of a bird data sheet (A) and specimen label (B). Courtesy of the Australian Museum.

background, the colour of the surrounds and so on, can influence the image of colour in a photograph. A photograph can only give guidance; it is not a perfectly reliable reference. Also, colour photographs fade over time.

The weighing and measuring of the specimen should commence as soon as possible after it is collected. It is best to weigh the bird first, then proceed with the measuring. The measuring must be carried out according to the internationally accepted rules and with the utmost accuracy (Figs. 5.6, 5.7, 5.8 and 5.9) and before rigor mortis sets in. If circumstances do not allow the collector to measure the bird before rigor mortis, one must wait until the specimen relaxes again and carry out the work then.

Observations concerning the plumage and so on can be made and recorded practically any time after the bird has been collected. Sometimes it is possible to determine the sex of a specimen by external characteristics. However, if it is entered (as it always should be) on the data sheet, the determination must be confirmed by internal examination. This is best carried out after the bird is skinned. The details of this are described later.

Fig. 5.6. The method of measuring the bills and tarsus.

Fig. 5.7. The method of measuring the wing.

The ossification of the skull (or other bones) which indicates the age of the specimens, the contents of the stomach and so on can also be determined after the skinning.

In order to keep the plumage in as good a condition as possible, special care should be taken with the freshly collected bird specimens. The success of preparation is greatly dependent on this; therefore, one cannot be too careful when handling birds.

The specimen must be treated swiftly and cleanly. In order to achieve this, the bill and vent should be plugged with cotton wool. If there is a shot wound, this also should be plugged. Blood should be wiped from the plumage with a wad of dry cotton wool. Bloodstains can be prevented from spreading by dusting the stained area with borax or whiting. Sawdust is more practical with very dark birds.

The specimen should be wrapped in a thin layer of cotton wool and placed in a paper cone, head down (Fig. 5.10). Under very hot conditions it is wise to let the bird cool as much as possible in the shade before wrapping. It is also advisable to push the cotton wool plug deep down the throat in order to confine the stomach contents, which decay faster.

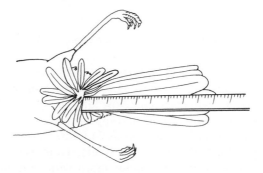

Fig. 5.8. The method of measuring the tail.

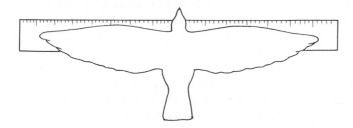

Fig. 5.9. The method of measuring the wing span.

Fig. 5.10. The freshly collected bird is placed in a paper cone. Drawing by G. Hangay.

The wrapped specimens can be carried in a fishcreel, as described earlier, or in a cardboard box. As soon as possible, the bird should be prepared properly. The climate will determine how long the specimen will last before decaying. Under temperate conditions (approximately 10–15° C), a specimen will remain in good condition for about 24 hours. Small birds need special attention: their feet dehydrate in a few hours. To prevent this they must be wrapped in a fine layer of cotton made moist with concentrated salt brine. The wet cotton should be separated from the plumage by another layer of dry cotton or cling wrap.

As an emergency solution, birds can be eviscerated and the body cavity swabbed with undiluted ethanol. This would greatly delay decay.

If it is necessary for the specimens to survive a longer period without refrigeration they must be skinned. The skin, once it has been cleaned thoroughly of all flesh and fat, is filled with salt and left for approximately 24 hours. After that the salt is removed and the flesh side of the skin is rubbed with fresh dry salt. After another period of drying (approximately three to four hours), the skin is sealed in a plastic bag. It can be stored in this manner for a long period, preferably in a cool place.

Instead of salt, a bird skin preserving formula can be used. This formula consists of 30 mL glycerine, 100 mL alcohol, 10 g carbolic acid, 10 g boric

acid and a few drops of clove oil. This liquid is painted on the flesh side of the skin, and small unskinned sections (for example, wingtips) are injected with it. The skin is sealed in a plastic bag. If kept cool, the skin will last for a long time.

Some collectors use embalming fluids to preserve birds in the field. One of these compounds, Disney goo (570 mL water, 30 mL formalin, and 4 mL 10% Zalkon, Zephyrin or Quatramine) was used for many years by John Disney, the curator of birds in The Australian Muscum, Sydney (Disney, 1979). The preservative was injected into unskinned bird specimens. It arrested decay for several days, and sometimes for weeks. However, specimens preserved in this way were not suitable for display taxidermy, as the compound contained formaldehyde which rendered the skins hard and unmanageable. Study skins prepared from such specimens suited the purpose, although their appearance left a lot to be desired.

The most efficient manner of storing specimens before full scale preparation is by freezing. The specimen, wrapped as described above, is sealed in a plastic bag, together with a label which can be read through the plastic. The label should show the specimen's number and name, and perhaps the locality and the date of the collecting. This enables the preparator to distinguish individual specimens without unwrapping them. Bird specimens kept in this manner can be safely stored for years.

FIELD AND LABORATORY PREPARATION

If a bird skin is prepared properly, it can be used as a study skin or it can be converted into a lifelike mounted specimen at any time in the future. However, if some of the steps described below are omitted, the skin can only be used for limited purposes for the result of the preparation will be poor.

It is most practical to prepare contact drawings of every specimen, regardless of its final destination (that is, study skin collection or lifelike display). A collection of such contact drawings is priceless for the taxidermist.

SKINNING THE BIRD

The unskinned bird is laid on a sheet of paper and a drawing of its outline is prepared by holding a pencil vertically and carefully tracing the bird's silhouette on the paper. Feather tracts can be sketched freehand on the drawing (Fig. 5.11).

Further contact drawings are prepared after the skinning in three views: profile, ventral, and dorsal. Shoulder, hip, knee and tail attachments are marked on the drawings (Fig. 5.12). The length of tail bones is noted and the tail is sketched.

Fig. 5.11. Contact drawing of a bird before skinning. Drawing by G. Hangay.

Fig. 5.12. Contact drawings of a bird after skinning. A. Profile. B. Dorsal view. C. Ventral view. X indicates the joining points of the wings and legs.

The neck, especially if the bird is a long necked species, is manipulated and sketched perhaps in more than one position. Characteristic anatomical features are also noted and sketched on the contact drawings.

The actual skinning operation should be done swiftly and continuously, but not in a rushed and disorganized fashion. In order to achieve this, all materials, tools and equipment must be ready and in good working order.

The immediate area on the work table where the skinning is to be performed is covered with several layers of newspaper. If the specimen is very lightly coloured, clean butcher's paper should be used. During the skinning, the uppermost layer can be discarded as the paper gets soiled, revealing clean sheet underneath.

There are several opening cuts for birds; the four basic cuts are illustrated in Figs. 5.13 and 5.14. The classic cut is a straight incision from the lowest point of the sternum to the vent.

Fig. 5.13. A. Long ventral incision. B. Short ventral incision. C. Dorsal incision.

Fig. 5.14. Side incision. Incisions on the underside of the wing faciliate the cleaning of the wing bones.

To make the first cut as neat as possible, blow on the feathers until they part and expose the naked skin of the belly. An incision can be made with a scalpel from the breastbone to the vent. The vent is not cut through (Fig. 5.15). The abdominal tissue must not be punctured. If it is cut, the body juices will soil the plumage.

From the moment the skin is cut until the skinning is completely finished the preparator's hands must be kept clean and dry. This is to keep the plumage clean all through the operation. To keep fingers and the specimen dry, plenty of dusting powder should be used at all times. Borax (powdered), whiting, light magnesium or cornmeal is suitable for light or medium dark birds; cornmeal or sawdust should be used on dark ones. If the bird is to be eaten after skinning, only cornmeal should be used. Under no circumstances use plaster. On contact with moisture it will set, and spoil the plumage.

Proceed by loosening the skin from the body as far as possible with the handle of the scalpel. Sprinkle the exposed flesh with powder. Peel the skin further down towards the knee. Pull and push the knee through the opening and cut through the joint between the tibia and femur (Fig. 5.16). Pull the leg out of the skin as far as possible (until the ankle joint) and cut off all flesh from the bone (Fig. 5.17). Repeat this with the other leg.

Work the skin loose from the body towards the tail. Carefully sever the vent from the inside of the skin. At this point, abdominal juices can flow freely if the cotton wool plug is not readjusted carefully. Sprinkle more powder on the freshly exposed flesh. Once the skin is worked loose around the tail bone it can be snipped through with a pair of bone cutters or side cutters (Fig. 5.18).

At this point the skin can be worked loose from the lower part of the body, including the legs. Now, work towards the upper section by standing the bird on its breast, the skinned part pointing upward. Using both hands (and plenty of powder) peel and push the skin downward towards the shoulders.

Fig. 5.15. The skin is peeled away from the abdomen.

Fig. 5.16. The knee joint is separated.

Fig. 5.17. The muscles are carved off the bones.

Fig. 5.18. The tail bone is cut through.

When the shoulders have been reached, cut through the shoulder joints, thus separating the wings from the body (Fig. 5.19). This part of the skinning operation seems to cause a lot of difficulty for beginners. It is sometimes helpful to suspend the carcass with the help of a skinning chain (Fig. 5.20); however, with a little experience it is possible to master quickly the technique described here.

When the wings have been severed continue to work the skin up the neck towards and over the head until the ears are reached (Fig. 5.21A). Separate the skin from the head by cutting on bone rather than on the skin (Fig. 5.21C); it is also possible to use forceps and simply pull the skin away from the earhole (Fig. 5.21B). This way one can avoid cutting big holes around the ears. After the skin has been peeled over the head, special care must be exercised when cutting through the connecting tissues which hold the eyelids to the eye sockets. Peel off the skin until the base of the bill is reached (Fig. 5.21D). Remove the eyes (without puncturing the eyeballs), the tongue, and carve off all flesh from the skull.

Now the head can be detached from the neck (Fig. 5.21E). Enlarge the foramen magnum and remove the brains. This can be done either with a brain spoon (currette probe), a pair of broad billed forceps or a swab of cotton wool. Sprinkle powdered borax into the inverted skin (Fig. 5.22).

Birds with large heads (for example, ducks, hornbills, many species of parrots and so on) represent a special problem. Their heads cannot be skinned by the above method. In order to remove the head skin in good order, without undue stretching and tearing, the preparator must proceed as follows.

REMOVING THE HEAD SKIN FROM LARGE HEADED BIRDS

The bird is skinned in the usual way: the skin is pushed and peeled off the neck until the base of the skull is reached. The head is severed at this point

Fig. 5.19. The wing bones are cleaned.

Fig. 5.20. Skinning hooks and chain.

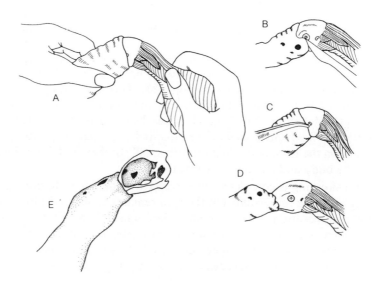

Fig. 5.21. The skinning of the head. A. The skin is rolled over the head until the ears are reached. C. The skin is separated from the head at the ears. B. The eyelids are carefully separated from the eyes. D. The skinning is completed as the base of the bill is reached. E. The skull is cleaned of all flesh, the eyes and brain are removed.

Fig. 5.22. The cleaned, inverted skin.

Fig. 5.23. Skinning incision on a large bird head.

and the skinned body is removed. The skin is turned right side in and an incision is made either at the nape and the upper part of the neck, or on the throat, or at the side of the head (Fig. 5.23). Through this incision, the head is skinned out, as described earlier. The cleaning of the skull is carried out as described before. Once the skin has been cleaned and degreased (as described below) and is about to be mounted or prepared as a study skin, the incision on the head is stitched up with small stitches. Stitching should start from the body and advance towards the head.

Once skinning is completed, turn the skin right side in to prevent further drying out. It is important that the skin remains moist and pliable through the whole operation. If the skinning takes longer than an hour the skin will start to dry out. The flesh side should be swabbed with a relaxing solution (*see* Formulae). More drying powder should be sprinkled on the moist skin. This will dry only the surface, while the underlying tissue will remain soft and moist.

CLEANING THE SKIN

Now proceed with the cleaning of the skin. This part of the work is of paramount importance. If it is not performed properly the finished specimens

Fig. 5.24. The wing bones can be cleaned through an incision on the underside of the wing.

will lack an aesthetically pleasing appearance and the uncleaned interior of the skin will attract insects and other vermin.

Begin with the legs. The bones should be scraped absolutely clean, right down to the ankle joints. Make a small cut at the sole of the foot and pull the tendons out using a heavy needle or an awl.

Once the legs have been cleaned, the wings should be worked on. Holding the humerus in one hand, pull and work the skin off the wing towards the elbow. Cut away the exposed flesh, scrape the bones clean, but do not cut through the ligaments at the elbow.

Turn the skin again right side in and lay it on its back with wings spread. Separate the feathers carefully in a straight line between the elbow and wrist (carpal) and make an incision exposing the flesh. Through this cut, snip and scrape all flesh from this section (Fig. 5.24). The metacarpal region can be left intact, except on large birds. This section of the wing must be injected with a preservative later on. On small birds, not even the carpal region needs cleaning out. However this section must be injected with preservative.

The entire inside of the skin must be cleaned now. The whole surface of the flesh side must be examined and every little piece of flesh or fat must be removed from it. With most bird skins this is not a very difficult exercise; most of the flesh will simply peel away. The roots of the wing and tail feathers require more attention and all muscle tissue must be removed from these spots. Most of the quills will be visible from the flesh side once the cleaning has been completed.

Fat birds, such as waterfowl, present greater problems. These must be cleaned with even more care as fat can ruin a prepared skin. If there is much fat under the skin, the fat forms a bacon like layer on the flesh side. It has to be removed physically. A converted spoon is the best tool for this (Fig. 5.25). First cut the layer of fat in a criss-cross pattern and then scrape off all

Fig. 5.25. A table spoon with serrated edge is a handy tool for scraping the fat from bird skins.

Fig. 5.26. Wire bristle brush.

the fat. Once the solid layers of fat have been disturbed, some fluid fat will be released. This should be soaked up immediately by sprinkling powder.

Another handy tool for cleaning the flesh side of bird skins is a wire bristle brush. This assists the preparator to remove tissue and fat from between the individual scapular feathers (Fig. 5.26).

The skins of large birds can also be fleshed with a pair of curved scissors. The unwanted tissue and fat can be snipped away little by little, but care should be taken to avoid cutting the end of the quills, as this may cause them to fall out. Large holes accidentally cut into the skin should be sewn up with a needle and thread.

SKINNING LARGE FLIGHTLESS BIRDS

The skinning of very large, flightless birds requires a different technique from those mentioned above. To avoid soiling the plumage of a large specimen such as an emu or an ostrich, the skin must be cut from the middle of the underside of the neck, with the cut continuing through the entire length of the body, and ending at the vent. Another incision must be made from the inside of one of the heels across the abdomen to the inside of the other heel. Thus the cuts form a cross. The feet should be cut off by the heels; the cut should be made just a little under the plumage. The purpose of this is to hide the seam when the feet are sewn back later on (Fig. 5.27).

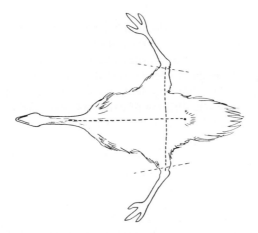

Fig. 5.27. The starting incisions on a large flightless bird. Drawing by G. Hangay.

The body is removed from the skin through these cuts. Plenty of dusting powder must be used during the skinning to avoid blood and body juices soiling the plumage. It is best to skin such large birds on a table, and avoid turning the body over and over. Rather, the body should be lifted out of the skin by peeling and cutting the skin all around it. The skull should remain in the skin. If blood happens to be smeared on the feathers, the skin must be washed in cold water soon after the skinning is completed.

If the skin is washed, the plumage must be dried with dry rags or simply air dried for a brief period, and the whole skin placed in undiluted alcohol (even household quality methylated spirits would suffice). This is the safest way of preserving the skin until the time comes to begin the actual mounting process.

Freezing the whole skin is also practical. Salting also preserves it, providing the flesh side of the skin is thoroughly cleaned of all fat and flesh (see Chapter 6 for a discussion of salting mammal skins — the same technique applies for salting large bird skins).

The severed feet must have the tendons removed and be injected with undiluted alcohol (either ethanol or methanol) and stored in the same liquid or in the freezer. Salting will not preserve the feet. The large cask of the cassowary requires special attention. It either can be cut and the inside scraped clean, or a hole can be drilled from the inside of the skull and the contents of the cask removed through that. Pouring alcohol inside the cask and skull before the entire skin is submerged in alcohol will guarantee the safe preservation of the specimen.

CLEANING THE PLUMAGE

After the physical cleaning of the skin has been completed, the skin is usually ready to be mounted. However, if the plumage has been soiled by blood, body juices or fat, the skin must be washed and degreased.

Skins which have begun to deteriorate due to decay, and specimens which were moulting or which have pin feathers, cannot take washing very well. If such specimens have scientific significance and must be prepared, it is wiser to make them into study skins without washing rather than risk further ruin by washing them.

In some cases spot cleaning will suffice. If only a small part of the plumage is soiled with blood (or something else) this simply can be wiped off with a small swab of cotton wool dipped in cold water. Soapy water could also be used, although plain cold water works better on blood. The soiled feathers are lifted on a glass plate and swabbed in order to prevent the diluted dirt staining the surrounding plumage. Stubborn stains can even be bleached out, using a strong solution of hydrogen peroxide. This chemical must be rinsed off once the bleaching is completed.

Stubborn blood stains (or dried lumps of blood) can be removed from the plumage by the following technique. The stained plumage is soaked in a 3%–5% ammonia–water solution which serves as a relaxing formula. In some cases this will loosen the blood particles, and the plumage can be rinsed clean in fresh, cold water. If dried blood still remains in the plumage, a solution of 70% alcohol and water with 2% hydrochloric acid can be applied for final removal.

Benzene and acetone are very good for removing grease spots, but they are also very flammable and special caution must be exercised when working with these dangerous substances.

Borax should be used to soak up the moisture after the cleaning process. Final drying can be completed by lightly beating the skin with a small stick.

Complete washing should only be done if the bird is dirty all over. If the plumage is very bloody, immerse the skin in a bucket of cold water and let it soak for a few minutes. Try to wash off the blood first. Once this has been achieved, change the water, raising the temperature to luke warm, and add a little detergent. Avoid strong, caustic detergents, as they can damage the feathers beyond repair and interfere with the pigments of the plumage. Let the skin soak for a little while then agitate it a little and gently wash it until it is clean. Change the water again and rinse until the water runs clear. All traces of soap must be washed off the plumage. Squeeze off the water, but make sure the feathers are not bent double or broken.

With clean towels, or paper towels, blot the skin. Under no circumstances rub the feathers as one would rub a dog after washing; just blot gently until most of the water has been removed.

If the bird is not fatty the skin does not need degreasing and can now be dried and mounted. Allow the skin to float freely in clean cold water and check whether the plumage looks fluffy and natural under water. Appearance at this time will be as it will look when completely dried. If it clings together and looks messy, it is greasy; therefore it must be degreased.

Greasy bird skins must be degreased otherwise they will never look lifelike. The fat, which will go rancid in time, attracts vermin and causes the general deterioration of the skin.

To degrease the skin, pour trichloroethane in a plastic basin and immerse the skin in it. The liquid should cover the entire skin. Work it by hand (wear industrial rubber gloves) and agitate the skin gently in the liquid. After a few minutes the fat will be flushed from the skin and the specimen can be squeezed dry and blotted as described above.

The used degreaser can be rebottled. The fat and water will settle on the bottom, so, if it is poured carefully into a bottle, the clean liquid can quite easily be separated from the dregs.

Degreasers should be employed in a fume cabinet or outdoors, or a fan should be used to drive the fumes away. As most degreasers are flammable, make sure that there are no fire hazards near when working with them.

Drying the plumage can be done in different ways. The simplest and cleanest is to use compressed air or heated air (from a heat gun or hair dryer). To speed up the procedure, the skin can be briefly immersed in full strength ethanol prior to drying. The ethanol should be squeezed and blotted off the plumage and the feathers are simply fluffed with the compressed air. Care should be taken to blow the air into the feathers in the right direction. Preferably, especially at the beginning of the operation, ply the air on the feathers in the direction they grow. Scapular feathers are always dried this way. Plumage of the breast, the back and under the wings can be dried any way until they are "fluffy". Drying must be complete; even the down feathers must be absolutely moisture free.

Drying can be speeded up even more if the skin is rolled in a desiccant (granulated borax is the best; whiting, light magnesium, and cornmeal are also suitable, but use only cornmeal on dark birds). As the desiccant absorbs the moisture from the plumage it becomes moist itself. Therefore, it should be shaken and gently beaten out of the feathers. Use a small dowel or a dried bird's wing to beat the skin. Roll the skin into more dry desiccant and repeat the shaking. Care must be exercised not to handle the skin too roughly and to avoid breaking the feathers.

The remaining desiccant (and moisture) can be blown off the plumage either by compressed air or with a hair dryer. Practically any instrument which omits a current of air can do the job. Vacuum cleaners with the hose attached to the opening where the air comes out, a hot air gun (the temperature must be controlled) or a compressor are all appropriate. The heat of

Fig. 5.28. Dusting box. A. Transparent viewing window. B. Compressed air inlet. C. Plastic or cloth sleeves. D. Hinges. E. Dusting box in use. Drawing by G. Hangay.

the air of a heat gun or a hair dryer must be kept moderate, otherwise feathers can curl or even singe.

After this treatment, the bird skin and plumage must be perfectly clean and fluffy. If the skin and plumage are not, it means that the plumage was not cleaned or degreased properly and the whole process must be repeated.

Dusting with desiccant and air fluffing is best carried out in a dusting box (Fig. 5.28) where the created clouds of dust are confined. It is harmful to health to inhale borax dust, or, indeed, any other dust.

Once the skin has been fluffed, it has to be prepared further. If the specimen is meant to be a study skin its preparation is as follows.

PREPARATION OF A STUDY SKIN

The skin is turned inside out again and the skull is examined. The ossification of the cranium is recorded on the regular data sheet (Fig. 5.29). The flesh side of the head skin is painted with an emulsion of arsenical soap (*see* Formulae) and sprinkled with dusted borax. The skull itself is also painted with arsenical soap. Two small cotton wool balls are placed in the eye sockets and the head skin is turned back over the skull. Now the entire flesh side of the skin is painted with arsenical soap and dusted with borax. The humerus is also painted and a wisp of cotton wool is wrapped around it. Both humeri should

Fig. 5.29. Ossification of the skull. A. Partially ossified skull. B. Fully ossified skull.

be positioned in their natural positions, spaced as they were attached to the body and tied together with two pieces of string. This is an important step and makes the setting of wings later on easy. Wrap cotton wool around the tibiae also until they resemble the legs before the flesh was cut away from the bones. Now turn the leg skin over them.

Cut and straighten a piece of galvanized wire, about 1.25 times the total length of the specimen and build a conical shaped artificial body on it from cotton wool (Fig. 5.30). Insert this body into the skin and ensure that it fits comfortably, but also fills the skin properly (Fig. 5.31). Once this has been achieved stitch up the incision with appropriately coloured thread and a needle, starting at the upper end of the cut. Make even stitches, approximately 5 mm apart. Ensure that feathers are not pinched in and that the plumage lies naturally over the seam (Fig. 5.32). Adjust the filling wherever it seems to be necessary. Use a long adjusting probe. This can be simply made from a piece of wire (Fig. 5.33). Dacron wool is most suitable for filling; however, ordinary cotton wool is also adequate.

The incisions on the undersides of the wings have to be attended to. After painting some arsenical soap into the wings at the radius and ulna, apply some borax dust and stitch up the cuts. On large birds, a little cotton wool filling is necessary to replace the removed flesh.

The metacarpal and carpal regions should be injected with a preserving solution (*see* Formulae) by using a hypodermic syringe with a fine needle. The feet, especially of larger birds, are also injected. A solution of 10% formaldehyde can be used instead of preserving solution if the skin is not to be relaxed later on. The effect of formaldehyde is permanent; therefore, a decision about the skin's future must be made.

Fig. 5.30. A. Making a wool body by winding the wool on wire. B. Wool body made on a wooden stick.

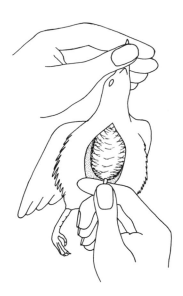

Fig. 5.31. Inserting the wool body in the bird skin.

Fig. 5.32. The filled skin is stitched up.

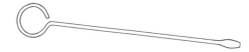

Fig. 5.33. Adjuster.

When working with formaldehyde and other preserving solutions wear protective goggles at all times, especially during the time when a syringe is used. The solution can squirt back unexpectedly and cause severe eye damage!

The cotton wool balls should be pulled slightly outward from the eye-sockets with a pair of forceps. This will stretch the eyelids a little and they will dry evenly and be clearly visible.

Now lay the bird on its back on a fine, even layer of cotton wool (Dacron wool is not suitable for this) and arrange the plumage as neatly as possible, first on the back, then on the breast, neck and belly. Fold the wings so that they lie naturally, cross the feet and tie them with string (reattach the label if it was removed during preparation) and gently wrap the bird in the wool (Fig. 5.34).

Lie it on a drying rack and let it dry in a cool, dry, well ventilated area (Fig. 5.35). An ideal drying cupboard has fine screened sides and doors which would keep insects out and still let the air circulate within the cupboard. Place some insecticide (pest strips, or some deterrent such as naphthalene) in the cupboard. Avoid drying specimens using direct heat or currents of hot air, as in a household drying cabinet. Drying which is too sudden will cause the skin to warp and the feathers to ruffle.

Mothproofing or more correctly, insectproofing specimens can be performed using three basic "proofs": borax; arsenic; and Edolan (Eulan). This aspect of the art seems to divide the world of taxidermists into two major

Fig. 5.34. The finished skin. A. Skin on a straight wire or stick. B. Skin on an alternative style wire.

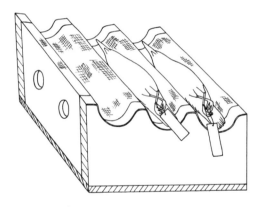

Fig. 5.35. Drying rack. Skins dried on a rack such as this will have nice, round backs. The wire mesh facilitates even drying.

camps: the borax users and the arsenic users. Leon Pray pioneered the use of borax for specimen preservation, and his technique follows.

The specimen is skinned in the usual way and powdered borax is used as a dusting powder. While cleaning the skin by scraping the flesh side, more borax is rubbed into it. Once the skin is cleaned it is washed in soapy water and rinsed in clear water, squeezed out and soaked in a saturated solution of borax. Soaking should take several hours, and preferably the skin should be soaked overnight. After soaking, the skin is dried with clean rags, and fluffed dry with more, preferably granulated, borax.

Small skins and others which could decompose quicker than usual are soaked in a formaldehyde–borax solution. This consists of 2 L saturated borax solution mixed with 1 mL full strength formaldehyde.

The advantage of this method is that borax is harmless when in contact with the skin of the preparator (although its dust must not be inhaled) and it is a cheap chemical. The disadvantage of the method is that skins must be submerged in a solution.

The preserving qualities of borax are often misinterpreted and many taxidermists use the chemical in the wrong manner. They merely sprinkle or rub dry borax on the flesh side of the skin, which is grossly inefficient as an insectproofing measure. In due course, the specimens are attacked by pests causing the method of using borax as a preservative against insects to be judged unfavourably.

If borax is used as described by Pray (1956) in his *Borax mothproofing for modern taxidermy* it is an efficient way of combatting insect pests in taxidermy collections.

Sodium arsenite is the most effective insectproofing agent for taxidermic specimens. The dangerous nature of the chemical renders arsenic an unpleasant material to work with and its effects can be detrimental to the health of the preparator who works with it. However, if the chemical is used only in a solution or emulsion and all skin contact is avoided, it can be considered relatively safe.

The arsenical solution or the arsenical soap emulsion (*see* Formulae) is always applied to the flesh side of the skin. The poison should be painted only on the part which is being worked at the time (for example, the arsenic can be painted on the skull and the skin of the head just before the eye sockets are filled and the skin is turned back on the skull). This will minimize the chances of the preparator accidentally touching the arsenic. If that happens, all traces of the poison must be washed off the hands immediately. It is also practical to smother the freshly applied arsenic with powdered borax. This harmless substance will cover the poison with an even layer of dust.

The effects of arsenic are purely poisonous and it is used only to combat insect pests in a collection. It is not a preservative which will arrest decay.

The third major chemical which is designed to do the same job is Edolan, which is a derivative of aromatic sulphonamide and is sometimes marketed under other trade names. The substance is a viscous, syrup like liquid and it is used as a solution with water. Edolan readily combines with the protein molecules of skin, fur and feathers, thus rendering them unpalatable for insects and other invertebrate pests. Its great advantage over arsenic is that Edolan seems to be harmless for the preparators. At present, there have been no known cases of illness caused by this substance; however, common sense would dictate that users handle the chemical with great care and avoid skin

contact as much as possible. Its application is as follows: the skin is weighed before washing and degreasing; 2% of this weight is the measure of Edolan added to enough water to cover the skin; the specimen is soaked in this solution for approximately 20 minutes and periodically agitated to allow the liquid to reach every part of the skin and plumage. During this time the Edolan achieves an affinity with the proteins of the specimen and the solution becomes exhausted, and thus useless for further use, so it can be discarded. The skin now can be degreased if necessary and dried (fluffed) as described earlier.

The disadvantage of this mothproofing technique is that the specimens must be submerged in a solution. This does not cause any problems if the bird requires washing anyway, but it can be a nuisance if the plumage has been kept spotlessly clean and dry during previous preparation. For such occasions, a compromise is to brush the Edolan on the flesh side of the skin (in the same manner as arsenical soap) and, once the preparation of the specimen has been completed, on the feet and bills. This method will give no protection to the feathers, of course, but neither would the arsenical soap. It is almost impossible to work out an exact formula for this method. The sensible thing to do is to overestimate slightly and make up a solution of 5% Edolan and 95% water as a brushing mixture. The total weight of the batch should be equal to the weight of the skin being treated, and the entire amount must be applied to the specimen.

Old specimens can also be treated with Edolan. The solution is brushed on externally.

It is practical to combine the above techniques if the occasion warrants it. For instance, if a specimen is treated on the flesh side of the skin with arsenical soap or Edolan, it makes good sense for the final fluffing of plumage to be carried out together with an ample dusting of borax. Borax is an excellent fluffing agent and there is no reason why it should not be used. Borax may dull birds with dark plumage, but this can be corrected with more air blowing and gentle beating.

DETERMINING THE SEX OF A BIRD

Since the determination of sex is important for future studies it is the preparator's duty to carry out this task. The best method of determination is by internal examination. This is most easily carried out on an unskinned bird. It is performed by means of a cut between the lowest part of the sternum and the vent (an incision similar to the opening skinning cut). If the specimen has been skinned already the examination should be conducted through a cut between the lowest rib and the vent on the left side of the carcass. Once made, the incision is spread open, and the intestines are pushed back to reveal the inside of the pelvis. The sex organs are found here as illustrated (Fig. 5.36).

Fig. 5.36. The shape and location of sex organs in birds. A. Male. B. Female. T. Testes. O. Ovaries.

In a male bird, the testes are usually two whitish grey, oval shaped organs, positioned just above the kidneys. Immature males have small, under-developed testes, of course, which are often difficult to recognize. The testes of adult males can also be very small, especially outside of the breeding and mating season. They also could be darker, bluish grey and easily confused with the adrenalin glands which are located in the same area.

The female bird of most species has one ovary which is positioned slightly ventral to the left kidney. The organ appears as a shapeless mass with a grainy surface of whitish colour. In the breeding season, it becomes larger and develops globular follicles of differing sizes. Its colour can change also, usually to orange.

If there is a lot of blood and body fluid in the pelvic area, it may be necessary to rinse the carcass until the fluids have been removed and the organs can be examined more easily. If the carcass is soaked in a mild salt solution, the organs become more easily recognizable.

The sex of hatchlings is especially difficult to determine as their sex organs are immature. It is often necessary to preserve the whole carcass of such birds in a solution of 10% neutralized formalin and examine them later when more time and perhaps additional reference become available (see later section on wet-preserved birds).

TAXIDERMY TECHNIQUES FOR DISPLAY PURPOSES

Unlike most aspects of taxidermy the mounting of birds remained relatively unchanged through the last century. Although some flair in sculpting is useful it is not absolutely necessary for the bird taxidermist to be an accomplished sculptor. The collecting and skinning of bird specimens is described earlier, but a few more points are worth mentioning.

Perfect birds should be selected for display purposes. Specimens with poor plumage (faded, worn, dirty or in moult) will make poor mounts, even if the taxidermist is an excellent worker. Special care should be taken so that the bird, once collected, will not deteriorate in the hands of the collector.

The skinning of display specimens should be carried out in the same way as described earlier. However, a few alterations can be made to those methods.

It is possible to skin a bird through a dorsal incision instead of the usual abdominal cut. This method of skinning is appropriate for specimens with extremely sensitive or sparse breast and belly plumage. The skinning procedure should be more or less the same as described earlier.

Another skinning method is to use the first incision under one of the wings; the whole body can be removed through this cut. The advantage of this method is that, if the bird is displayed in a sideways presentation, no disturbance of the plumage is visible. These skinning methods were developed by different taxidermists at different times, and are sometimes applied only for a particular species.

The most commonly used abdominal incision technique is the most practical one to be applied to most of the species.

Taxidermists often prefer to leave the thigh bone attached to the leg when skinning. This bone aids the worker to wrap the thigh more accurately and place it with more precision. If this bone is left on the carcass during skinning and the body is still available, best remove it now, clean it and attach it to the tibia. However, it is possible to mount a bird without the femurs, especially if the preparator is an experienced taxidermist.

If some of the major bones, which are important for the taxidermist, are broken, they must be repaired. The illustration (Fig. 5.37) shows how these bones are repaired. If parts of the skull are missing these should also be replaced either with a piece of carved balsawood or polyurethane foam and cemented in position with a fast setting glue (epoxy or similar).

The treatment of the skin (cleaning, washing, degreasing, fluffing, and mothproofing) for a display specimen is the same as for any other bird specimen, as described earlier.

Once the skin and plumage are spotlessly clean, the specimen should be placed in a plastic bag and temporarily stored in a refrigerator while the artificial body (or mannikin) is being made.

Fig. 5.37. The method for repairing a broken bone. Drawing by G. Hangay.

MAKING THE ARTIFICIAL BODY OR MANNIKIN

To make a perfect mannikin the skinned body of the bird is used as a guide. The contact drawings which should have been prepared earlier are now of immense help. It is also worthwhile to keep the skinned carcass (perhaps stored in the freezer) as a reference until the artificial body has been completed.

To make the artificial body, first, a piece of wire is bent into the shape of the contours of the carcass from a side-on view. The body is placed on a sheet of paper and its outline is drawn with a pencil. The pencil should be held in such a way as to give the drawing the perfect dimensions of the body (Fig. 5.11, 5.12). Now lay the body on its back and make another drawing of it, using the same technique. A piece of wire is then selected and placed on the drawing; it is bent to shape. Now, some wood wool should be wet, wrung out and squeezed into an elongated ball. This ball should be fitted into the wire frame and flattened without disturbing the shape of the wire. Fine cotton thread should be wound all around until it has been securely fastened into the frame. Make sure that all wood wool remains inside the frame so that the actual shape of the wire is not changed.

The thickness of the body is built up by the addition of more wet wood wool to both sides. The artificial body should be placed on the second drawing from time to time, so that the true dimension of the bird's body can be reconstructed.

Plenty of thread should be wrapped around and around the mannikin until it becomes perfectly smooth, free of lumps and similar in shape to the original body. Make sure that the mannikin is no larger than the original body. It must be a little smaller.

Place the skin on the mannikin. The incision should close with ease, but the skin should still have some slack. It is essential that the mannikin fit the skin easily, otherwise the skin will be too tight and feathers will not lie on the mount in a natural manner. If the mannikin proves to be too large, a new one must be made; an oversized artificial body cannot be reduced except by complete dismantling and reconstruction.

Experienced taxidermists can form a wood wool body without the aid of the wire frame, and even without a contact drawing. However, it is necessary to keep the natural body at hand until the mannikin has been completed.

Instead of wood wool, rigid polyurethane foam can be used as the material for mannikins. Chunks of this plastic can either be bought or "home made" from the two liquid components of the foam. For bird work, a foam with a density of at least 16.2 kg m^{-3} should be used. A lighter foam is not strong enough to accommodate the neck, wing, leg and tail wires of the mount. The chunks of foam simply can be carved and rasped until they take the shape of the required bird's body.

Commercial taxidermists and taxidermy suppliers manufacture bird mannikins. These polyurethane bird bodies are cast from liquid components into aluminium or fibreglass moulds. In commercial taxidermy, supplies such as bird mannikins can speed up production greatly.

The artificial neck can be made in a number of ways. A commonly used method is to cut a length of wire of appropriate thickness according to the size of the bird approximately twice the length of the original neck. Both ends should be sharpened on a grinder or by filing, the length of the natural neck marked, and that section wrapped with cotton wool. Ensure that the wool wraps around the wire very evenly. Lumps and uneven thickness of the neck will cause difficulties during the mounting process. Wrap the cotton wool tightly, thus making the artificial neck reasonably solid. Once the required thickness has been achieved, fine thread must be wrapped around the neck. If this reduces the proper thickness another layer of cotton wool should be added, and more thread.

Instead of cotton wool, loose sisal or plumber's taw can be used to build a neck. Taxidermy suppliers sell a flexible foam "rope" which can also be used as an artificial neck. This flexible foam comes in various gauges but it must be noted that, if it is slightly thicker than the original neck, mounting will be difficult. The appropriate gauge should be selected; alternatively a slightly smaller gauge may be selected for the job and built up to the appropriate thickness with cotton wool. This flexible foam has a great advantage if the material is used wisely and in combination with cotton wool. Commercial taxidermists favour the use of flexible foam necks in order to achieve faster production.

Once the artificial neck has been constructed, the protruding end of the wire should be inserted into the mannikin; lead it through towards the belly section, let it emerge, bend it over, and insert it back into the body. Use a

pair of pliers to force the end deep into the body, thus anchoring it very well. A little cotton wool may be necessary to fill the section where the neck joins the body. This wool should be wrapped into position with thread.

WIRING THE BIRD SKIN

For a small or medium sized bird, once the mannikin has been completed the leg and wing wires should be installed in the skin. These wires are essential to keep the specimen in the required pose. Wires of appropriate thickness and twice the length of the limbs they are intended to support should be selected. Both ends of the wires should be sharpened.

Begin with the wings. Insert a wire from the inside of the skin and push it along the bone until it reaches the tip of the wing. The procedure is the same with the other wing. Once the wires are in position, bend the protruding ends out of the way (Fig. 5.38). The leg wires are inserted the same way; lead them from the inside, or, if this is difficult, start from the soles of the feet and push the wire along the bone. Try to find the space created by the removal of the tendons and push the wire in there. This serves two purposes: the wire moves along easier in the hollow; and, as the drying and slightly shrinking mount will not show the outlines of the wire, it will look like the tendon of a living bird (Fig. 5.38D).

Fig. 5.38. A. The wiring of the wing bones. B. Alternative method of fixing the wing bones in position, using short pieces of bent wires. C. The position of wing bones on a mounted bird. D. The method of pulling the tendons out of a bird's foot.

Wings do not need to be wired if the specimen is small (up to the size of a partridge), or will be mounted with closed wings. Some species, such as most ducks, grebes or pheasants, will not require wing wires as they will have closed wings. Some others, such as cormorants, ibises, and most birds of prey, will have to be wired every time. A taxidermist must have extensive knowledge and experience before being able to mount birds in a lifelike manner without using wing wires.

MOUNTING THE SKIN ON THE MANNIKIN

Just before beginning mounting, the skin must be treated to avoid insect damage. The various methods of insectproofing have been described earlier.

To begin the mounting process, turn the head and neck inside out, treat the skull and skin with borax or arsenic, place a little cotton wool inside the eye socket and fill up the rest of the cavity with water based modelling clay or stiff papier mache. Place a small amount of stiff papier mache or clay inside the skull. Turn the skin right side in. Tie the wing bones to the wing wires, if wing wires are being used (Fig. 5.38) with light string and wrap a small amount of cotton wool around the bone, thus replacing the muscles which were cut away from the bones. If no wing wires are used, tie the wing bones together as shown on Fig. 5.39. It is necessary to tie the bones as illustrated, otherwise the wings will never lie properly and will cause ruffled plumage on the back of the bird.

Tie the leg wires to the leg bones and build up the mass of the leg muscles by wrapping cotton wool around the bones and wires. Thread should be wrapped around the legs to make the wrapping firm. The skin should now be ready to receive the mannikin.

Fig. 5.39. The method of tying the wing bones of a bird. The arrows indicate the points where the knots should be tied. Drawing by G. Hangay.

First, push the neck into the skull cavity. The protruding end of the neck wire should be firmly lodged in the upper mandible. The lump of papier mache or clay in the skull will harden during the drying process and will anchor the neck wire firmly. Next, anchor the wing wires in the same way. Turn the bird over and determine that the wires are positioned in the right spot. If they are not, they should be immediately repositioned. It is appropriate to mark the artificial body before it is inserted into the skin to show where the limbs should join. As a taxidermist gains more experience this should be no longer necessary.

Once the positioning of the wings is satisfactory, the leg wires should be anchored to the body. Here again, careful consideration must be given to positioning.

If the right position has been chosen, the mount can stand in a lifelike pose. At this stage it is necessary to decide how the bird should stand (or fly or sit); the leg wires should be inserted accordingly. The taxidermist must understand how a bird's legs work, how the bones are articulated and what their functions are. By studying the natural body of a bird, it is possible see how the thigh bone moves in an arc. The leg wires must be attached to the artificial body somewhere along the arc formed by the forward end of the thigh bone (Fig. 5.40).

Push a sharpened wire into the root of the tail and anchor that to the body. Ensure that the skin fits neatly everywhere. If the skin shows signs of drying, swab the flesh side with a relaxing solution (see Formulae). If the skin is loose, pack it carefully with smooth layers of cotton wool. Do not overstuff the skin, as this will cause it to stretch and the plumage will not lie in a natural manner.

Fig. 5.40. A. Dotted line from a to b indicates the length of the femur. The arched dotted line from c to d indicates the path of the knee when the bird is walking. If only the tibia was retained, the point of attachment for the leg wire should be located along this arc. B. The method of assembling the bird.

Fill the crop area with wool, and sew up the incision, starting at the breast. It is not necessary for the stitches to be small as the plumage will cover the seam. It is essential that feathers should not be pinched in by the stitching and that the skin is not pulled out of its natural shape by uneven stitches. If the head skin was cut, this cut should be sewn as well; begin at the bottom of the incision and proceed towards the head (Fig. 5.40).

Once all incisions have been sewn, pick up the bird by its legs, shake it gently and blow its feathers with a hair dryer, using cold air. This will help the plumage fluff and arrange itself in a more or less natural position. It will also remove all surplus borax, sawdust and so on.

POSING THE BIRD

The specimen should now be placed on its stand or perch. It is better to put the bird in its final position as it can be posed with more accuracy and certainty.

Reference pictures are necessary for this phase of the work. Very often, a good artist's sketch or painting is more suitable as a reference than a photograph. The photograph will show a bird frozen in action, and this can be misleading. Such an image transformed into a sculpture or a taxidermic specimen can look completely wrong, as it may be out of balance, or have an unnatural stance, or simply be aesthetically undesirable. A good artist's impression is not only true to nature, but also aesthetically pleasing.

It is necessary for a taxidermist to have some knowledge of the habits and general behaviour of the bird being mounted. In a museum exhibition, where the aim is to help the public identify birds by sight, it is essential for specimens to be posed in such a way that their morphological identification marks are clearly visible.

Once the bird has been placed on its perch (which is achieved by drilling two holes into the perch or stand and leading the protruding ends of the leg wires through them), the final pose needs to be arranged. In most cases, the legs should be slightly bent, the neck curved and head, perhaps, turned to one side. It is impossible to impose more general rules. Poses are infinitely variable. Each species of bird has a number of very characteristic stances; however, clichés, such as flying ducks mounted in a diagonal line on a wall, should be avoided.

Eyes

Once the specimen has been posed in the required way, the head can be finished. Insert a blunt wire into the eye socket and move the scalp around from the inside, loosening the skin from the skull (Fig. 5.41). This will free

Fig. 5.41. Arranging the skin around the eye.

all the little snags in the head and neck skins (if there are any) and allow the plumage to lie in a natural manner. Small balls of cotton wool can be pushed under the skin, through the eye sockets, to fill the cheeks and wherever else filling is needed. Some more wool could be pushed through the bill into the throat section. Thread some sewing cotton through the nostrils and tie the bill shut. Glass or plastic eyes of the appropriate colour can now be fitted. Select the right size, making sure that they are neither too small or too large. Simply push the eyes under the eyelid into the soft papier mache or clay and arrange the lids in a lifelike manner. The positioning of the eyelid, alone, can influence the appearance of the mount.

The eyes of many species, but especially owls, require special attention. Owls have huge eyes and these differ anatomically from other birds. When preparing an owl's head, remove the eyes from the skull, cut around the iris, drain the fluid and clean the bony eye cup with cotton wool and treat it with borax. Before mounting the head, press a small amount of modelling clay or papier mache into the cup and position the artificial eye in it. Then, the whole eye can be placed into the skull and held in position with a little more clay. Mounting can proceed as with any other bird.

Eyes are a very important part of any taxidermic specimen; therefore, much attention should be given to this area. Good quality glass eyes will improve the appearance of the mount. If they are set correctly with carefully positioned eyelids, they will enhance that further. Fine insect pins should be used to hold the eyelids in the required position. They should be inserted in each corner of the eyes.

Wings

The wings should be set next. If the bird is to be mounted with open wings, the spread wing feathers will need some support. They should be "sandwiched" between strips of cardboard and fastened with pins. Often, the wing

is too heavy to be supported by the wing wire alone. In this case auxiliary wires can be pushed into the bird's body and the wing held in position with the help of these and string or fine wire.

If the bird is being mounted in an in-flight position, the wing feathers should have a slight curve towards their tips, indicating the resistance of air. To achieve this effect, a wood burning tool can be used to heat each individual feather once the wings have been set in the required pose. The feathers must be held by hand, using a small wooden modelling tool, while the wood burning tool is pushed upward, against the shaft of the feather, causing it to bend. This is a tedious process, but the end result is most spectacular, and lends the specimen that extra life like look.

If the bird is being mounted with wings closed, the wing feathers should still be held with strips of cardboard (Fig. 5.42).

If the wings were not wired, they can be positioned by pinning them to the body. Great care should be taken so that the wing bones (humeri) are positioned properly on top of the back and that the skin and plumage is arranged properly on top of them. If this is neglected, the bird will have a hunchback appearance.

Tail and plumage

The tail should be arranged in the required pose; cardboard strips are also used to keep the feathers in a regular arrangement during the drying process (Fig. 5.42). Some birds' tail feathers form an arch. This can be recreated by using cardboard strips and bending them downwards. They should be fastened with a length of masking tape or a rubber ring. Once the mount dries the tail feathers will stay in position after the cardboard strips have been removed.

The entire plumage should now be preened with fine forceps. Twisted feathers and gaps in the plumage should be corrected by working the skin with the forceps. Gaps can be remedied by pulling the skin over the gap from one direction and pushing it the opposite way. Once the plumage has been immaculately dressed, with every feather in place, a thin layer of cotton wool is wrapped over the entire bird. This layer must be very thin and very even. The method of wrapping it around the bird is an art of its own (Fig. 5.43). Some taxidermists use fine thread, or spun wool, to wrap their specimens, but this is even more difficult than the application of layered wool. The effect of a properly wrapped plumage is excellent. The fine layer of wool acts as a hair net, keeping the feathers gently pressed in the correct way until the skin has dried thoroughly and set.

Fig. 5.42. The wings and the tail of the drying bird are carded.

Fig. 5.43. The drying bird is wrapped with cotton or wool thread.

FINISHING THE SPECIMEN

The mounted and wrapped specimen should be checked at least once every 24 hours during the first week after wrapping and every 48 hours during the next week. After this, the skin should be dry enough, even in wet weather. The wrapping should not be removed for at least three to four weeks; on larger birds it must be kept on the plumage for even longer.

During the first few days, the bird occasionally has to be readjusted. The drying skin can pull out of shape here and there and, if left unattended, this can cause the mount to disfigure and deteriorate. The eyes should receive special attention.

On the second day after mounting, a 15%–20% formaldehyde–water solution should be injected into the wingtips, the heels, the toes and the tail.

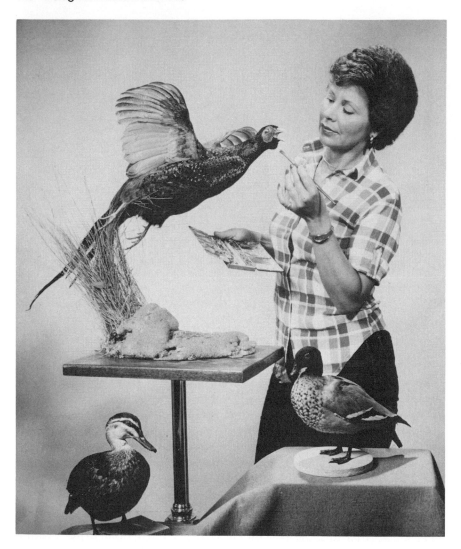

Fig. 5.44. The naked parts, such as wattles, feet and so on are touched up by artist's oil paints or acrylic paints. Photo J. Fields. Taxidermy by K. Hangay. Courtesy of the Australian Taxidermy Studio.

If the bird is large, the head, the interior of the bill and the feet must be injected. Small birds will not need to have formaldehyde injected into their feet or head.

Once the bird has thoroughly dried, the wrapping and cardboard strips can be removed. The naked parts, if they have lost their colour, will need to be recoloured.

Colouring specimens is not a simple matter of painting them by hand. In some cases, this method would be sufficient, but small spray equipment would probably be needed.

Either nitrocellulose or acrylic enamel can be used to colour the naked parts, which should be sprayed first with a thin coat of white undercoat. The colours can be built up on this plain base until the proper hues are achieved. Most artists' air brushes are suitable for this work; however the equipment should be checked to ensure it is suitable for spraying nitrocellulose or acrylic thinners. In some cases, the skilful application by brush of artists' oils or acrylic paint obtains good results. Acrylic paint is a better medium to work with than oil paint as it can be thinned with water and will dry in minutes. However, some birds' legs and bills are coated with a waxy layer which will repel water. These must be painted with oils (Fig. 5.44).

In any case the "painted look", which is mostly caused by too much paint or the wrong colours, must be avoided. It is a good idea to apply the paint in thin washes instead of heavy layers. The high gloss which is characteristic of most nitrocellulose or acrylic lacquers and enamels should be toned down by spraying the finished parts with a semi gloss, or even matt, clear varnish.

Artists' oils and acrylic paint dry to a matt finish, and this is often too matt and "dead looking". A coat of semi gloss clear varnish improves the appearance of such surfaces.

If a spraygun or a small airbrush is being used, care must be taken to avoid overspraying and accidentally colouring the feathers. It is very difficult to remove any sort of paint from the plumage. Mostly, the feathers simply can be covered with a cloth, or gently shielded from the spray by a sheet of paper.

If the bird has been mounted on a temporary perch, and has to be placed on its final stand or perch after the drying and finishing, difficulty could be encountered in the fact that the toes will have set hard; they must be relaxed before the mount can be removed from its perch. The toes can be relaxed by wrapping wet (*see* Formulae) cotton wool and plastic tissue (cling wrap) around the feet. If the toes have not been injected with formaldehyde and have not yet been painted, the feet will relax in a few days, and the toes can be manipulated again. Once the bird has been placed on a permanent perch, the toes should be wrapped around it and allowed to dry before painting.

MAINTAINING THE MOUNTED BIRD

As can be seen, the taxidermy performed on each mounted bird is considerable. The specimen should be treated as a valuable item which has not only cost the life of a living creature but also a lot of hard work (and, in many cases, a fair amount of money). To keep the mount in top condition for as long as possible it should be kept in a well ventilated, dry place. It should be kept

away from dust and direct light, as these will cause colours to fade and dull, and will eventually cause total deterioration of the bird.

A light, occasional dusting with a feather duster will remove the inevitable small amount of dust from the plumage, but under no circumstances should the bird be cleaned with a wet rag or with any household cleaning agent.

CLEANING FEATHERS

An efficient but not too elaborate cleaning method has been described and contributed by Mr GEZÁ MARTON, Assistant Curator of Conservation, Applied Arts and Sciences (Powerhouse) Museum, Sydney, Australia: "Feathers are divided into two types when deciding on the method of cleaning. These methods are dependent on the structure of the pennaceous and plumose feathers. Pennaceous feathers have been successfully cleaned with the nonionic detergent Lissapol N* and water. Brushing along the feather, away from the quill helps in the cleaning process. The fluffy plumose feathers are so prone to tangle because they lack the barbules and therefore require a different cleaning technique to the pennaceous type of feather. In plumose feathers in which the keratin has lost some of its elasticity, untangling the barbs is very difficult indeed. Cleaning plumose feathers with an organic solvent, such as trichloroethylene, overcomes this difficulty because the solvent dries rapidly releasing the barbs which can be brushed back into position quite easily. The addition of 1% potassium oleate soap (dry cleaning soap) to the solvent assists with the removal of the dirt in the cleaning process. When the complete immersion of the object is impractical the cleaning fluid can be applied with a very soft bristle brush to each feather or bunch of feathers. The feathers should be laid on absorbent material and brushed in the direction of the barbs".

PARADICHLOROBENZENE CRYSTALS

Under very unfavourable conditions, such as in equatorial tropical regions, paradichlorobenzene crystals must be employed in large quantities to prevent the rapid deterioration of the specimens.

Another problem in the preservation of all mounted specimens is that of insects. Moths, beetles, silverfish, cockroaches and so on can all damage or totally destroy a mounted specimen if it is left unattended for an extended period of time. Apart from the "built in" insectproofing agents such as arsenic and borax, some other pest control should also be exercised. Various household insecticides are capable of keeping most common insects away

* This proprietary substance is manufactured by ICI (Imperial Chemical Industries): There will be agents and subsidiaries of this company in countries throughout the world.

from the mounts. Naphthalene flakes, mothballs or strips of an anticholines-terase compound should be kept close to the specimens.

In a hot, wet climate, mould can create a problem. This can be combated with thymol crystals.

PREPARING THE COMBS OR WATTLES

Birds which have combs, wattles or other fleshy, visible appendices present special problems for the taxidermist. Often, these parts are just ignored and the bird is mounted in the conventional way. The final appearance of the mount is unnatural and the whole specimen will have that most undesirable "mummy" look caused by the shrivelled, shrunken wattle or comb.

The best way to handle these parts is to freeze dry them. If access can be gained to a large freeze dryer apparatus, the bird can be mounted in the conventional way and the fleshy parts simply left unskinned. They should be pricked all over with a fine pin; then the mount should be placed into the freeze dryer. After a period, the entire specimen will be freeze dried and the fleshy parts can be finished in the usual way, as with any other freeze dried specimen (see Volume 1, Chapter 9).

If the apparatus is not big enough to handle the whole bird, the fleshy parts must be cut off, carefully posed (after pricking them) and placed in the chamber. After the appropriate curing period they can be finished and glued on the specimen. It is also possible to cut off the head of the bird, and freeze dry it with the comb and wattles attached. This is especially recommended for the preparation of a turkey.

If no access can be gained to a freeze dryer, the fleshy parts must be opened from inside the skin, using a fine surgical scalpel and a small ear-opener (see Volume 1, Chapter 6; mammal ears). The skin of the fleshy parts must be thinned and the pockets formed by this operation filled with modelling compound (see Formulae). The modelling compound, if applied skilfully, will give a fleshy appearance to the specimen. This fleshiness will be preserved after the skin of the comb and wattles has dried.

Another method of preserving the wattles and comb is moulding and casting. A mould should be prepared from the parts while they are still fresh. A cast is made from the mould and attached to the specimen. The cast can be coloured in the same way as any other naked parts of the bird. A number of materials can be used for making the mould and the cast.

SKINNING AND MOUNTING VERY SMALL SPECIMENS

Very small birds, such as the smallest wrens, finches, and hummingbirds, have to be skinned in the same way as any other small or medium sized bird.

Fig. 5.45. The preparation of a small bird skin requires skill and patience. Photo G. Millen. Courtesy of The Australian Museum.

However, the skin must be handled even more delicately and great care must be taken to prevent the rapid drying of the skin. If fine sawdust (wood flour) is used instead of borax during skinning, drying can be slowed down a little. After skinning is completed, it is often necessary to gently swab with relaxing solution (*see* Formulae). The mannikin for small birds should be made of very fine wood wool or sisal, or even fine, dry moss. The contact drawing–wire frame technique is a bit too cumbersome for such a small body; therefore, the mannikin should be constructed in a simpler way. Using the natural body as a guide, press the material used for body making into a small ball and wrap fine thread around it until it takes the shape of the bird's body (Fig. 5.45).

Fig. 5.46. A desiccating jar can be used as a humidor.

Use very light wires for the neck, wings (if they will be mounted open), legs, and tail. Birds mounted with their wings closed will need no wing wires.

MOUNTING BIRDS FROM DRIED OR STUDY SKINS

It is possible to produce an excellent mount from skins previously prepared and dried. However, it is vital that the skins are prepared in a very thorough manner. This means:

1. No dirt or blood can be left on the plumage.
2. The flesh side of the skin has to have been perfectly cleaned of all flesh and fat, especially between the roots of the feathers. This is a slow and tedious job which is more often than not neglected by study skin preparators. If a skin is not treated in this manner, it will still make a reasonable study skin, but it will be totally useless for the purposes of mounting.
3. The skin has to have been properly degreased before drying.

If the skin has been well prepared, it can be placed in a humidor (Fig. 5.46). A humidor can be made from an aquarium or a plastic box (such as a fix box) or even from a portable cooler. The high humidity within the humidor will relax the skin in from 24 to 48 hours. There is a great danger, especially when old (more than 20 or 30 years of age) skins are used, that the skin will rapidly deteriorate during the process. This could be caused by improper initial preparation of the skin. If the skin contains fat, this can cause "fat-burn" in the humidor which will cause the bird to fall apart.

If that happens, and the bird is an irreplaceable specimen (a very rare or even extinct species) only one option is left; the mannikin must be modelled in complete detail (a sculpted mannikin) and the feathers or pieces of skin must be glued carefully onto it. This is a very slow operation which requires

great skill and patience. However, the result can be excellent and the specimen will last for a very long time once it has been completed.

A well prepared skin should not deteriorate in the humidor, but should relax. Once it has become soft, the entire inside must be worked gently by scraping it with a dull scalpel and fine wire brush. The roots of the feathers require special attention where little bits of dried flesh might have anchored the plumage in an unnatural fashion. Once the skin is completely pliable and the feathers can be manipulated almost as easily as those on a fresh skin, the bird can be mounted in the usual way.

Especially stubborn feathers, which have been bent, twisted or just badly creased, can be adjusted by steaming. The simplest method of doing this is to hold the bird (the part which should be adjusted) over the steam vent of a boiling kettle. For more sophisticated work a steaming apparatus can be built (Fig. 5.47).

MOUNTING BIRDS WITH OPEN BILLS

A bird with an open bill is mounted in the usual way, then the bill is propped open and left to dry. An artificial tongue can be carved from soft wood and the interior of the mouth modelled with fine papier mache (*see* Formulae), with an epoxy putty, or even with wax. The tongue can be incorporated into the modelling simply by embedding its root, or by drilling a tiny hole into it and wiring it into the soft putty through this. After the putty has dried, the interior of the mouth can be coloured.

PREPARATION OF LARGE BIRDS FOR DISPLAY PURPOSES

The taxidermy of large birds is somewhat similar to the sculpted taxidermy methods for large mammals. However, the technique described below is one of the simplest. The specimen is skinned, as described earlier, and the skin is treated in the usual way. The feet are separated from the skin and treated. Rhea, emu, cassowary, and ostrich skins can be drummed with fine hardwood sawdust, like mammal skins, in order to fluff the plumage. Care must be taken with the male ostrich since its fine white plumes can be discoloured by sawdust. It is best to use borax or light magnesium in the drum instead of sawdust.

CONSTRUCTING MANNIKINS FOR LARGE BIRDS

Birds larger than a big rooster or domestic goose require a solidly built artificial body. Prepare a contact drawing, as explained earlier, using com-

Fig. 5.47. A simple steaming apparatus. Instead of the flameproof retort, a tea pot can be used. Drawing by G. Hangay.

Fig. 5.48. Centreboard cut out of timber for a large bird mannikin.

posite board or plywood at least 10 mm thick instead of paper. Cut the side board view with a jigsaw. This timber silhouette is called the centreboard (Fig. 5.48). Mark on it the positions where the legs should attach to the body, using the original body as a guide. Cut blocks of timber and drill holes into them to accommodate the leg wires. Fasten these blocks to the marked spots on the centreboard, making sure that they protrude sufficiently on either side. Otherwise the legs will be placed too close to each other. Use wood glue and nails or screws to secure the blocks.

Repeat this procedure for the neck wire. The artificial neck can be built up as described above and attached through the block. The neck wire can also be nailed to the centreboard. Select wires which are strong enough for the legs and insert them into the holes in the blocks. The ends of the wires can be nailed to the centreboard.

With the original body as a guide, build up the bulk of the mannikin using wood wool. To save weight and material, tightly crumpled newspaper or chunks of foam can be fastened to the centreboard before the wood wool is applied. Alternatively, wood wool can be replaced with shredded paper in this kind of mannikin.

Once the mannikin has been completed and it has been ascertained that the skin will fit, coat the entire body (except the neck) with papier mache (*see* Formulae), and let it thoroughly harden for a day or two.

For very large birds such as emus, ostriches, cassowaries, an even stronger mannikin is required. The construction of such an artificial body is similar to the method used for the lesser large birds. A timber centreboard with blocks is prepared, and leg and neck wires are fastened to the blocks, but no wood wool or loose packing material is used to build up the bulk of the body.

Polyurethane foam should be employed instead of these materials. Staple or nail a strip of cardboard, approximately 25 cm–30 cm wide, all around the centreboard to form a fence. Lay the centreboard on its side and pour the polyurethane foam onto it. The foam will soon rise and fill the fenced-in space, embedding the blocks and the ends of the neck and leg wires. Let it harden, remove the cardboard strip, and turn it around to form a fence for the other side. Attach it to the centreboard. Repeat the process with the foam. Finally, remove the cardboard and, with a rough rasp, shape the body to the required size and dimensions. Use the original body as a guide, or refer to field measurements, moulds and casts (see Chapter 6; large mammal taxidermy).

In shaping the body, it must be remembered that the plumage of the bird will cover most of the anatomical surface detail; therefore, it is not necessary to carve every little muscle definition into the surface of the mannikin. If the proportions and size of the artificial body correspond to those of the original body, the skin should fit it perfectly and the mount would look lifelike.

The only exception perhaps would be the legs of an ostrich. These have to be modelled in detail, as the lack of plumage allows the detail to be visible.

The legs should be carved in detail and coated with a layer of papier mache. The main part of these polyurethane foam mannikins does not have to be coated with papier mache.

WIRING THE WINGS ON LARGE BIRDS

When mounting sculpted mannikin birds, the wiring of the wings can be done

in a different way. No wiring is necessary before mounting. The skin is arranged on the mannikin, as described below and the wings are pinned rather than wired in position. Make sure that the pins do not pinch the feathers and that they are completely covered by the plumage.

MOUNTING THE SKIN OF LARGE FLIGHTLESS BIRDS

Mounting a large bird's skin on a sculpted mannikin is very similar to the mounting of large mammal skins.

First, the damp skin is draped over the mannikin, then the neck wire or rod is firmly anchored into the skull, the skin is adjusted precisely around the legs, and the incisions are sewn up.

If the bird displays naked parts where muscle detail would show (like the long neck and legs of an ostrich), the mannikin should be coated with a heavy layer of modelling paste (see Formulae). This compound can be shaped through the skin into the required definitions once the bird has been mounted. The skin should be pinned to depressions in the body to prevent the drying skin drumming. Cardboard or leather strips can be used to hold the skin in position while drying takes place. The skin of the feet will need to be stitched, with small stitches, to the leg skin and in such a way that the feathers cover the seam.

MOUNTING THE FEET OF LARGE, FLIGHTLESS BIRDS

The feet of large birds create special problems for the taxidermist. There are three basic methods for mounting them.

1. Complete skinning and mounting

The entire foot can be skinned through an incision at the back of the foot, a cut through the sole and a cut on the underside of each toe. The skin is left attached at the toenails. The bone structures of the foot should be cleaned of all sinews, flesh and fat, and the heel has to be drilled to receive the leg rods. The feet should be positioned on the leg rods and the mannikin bolted to its stand. The bones can be covered with a coat of slow drying papier mache (see Formulae) and the skin sewn up using very small stitches. When the time comes to treat the toes, the mannikin can be taken off the stand and the underside of the toes stitched up. The mannikin can then be bolted back onto the stand, and the rest of the bird mounted.

To prevent the skin drying, the top of the feet should be wrapped in cling wrap. This area must be kept damp until the entire bird skin has been mounted to enable the easy stitching of the leg skin to the skin of the feet.

2. Partial skinning and mounting

In this method, only the toes are skinned and stiff papier mache is forced under the skin. The skin is stitched up and the feet are mounted as described above, except that the leg rods are not pushed through the bone, but through the cavity created by the removed tendons. The toes will have a puffy look; however, during the drying period they will shrink a little and regain their original appearance.

3. Moulding and casting

In this method a complete plastic reproduction is made of the feet. The unskinned feet must be mounted on leg rods, the mannikin bolted on its stand, and the feet arranged in a natural position. A complete mould can then be prepared, and, from this, a plastic cast. Before the cast is made, the leg rods have to be removed from the mannikin and placed into the mould; the casting material is then poured around, thus embedding the rods. After removal of the mould, the plastic feet can be installed on the mannikin and mounting of the skin can proceed. The leg skin obviously cannot be stitched to the plastic feet; instead, it has to be pinned and glued into position. Finally, the cast should be painted in natural colours.

PEREIRA'S METHOD

Mr A. PEREIRA of the McGregor Museum, Kimberly, Republic of South Africa, contributed the following description of a technique employed to reproduce leg and feet of large birds:

"The bird is skinned in the usual way but for casting the legs an incision is made along the ventral side of the bird and then in a V-shape to the femur of each leg. The bone of the leg is severed at the knee and the skin around each leg is carefully cut at the point where the tarsus and tibia meet below the base of the feathers. The legs are then removed from the body, supported with strong wire and positioned for casting.

"The legs are evenly covered with a coat of rubber latex. The second layer is exactly the same. The third layer of latex is reinforced preferably with gauze.

"This is allowed to dry and coated with a separator. A supporting plaster jacket must be made in two halves. When an adequate amount of plaster has been applied to the first half and allowed to dry a separator is applied to the neatened edge. More plaster is then applied to the second half. When this is completely dry, one half of the plaster jacket only is removed. Then with

Fig. 5.49. A mounted cassowary. Taxidermy by G. Hangay. Photo John Fields. Courtesy of The Australian Museum.

sharp knife proceed to cut neatly and precisely along the edge of the remaining plaster, cutting the latex along this line. Extreme care must be taken at this stage of the procedure. The leg may then be removed from the latex mould and plaster jacket.

"When casting it is advisable to glue one half of the latex to its jacket in order to keep it firmly in position. A release agent is then painted in the latex mould. A length of strong wire is cut and used as reinforcement, preferably longer than is actually required. A mixture of polyester resin and 30% flexible resin with dolomite or asbestos as a thickener is made and colour added. This is poured into the latex mould and reinforced with fibreglass matting. When full it is pressed down with the second half of the latex mould and supporting jacket and clamped. Allow to dry and remove the plaster. The legs are then painted the correct colour and inserted into the bird's body.

"The result is a detailed cast of the bird's legs which will remain intact for longer than is possible with any other method of mounting the real legs" (Pereira, 1981)

None of the above techniques is easy or quick. The feet must be mounted before proceeding with the mounting of the bird's skin.

Another variation can be applied to the mounting of an ostrich. To overcome difficulties when the leg skin is stitched to the skin of the foot, the whole leg and foot can be skinned as one, but severed from the body. The skin of the "drumstick" can be left attached to the skin of the foot and they can be mounted in one piece. The skin of the leg simply can be tacked around the edges where it joins the body; the rich plumage of the bird will cover this area well (Fig. 5.49).

NESTS

Preserved birds' nests form a large part of ornithological collections in major museums.

As a general rule, nests should be collected together with the bases on which they are built. This is a simple matter for the collector if the nest is small and constructed on the thinner branches of a tree or shrub. Larger ones built in a tree could still be removed with the branch which serves as a base. However, it must be borne in mind that the mutilation of the tree can be even more harmful to the environment than the removal of the nest.

Large nests built of sticks and loosely fitted twigs can be dismantled then collected. The nest must be photographed and sketched before dismantling in order to rebuild it later. The microfauna of nests, especially of the large ones which may contain an accumulation of droppings, bits and pieces of dead animal matter and so on, consist of numbers of interesting species of invertebrates, particularly insects and arachnids. The scientific value of these can be far greater than that of the nest itself; therefore, the collector must make a sincere effort to collect as much of this material as possible.

Nests which are collected in one piece should be packed in such a way that they cannot suffer any damage during transportation from the field to the laboratory. The interior of the nest should be filled with a ball of wood wool or paper and the whole nest wrapped in paper. To prevent the nest falling apart, the whole specimen should be wrapped up and tied with string, then placed in a box. The vacant space in the box can be filled with crumpled paper or wood wool.

Even if stored for only a short period of time, the nest must be insect-proofed. A light spray of water-based contact insecticide and a "pest-strip" will suffice at first; later on, the nest must be placed in a fumigation chamber. Once the nest has been placed in the collection it should be maintained as any other dry ornithological material.

If a nest is going to be used for display purposes (for example, in a diorama) and it is to be mounted on a different branch to the one on which it was built originally, the shape of its base can be slightly altered. To achieve this, the nest should be wrapped in a wet towel and placed in a plastic bag overnight.

The moisture will soften the nest's material allowing it to be slightly re-arranged without damage.

To consolidate delicate nests one can simply spray them with thinned lacquers, according to Piechocki (1967), or with plastic, according to Spencer and Kennard (1956). In recent years more techniques and materials have been perfected to achieve this.

PELLETS

Bird pellets can give valuable information to workers who study birds, small mammals, population dynamics and environmental matters. The pellets can be collected from under roosting places, nest sites and similar places where the bird spends considerable time.

Fresh, still moist, pellets simply can be air dried and sprayed with a contact insecticide to prevent insect damage. For longer storage and display, they should be soaked in an arsenical solution, or in an Edolan solution, for approximately 10 minutes and air dried.

If the contents of the pellets are to be studied they should be soaked in water for 24 hours. During this period the components separate and the bone fragments, fur and feathers can be sorted and studied.

WET PRESERVATION OF SPECIMENS

It is often necessary to preserve specimens in liquid preservatives. The most commonly used substance for wet preservation and storage is a solution of 75%–80% alcohol (ethanol). The entire specimen is injected with this sol-ution, and stored in the same liquid. The water content of the body dilutes the alcohol in time; therefore the liquid must be checked from time to time and the alcohol level brought up to the required 75%–80%. Alcohol has a detrimental effect on certain colours of the plumage and fleshy parts. If the specimens are stored in dark containers, such as black polyethylene drums, the fading is retarded. Ultraviolet light encourages fading.

Larger specimens can also be injected with alcohol but they should be stored in a solution of 3% formalin. Specimens which have been stored in this manner, for a short period of time can still be skinned and prepared as study skins (or even be mounted as lifelike display specimens), but if they are kept in the formalin for a prolonged period their tissues become rigid.

Nestlings and hatchlings should be stored in a solution of 1.5%–2% formalin. The formalin is always a buffered solution (*see* Formulae).

For the purpose of anatomical studies the specimens must be handled with special care, since distorted organs, or squashed specimens, are of very little value. In order to preserve specimens in their correct shape, they should be

laid out in an outstretched position, injected with a solution of 1 part 40% formalin and 15 parts water (Chapin, 1946) and stored in the same liquid.

Inner organs, if prepared individually, should be laid on a layer of cotton wool or soft rubber foam to prevent distortion then injected with the formula mentioned above.

If flattening of one side of the organ does not matter, it can be pinned on a sheet of cork or timber and fixed in the formula in this way. Once the tissues have hardened the organ will retain the shape in which it was fixed. It can be stored the same container as other organs.

Windpipes and tongues can also be fixed this way and stored in the same formula. These small specimens can be stored in individual glass vials. A number of these vials may be placed in one large storage jar which can be filled with the same preservative–storage liquid.

The labelling of specimens is of paramount importance. Only waterproof India ink or graphite (not indelible) pencil should be used on parchment type paper labels for specimens which are kept in wet storage.

EGGS

Previously, egg collecting has been not only a popular hobby among amateur naturalists but also an important aspect of ornithology. In the present age, the importance of collecting egg specimens has been somewhat lessened because extensive ornithological work has been carried out in most parts of the world and the eggs of most known bird species have been collected by scientific institutions. During the time when egg collecting was so popular that it even supported dealers, many bird species suffered considerable damage due to the greed of the collectors.

Egg collecting is still carried out by scientific workers, especially in the tropics and areas where the avifauna has not yet been properly researched. However, the generally adopted policy is to collect as few specimens as possible. In the case of rare species, no specimens are collected. Scientific information can be gathered through weighing, measuring, photography and observation, without actually collecting eggs.

COLLECTING

Once the nest has been discovered, it should be photographed with the undisturbed clutch of eggs. Each egg should be weighed on a small, ornithological scale and measured. If the clutch is large and the species is not considered rare or endangered, three eggs are taken: the smallest, the largest, and one of average size. The species must be positively identified. All these facts are recorded on the data sheet, which should be numbered. The same

Fig. 5.50. The method for drilling an egg.

number is written on the eggs, and individual eggs are marked with a letter. The most important items on the data sheet are the proper name of the hen bird and the fresh weight of the egg. Without this information the eggs' value as scientific specimens is practically nil.

Small eggs should be transported in cotton wool in small cardboard or metal boxes (for example, tobacco tin); larger eggs should be wrapped in tissue paper first, then embedded in wood wool or hay in a larger box or basket.

PREPARATION

To prepare the egg, hold it between the thumb and forefinger and direct a strong light source, such as a slide projector or a desk lamp, to the rear. If the light passes through the egg, making it seem translucent, it has not been fertilized (or, if it has been, the embryo is in a very early state of development). The preparation of such eggs is relatively simple. First, a hole is drilled into the side of the egg, using an egg drill. The hole is begun as a slight prick onto the shell with a pin or pointed scalpel. This prevents the drill "walking" over the shell. The hole is then made by holding the drill in the hand and twirling it, first in a clockwise motion, and then in an anticlockwise motion, repeating this until there is a hole of the required size (Fig. 5.50).

Eggs up to the size of a chicken's egg require a hole about 2 mm–4 mm in diameter, whereas larger eggs need holes of between 4 mm–6 mm in diameter.

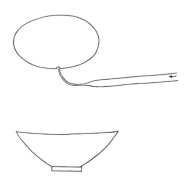

Fig. 5.51. Inserting the blow pipe.

The egg is then held with the hole pointing downwards. The widest end of a curved blowpipe should now be put to the lips; the narrow end should be held close to the hole (Fig. 5.51). Blowing through the blowpipe forces air up into the egg cavity and this in turn forces the contents out through the same hole. When all the contents have been removed, water from the tap is injected into the cavity to rinse the inside of the shell and the blow pipe procedure is repeated to remove it.

The egg should be allowed to dry in the air, with the hole uppermost, for a few days. If the hole is placed downwards the shell will stick to whatever surface it has been laid upon once the fluid has drained out. If the hole is placed uppermost the fluid will evaporate without sticking the shell.

Small eggs must be held very carefully. The shell wall is very thin. Particular care should be taken during the blowing procedure as too much force can crack or break the shell.

Small eggs can be drilled with more safety under water. It is also possible to make the hole in the egg shell using a needle instead of an egg drill. The needle is used as the drill (as described earlier), and a series of tiny holes is made in a circular pattern to form a circle of 2 mm–4 mm diameter. The last pinprick, applied at the centre of this circle, pushes the small section of the shell into the interior of the egg. This can be removed with a pair of forceps and the contents blown out as described above.

Blowpipes can be bought commercially, but the authors use blowpipes made from glass tubing. They are very simple to make and have the advantage of being made to measure according to the hole size and egg volume.

For small eggs, glass tubing with an outside diameter of 4 mm and an inside diameter of 2 mm should be used. To make the pipe, 25 cm length of tubing is centred and rotated in a Bunsen burner flame. It is heated until the glass

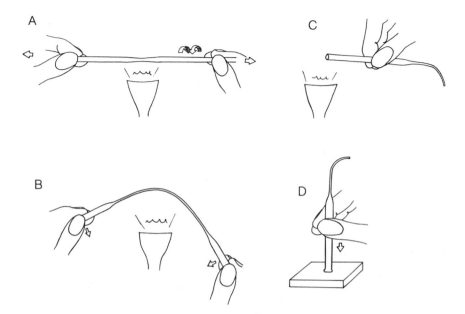

Fig. 5.52. The method for making a glass blowpipe. A. Heat and twist a glass tube. Pull the ends at opposite directions to stretch the softened section. B. Bend the tube. C. Break it and flame polish the ends. D. Making a small flange.

becomes soft, when it is pulled apart and down to form a tapered and bent tube (Fig. 5.52). After the glass has cooled, a triangular file should be used to cut the tubing at the thinnest part, which is approximately half way along the tube length. The widest end is rotated in a flame until the sharp edge becomes smooth enough so as not to cut the lips during the blowing of the egg. It can be flattened as shown in Fig. 5.52.

With large eggs (chicken eggs and larger), glass tubing with an outside diameter of 7 mm and an inside diameter of 5 mm should be used.

If, on examination by light, the egg's interior seems to have a dark, opaque appearance, it has been fertilized and contains an embryo. Such specimens leave the preparator with two alternatives: the embryo can be preserved within the shell; or the entire contents of the egg can be removed.

To preserve the embryo in the shell, the egg should be drilled and the liquid content removed as described above. Once this has been completed the shell should be filled with a solution of 2% formalin for two hours, or with a solution of 70% alcohol for three hours. This fixes the tissues of the embryo. The formalin and alcohol should then be removed, using a syringe, and the

Fig. 5.53. Assembling a broken egg shell.

egg injected with water several times, emptied, and placed in a drying cabinet, with the hole uppermost, until the embryo has dried out completely.

After drying, water soluble glue can be injected through the hole to adhere the dried embryo to the inside of the shell. The glue should be allowed to dry before the egg is placed into the collection.

If the entire contents of the egg have to be removed, the egg should be drilled and blown as described above, leaving the embryo in the shell. A pepsin or tripsin solution (Volume 1, Chapter 10) can then be injected into the shell. If the shell is kept at an even 37°C, this solution will macerate the embryo. The liquid can be removed from the shell either by blowing in the usual way or by suction with a small vacuum pump (see Chapter 9).

Instead of pepsin or tripsin, potash, ammonia or potassium hydroxide can also be used for the chemical maceration of the embryo. These solutions also work well on embryos which have been dried, but have not been fixed with formalin.

Eggs which have been broken into six or eight pieces can be repaired using a technique described by A. Hiller of the Queensland Museum (1972). The general method is as follows: Select the two largest portions of the shell and add smaller pieces which are then finally stuck together. Any sections which are cracked and slightly warped, but still held together with the internal membrane, are soaked in warm water to soften the membrane so that the shell can be repositioned correctly to form a perfect seal. As the broken pieces are fitted into their rightful position, strips of self adhesive paper are placed on the outside of the shell to hold the pieces in position. The insides of the final two large pieces are painted with a soluble nylon glue and left to dry.

Thin strips of fibreglass surfacing mat can then be pasted onto the inside of one section, leaving half of each strip exposed so that they can adhere to the other section of shell when the two halves are finally brought together (Fig. 5.53).

To position the two halves together, thus producing a complete egg, the fibreglass strips are saturated with glue and the two halves are brought into perfect contact and sealed on the outside with adhesive paper. When the glue has set, more adhesive can be introduced through the blow hole and the egg rotated until a thin layer of adhesive coats the inside of the shell.

This should be repeated until a strong bond has formed. If the egg has been prepared properly, there should be no visible cracks.

REFERENCES

Chapin, J.: The preparation of birds for study. American Museum of Natural History, New York, *Guide Leaflet*, no. 58 1946.

Disney, H. J. de S.: Temporary preservation of specimens. *Corella* (Sydney) 3/2 1979.

Hiller, A.: A technique for repairing birds' eggs. *Kalori* 44/1972.

Johns, J. E.: A new method of capture utilising the mist net. *Bird-Banding*. 1963/34:209.

Pereira, A.: Casting the legs of a large bird. *Taxidermy Review* 9/4 1981.

Piechocki, R.: *Makroskopische Präparationstechnik: Wirbeltiere*. Akademische, Leipzig 1967.

Pray, L. L.: *Borax mothproofing for modern taxidermy*. Modern Taxidermist Greenfield Center, NY 1956.

Spencer, J. L., and W. C. Kennard: Preservation of birds' nests with plastic spray. *The Auk* 73/ 1956: 280.

Wilson, S. J., S. G. Lane and J. L. McKean: *The use of mist nets in Australia*. CSIRO, Melbourne 1965.

SOURCE MATERIAL

Amadon, D.: Birds weights as an aid in taxonomy. *Wilson Bulletin* 55/1943: 164–177.

——. The use of scientific study skins of birds. *Curator 1/1 1958: 77–80*.

Anderson, R. M.: Methods of collecting and preserving vertebrate animals. *National Museum of Canada, Bulletin No. 69*. Biological Series No. 18, 1960.

Anonymous: Fangverfahren fur den Beringer, Zusammengestellt von den Vogelwarten Helgoland, Radolfzell und Sempach, *Ornithol. Merkblätter* Nr. 3, Aachen 1955.

——. Birds and their eggs. British Museum (Natural History). *Instruction for collectors Number 2*, 1954.

——. Poly paint colour matching system (Product review). *American Taxidermist*. 16/6 1983.

Arevad, K., B. Bindel, and H. Hjortaa: Erprobung verschiedener Methoden der Schutzbehandlung von Vogelbalgen gegan Schadinsektenangriffe. *Der Präparator* 27/1 1981.

ASTM standard method of specifying colour in the Munsell system. ASTM D 1535-68. Munsell Color Co., 1970.

Baege, L.: Uber "aufgelegte" Vögel. *Der Falke* 11/1964: 203–207.

Barnes, R.: The oologist, birds-nests-eggs. *Taxidermy* Numbers 575–640/ April 1935–September 1940.

Berger, A. J.: Suggestions regarding alcoholic specimens and skeletons of birds. *The Auk* 72/ 1955: 300–303.

——. Further notes on alcoholic specimens. *The Auk* 73/1956: 452.

Blake, E. R.: Preserving birds for study. *Fieldiana: Technique* Series No. 7, Field Museum of Natural History, Chicago 1949.

Borg, K.: Uber die Anwendung von Chloralose zur Vernichtung schädlicher Vogel. *Z. Jagdwiss.* 2/1956: 180–182.

Bourliere, F.: Formulaire technique du zoologiste. *Préparateur et Voyageur* 1941.

Browne, M.: *Artistic and scientific taxidermy and modelling.* London 1896.

Bub, H.: *Vogelfang und Vogelberingung. Teil I. Fang mit Siebfallen und Reusen.* Die Neue Brehm-Bücherei, H. 359, Wittenberg 1966.

Burk, B.: *Waterfowl studies.* Winchester Press, New York 1976.

Cappel, A.: *A guide to modelmaking and taxidermy.* A. H. and A. W. Reed, Sydney, 1973.

Chapman, F. M.: *Handbook of birds of eastern north America,* New York 1932.

Congreve, W. M.: On preparation and data, Parts I and II. *Oologist's Record* 22/1948: 49–55; 23/1949: 19–28.

Cook, N.: New displays of birds. *Museum Journal* (London) 36/1936: 16.

Cordier, C.: La capture des oiseaux-mouches et les soins a leur donner. *Oiseau* 16/1936 144–151.

Davis, D. E.: Size of bursa of Fabricius compared with ossification of skull and maturity of gonads. *Journal of Wildlife Management* 11/1947: 244–251.

Didier, R. and Boudarel A.: *L'art de la taxidermie.* Paris 1921.

Donovan, E.: *Instructions for collecting and preserving subjects of natural history.* London 1794.

Dupond, C.: Bird skins. Two taxidermic suggestions for bird collections. *Taxidermist News* 11/1949: 4–5.

Ehrlich, R.: Big bird — little bird. *American Taxidermist* 11/4 1977.

Eichler, W.: Sammelanleitung fur Vogelparasiten. *Vogel der Heimat* 18/1948: 1–4.

Eykmann, C.: *Taxidermic (Vor het opsetten van vogels en zoogdieren).* Uitgever, Gravenhage 1949.

French, N. R., and Swenson, L. E.: Liquid preservation of birds. *Journal of the Colorado-Wyoming Academic Society* 4/1951: 78.

Geiler, R.: Sammlung und Inhaltbestimmung von Eulengewöllen für die Vorhersage von Massenvermehrungen der Feldmaus. *Der Falke.* 2/1955: 61–62.

Gower, W. C.: The use of the bursa of Fabricius as an indication of age in game birds. *Transactions of the 4th North American Wildlife Conference,* 1939: 426–430.

Grantz, G. J.: *Home book of taxidermy and tanning.* Stackpole, Harrisburg, Penn. 1969.

Guerra, M.: Metodo rapido per la conservazione dei piccoli uccelli. *Riv. Ital. Orn.* 24/1954: 174–177.

——. Th. Eine Möglichkeit zur künstlichen Erzeugung von Torsionverwindungen am Vogelpräparat (in Flugstellung) *Der Präparator* 26/1 1980.

——. Th. Restauration von unansehnlichen Paradiesvogel-Bälgen. *Der Präparator* 23/1 1977.

Harrison, J. M.: *Bird taxidermy.* David and Charles, London 1977.

Hartman, S. G.: New designs for a systematic exhibit of birds. *Curator* 15/2 1973: 113–120.

Hasluck, P. N.: *Taxidermy.* London 1901.

Hochbau, H.A.: Sex and age determination of waterfowl by cloacal examination. *Transactions 7th North American Wildlife Conference.* 1942: 299–307.

Hohlfeld: A different pheasant mount. *American Taxidermist* 12/6 1979.

——. One legged mount. *American Taxidermist* 13/6 1980.

Hollom, P. A.: *Trapping methods for bird ringers.* British Trust for Ornithology, Field Guide 1, Oxford 1950.

Huber, W.: A method of salting and preparing water bird skins. *The Auk.* 47/1930: 409–411.

Hudson, G. E.: A practical method of degreasing bird skins. *The Auk.* 52/1935: 102–103.

Jaffe, M.: Falconry and the taxidermist. *Taxidermy Review* 8/5 1980.

——. Open wings. *Taxidermy Review* 7/6 1979.

Kelly, P.: The dorsal incision. *American Taxidermist* 11/4 1977.

——. Balancing a bird. *American Taxidermist* 13/5 1980.

——. Borax, good or bad. *American Taxidermist* 15/4 1981.

Kemp, J.: Collection policy and practice. Department of Birds, Transvaal Museum. *Sama* No 4. Pretoria 1981.

Kennard, F. H.: Moulds and bacteria on egg collections. *The Auk* 28/1921: 345–356.
——. A method of blowing eggs. *The Auk* 45/1928: 234–236.
Kessel, B.: Criteria for sexing and aging european starlings (Sturnus vulgaris). *Bird-Banding* 22/ 1951: 16–22.
Kirkpatrick, C. M.: The bursa of Fabricius in ring-necked pheasants. *Journal of Wildlife Management* 8/1944: 118–129.
Kish, J.: *The Jonas technique.* Vol. 1. Birds. Denver 1980.
——. Turkey heads — an experiment. *Taxidermy Review* 8/4 1980.
——. and B. Gonzales: Waterfowl and gamebird colour studies. *Taxidermy Review* 9/5 1981.
Knudsen, J. W.: *Collecting and preserving plants and animals.* Harper and Row, New York: 1972.
Lachner, R.: Biologie der Turkentaube (Fang am Futterplatz). *Journal of Ornithology* 104/ 1963: 317–319.
Laplante: A turkey for New York. *Taxidermy Review* 6/5 1978.
Lehmann, D.: Mottenschutzbehandlung textiler und zoologischer Museums objekte. *Der Präparator* 11/1965: 187–194; 221–230.
Leonhardt, E., and K. Schwarze: *Das Sammeln, Erhalten und Aufstellen der Tiere.* Melsungen 1909.
Lloyd, H.: The extraction of fat from bird skins. *The Auk.* 35/1918: 164–169.
——. A method of cleaning large bird skins. *The Canadian Field—Naturalist* 42/1928: 207–208.
Lovassy L.: A madártojásnak gyújtemények számára való készitéseról. *Term. Tud. Közlöny.* 1893: 61–72.
Lockley, R. M., and R. Russel: *Bird-ringing* London 1953.
McCabe, T. T.: An aspect of collectors' technique. *The Auk* 60/1943: 550–558.
McCowan, T. J.: Mounting bird skins, nests and eggs for circulation. *Museum Journal* (London) 38/1938: 269.
McGregor, R. C., and L. L. Gardner: Philippine bird traps. *Condor* (Berkeley) 32/19930: 89–100.
Mahoney, R.: *Laboratory techniques in zoology.* Butterworths, London: 1966.
Matusewitsch, W. F.: Technik zur Herstellung von Vogelbalgen. *Jahrbuch. Naturwiss. i. d. Schule. Nr. 3;* Erganzungen dazu von P. Resenik: 1948.
——. Der Vogelbalg vom Blickpunkt des Ornitologen gesehen. *Der Präparator* 7/1961: 141–156.
Marz, R.: Das sammeln von Federn. Mitt. Thur, Orn. 3/1952: 40–42.
——. *Von Rupfungen und Gewöllen.* Die Neue Brehm-Bücherei, Leipzig 1953.
Meves, W.: *Kurzer Leitfaden zum Präparieren von Vogelbalgen.* 3rd ed.
Mollison, B. C.: A live-trap for birds. *C.S.I.R.O. Wildlife Research* 2/1957: 172–174.
Moyer, J. W.: Bird mounting from dried skins. *Museum News* 10/1932: 6–8.
——. New method of mounting birds. *Museum News* 11/1933: 7.
——. *Practical taxidermy.* Ronald, Somerset, NJ 1953.
Murr, F.: Die Federsammlung. *Orn. Mitt.* 3/1951: 99–101.
Myers, E. C.: Taking body weights of birds. *The Auk* 45/1928: 334–338.
Naumann, J. Fr.: Taxidermie oder die Lehre, Thiere aller Klassen am einfachsten und szeekmassigsten auszustopfen und aufzuberwahren, 2. Aufl., Halle 1848. Allgemeine Literatur.
——. A new hall of North American birds, 7/3, 171–178. Curator 1965.
Nice, M. M.: The biological significance of bird weights. *Bird-Banding* 9/11938: 1–11.
Niethammer, G.: *Handbuch der deutschen Vogelkunde.* Leipzig 1937.
——. Der Vogelbalg vom Blickpunkt des Ornithologen gesehen. *Der Präparator* 7/1961: 141–156.
Norris, R. A.: A new method of preserving bird specimens. *The Auk* 78/1961: 436–440.
Petrides, G. A.: Notes on determination of sex and age in the woodcock and mourning dove. *The Auk* 67/1950: 357–360.
Piechocki, R.: Uber Verhalten, Mauser und Umfarbung einer gekafigten Steppenweihe (Circus macrourus). *Journal of Ornithology* 96/1955: 327–335.
——. Uber die Mauser eines gekafigten Turmfalken (Falco tinnunculus). *Journal of Ornithology* 97/1956: 301–309.
——. Augenkatalog der Vogel Europas. Sonderausgabe der Z. f. Museumstechnik. *Der Präparator* 11/1965.

Pray L. L.: *Taxidermy.* Harper and Row, New York, 1943.
——. *Bird studies for the taxidermist.* New York. 1956.
——. *The pheasant mounting book.* New York. 1956.
——. *The fish mounting book.* Modern Taxidermist Greenfield Center NY 1965.
——. *Modern taxidermy tips.* Modern Taxidermist Greenfield Center NY 1981.
Quay, W. B.: Bird and mammal specimens in fluid — objectives and methods. *Curator* 17/2 1975: 91–104.
Ridgway, R.: *Color standards and nomenclature.* National Museum, Washington, D.C. 1912.
Septon, G.: Reproductions on displaying grouse. *Taxidermy Review* 7/2 1978.
——. Comb reproductions for domestic fowl. *Taxidermy Review* 7/6 1979.
——. Observations on dead game mounts. *Taxidermy Review* 9/4 1981.
——. Bobwhite quail studies. *Taxidermy Review* 10/2 1981.
——. Painting bills and feet. *Taxidermy Review* 10/1 1981.
Serie, P.: Nociones sobre preparation y conservacion de aves. *Mem. Mus. Entre Rios* 28/1948: 17–22.
Sherfey, K.: Uses of Edolan U in museum preparation and conservation of zoological material. *Curator* 18/1 1976:68–76.
Shillinger, J. E., and W. Rush: Post-mortem examinations of wild birds and mammals. *Mite. Publ. U.S. Dept. Agric.* 270/1937: 1–15.
Snyder, L. L.: Some equipment and appliances developed at the Royal Ontario Museum of Zoology. *Toronto Museum News* 13/1935: 6–7.
Sokolowsky, A.: Wegweiser zum Sammeln und Konservieren zoologischer Objekte. *Tropenbibl.* 8/1926.
Soper, J.: A method of remaking old birdskins. *The Auk* 60/1942:284–285.
Stemmler, C.: Erfahrungen und Verbesserungen beim Aufstellen von Vögeln. *Der Präparator* 3/1957: 8–14.
Stresemann, E.: Die Anfange ornithologischer Sammlungen. *Journal of Ornithology* 71/1923: 112–127.
Thiem, E.: Eine neue Massnahme zum Schutz der Getreidesaaten gegen Krähen. *Nachr.-Bl. Dt. Pflanzenschutzdienst* (Berlin) new series 13/1959: 108–112.
Szunyoghy J.: Emlős-eś madárbőrok kikeśziteśe tudományos gyüjtemények számára. *Állattani közlemények.* 46/1958: 287–296.
Thomas, T.: A note on the display and storage of small fragile specimens. *Museum Journal* (London) 37/1937: 150–152.
Tyne, J. van: Principles and practices in collecting and taxonomic work. *The Auk* 69/1952: 27–33.
Voegler, R.: *Der Präparator und Konservator. Eine praktische Anleitung zum Erlernen Ausstopfens, Konservierens und Skellettierens von Vögeln und Saugetieren.* Magdeburg 1933.
Wagstaffe, R., and J. H. Fidler: *The preservation of natural history specimens* (volume 2). H. F. & G. Witherby, London 1968.
Williams, J. G.: The temporary preservation of small birds with fine table salt. *Journal of the East African Natural History Society* 22/1953: 74.
Williamson, K.: The fair isle apparatus for collecting bird ectoparasites. *British Birds* 47/1954: 234–235.

6
Mammals

THE PREPARATION of mammal specimens is perhaps the most complex aspect of the preparator's work. From the preparator's point of view, mammals are divided into two major groups: small mammals and large mammals. The methods of collecting and preparation are different for each group.

Most museums of natural history possess a collection of mammals, either as a study collection or as an exhibition of lifelike, mounted specimens, or perhaps both. For most scientists and students who work on projects related to mammals (and often for the general public) an extensive, well kept mammal collection is of very high value.

REGULATIONS REGARDING COLLECTING

The collecting of mammals is regulated by law in every country of the world. The regulations concerning the killing, possessing, exporting, and importing of mammals vary a great deal in each country or region, although some (for example, the endangered species list) are applied internationally as well. It is the collector's duty to familiarize him/herself with the law before embarking on a collecting trip.

COLLECTING SMALL MAMMALS

All mammals under the size of a fox are considered small mammals with regard to preparation. These species are easier to collect than the large mammals; however, experience in hunting and trapping and general "bush-craft" helps the collector enormously.

SHOOTING

A person who can use a rifle or shotgun efficiently is more successful in collecting than a person who cannot. Shooting seems to be the most practical method of collecting animals from the size of a rabbit up to a fox.

Table 6.1 provides as a general guidance.

Table 6.1: Small mammals and size of shot.

Size of animal	Calibre or type of firearm
Rabbit	.22 rifle, 12g shotgun, No. 4–6 shot size
Opossum, hare	.22 rifle, 12g shotgun, No. 4 shot size
Badger, small antelope	.17 rifle, 12g shotgun, No. 2 shot size.

As the majority of small mammals are nocturnal, it is practical to use a spotlight. In some regions (for example, Australia), it is almost impossible to collect these animals during the day. Arboreal species, such as phalangers, can be collected very successfully at night with a spotlight and a .22 rifle. If the terrain is too rugged for vehicular access, the light can be mounted on the rifle and powered by a motorbike battery, carried in a shoulderpack.

It is best to collect fast moving animals using a shotgun. They can be collected during the day or at night.

Successful "shotgunning" is a particular art; the subject is beyond the scope of this publication. However, one aspect of it should be mentioned here, as it can ensure a successful collecting trip for someone who is after insectivorous bats.

A double barrel shotgun (12, 16 or 20 gauge) should be used, loaded with fine bird shot (No. 10 or 12). To collect the animal, aim the gun at the approaching bat and fire one barrel. In most cases if the shot misses the bat, it will take a swipe at the pellets, as it associates them with flying insects. The second barrel should then be fired, without the shooter changing his/her position; the bat will be hit with the shot.

TRAPPING

Trapping, is also a very successful method for small mammal collection. Here again, there are so many different kinds of traps, with different usages, that

Fig. 6.1. Trap with box over bait.

it is impossible to list them all in this publication. However, the few mentioned here will give enough guidance for readers to choose a suitable type of trap for their purpose.

One of the cheapest and simplest of traps is the common "snap" type rat or mouse trap which is available from most hardware stores. This trap is designed to destroy its victims by crushing their skulls. In order to prevent destruction of the skull, the bait should be placed towards the centre of the trap. This forces the animal to stretch its neck to reach the bait. To prevent an approach from the side or from the direction of the trap's mechanism, a small, boxed cover can be constructed and placed on the baited and set trap (Fig. 6.1). This leaves only one direction for the animal to approach. The animal takes the bait in an outstretched position, and receives a mortal blow from the jaw of the trap.

If the ectoparasites of the animal are to be collected, this simple trap can be developed further. Since a trap line for serious collecting could consist of over a hundred traps, a considerable time may elapse between inspection of the traps. Ectoparasites could leave the trapped host animal after its death and before it is discovered by the collector, according to Simonovic and Sviderski (1960). In order to capture the parasites before they can escape, a small post may be fastened to the side of the trap and a small bottle fitted (Fig 6.2). The bottle should be sealed with a cork to which a hook has been fitted. The bait must be placed under the bottle so that, as the animal activates the trap, the trap jaw hits the hook, thus uncorking the bottle. The contents of the bottle (benzine) pour on the animal, killing all the ectoparasites instantly. Recommended usage is at least 25 mL benzine in a mouse trap, and perhaps 50 mL in a rat trap. The cork must be real cork, not rubber; it should be rubbed with unscented soap to protect it against the effects of the benzine. The hook may be made of a strong nail and the cork should be tied to the post, otherwise the jaw of the trap can send it flying into the undergrowth where it cannot be found again.

For fur bearing animals, such as foxes or racoons, commercially made traps are available. If these have been obtained, it is best to follow the instructions given in the appropriate literature.

To overcome the problem of spoilt specimens, many collectors use traps which do not kill the animals, but instead capture them alive.

There are many different traps which do not harm the trapped animal, but merely confine it. The live animal can be extracted from the trap by the collector and studied in detail. The parasites, if there are any, also stay with the host animal.

These live traps can be divided into three major groups: mechanical traps; pit traps; and bat traps.

The mechanical traps are used most frequently by researchers. Simple traps can be made out of a flower pot and some scrap timber. These are only suitable for small animals, especially mice. The illustrations (Fig. 6.3) show how they are constructed and set. Box or cage traps are more efficient, but also more costly. These are recommended for serious work since the well made boxes can be folded flat and neatly packed in carry boxes for transport.

The Elliot trap is an excellent model (Fig. 6.4). Made of aluminium, it is almost totally impervious to moisture; it is very light, and can be erected and set in a few seconds. Once the trap has been unfolded (erected), a small amount of bait should be placed at the rear of the interior and the pressure plate pressed down (set). As the animal approaches the bait it walks on or touches the plate and the trap shuts behind it. If animals are trapped on cool nights, they can die of exposure if not retrieved soon enough.

Cage traps can be constructed on the same principle as the Elliot traps, but the triggering mechanisms of the many varieties of traps differ a great deal.

Fig. 6.2. Modified trap to capture small mammals and kill and preserve their parasites. A. Detail of the stopper.

Pit traps are simple and effective devices but setting up a long line of these can be very tiresome. A pit trap consists of a metal or plastic bucket dug into the ground. The bait is simply dropped in it and the animal in jumping down to get to it becomes trapped. The traps must be deep enough to prevent the animal from jumping out.

Some species cannot jump very high and these are the ones most likely to be collected. If the pits need to be deeper than the available buckets, galvanized sheet metal can be cut to the required size, a hole dug, and the metal sheet placed in to form a cylinder. If the animals that are to be collected are burrowers, a piece of flat sheet metal should be placed at the bottom of the hole to form an impenetrable trap. Some species do not dig their way out of a pit which has a natural bottom (for example, Planigale).

Fig. 6.3. Flower pot traps.

Fig. 6.4. Elliot trap. A. Animal enters trap this way. B. Hinged and spring loaded door. C. Catch. D. Bait tray. E. Bait. As animal steps on bait tray, catch releases door (B) thus animal becomes trapped.

It is often necessary to erect a drift fence (Fig. 6.5). The fence should stretch the entire length of the trap line and the traps should be placed under it, as the animals which roam the ground (mostly at night) will come to the fence from either side. If the bottom of the fence is buried in the ground the animal tries to find its way around it by running along the side, and so falls into one of the pits. It is possible to obtain good results using a combination of drift fence and pits, even without the use of a bait (Fig. 6.6).

Fig. 6.5. Drift fence. The pit trap is placed at the arrow.

Fig. 6.6. Simple drift fence and pit traps. Drawing by G. Hangay.

Pit traps can be converted for killing and preserving the trapped animals at the same time. Howard and Brock (1961) describe a preserving trap (Fig. 6.7) which is a very practical instrument for collecting, killing and preserving small mammals. The advantage of the trap is that it secures not only the mammal specimens, but all their parasites as well; the animals should be safe from deterioration for up to four months (presumably only in temperate or cold climates). The trap is reasonably complicated to build and it should be used in conjunction with a drift fence. In addition, funnel like fences should be erected on either side of the trap. This trap could be quite lethal for the entire population in the area where it is set; therefore it should be used only after earnest consideration.

The success of trapping is dependent not only on the style of the traps but also on the composition of the bait used. There are many recipes for baits, and a few examples follow.

Baits

Materials generally used as baits for small mammals are dog biscuits, bread, hard cheese, sunflower or pumpkin seeds, rancid nuts, meat and bacon pieces.

A widely used standard bait for rodents and small predators (for example, Antichinus) is finely chopped bacon, peanut butter and rolled oats kneaded into the consistency of hard dough, with a few drops of aniseed oil added. Piechocki (1967) recommends the following bait for small predators: finely chopped bacon; cheese; dried or smoked fish; peanut butter; and a few drops of Valerian oil or tincture. Voronzov (1963) used small pieces of synthetic

Fig. 6.7. Preserving trap. A. Container. B. Level of preserving fluid. C. Metal sleeve.

sponge saturated with sunflower oil as a bait to trap rodents. When fish stock was added to the oil it proved to be very successful in attracting Gliridae.

The American Museum of Natural History collectors have formulated a very good bait which has served the authors well. It is composed of the following ingredients: one part bacon cut into small pieces; one part raisins cut into small pieces; two parts smooth peanut butter; enough rolled oats to make a stiff texture; and a little honey. It should not be too moist, nor crumbly. Some collectors omit the bacon as the mixture keeps better without it. Some also add a few drops of aniseed, whilst others use only walnuts as bait.

The bait mixture can be made up as it is needed and carried around in a plastic bag so that it does not dry out. A small amount of the mixture can be rolled into a ball about 2 cm in diameter and placed on the trigger of a rat trap or on the other side of the trip plate in an Elliot trap. On exposure to rain or very moist conditions, rat traps lose the bait as it washes away; therefore, the traps must be placed under some sort of cover or the bait can be wrapped inside a piece of cheesecloth.

Setting traps

If the collector has a sound knowledge of the animals to be trapped, it helps greatly in choosing the right bait. Also of importance in trapping is correct setting of the traps. Here again, the knowledge of the animals' habits is of extreme importance. Choosing the trap site is a major decision.

Depending on the nature of the country and the animals to be trapped, the collector must choose an area which has not been interfered with by unauthorized persons and livestock. A likely favoured habitat for the animals which are to be trapped should be chosen, and the traps set so that they can be found again. Outside interference is an obvious nuisance; traps can be disturbed, or even stolen, by ignorant or wilful individuals, and they can be trampled by grazing cattle and other livestock.

Most small mammals are nocturnal, shy and very cautious. They do not like to cross large, open spaces and, if obstacles are met, they would rather go around than climb over them. Therefore, the traps should be set alongside natural obstacles, such as fallen trees and rocks, or at the edge of clearings, but they should never be set in the middle of a large, open area. When trapping in open, treeless country, the collector should try to find areas where the animals could hide during the day and set the traps near by.

If a large number of traps are set the possibility of success is increased, but the workload and the likeliness that some of the traps cannot be found again are also increased. To prevent losses, the trap line should start at a definite landmark and the traps should be spaced out an equal number of steps from each other.

If the trapping is to take place in dense forest, bright coloured markers should be tied above each trap. Iridescent orange, plastic ribbons are very suitable for the purpose. If using snap type traps (Fig. 6.1), or similar traps, they will need to be tied to a nearby bush or tree or pinned to the ground. This will prevent the trap being dragged if the animal is not killed instantly. Traps of this kind should be closed during the day. Otherwise, birds can get onto them. In some areas it is necessary to remove the bait to save it from drying out or being devoured by birds or insects.

Some mammals are more cautious than others. Often it will be found that certain species fall into the traps first; others will do so a few nights later, when they have become more accustomed to the presence of the traps. Some species will never enter a trap which has recently captured an animal, especially if it urinated on the trap. These traps should be washed with hot water before being placed out again.

Bat traps are specifically designed to capture specimens alive. The instrument consists of a collapsible metal frame with fine wire or fishing line strung across it from top to bottom, in a harp like fashion (Fig. 6.8). At the bottom of the frame a strong canvas trough serves as a catching bag for the bats which fall into it after colliding with the fishing lines spun across the frame. The trap is erected in the natural flight path of the bats.

Insectivorous bats can be attracted by a congregation of flying insects. If a strong light is placed near the trap, this will attract insects; bats will soon appear to feed on them. After a short period of observation the collector can identify the most popular flight path of the bats and, if necessary, the trap can be repositioned in order to catch them.

Another clever bat trapping method has been described by Klemmer (1957). Based on Borell's (1939) technique, which was practised in Texas, Klemmer collected bats with his improved method in Sicily. Nylon fishing line (0.4 mm) with a 6.3 kg breaking strength was stretched across a body of water (Fig. 6.9) and, as the bats swooped down to the surface of the water in order to drink, they collided with the line and fell in. After a few seconds they swam towards the shore where the waiting collector could catch them. The line should be stretched approximately 20 mm above the surface so that it does not get wet. The line must also be across the flight path of the bats.

Bats can be collected by mist nets erected in the usual way (see Volume 1, Chapter 5) or stretched over water, parallel to the surface. In Papua New Guinea and in other tropical countries, large fruit bats are captured (for human consumption) with big fish nets spun between tall trees.

Nets can also be used at the opening of caves, hollow trees and mine shafts which serve as roosting places for bats. As the animals try to fly through the opening, they become entangled in the net and can be collected without difficulty.

A = wires
B = canvas through
C = inner plastic lining
D = canvas

E = plastic
F = trapped bats climb in here
G = frame

Fig. 6.8. Bat trap. Drawing by G. Hangay.

Fig. 6.9. Bat trap over a body of water.

OTHER COLLECTING METHODS

There are some other collecting methods apart from shooting and trapping. Small mammals which live in subterranean burrows can be flushed out with water, gas or with the help of domesticated ferrets. All escape routes (some subterranean burrows have many openings) must be sealed with nets which capture the animals as they try to leave the burrows. In Mongolia, Piechocki (1967) used the exhaust fumes of a car to drive small mammals from their burrows. The exhaust pipe of the car was extended with a long hose which was pushed deep into the burrow while the opening was sealed with rags. Young animals emerged first, almost immediately, and adults after approximately 10 minutes. Citellus species and foxes were also collected by this method.

Some nocturnal mammals can be collected with a strong searchlight or spotlight. The animal can be caught in the spotlight shone from a moving vehicle. The animal will stay in the light, and the vehicle can approach to a position where the collector can leap off and capture the animal with a hand net. After capture, the specimen should be placed in a canvas bag.

When handling live animals, one must be very cautious even if they seem to be small and harmless. It is best to wear strong leather gloves and grasp the animal firmly behind the head, but not so as to cause it unnecessary pain and injury.

The killing of small mammals must be carried out with the least amount of pain and anxiety to the animal. The larger ones, that is, anything over the size of a hare, can be killed quickly with a .22 hand gun or an injection of

barbiturates. Barbiturate injections can be used on all mammals. The effect is very swift and presumably painless to the animal. However, the preparator must know how to give the injection and how much barbiturate to administer. Clumsy handling and sketchy knowledge of the procedure causes unnecessary suffering to the animal, and this should be avoided always.

If the preparator is not sure how to inject an animal with a lethal dose of barbiturates, it is better to use chloroform to kill it. Anyway, most barbiturates are supplied only on prescription. When using chloroform, the animal should be placed in a small cloth bag or in a small cage; then, a wad of cotton wool soaked with chloroform is placed next to the animal. The cage can be sealed inside a plastic bag with the animal and the chloroform, and left until the specimen is dead. Death should occur within five to 10 minutes, although the animal becomes unconscious after a few seconds.

The exhaust fumes of a petrol engine can be used instead of chloroform. A plastic bag, with the animal inside, is held to the exhaust pipe of the running engine. The fumes will inflate the bag within a few seconds and kill the animal.

FIELD PREPARATION OF SMALL MAMMALS

The ideal small mammal specimen is one which has been collected live. Rodents and small predators can be kept alive for a considerable time under field conditions or during transport. Unlike reptiles, mammals do not keep well in canvas bags for extended periods. A small mammal can be kept in a strong wooden or metal box provided there is adequate ventilation. Biscuit boxes of two to three litre capacity are suitable if a large hole has been cut in the lid and securely screened with wire mesh. A handful of moss or hay will give sufficient hiding place for the animal and, so long as a little water and food is provided, the animal will last at least a few days. Some species are very sensitive to sudden changes in temperature. Once removed from their original habitat they are unable to combat variations in heat or cold; therefore, in cold weather their boxes must be kept indoors. In hot climates they must never be left in the sun or in a locked car.

If an animal is kept in a small container for a long time, the container must be cleaned periodically (at least every two to three days). The best method is to have another clean container ready with fresh hay, food and water, and simply transfer the animal from the soiled one to the clean one.

DATA RECORDING

The process of recording data should begin while the animal is still alive and in good condition in order to collect and record as much data as possible from the animal.

A few good quality colour photographs showing every part of the specimen are invaluable. A practical way of taking these photographs is to place the animal in a small glass or acrylic box (like a terrarium) with some natural surroundings, such as a little soil or clump of grass. Make sure that no hiding places are provided in the box. The animal can be photographed through the glass, and with a little practice, and luck, some of the photographs will give the impression that they were taken in the wild. Photographs such as these can be used not only as a record but also as illustrations for articles, exhibitions and lectures.

Larger animals, that is, over the size of a hare, can be successfully photographed in a larger cage if the side has been camouflaged by vegetation. The photographs can be taken through the grill of the cage when the animal is against the backdrop of vegetation. If a cage is not available, photographs can be taken of the animal while it is held in the hand (using gloves); these will be useful only as a record. Photographs of the head, especially the eyes, are very useful for the taxidermist.

The live weight of the specimen can be recorded by placing the animal in a bag, of which the weight is known, and weighing it. Scales as described in Volume 1, Chapter 5 can be used for smaller species, but larger animals will require scales with a greater range.

Body measurements and species, sex and age determinations are best carried out once the animal is dead. Immediately after death, the specimen must be labelled with a small cardboard tag tied on one of the hind legs. The specimen's workshop number should be written on the tag with India ink or graphite pencil. The same number is shown on the data sheet on which all the specimen's detailed data are recorded (Fig. 6.10).

The measurements taken from a small mammal by most scientific institutes around the world are illustrated in Fig. 6.11.

Total length (tip of nose to end of tail): If the mammal is opossum size or less, the total length is measured by placing it dorsal side down on a sheet of rigid foam or soft timber. The tail is laid flat and the head and body are gently pulled so that the vertebrae are at the maximum length. When the tail and body are in a straight line, pins are inserted into the foam or board, with one at the end of the tail and the other one at the tip of the nose. The distance between the two pins is measured (Fig. 6.11A).

Tail length (tail tip to vent): Using the same animal, let the body hang over the edge of a table while keeping the tail straight on the top. Be very careful when measuring some small rodents as their scaly tail skin is likely to slip or peel off. Insert a pin at the end of the last tail vertebra and measure from this to the edge of the table (Fig. 6.11B). If the mammal has a tuft of hair extending beyond the last vertebra disregard it.

Hind foot (back of heel to the tip of the largest toe): In various countries, two measurements are made of the hind foot. They are recorded as length of

The Australian Museum, Sydney. N.S.W.

MAMMAL FIELD DATA SHEET

Field No........

Species .. Sex 0 A/J Prep. No........

Collector................. DateTime..... Reg.No.M........

Locality.. ° 'N/S

.. ° 'E/W

..Alt........

Habitat..

Capture details ...

Dimensions TLTV..... Hf......EFA......mm/cm Wt g/Kg

Measured byPrepared by Condition G F P

Parts preserved StomachU/Gs....Embryos Parasites...........

Gut contents..

..

Parasites ..

..

Ovary/Testis..

Uterus/Epididymis... Preg.....

Mammae + = Lact.......

Embryos/Pouch young Av. CRL mm

Remarks ..

..

..

..

Skin......Skull.....Skel.....Alc........Form.......Freeze dry..........

Fig. 6.10. A data sheet for mammals.

hind foot, *cum unguis*, which is the measurement taken from the heel to the tip of the longest claw, and length of hind foot, *sine unguis*, which measures from the heel to the end of the fleshy part of the longest toe (Fig. 6.11C). Measurements can be taken using a ruler or vernier calipers. Bats are measured *cum unguis*. Tufts of hair extending the above mentioned points are disregarded.

Ear: Using a rule, vernier calipers or dividers, the measurement is taken from the notch at the base of the ear to the tip (Fig. 6.11D).

Forearm: This measurement is only recorded for bats and is taken from the elbow to the wrist along the radius (Fig. 6.11E). The units used are millimetres.

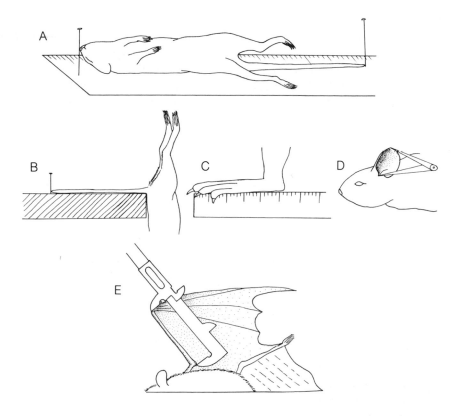

Fig. 6.11. A. Total length. B. Length of tail. C. Length of hind foot. D. Length of ear. E. Length of forearm of a bat.

DETERMINATION OF SEX

In most cases, determination of sex is quite simple. The external sex organs are clearly recognizable in many small mammals. However, there are species, such as small rodents, marsupials and bats, where the determination of sex can be very difficult. To determine sex in individuals of these species an internal examination is often required. Outside the breeding season, some small mammals, such as shrews, have sex organs so non prominent that, in order to find the testes, it is necessary to use a magnifying glass. Males have a penis bone, and the presence of this is a sure indication of the male sex. If the sex of the specimen cannot be determined in the field, or shortly after the animal is killed, it is better to preserve the whole body for later examination, perhaps with the help of an expert.

The sex of the specimen must not be guessed. If in doubt, the sex of the specimen should be marked with a question mark.

DETERMINATION OF AGE

In some cases, the determination of age can also be simple but, in many cases, especially when dealing with lesser known species, it can be very difficult. If the age of the specimen can be identified through external signs, this should be noted on the data sheet. If age cannot be established with certainty, this should also be noted and the whole body must be preserved for future study.

PRESERVATION

Once all the necessary data have been recorded the specimen can be preserved. A number of different preserving methods could be applied depending on what the specimen is to be used for.

If the preservation needs to be delayed for a few hours in a cold or temperate climate, the small mammal specimen can be stored without refrigeration. If it is placed in the shade, protected from insects and scavenging animals, and preferably stored in a cloth bag, the specimen will remain in good condition for approximately four to five hours. After this period if the temperature ranges from $10°C–13°C$, the viscera will start to decompose and the fur on the abdomen will fall out in patches. Deterioration can be delayed for a further few hours if the specimen is eviscerated soon after death. The blood and body juices must be wiped off the fur (and preferably rubbed with borax), while the body cavity should be filled with sawdust mixed with borax. This method is only recommended in special situations such as when a collector is travelling on foot and must carry the collected specimens all day.

The best way of storing specimens until preparation begins is freezing. The dead animal's mouth and vent must be plugged with cotton wool; the specimen can then be wrapped in a fine layer of cotton wool and sealed in a plastic bag before being placed in the freezer. Thus packaged, the specimen can be stored in the freezer for years.

Specimens can be preserved successfully if they are injected in the thoracic and abdominal cavities, the fleshy muscular areas and the brain with a solution of 75% ethanol, and then stored in the same liquid. Alcohol has a bleaching effect on fur, and some colours (especially red or rufous colours) can be effected more than others. If alcohol specimens are kept in a dark jar, such as the black polyethylene drums widely used by museums (Fig. 6.12), the fading of colour is minimized. Alcohol specimens, although they become rigid in the liquid, can be relaxed later on if soaked in a 2% carbolic acid–water solution. Instead of alcohol, formaldehyde can be used to preserve specimens. The specimens are injected with a 10% neutralized formalin solution. The fading effect is the same. Formalin specimens cannot be relaxed afterwards; therefore, they are unsuitable for taxidermy. However, the best preparation results can only be achieved if the work on the specimen commences soon after death, and the specimen is not preserved.

Fig. 6.12. A practical design for an alcohol storage container. Photo G. Hangay.

Fig. 6.13. A. Contact drawing of an unskinned small mammal. Dorsal view. B. Contact drawing of an unskinned small mammal. Profile.

A contact drawing is prepared to record the shape and dimensions of the animal. If the animal is designated to be a scientific specimen, or study skin, it is positioned in an outstretched position (Fig. 6.13A) on its belly; the outlines are then traced on paper with a pencil. If the specimen is to be mounted in a lifelike position, a contact drawing should be made in profile. For this drawing, the animal is arranged in a more or less lifelike position (Fig. 6.13B). Folds in the skin (for example, as on the neck of a dog) are sketched on the drawing.

Skinning the animal

Once the contact drawings of the unskinned animal have been made, the skinning operation can begin. This is best done in the laboratory, but, on extended field trips, may be done in a sheltered spot.

During skinning some more information can be recorded. If the specimen is a female, the position and milk content of the mammaries should be noted, internal reproductive organs should be examined and embryos, if any are present, should be preserved in alcohol or formalin.

In order to prepare a study skin the specimen has to be skinned in the following manner.

The animal is laid on its back and an incision is made with a scalpel, not too deep but just enough to cut through the skin, from the base of the sternum (breast bone) to the anus on the ventral surface (Fig. 6.14A). The anus or genitalia should not be cut through. Female marsupials will need the incision to go around the opening of the pouch. The skin should be lifted at the cut edge and, using forceps or the handle of the scalpel, probe between the skin and the abdominal wall, breaking up the connective tissue (Fig. 6.14B).

Continue breaking away the skin until the femur has been reached and a large cavity produced. Expose the muscles of the femur by cutting the connective tissue, and cut through the knee joint using scissors (Fig. 6.15A). Repeat this for the other hind leg. Keep pushing the skin away from the abdominal wall until the skin has been loosened from the torso. Using bone cutters, cut through the abdomen at the narrowest point near the hind legs

A B

Fig. 6.14. A. Opening incision. B. Pelvic area exposed. Drawing by G. Hangay.

and pelvis (Fig. 6.15B). The legs should still be joined to the pelvis and tail. Carefully hold the abdomen and peel the skin, working down towards the shoulders. After reaching the scapula, cut through the scapula–humerus joint on both legs and continue peeling the skin up to the head (Fig. 6.16).

Unlike a bird, the mammal skull has to be skinned completely. The first obstacle is the eustachian tubes which connect the outer ear (pinna) to the inner ear. They appear as white bags and should be severed as close to the skull as possible. From here, the connective tissue has to be cut with the scalpel as close to the skull as possible (Fig. 6.17).

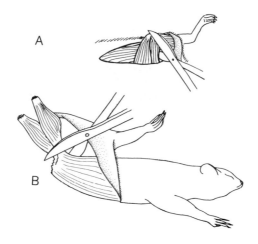

Fig. 6.15. A. The legs are separated at the knee. B. Separation at the pelvis.

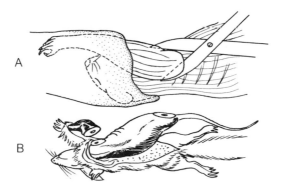

Fig. 6.16. A. Separation at the shoulder. B. Lifting out the body. Drawing By G. Hangay.

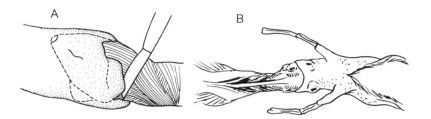

Fig. 6.17. A. Cutting the base of the ear. B. Inverting the skin of the head. Drawing by G. Hangay.

Fig. 6.18. Skinning the eye.

Fig. 6.19. Skinning the snout.

Fig. 6.20. The method of skinning the tail without cutting the skin.

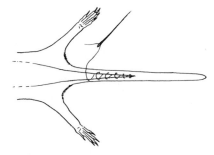

Fig. 6.21. Stitching the skin of the tail.

The eyes are the next obstacle, and they should be cut where white tissue can be seen (Fig. 6.18). Make sure not to cut the eyeball, as this will soil the skin, and not to cut too close to the skin. Keep cutting the connective tissue down the snout until the nose is reached (Fig. 6.19). Cut through the cartilage at the end of the nose to release the skin. Some long snouted mammal specimens have, due to dehydration during storage, a very dry snout which needs to be soaked in 2% carbolic acid and water for half an hour to soften and make the skinning easier.

Now, the head can be severed from the neck. A label must be attached to it bearing the same workshop number as the skin.

The tail has to be removed next, and, for small mammals, the following procedure is recommended. With the thumb and forefinger of both hands, carefully break up the connective tissue under the skin by twisting the skin back and forth and up and down the tail a few times. Cut the genital tubes and skin a little way down the tail, cutting through the rectum as well. Grasp the tail vertebrae with a pair of long forceps or two sticks. Hold the pelvis and tail vertebrae with the other hand and pull at the same time that pressure is applied with the forceps (Fig. 6.20).

The idea is to pull the tail vertebrae from the skin without turning the skin inside out. If the skin has been turned inside out it usually has to be split all the way down to turn it right way round. Hard, dry tails which cannot be pulled out are cut down the ventral surface and the tail vertebrae are cut away or pulled out. If the tail is slit down its entire length, it will have to be sewn up before the specimen is filled with fibre (Fig. 6.21).

With small mammals such as rats, mice and small possums, the small traces of fat, muscle and connective tissue can be removed using a combination of fingers, scrapers and forceps.

The legs are skinned by simply pulling them out, as one pulls a finger out of a glove. With larger specimens the scalpel has to be used here and there. Skin

right down to the last joint of the fingers in the case of larger small mammals such as a fox. Remove all flesh and fat from the bones (on the front legs the humerus can be cut off altogether). It is often necessary to make an incision on the pads of each foot and clean out all fat and flesh through these cuts.

With larger specimens, the ears are turned inside out. The ears of specimens under the size of a large rat are not turned inside out.

After skinning has been completed, the head can be separated from the body and the skull prepared (see Volume 1, Chapter 10). It is very important that the skull is labelled immediately with the same workshop number as the specimen.

If determination of age was not completed earlier, the bones of the body can be examined now. This should be done immediately; or the body should be stored, either in a frozen state or pickled in alcohol. Storing bodies in formalin is not recommended if they are going to be macerated. Formalin treated protein is very difficult to macerate.

If there is blood or dirt on the skin, wash it in clean, cold water. If the blood has coagulated and dried, it may be necessary to scrape the blood away (see Chapter 5). The skin may be washed in a household detergent in cold water, but it must be thoroughly rinsed in clean water. When the skin is the right way out, check whether the fur appears to float in water. This signifies that it is completely clean. If the fur does not float, it generally means that it is greasy. If the specimen is exceptionally fatty, soak it in acetone for a few minutes to remove the fat. Other degreasers such as Genklene (1,1,1–trichloroethane) are also suitable. After rinsing the skin in cold water, place it in a container holding a 95%–100% solution of alcohol for 10 to 30 minutes to preserve the skin slightly and enable faster drying of the fur. When it is taken from the alcohol, squeeze as much of the alcohol from it as possible, using paper towelling to pat it dry.

The above method of skin preservation is adequate for most small mammals between the sizes of a larger rat and a ferret. Mammal skins over the size of a large ferret should be properly tanned (see later). Very small mammals, that is, those under the size of large rats, are prone to slip easily. Therefore, it helps to drop the eviscerated, but unskinned, specimens into a preserving solution of 1 L water, 1 L alcohol, 100 mL formalin, 20 g carbolic acid and 200 g glycerine and leave them for approximately one to two hours. If the specimens are left in the alcohol much longer they dehydrate and stiffen up, and should then be placed in a carbolic acid–water relaxing solution in which they will soften up enough to skin without any difficulties.

Mounting small mammals

Once these small animals have been skinned turn the skin inside out and sew the lips together. This can be done very neatly and evenly if the first stitch is

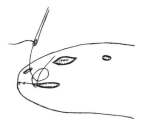

Fig. 6.22. Stitching the lips.

made at the nose. The stitch is tied and the thread is cut off. The next stitch is made at the corner of the mouth and the lips are sewn together from here to the nose (Fig. 6.22). Sew up any holes that might have been made during the skinning.

The next step is to sprinkle borax powder onto the inside of the skin and to rub it well in. This is followed by the painting of arsenical soap onto the skin to prevent insect damage and to preserve the skin. Arsenical soap should not come in contact with the preparator's skin; wash thoroughly if spillage does occur (see Volume 1, Chapter 5). Now, wrap cotton wool around the leg bones and, using forceps, push the legs back the right way out. Do not pull the legs by grasping the feet as the cotton wool will slide off the bones. Once this has been done, the whole skin can be turned the right way out and laid on the bench, ventral side up. To fill the head, select a wad of cotton wool, similar in size to the skull, and wrap polyester fibre around it. Push this ball into the head to produce a firm, but not stretched, head.

The body is also filled with polyester fibre. One large piece of fibre should be used rather than several pieces which cause lumps to appear after the skin has dried. Form the fibre into a cone shape and push the narrow end into the neck. Using forceps, push the fibre into the thoracic and abdominal region until the skin has been filled to the appropriate shape (Fig. 6.23); filling should reproduce the approximate size and shape of the live animal. The specimen's shape should be continually compared with the contact drawing and measurements, and adjustments made when necessary.

Use galvanized wire to support the outstretched tail. The wire should be tapered using a bench grinder, and notched along its length to enable cotton wool to adhere to it. The length of wire required is determined by measuring from the tip of the tail up to the incision at the sternum, leaving enough to be doubled back towards the anus. Doubling back the wire in this way provides a support. Cotton wool can now be wrapped around the wire in a thin strip to produce a smooth tapering surface. Care must be taken to avoid making it too thick (Fig. 6.24). The original tail should be kept as a guide.

Fig. 6.23. Applying the filling.

Fig. 6.24. The construction of the tail.

Fig. 6.25. Stitching the filled skin.

Paint the finished tail with arsenical soap, then slide it into the body skin. The end of the tail wire should be doubled back inside the abdomen. Place a thin layer of cotton wool on top to prevent the wire sticking through the abdomen once it has been sewn. Ensure, before it is sewn up, that the animal has not been overstuffed or understuffed.

When sewing the animal, the stitching begins at the anus, or at the sternum. A strong thread and a surgical needle should be used. Pull the thread to bring the cut edges together and tie the end securely. Do not pull too tight or the skin will concertina, but ensure there are no gaps. On a well finished specimen, the incision should not show (Fig. 6.25).

Smaller male specimens, such as small rodents, should have their penises everted before the skin dries. At a later state, identification can prove to be very difficult or even impossible if the penis is allowed to dry in its usual, semi-inverted position.

The fur should be dried using a hair drier on a medium heat. The animal can then be pinned out on a board, such as a sheet of rigid foam or cork, to fix it in position. It should be placed on its ventral surface and pinned through the feet. The head and tail are positioned so that they are in a straight line and pins are inserted into the board as close to the tail as possible. Two pins should be inserted through the eye holes and stuck into the board (Fig. 6.26). A pin is stuck on each side of the nose. The fur should be brushed to make it smooth and even. The ears can be pinned to a piece of card which has been shaped to fit the ears (Fig. 6.27). The cards should be removed once the animal has dried and is set in position. The tail, feet and head can be held in position with strips of cardboard (Fig. 6.28). The animal should now be placed in a drying cabinet for several weeks to completely dry. It must be fumigated before it is placed in the collection. The finished specimen, and finished skull, are shown in Fig. 6.29.

Some museums use a technique which produces a flat skin with a card inserted into the body instead of polyester fibre, and no attempt is made to produce the shape of the animal. In this method the animal is laid on its dorsal surface and incisions made from the knee to the anus on both hind legs. The skin can then be parted and the rectum and urogenital tract cut. Peel the skin

Fig. 6.26. The filled skin pinned on the drying board.

Fig. 6.27. Carded ears.

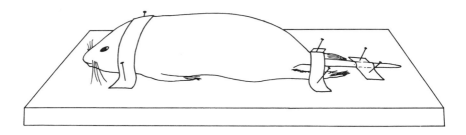

Fig. 6.28. Drying study skin held in position by strips of cardboard.

Fig. 6.29. A. Finished study skin with label attached. B. Cleaned skull with label attached.

right around the pelvis and tail. If the animal is small and fresh, the skin around the tail may be held whilst the tail vertebrae are pulled up and out, or the pelvis and back vertebrae can be severed as previously described. Which ever method is used, the skin is peeled back over the body. After skinning, the cleaning, washing and preserving techniques are similar to those described above.

Fig. 6.30. Card mounted skin (ventral and dorsal view).

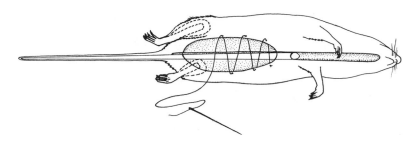

Fig. 6.31. Full length inner support.

A thin wooden skewer, or galvanized wire tapered to a point, is used to fill the tail skin. If there is enough space within the tail, cotton wool may be wound around the stick and painted with arsenical soap before insertion. Now, a piece of white card is cut (Fig. 6.30) on which the appropriate data are written with India ink or a carbon based ink and allowed to dry. The card is pushed into the open end of the skin until it reaches the nose. If the card is obstructed, carefully twist the skin and card until they engage properly. The tail should be straightened and tied, with the hind feet, to the card using nichrome or fuse wire. The forelegs can be positioned and kept in position with a spot of water soluble glue. The ears should be pinned onto a thin cardboard cut out until dry. The fur should be combed to arrange it evenly.

There are several variations on the technique described above. Most scientific institutions have a well proven, time honoured method to which they adhere.

In many collections, study skins are prepared with a full length inner support (Fig. 6.31). Larger skins such as those of rabbits and opossums, are prepared with two parallel supports (Fig. 6.32).

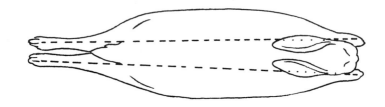

Fig. 6.32. Parallel support. Drawing by G. Hangay.

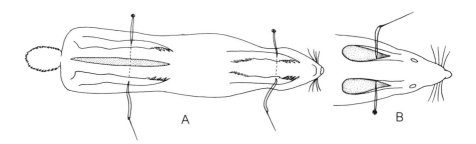

Fig. 6.33. A. Legs held in position by stitching. B. Ears stitched.

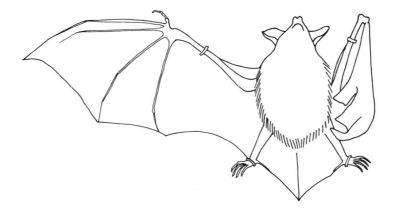

Fig. 6.34. Bat study skin.

Anderson (1961) describes a method which saves time in preparation and space in storage. The specimen is skinned through a ventral cut and the skin is prepared in the usual way. A piece of cardboard is cut corresponding with the general dimensions of the body and padded with a thin layer of cotton wool. This is inserted into the skin. The front and hind feet, and the ears, are stitched through and to the body (Fig. 6.33). The tail is prepared by inserting a wire wrapped in cotton wool. Finally the mouth and the ventral incision are stitched up.

The preparation of a bat skin is very similar to the preparation of any other small mammal except that special care must be taken to fill out the lower arms and thighs by wrapping a layer of cotton wool on the bones. The wings are often folded to save space, but specimens intended for demonstrations or determination exercises should have one wing and the tail membrane dried in an outstretched position (Fig. 6.34). The ears of bats are often of special interest; therefore, they should be prepared so that they can be studied with ease.

Over time, preparators will develop their own techniques for the preparation of skins. Many of these techniques will never be shared with other preparators, which is unfortunate as they may be better than the techniques outlined here.

One technique has come to notice and is mentioned here as it deals with the preparation of small mammal tails which are often difficult to shape properly. The traditional method is to use wire wrapped in cotton wool. With this method, it is often difficult to build up the thickness and shape of the tail. If the artificial tail is too thick, it is impossible to insert it into the tail skin; if it is too thin, the drying skin deforms and makes the specimen unsightly. Ehman (1983) uses silicone rubber sealant (the common, hardware store variety which comes in cartridge pack to be used with a dispenser gun). The tail should be skinned and insectproofed in the usual way, although insect proofing is not absolutely necessary. A hypodermic needle is inserted at the very tip of the tail to provide an air vent. The sealant is squeezed into the tail skin through the cartridge nozzle until a little of the material starts to come out the air vent. A wooden or wire support can now be inserted into the tail, and the skin can be finished in the usual way. This technique is especially suitable for species with naked or sparsely haired tails as the silicone's acetic acid renders the skin somewhat translucent, and thus more lifelike. With this method, a perfectly shaped tail can be easily achieved. If the tail is flattened, the filling can be gently shaped before it sets, by pressing the tail, with the fingers, to the required shape. If the skin is dismantled for some reason later, the filling can simply be removed by pulling it out of the skin.

However, the technique should be used with some caution. The long term effects of the acid and other components of the silicone can be harmful to the skin. Valuable specimens should not be prepared with this technique.

TRANSPORTATION OF COLLECTED MATERIAL

The transportation of the collected material often causes difficulties and inconvenience for the traveller. However, once the effort has been made to obtain and preserve the specimens, the correct method of transport and field conservation is very important.

If the specimens have been wet preserved, they can be stored and transported in nonbreakable containers, such as black polyethylene drums, with liquid proof, screw-on lids.

Frozen specimens can be transported safely if they are wrapped in 15 to 20 layers of newspaper and placed in insulated boxes for the duration of the trip.

If the specimens have been skinned, and filled, out in the field, their transportation and conservation require more precaution. These skins are most vulnerable to attack by various pests and fungi during the drying period. The drying skins must be protected against insects (for example, blow flies), and vermin (for example, rats), by placing them in a screened enclosure. A large crate, with two sides replaced with metal insect mesh, would suffice. Naphthalene flakes, sprinkled freely on and around the skins, will keep most insects away. Occasional spraying with a surface contact insecticide, and the additional protection of the screen, should keep the specimens safe. Paradichlorobenzene crystals or thymol control fungus.

Once the skins have dried properly they can be packed for transport. It is best to have a specially constructed box or trunk for this purpose. Anthony (1950) described a method of converting a regulation United States army locker trunk into a specimen transporting box (Fig. 6.35). Using this description, it is possible to make a similar box from a trunk of similar dimensions. It is important to use a trunk which closes well and is waterproof. The specimens can be placed close together on the shelves and, preferably, pinned out. If layers of cotton wool are laid upon the specimens, they will make them still more secure when pressed down by the tray above. A larger, deeper tray can be placed on the top of the stack of trays to serve as a container for tools and preserving chemicals. This tray can be supported by four vertical cleats; the specimen trays are spaced with loose wooden strips (Fig. 6.35).

Naphthalene flakes, paradichlorobenzene crystals or pieces of pest strip should be placed on each tray to prevent insect damage and mould.

Fig. 6.35. Army Trunk converted to specimen transport box.

TAXIDERMY OF SMALL MAMMALS FOR DISPLAY PURPOSES

The skinning of a display specimen is conducted in the same manner as that of a study specimen. However, the humerus and the femur are left attached to the leg. When the bones are being scraped clean, special care must be taken to avoid damaging the ligaments, which would prevent the disjointing of the bones of the leg.

If a modelled mannikin with legs (for example, a commercially available body) is to be used in the mounting process, the specimen has to be skinned either through a dorsal incision (Fig. 6.36A), or, if a ventral cut is applied, the legs must be split open (Fig. 6.36B).

The skin is fleshed, pickled and tanned as described earlier. The thinning (shaving) of the face of the skin must be carried out with great care and thoroughness. If the skin is left thick, or shaved to an uneven thickness, the facial features of the specimen will not look lifelike as they will dry and shrink unevenly. Oiling and softening (steaking) must also be carried out very carefully, otherwise the whole specimen's appearance will suffer. While aesthetics are not of paramount importance in the preparation of a study skin, in producing a lifelike taxidermic specimen aesthetics are very significant.

MAKING THE ARTIFICIAL BODY

The easiest and therefore the most frequently used method of building an artificial body for a small mammal is the excelsior (or wood wool) method.

Fig. 6.36. A. Opening incisions for dorsal skinning. B. Opening incisions for ventral skinning.

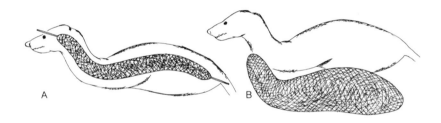

Fig. 6.37. A. The wrapped wood wool body in its first stage as compared with the contact drawing. B. The completed wrapped wood wool body.

The body can be built as described in Volume 1, Chapter 5. Alternatively, a length of wire, marginally longer than the total body length of the animal, can be wrapped with wood wool and string to form a 'sausage'. The wood wool may be dry, but for better shape retention it can be dampened with water. The 'sausage' should be bent to resemble the shape of the animal's body (Fig. 6.37A). More wood wool can be added and wrapped on with string until the shape of the animal (using the contact drawing as referred) has been duplicated in three dimensions (Fig. 6.37B). The wrapped body should be constantly checked against the contact drawings. Mark the hip and shoulder joints on it.

Using the contact drawings as a guide, the head can be carved from a piece of balsa wood or dense, rigid foam. The facial features should be carved in detail, with a slot in the mouth to receive the skin of the lips. Eye sockets need to be hollowed out to accommodate the glass eyes. Last run a light wire through the artificial head and use this to fasten it to the body.

There are alternative methods for making the artificial head. One of these is described by Kish (1978), who recommends the technique for medium to large size small mammals. In this method, the head is sculpted in modelling clay (Plasticine) using the cleaned skull as a base. A mould is made from the model to produce a laminated paper head. (If the mould is made strong enough a polyurethane cast can be made from it.) The procedures of modelling, moulding and casting are discussed later.

Another alternative is to use the actual skull in the mounting process. The skull should be cleaned very thoroughly and insectproofed. The brain cavity can then be filled with plaster with the curved end of a piece of wire embedded in it. After the plaster has set, the skull can be attached to the body by means of the wire. Just before the skin is mounted on the body, the skull has to be covered with an epoxy modelling compound (see Formulae) to replace the flesh. Once the skin has been mounted, facial features can be formed through the skin. A disadvantage of this method is that the soft modelling compound will not hold pins which otherwise would be used to fasten the skin in position.

It is often most sensible, especially when dealing with very small mammals, to carve the entire body out of rigid foam or balsa wood. Using accurate contact drawings, or, better still, the actual body as reference, the artificial body can be carved and sanded to provide good detail. The head can be modelled detached, with the neck made of a length of wire wrapped with cotton wool, to provide some flexibility.

It is often necessary to give an added turn to the body once the mount has been assembled. Repositioning of the mount in this manner can improve the otherwise rigid appearance of the animal. It is impossible to do this with a carved body, but it is a quite simple process with a wrapped wood wool mannikin.

MOUNTING

Once the artificial body has been prepared, the skin can be prepared for mounting. The skin must have been properly treated. It should be clean, moist and soft on the flesh side, and its fur should be dry and fluffy.

If the tail was split it should have been stitched up by now and the entire skin should have been checked for holes and tears. To sew up holes in small mammals, simply join the sides of the tear with small, even stitches. Fine surgical needles and thin, but strong, thread are the best tools for this work.

Galvanized wire, sharpened on both ends, should be selected for each leg. The wire should be twice the length of the limbs. It is inserted into the foot and along the limb bones, and pushed further until it protrudes approximately one third of its length past the head of the humerus or the femur (Fig. 6.38). The wire can be tied to the bones with string. The procedure needs to

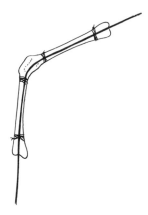

Fig. 6.38. The leg wires are attached to the leg bones.

be repeated with each leg. If the specimen is to be treated with arsenic, the bones should be painted with it at this point.

To replace the muscles of the legs, fine layers of cotton wool or taw can be wrapped on the legs. As the wool replaces the volume of the muscles, it should be wrapped with fine thread to give it the appropriate shape (Fig. 6.39). The skin can be pulled back on the wrapped bones and checked to ensure a good fit. If the fit is satisfactory, the skin should be turned inside out and painted with arsenical solution (emulsion), while the wrapped leg is coated with paste (*see* Formulae), then pushed into the skin again. The procedure is repeated with each leg.

If the pads were cut open for cleaning, they should be painted with arsenic through the incision. A little modelling compound (*see* Formulae) can be pressed into the incision which is closed with a few small stitches.

The tail can be made of cotton wool wrapped around a length of wire approximately one and a half times as long as the actual tail. A tail can be quickly and efficiently wrapped from fine, layered cotton wool as pictured on Fig. 6.40. Fine thread is wrapped around to make the tail firmer. Arsenical solution can then be painted on before it is slipped into the tail skin. It is often necessary to puncture the tip of the tail skin to provide an air vent. Ehman's (1983) method, described earlier, can also be applied with success.

The ears which were pocketed during the skin preparation can now be painted with arsenical solution, filled with a small amount of modelling compound and shaped from the outside. Specimens with small, hairy ears are especially suited for this technique. Rats and mice do not need this ear filling. Medium and larger sized small mammals need proper earliners. However, for most small mammals the ear filling method is sufficient. The filling makes

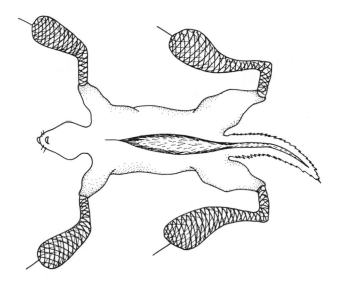

Fig. 6.39. The legs are built up on the bones.

Fig. 6.40. The method for wrapping cotton wool on the tail wire.

the ear thicker than in the natural state, but it is not too obvious. The rest of the skin's flesh side can now be painted with arsenic.

It is now appropriate to coat the artificial body with paste and insert it into the skin. First, the wires of the front legs, then of the hind legs, and, finally, the tail wire are inserted into the body at the marked spots. The specimen is laid on its back and the legs placed in an outstretched position. The heads of the humeri and femurs are pulled snug against the body by the ends of the

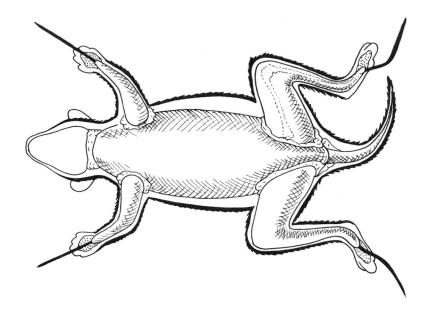

Fig. 6.41. The construction of the mounted specimen.

wires, which, after being inserted in the body, now protrude on the ventral side. These ends need to be bent over and pushed back into the body, thus strongly anchoring the legs and tail (Fig. 6.41).

It is often necessary to fill the areas where the legs and tail join the body with small wads of cotton wool. Long forceps should be used. It will be necessary to turn the specimen around frequently to check progress.

Once the specimen appears anatomically correct, the ventral incision should be stitched up. Great care must be taken not to pinch in any fur. If sewn properly, using a "baseball stitch", the incision should be practically invisible.

The specimen can now be erected on a temporary or permanent base. If it is to stand on its four feet, four corresponding holes are drilled into the base, which will receive the leg wires. Once placed in the holes, the wires hold the specimen firmly to the base. The ends of the wires can be clinched into the bottom of the base and the legs bent to the required position, the arch of the back adjusted, and other adjustments made until the animal adopts a lifelike stance. It is often necessary to redrill the holes and reposition the feet of the specimen.

If the artificial head is made of foam, balsa wood or laminated paper, a little glue should be squeezed under the skin of the face which is then pinned

in position. However, it is practical to use a little modelling compound at the nose to replace the removed cartilage and to press a little compound into the mouth slot. This makes the lips a little fuller. Epoxy modelling compound is especially suitable for this purpose, and if it is accidentally smeared on the fur, it can be wiped off with a watery rag or a wad of cotton wool. As the nose and lips acquire their proper shape they can be pinned with fine insect pins. Normally, it is necessary to pin features where the skin covers hollow sections to prevent the drumming of the skin, and at the corners of sharp features (the corners of the eyes, nostrils, and lips) to prevent the skin distorting.

Where the natural skull has been covered with pliable modelling compound, the features of the face can be modelled at this point. As indicated earlier, this method is not very practical as the compound will not hold pins. However, with some experience, it is possible to achieve reasonably good results with this technique. Once the epoxy compound sets it will adhere to the skin, thus preventing warping during the drying period.

The artificial eyes can be inserted either at the beginning of the final arrangement of the skin on the face or afterwards. In either case, absolute care must be exercised as the wrong setting of the eyes can ruin the appearance of an otherwise correct mount. Quality eyes only should be used; the cost difference between a quality and an inferior eye is minimal when the total value of the specimen is taken into consideration. Commercially made, high quality glass eyes are available in most Western countries, and many eye makers are capable of making specifically coloured ones on special order.

In most small mammals, only the irises of the eyes show. However, the whites of the eyes are visible occasionally and, in some species, this is a characteristic feature. Modern commercially made eyes are made without white corners (in the past it was possible to buy eyes with white corners). The white effect can be achieved if the eye is set in white epoxy compound instead of the usual modelling compound. The eye should be slightly undersized, to show some of the epoxy at the corners. If necessary, the white corners can be modelled with a fine brush dipped in water.

The ears of rats and mice need a little special attention. Their thin skin permits the penetration of preserving chemicals; therefore, they are in no danger of spoiling easily. After the specimen has been mounted and the final arrangement of the face completed, the ears can be pinned in the required position. Paint some formalin on the ears with a small brush and clench aluminium foil, folded double and cut to the shape of the ears, on them. Check the ears during the drying period a few times; if necessary, adjustments should be made.

The ears of larger species, or those with ample hair on them, are filled with modelling compound and arranged in position with pins.

Species with large ears (for example, rabbits) should be treated as large mammals. The ears are pocketed and the cartilage removed during the skin preparation, and earliners installed. After the animal has been mounted the ears are "sandwiched" between pieces of cardboard and left to dry. The ear can be angled by pushing a sharpened wire through the ear hole into the head then tying or fastening the cardboarded ear to it with string or masking tape. The cardboard and wire are removed only when the specimen is completely dry.

Some species have such delicate skins (for example, cotton tail) that pocketing of the ears is almost impossible without tearing the skin. To overcome this problem the authors have evolved the following process.

The ear is not pocketed. The skin is pickled in alcohol, which also preserves the ears. After the skin has been finished in the usual way, the ear should be laid on a bed of fine sawdust or damp sand and coated with Vaseline; a mould has to be made of the inside, using plaster and cheesecloth (muslin). Three or four layers of cloth impregnated with wet plaster make a sufficiently strong mould. Once the mould has been made, the ear is turned with its inside down and another mould is made of its hind side, so that the ear is 'sandwiched' between two laminated plaster and cloth moulds. After an adequate setting time, the moulds can be removed, clamped together and dried in a drying cabinet. The skin should be mounted and the specimen set up in the usual way. The ears can be positioned and two strong wires driven into the head through the ear holes. The ears are painted (larger specimens also injected) with a 10% formalin solution, and then the dried plaster moulds are clamped on the ears with alligator clamps or masking tape. Tape or clothes pegs can be used to fasten the moulded ears to the wires, thus ensuring that they dry in the proper position. The plaster moulds help drying of the ears, and the formalin fixes them permanently.

Tufts of hair and bristles (for example the back of some *Hyrax* species) which should stay in a particular position can be propped and fastened with sticky tape until dry. Once all the anatomical detail has been taken care of, the fur can be worked over with a hair dryer. Using a medium heat position, the moisture can be driven out of the hair and, by blowing in the direction of the natural flow of the fur, arranged in a lifelike manner.

If it is warranted, hair conditioners and setting lotions designed for human usage can be applied to some specimens. This is sometimes necessary to restore the lifelike appearance of very fine, silky hair peculiar to some species of small monkeys or breeds of domestic dogs. These substances should be applied before all the fine detail has been worked into the mount.

After the drying period, during which the specimen should be kept in a well ventilated dry room, pins, wire, cardboard and so on can be removed and the specimen finished.

The coat should receive a final blowing, and should be combed and brushed if necessary. Glazing may also be appropriate. Glazing is done with an old nylon stocking folded into a pad. With this pad or ball, the fur is rubbed in the direction of its flow until it becomes shiny.

Small cracks, pinholes, and gaps at the lips can be filled with small amounts of modelling wax or epoxy modelling compound. The colour of the fleshy parts can be restored by airbrushing thinned artist's oil paint or automotive lacquers. Parts where the colour of the skin shows through, but which are also covered with sparse hair, can also be sprayed until the required colour is restored; the colour can be wiped off the hair with an appropriate thinner.

COLLECTING LARGE MAMMALS

Mammals larger than a fox are considered to be large mammals in this book. To be a successful collector of such animals, one must be an experienced hunter with a wide knowledge of the habits of the species to be collected. As most large mammal collecting is done under strenuous physical conditions, the collector should be reasonably fit.

Most collectors obtain their specimens by shooting them. It is not the aim of this publication to elaborate on hunting, as that subject has been very well covered. However, some points need mentioning. The choice of firearms is more or less obvious for those with experience in hunting: the smaller the animal, the smaller the calibre. Table 6.2 provides a general guide.

Table 6.2: A guide for shooting large mammals.

Size of Animal	Calibre or type of firearm
Fox, jackal	.17, 222 centrefire rifle or 12g Shotgun No. 2 Shotsize
Wolf — medium sized antelope	.222-243 Centrefire rifle or 12g Shotgun, Buckshot
Medium sized deer	243-270 Centrefire rifle
Large antelope	7mm Remington Magnum, 375 H & H Mag Centrefire Rifle
Buffalo	375 H & H Magnum, 458 Win. Magnum Centrefire Rifle
Elephant, rhino	458 Win. Mag., 460 Weatherby Centrefire Rifle.

Safety precautions should be observed while firearms and ammunition are being handled; this cannot be stressed enough.

While shooting for the purpose of collecting specimens for natural history studies must not be confused with 'sporting shooting', there are certain ethics, valid for both, which must be observed. No animal should be caused any unnecessary, prolonged suffering; therefore, animals should be dispatched as quickly and humanely as possible. Wounded game must be followed, and

killed instantly with a close range, single shot. This is done best with a .22 handgun through the ear or through the neck at the back of the head. Dangerous game cannot be dealt with in this manner, of course, but in most cases it is possible to approach the wounded animal and kill it with a single, well aimed heart shot. Specimens which are designated for skeletal preparation should not be shot in the head. If these have been wounded and must be shot again, they should be killed with a bullet through the spinal cord, just at the back of the head, or with a heart shot from a rifle. As a general rule specimens should not be shot in the head; damage there is difficult to repair.

Using a searchlight or spotlight to shoot at night is considered unsporting by hunters. However, collecting is not a sport. If the use of a light proves to be effective, one should be used. Many species of mammals which cannot be approached during the day seem to be mesmerized by a sharp light at night. These species can be collected with ease. In most cases a vehicle can approach the animals, sometimes closer than a hundred metres, thus enabling the collector to shoot very accurately, thus achieving a quick kill and little damage to the specimen.

Captive large mammals can be killed painlessly with a dart from a blowpipe administering pentobarbitone or lignocaine. This anaesthetizes the animal temporarily; a lethal dose of barbiturate can be injected manually. This method causes little agony and hardly any stress for other animals nearby (as, say, in a zoo). Where animals are in larger, open enclosures, where a blowpipe could prove ineffective, it is possible to use a dart gun. The disadvantage of this method is that dart guns, just like any other rifle, are noisy and frightening for all the other animals in the enclosure.

There are many methods for trapping large mammals with traps, pits, maze-like enclosures, and nets. These methods are seldom used for collecting natural history specimens; therefore they can be ignored as museum collecting methods.

Collectors should concentrate on specimens that have had a natural or accidental death. It can be most satisfying to collect these in time and turn them into useful preserved specimens. This is the collecting method that is least harmful for the environment and the species itself. It is often possible to obtain excellent specimens after they have been hit by cars, or have been electrocuted by power lines (bats). A visit to a seal colony yields a few freshly dead specimens, especially juvenile specimens. Some endangered species, such as whales, should only be collected if they are found dead.

Caution must be exercised when handling specimens which have died of unknown causes. Collection in regions where dangerous diseases kill mammals should be avoided, as many such illnesses can be contracted by humans also.

FIELD PREPARATION OF LARGE MAMMALS

Once the specimen has been procured the collector must immediately proceed with the recording of scientific data. Part of this work must be done swiftly, as changes begin to appear in the animal's body shortly after death. The colour of the eyes and the shape of the pupil must be noted first, using a standard colour chart such as the Munsell system, to identify colours and a good quality camera and colour film to record the complexity of the colour patterns of the eye. The colour of body parts which are not covered by hair should be recorded in the same way. Detailed measurements should be taken of the body as illustrated (Fig. 6.42).

The weight of the animal should also be recorded. This is often difficult to record if the collecting takes place where vehicle access is impossible. If collecting in an area where vehicle access is possible, the recording of weight presents smaller problems. The carcass of the mammal can be hoisted on a suitable tree branch with the aid of a long rope and the vehicle.

Once all the necessary information has been recorded (for a specimen which is designated for display purposes much more information must be recorded than described above) the animal should be skinned as soon as possible.

Fig. 6.42. Body chart for a dog-like animal. Courtesy of Joseph M. Kish.

SKINNING THE SPECIMEN

A sharp knife is absolutely essential for skinning. A well made sharpening steel and an oilstone are also necessary to keep the knife sharp. Areas where there is much detail, such as around the face, can be skinned with a surgical scalpel, preferably one with changeable blades.

Specimens without horns can be skinned through the incisions illustrated in Fig. 6.36. Specimens with horns are incised as shown in Fig. 6.43A; then, in order to free the head with horns attached, incisions are as shown in Fig. 6.43B and C, on the head and the back of the neck. An alternative skinning method is shown in Fig. 6.44.

The skin can be prised off the base of the horns or antlers with a blunt instrument, such as a large screwdriver. It is often easier to do this than cut around the horns with a sharp knife (Fig. 6.45).

The ventral cut, extending from the chin to the tail or from the chest to the tail, should slightly bypass the genitals and, in the case of marsupials, the pouch. The anus should also be bypassed.

To avoid accidentally cutting the hair, the opening cuts are always made by pushing the point of the knife under the skin, with the blade upwards. This ensures the skin is cut from underneath, and not through the hair.

Scientific specimens should never be incised through the lips, except for the walrus and warthog whose tusks prevent the skin of the head being pulled over their muzzles. It is possible to skin a warthog without cutting through its lower lip by starting skinning with incisions around the gums, then peeling the skin as far back towards the eyes and down the chin as possible, then sawing through the upper and lower jaws. The walrus can also be skinned

Fig. 6.43. A. The opening incisions on the ventral side of a horned animal. Drawing by G. Hangay. B. Standard opening incisions on the dorsal surface of the neck of a horned animal. C. Alternative opening incisions.

in this way. However, the method is not recommended, as it is very time consuming and also damaging to the skull.

Very large animals, such as the elephant, rhinoceros and hippopotamus, can be skinned by removing the skin from the carcass in sections. It is pointless trying to take the skin off in one piece; the various processes of preparation demand that it be cut up anyway.

The skinning of large mammals requires a certain amount of skill and experience; physical fitness does not go amiss, either. Specimens of up to

Fig. 6.44. Opening incisions for dorsal skinning.

Fig. 6.45. Separating the ears and skinning the neck of an antlered animal.

70 kg body weight can be handled by one person comfortably; over this weight at least two pairs of hands are needed.

It is always easier to work on a bench (a veterinary dissecting table is ideal) than on the ground. It is even more comfortable for the preparator if the animal can be hung.

It is worthwhile to make the opening incisions, then to skin out the feet and lower legs and tail. The next step is to separate the skin from the abdomen and chest and skin out the area around the genitals and anus. It is best to separate the skin from the thighs, upper arms and the neck region as much as possible without turning the carcass over. When it is no longer possible to skin any further at any points of the body, turn the carcass over and, by pulling the tail towards the head, peel off the skin from the back, up to the head, and the unskinned sections of the limbs. If the specimen is hornless, peel the skin over the head as far as possible. The ears should be cut as close to the skull as possible and the eyelids carefully separated (a surgical scalpel should be used for this work). Incise close to the gums and leave the linings of the lips attached to the skin. The last step in skinning the head is to skin and separate the nose, with parts of the cartilage still attached, and the tip of the chin from the rest of the carcass.

Once the skin has been taken off the animal it requires further attention. In order to remove the skin in the shortest possible time, it is normally separated from the feet by leaving the third or even the second phalanges in the skin. These must be removed at this time. Removal is a difficult procedure and is best done with a sharp, pointed, short bladed knife. The lips have to be flayed open as shown (Fig. 6.46), and all excess flesh must be carved off the flesh side of the skin. The area around the eyes must be thinned, and, in the case of large animals, the eyelids should be flayed open in the same manner as the lips. The cartilage from the nose must be removed. The earbutts need to be skinned out with the cartilage of the ear being removed in one piece. This is a very difficult procedure in some species. First, the back of the cartilage must be separated from the skin of the ear. A commercially made ear opener is excellent for this (Fig. 6.47). It works like a pair of reversed pliers. The flat ended, closed jaws are pushed into the ear between the cartilage and the skin. By compressing the handles the jaws open up, thus forcing the cartilage and the skin apart.

With practice, the collector can learn to pocket ears quickly and efficiently with such a tool. After the ear has been "pocketed" all the way to the tip, it is turned inside out, like the finger of a glove. The cartilage is then peeled off; it should be separated at the edges with the thumb and fingernails, and then worked loose towards the base. If this process is omitted and the ear is not treated as described the tanning chemicals will not penetrate the ear properly. Also, salt cannot preserve the skin if it is applied from the outside. Ears which are not rubbed with salt from the inside soon spoil and the epidermis "slips",

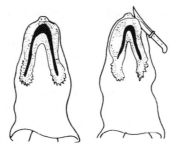

Fig. 6.46. Opening the skin of the lips.

Fig. 6.47. Ear opener tool.

which will result in the patchy loss of hair. The removed cartilage should be kept for further reference.

Finally, the genitalia must be treated. If they were skinned in an incomplete form, they should be skinned out perfectly, in the case of a male, removing the penis and testicles, or, in the case of a female, cutting away all the flesh and fat from the flesh side of the skin.

By this stage the skin will most likely be soiled with blood, body juices and faeces. If water is available, even if muddy, the skin should be thoroughly washed and hung in the shade to drip dry. If there is no water available, the bulk of the dirt and blood can be removed by rubbing the hair side of the skin with clean sand and salt.

SALTING THE SKIN

The cleaned skin should then be laid on a ground sheet with the flesh side up, and liberal amounts of salt should be rubbed into it. No detail can escape attention. Plenty of salt must be applied to all folds and creases in the skin, especially around the eyes, lips, ears, nostrils, genitalia and feet. After this the skin should remain in the shade, preferably in an open shed or tent.

After approximately 24 hours, the salt will have firmed up the tissues of the skin. The hide will become less rubbery and slippery. This is the time when all surplus flesh and fat should be removed. This is best done with a two handled fleshing knife and a beam.

After fleshing, the skin is resalted. The first application of salt will draw most moisture from the tissues, causing brine to accumulate. The salt and brine should be removed before covering the skin with a quantity of fresh, dry salt. When treating large skins, salting must be repeated several times.

When the salt no longer draws moisture from the skin, a powdered insecticide can be dusted on, or naphthalene can be rubbed on. Before the skin has dried hard it should be folded into a convenient package in order to best utilize space during storage and transport.

A salted and dried skin packed with naphthalene, which should be replenished periodically, can be stored in a dry environment for a very long time.

For the successful field preservation of large skins, it should be noted that a large quantity of salt is necessary. To salt the skin of a large antelope (for example, greater kudu), 50 kg–80 kg salt is necessary. At least 50% of this can be recycled once the skin has been cured, but the entire quantity will be needed.

A South African method of treating the skin

The following additional information was contributed by Mr T.W. COFFIN-GREY, National Museum, South Africa.

Salting: This is the normal procedure. Wash away blood and dirt with a saturated salt solution (1.5 kg salt to 5 L water, specific gravity reading 1200). Squeeze dry and salt heavily with fine dairy salt, roll up and put away in a cool place overnight. Shake out old salt and resalt, hand stretch and allow to dry in the shade. Fold when damp dry, hair side inwards. Fold into a neat square. Do *not* fold dry skins. They will surely crack like cardboard and there is no better way of ruining a good skin.

Salting heavy hides (*buffalo, eland*): First make a soaking solution (in a plastic drum) of 1.5 kg salt, 250 g (approximately) sodium fluosilicate, and 5 L water. Add ingredients and mix until a specific gravity reading of 1200 is obtained. Add more salt if necessary. Soak the skin in this solution for at least 16 hours. Remove, hand stretch (it will be very stiff), and shave off some of the heavy neck tissue to allow better penetration of the final salting. Salt heavily and proceed in the normal way.

Salting giraffe hide: A very difficult hide to preserve without shaving tools and beaming boards. Soak the hide in the saturated salt solution (specific gravity 1200), with sodium fluosilicate, but add formic acid to the liquid until a reading of pH 1 is obtained. Use Whatman-BDH indicator paper with a full range of pH from 1 to 14. Leave the hide in this solution for 16 hours. The hide must now be beamed down until at least 6 mm to 7 mm thick. Replace

in the solution and leave for another 16 hours. Remove and salt in the usual way.

Hints on skinning knives: Ordinary hacksaw blades of lesser quality (these are not as brittle as high quality carbon steel blades) make first class knives for light work — skinning of ears, lips and so on. Handles are made from either strips of hard wood glued together with epoxy resin or epoxy putty shaped over the blade. Heavier hacksaw blades are used for heavy duty work. These are easily sharpened on a coarse carborundum wheel and honed on an oil stone.

Investigation has revealed that the cheap skinning knives being sold today are made from offcuts of steel used in the manufacture of shovels. This steel may be purchased from steel merchants, and cut to size. For skeletonizing, and other rough work, knives made from this steel have proved to be adequate and easily sharpened on the nearest half brick!

Experience has shown that no skinner should be without a linoleum cutter in his/her set of tools. This adjustable blade can be honed to razor sharpness and it cannot be surpassed for making the opening incisions. Some of these knives are fitted with a spare blade of a hooked shape. This is ideal for skinning over distended bellies without cutting into the stomach wall.

Instant ear skinning: Fix a large hypodermic needle to an air hose, foot or hand pump and blow up the ear by inserting the needle into the back of the ear near the base. The air bubble should be worked towards the tip and edges of the ear.

This method has been used in Arabia to skin out goats. An incision is made in the lower leg and air is forced under the skin by blowing through a small tube.

While it is not suggested that this "blow up" skinning technique takes all the sweat out of skinning, it certainly does help speed up the operation.

After skinning has been completed, further information can be gathered from the specimen, as described earlier with regard to small mammals.

The field treatment and further preparation of skeletal material of large mammals is discussed in Volume 1, Chapter 10.

PREPARATION OF LARGE MAMMAL SKINS FOR SCIENTIFIC PURPOSES

The skins of large mammals are always prepared as flat skins; in other words, they are tanned and placed in the collection thus. In well equipped museums, flat skin collections are kept in refrigerated rooms to prevent, or at least slow down, the aging process. The various tanning processes are described later.

TAXIDERMY OF LARGE MAMMALS FOR DISPLAY PURPOSES

If the mammal has been designated for lifelike display purposes, photographs should be taken of every detail of its anatomy. The large veins which are visible on most short haired animals must also be sketched since they often will not show prominently on photographs. The facial veins on ruminants are especially important. The veins of the legs, especially the saphenous vein on the hind legs, should be noted.

In order to create a lifelike taxidermic specimen, the preparator is faced with a number of very difficult and complex chores. The first one, after the specimen has been procured and its skin and major bones preserved, is to make a life size model of the animal on which the tanned skin can be mounted. This model has to be as accurate a replica of the original body as possible. In order to achieve this, accurate measurements must be taken first. Ellenberger *et al.* (1949) record 65 measurements for each of seven varieties of horses. This is far more than a scientific data sheet usually requests, but it cannot be considered too much for a sculptor who tries to model an accurate sculpture of a horse! Fig. 6.42 is a standard recording sheet for taxidermic specimens. Measurements recorded in accordance with the chart and accompanied by detailed photographic records of the specimen help the preparator to make an accurate model of the animal.

It is also helpful to use the cleaned and preserved bones of the animal during the construction of the model as well as casts of the face and other sections of the unskinned animal, and casts of the skinned carcass.

A cast of the unskinned face of the animal (called a death mask) is an important aid for the sculptor taxidermist. The facial expression of a dead animal differs from that of a live one; still, an accurate reproduction of the face can show a lot of detail which would be very difficult to record by any other means. A death mask should be used purely as a reference, in conjunction with photographs, sketches and measurements of living animals. In some cases it can be used as a base for modelling. For the best results, the death mask should be prepared as soon as possible after the animal has been killed. It is possible to use a frozen specimen for the purpose, especially if it has been prepared as described below before freezing.

The preparation of a death mask requires skill, and the work must be carried out in an efficient manner. In order to work swiftly, the preparator must make sure that everything is at hand before the start of the procedure.

The head should be prepared first. It is propped in a suitable position, but the nose should not be pointing straight upwards because this will cause the flesh to sag backwards, giving the face an unnatural expression. If the lips part, they should be sewn shut with a few inside stitches. If the eyes have

collapsed due to dehydration they can be injected with water, using a fine hypodermic needle and syringe. To protect the skin which is not being worked, a plastic sheet can be draped around the face in such a way as to expose only the section to be moulded. A large plastic bag with a corner cut off is ideal for this; if the hole is the proper size it will fit snugly around the face. It is possible to include the ears or parts of them in the mask.

It is worthwhile to lay the ears on a bed of damp sand or sawdust. They will retain their shape better this way and will not flatten under the weight of the moulding plaster.

The nostrils, especially if they are large, should be plugged with potters' clay, but not to the rim; this is to allow some of the moulding plaster to enter and capture the detail of the first 4 mm–5 mm of the interior.

An atomizer can be used to wet the hair (Kish, 1978). In hot climates add 1% formalin to the water. A clay slip can then be applied. The clay slip is potter's clay mixed with water to form a thin emulsion. The slip must cover every part of the face except the eyes and the nose. It is now time to check the eyes; they should be opened and made to look as lifelike as possible. Sometimes it is necessary to pin the eyelids, or the corners of them, into the skull, or in the underlying tissues, with long, strong pins.

A medium plaster mix can then be made and a splash coat applied to the entire surface of the face. The plaster must not be rubbed into the hair, and the thickness of the splash coat should not be more than 5 mm–8 mm overall. Before this layer of plaster can set, a length of string should be embedded in it. The string should run from the top of the head, along the centreline of the face, across the nose and down the chin to the bottom end of the mask, forming a straight parting line. The string can simply be pressed into the plaster with a finger. Both ends of the string must protrude from the top and bottom edges of the mask.

Another batch of plaster, a little thicker mix than the first one, is now applied to a thickness of approximately 10 mm–12 mm. After a few minutes the plaster will begin to set; as it becomes warm, the string should be removed. This is best done by grasping both ends at once, then pulling it up, thus halving the mould. The mould can now be reinforced with pieces of burlap soaked in a thin mix of plaster. The burlap should be plastered on the outside of the two halves, but carefully avoiding the parting line.

Animals with no undercuts on their faces (for example, badger, fox, and some cats) can be moulded without cutting the mask in two. Those with fleshy, floppy faces can also be treated in this way as the flexible features will pull out of the plaster easily.

Once the plaster has heated up and started to cool again, it will have hardened sufficiently for removal of the head. A gentle rocking motion should be used to detach the mould from the head.

The heat of the setting plaster as well as the passing of time can be detrimental to the epidermis of the face. As soon as the mould has been removed the head should be skinned and treated in the usual manner.

It is best to make a positive from the mould as soon as possible, even in the field, and especially if the mould has to be transported.

To make a positive, the two halves should be tied together with wire or masking tape. Oil or a thin clay slip should be applied to the inside (or poured in, swirled around and poured out again). Every part of it should be coated.

A medium thick mix of plaster can then be made and poured in the mould. There should be enough plaster to fill the mould approximately one third. The inside of the mould can be coated with the plaster if the mould is turned. If the mould is rotated periodically or continuously, the thickness of the plaster will be even. Once this coat has set, the inside should be lined with two to three layers of burlap soaked in a thin mix of plaster. If the mould is to be transported, the positive should remain in it until arrival at the workshop.

Removal should be simple. In most cases, the halves come apart easily when gently forced with a broad chisel. if the mould does not come off in one piece, it has to be cracked off with a chisel and mallet (Fig. 6.48).

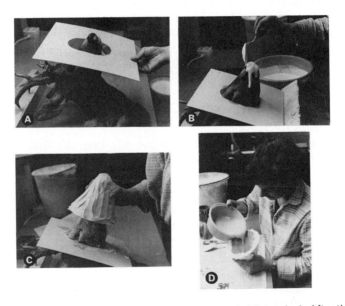

Fig. 6.48. A simplified but effective method of making a death mask. A. After the fur has been coated with a release agent, the area which is not to be moulded is protected by cardboard. B. Plaster of Paris is applied to the face. C. The mask is removed. D. The mask is brushed with a separator-releaser, then a cast is prepared by filling the mask with plaster. Moulding/casting by K. Maslowski. Photo R. Buob. Courtesy of the Staatl. Museum für Naturkunde, Stuttgart, Germany.

Sometimes whole unskinned carcasses are moulded for reference purposes. Koshi (1978) casted entire unskinned specimens in Namibia for the same reason. Large antelopes were suspended with the aid of wires in lifelike poses (for example, running, jumping) and multipiece plaster moulds were prepared from them.

SKINNING LARGE MAMMALS

The skinning of large mammals for display taxidermy can be carried out in the same manner as described earlier. This skinning method requires the preparator to sew the maximum number of stitches during the mounting process. It is often impossible to hide all the stitches on short haired animals. On most animals, the hair is always short on the inside of the legs, and long visible seams can make the best mount unsightly. To overcome this problem, at least partially, the animal can be skinned through a main dorsal incision (Fig. 6.44) and through incisions on the legs between the phalanges and the pisiform. Skinning starts at the feet where, through the incision, the skin is worked loose as far as possible using a special tool called the leg iron (Figs. 6.49, 6.50). The phalanges are then cut from the metatarsus and metacarpus. The rest of the body can be skinned through the dorsal cut and lifted out of the skin. The phalanges are removed from the skin afterwards.

The procedure can be speeded up by incising the legs all the way up to the tarsus and carpus. This makes skinning easier, but defeats the purpose by increasing the length of seams on the mounted specimen.

If it is certain how the mounted specimens will be displayed (which will be the view side, what position it will be in) the dorsal incision and the incision of the legs can be made so that they are invisible from the viewing side.

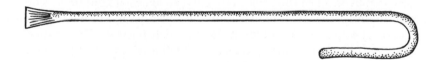

Fig. 6.49. The leg iron, a tool used to loosen the skin of the legs of large mammals.

Fig. 6.50. Side view of the tip of the leg iron.

Akeley's method of skinning

Another variation to the skinning technique of large mammals is Akeley's method. In this method, the legs are split from phalanges to pisiform and the skin is worked off with the leg iron, then the phalanges are separated from the legs. Another incision is made from the sternum to the anus and the body is skinned out as far as possible through this. The legs are disjointed at the pelvis and shoulders (in the same manner as small mammals are skinned) and they are skinned out by being pulled out from the skin. The head, if horned, should be skinned through a cut on the back of the head and neck, but this incision must be kept as small as possible.

The disadvantage of these methods is that they cannot be tried on the clay model during modelling. A flat skin can be slipped on and off the model with ease, but skins with seamless legs can only be pulled onto a rigid model which has not been fastened to a base. Akeley's skins cannot be put on the models unless these have detachable legs.

After the skin has been removed from the specimen it should be treated in the usual manner.

MAKING A MOULD

In order to preserve the maximum amount of detail of the animal, a complete plaster mould should be made of the skinned carcass. This is a large undertaking, especially if the animal is of considerable size, but the benefits that such a full body mould can provide for the taxidermist are incalcuable.

The technique, although practised by earlier workers, was perfected by Henry Wichers Inchmuk, one of the greatest living taxidermists, who demonstrated the technique to George Hangay at the Denver Museum of Natural History.

The carefully skinned (but not mutilated) carcass is laid out on its side (or perhaps in some other required position) on a bed of sand or damp sawdust in as close approximation of the intended pose as possible. The outlines of the muscles (which become flattened or "deflated" in death) should be marked with an indelible pencil. A plaster piece mould can then be made of the entire body. Only the parts showing in Fig. 6.51 should be exposed. This exposed section should be covered with casting plaster which can be re-inforced with burlap. When the plaster has hardened sufficiently, the body, together with the mould, has to be turned over. The side which is now in the plaster should be dug into a bed of sawdust. The other side needs to be arranged in the same way as described above. The legs have to be positioned and supported by sawdust. A plaster mould can then be prepared from this side. Once the plaster has set, the sawdust can be cleaned away from between

Fig. 6.51. The skinned carcass is laid on its side in a bed of sawdust and a retaining wall is built around it.

the legs and to allow these sections to be moulded. Those areas where plaster was poured on plaster (at the joining edges of the mould) should have green soap emulsion applied to them to assure separation. Great care must be taken to eliminate small undercuts on these surfaces (the section which has set should be carved smooth with a knife before the next piece of the mould is made) as these could lock the joining pieces together, thus making separation impossible without breaking the mould. Once all the pieces have been made and the plaster has hardened, the carcass can be demoulded. The pieces of the mould can be tied together with wire.

While the method above demonstrates that it is possible to arrange an animal (either skinned or unskinned) for moulding in a bed of sand or sawdust, for best results the carcass should be set up with the help of an armature.

To mould carcasses of medium size, large mammals (for example, from the size of a fox up to the size of a large domestic goat) the animal has to be carefully skinned and eviscerated. The body cavity should be filled with some suitable material (sawdust, shredded paper, or cotton wool), and the incision stitched up. The carcass can then be erected in a suitable pose by means of wires or rods inserted into the limbs and neck (Fig. 6.52) and the specimen fastened to a light base. It is also possible to lightly rest the body (the weight

will be partially supported by the legs) on a mound of clay (Fig. 6.53). Instead of clay, builder's "fatty sand" can be used. This material, which is slightly clayie, dense loam sand, can be packed tightly once it has been wet. The clay or sand should be built up to the belly, as well as to the inside of the legs. The clay or sand should embed the legs on the inside, with only the outer surface exposed. A neat flange can be modelled all around the legs and at the side of the belly.

This work has to be done swiftly and preferably before rigor mortis sets in. If rigor mortis occurs before the animal is prepared, it is better to wait until it relaxes again and the muscles are more pliable. To prevent sagging, the carcass should be injected with a 5%–10% solution of formalin. The eyeballs need to be removed and the sockets filled with clay. Suitably sized glass eyes should be pressed into the clay, then removed, leaving accurate impressions of the eye in the clay (Fig. 6.54). If the nose has been cut off during the skinning process it will have to be remodelled with clay; if the mouth is required to be moulded open, its interior should also be filled with clay. The edges of the lips, if cut off during skinning, also need to be remodelled with clay. If necessary, ear butts can also be remodelled with clay. A long ribbon of clay can now be placed to form a wall or dam. The clay should be positioned so that one side of it is exactly on the centre line of the body (Fig. 6.55). This side is moulded first, once a similar clay ribbon has been placed on the underside of the chin and neck. The ribbons should join at the mouth to form a smooth, continuous line, and halving the carcass exactly. The thickness and strength of the plaster can be built up in the usual way. Once this side has been made, the clay ribbon can be removed.

Fig. 6.52. The skinned carcass is erected. The dotted lines indicate the heavy wire or rod armature.

The exposed surface must be painted with oil or a clay slip, then the other half of the carcass can be moulded in the same way as the first. Once this piece has been made and the plaster has set properly, the whole specimen can be turned upside down and the clay or sand removed. The exposed plaster surfaces should have loose sand and lumps of clay brushed from them, and separator (oil or slip) applied. The rest of the body can be moulded in the same way. After sufficient setting and hardening, the carcass can be demoulded and the mould cleaned and wired together. It should dry in the usual way and be used only after the plaster has thoroughly dried.

Fig. 6.53. The skinned carcass is erected by placing it on a mound of clay.

Fig. 6.54. A glass eye is pressed into the clay.

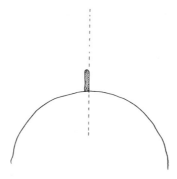

Fig. 6.55. The placement of the clay ribbon.

Filling the mould

If the animal has been set up with great care, and the muscles carefully injected and massaged into the required lifelike shape, a direct body mould taken as described above can be used to reproduce a mannikin without much further modelling. However, distortions occur frequently in the carcass, mostly due to sagging muscles and rigor mortis. These faults can only be corrected by remodelling the cast made from such moulds.

Once the carcass has been removed from the mould the indelible pencil marks clearly show where the muscles were, even where the mould would not indicate otherwise. Once the mould has properly dried, it is lined with cling wrap so that the plastic closely follows all the contours of the plaster. The pencil marks can then be redrawn on the cling wrap. An armature is laid into the mould. The mould's surface should be covered with Plasticine. For larger animals, such as a medium sized deer, a layer about 25 mm–30 mm thick is necessary. This initial layer of Plasticine has a burlap–plaster backing applied in the main section of the body, but not in the legs and neck. A strong post should be embedded into this reinforcement in the belly to serve as a central support for the whole cast when it is erected (Fig. 6.56). The squeeze cast must be completed by pushing Plasticine into the leg sections and embedding the flexible armature in each limb. At the pelvis and shoulders, the limb armatures should be solidly attached to the burlap–plaster reinforcement. The neck should be squeezed full of Plasticine also. The head must have a plaster core, too, and be well attached to the neck armature.

If the animal is small, about the size of a fox, or smaller, the entire mould could be filled with Plasticine, omitting the plaster cores in the body and

Fig. 6.56. Squeeze-casting. A. Mould's flange. B. Plasticine. C. Articulated centreboard. D. Adjustable centrepost. E. Foam core.

head. However, a timber core is still necessary to attach the central support-ing post and the armature for the neck, limbs and, perhaps, tail (in the case of macropods). The timber core could be articulated to allow some readjust-ing of the body once the squeeze cast has been completed.

Once all the pieces have been completed (filled with Plasticine), the mould should be joined by pressing the components together. Before the last piece is pressed into position, some plaster should be poured inside the cavity formed by the burlap–plaster reinforcement. If it is sloshed around inside after the mould has been closed, it should bond the halves together (with larger specimens, this is a job for three to four persons. The authors have also found it necessary to pour some molten Plasticine into the mould as the pieces are joined together. The molten material acts as an excellent "glue", fusing the pieces into one.

Smaller moulds can be handled in a different way (without a plaster core). The last piece to be joined to the rest of the mould (normally one of the large side sections) is cut into three or four slices (Fig. 6.57). These slices need to be placed in position one by one and the Plasticine is pressed in piece by piece until all slices are in position and the mould has been completely filled with Plasticine.

Fig. 6.57. One side of the mould is cut into pieces.

The most difficult part of the whole operation is the joining of the mould once the squeeze casting has been completed. The pieces must join neatly to ensure an accurate cast. If necessary, the pieces can be pressed together forcibly with large clamps or torniquets. While the mould, filled with Plasticine, is still in one piece, it should be erected on its central supporting post. If these squeeze casts are being made often, it pays to have a permanent stand made up into which the centre support will fit and be held in position by nuts and bolts. The mould should be positioned high enough above the stand to allow the legs enough room to be repositioned if required after demoulding.

The mould should now be carefully removed. The cling wrap can be peeled off the Plasticine. The indelible pencil marks will have rubbed from the cling wrap onto the Plasticine surface, and so will clearly mark where the muscles were. The cast should be an exact replica of the skinned carcass posed in a more-or-less lifelike way. Of course the model will be somewhat lopsided, or the position unnatural to some degree.

The legs can be repositioned slightly as the flexible armature will allow minor adjustments. The head and neck can be slightly turned, raised or lowered if a soft metal neck rod has been used. Asymmetry in the body can be corrected by carving some Plasticine from one side and building it up on the other. The pencil marks showing the exact location and shape of the muscles can be deepened by modelling, thus making the model more lifelike. When the cast is remodelled, measurements, sketches, and photographs taken of the freshly killed animal should be used as reference.

The entire model can be finished in the usual manner (making the surface perfectly smooth by modelling and flame polishing) and a final mould prepared. Either plaster and burlap or fibreglass/polyester should be used, in order to make a mannikin of a more permanent material than plasticine.

On larger mammals, such as a large antelope, or a red deer, this technique is best used in combination with Akeley's method (see above). The head and legs can be made using the squeeze cast method, but the body should be made with the conventional free sculpture process, using the bones and accurate measurements for guides.

The main advantage of the squeeze cast method is that it enables taxidermists to have the main masses of their model prepared by mechanical rather than artistic skill. The duplication of the animal's body is very accurate and the skeleton is not needed for the preparation of the model.

The technique described above can also be applied to parts of the body, without the need to make a whole body mould.

Making a slip cast

Another aid for the sculptor is the slip cast. These casts can be made of heads, parts of the body or the whole body. A slip cast, as its name indicates, is the reproduction of the unskinned body from which the hair has been "slipped" off or removed. A specimen from which a slip cast has been prepared is useless for further taxidermy work. However, a collection of slip casts of various species and age groups is extremely useful for study purposes and references for modelling (Fig. 6.58).

The hair can be removed from the animal by immersion in a solution of sodium sulphide and lime. The chemicals curl and swell the hair which soon starts to fall off in patches. With the help of a wooden blade or dull knife all skin surfaces can be scraped free of hair. The solution must not come in contact with the worker's skin. Rubber gloves, goggles and a rubber or plastic apron should be worn while working with the solution. After all the hair has been removed the body can be moulded with plaster, following the above methods (death mask or full body mould). A slip cast will record the fine detail of skin folds which are all lost when the specimen is skinned.

PRESERVING SKELETAL MATERIAL

Skeletal material from the specimen will be needed if an accurate model of its body is to be built. The process differs very little whether the skeletal material is to be saved for display purposes, or for the scientific collection. The techniques for the preparation of skeletal material is described in Volume 1, Chapter 10.

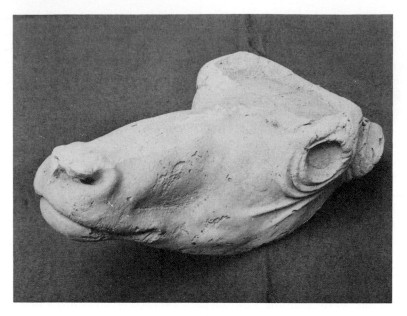

Fig. 6.58. A slip cast of a hairless pronghorn antelope head. Photo by A. Pitman. Courtesy of The Australian Museum.

PRESERVING THE SKIN

Before the skin of a mammal larger than a ferret can be turned into either a scientific or display specimen, it has to be tanned. It is possible to keep a skin from decaying in many ways, but the most efficient method is proper tanning, which ensures that it will stay in a good, stable condition for a very long time.

A fresh animal skin consists of three major layers (Fig. 6.59): the epidermis; the dermis (corium); and the apidose layer. The outermost layer is the epidermis. Its hard, flat cells are made up, mostly, of sulphur bearing protein (keratin). Since it is chemically inert, keratin remains unchanged throughout the tanning process.

The underlying layer, the dermis (corium), is the main subject of tanning. This layer is made up of a complex variety of components, but mainly collagen, soluble and insoluble proteins, elastin, and fats. The roots of the hair are embedded in this layer; it is rich in blood vessels. Collagen, the main component, forms large bundles of fibre. The consistency of these gives the skin of a particular species its character. The fibre structure also varies in different parts of the skin; where the fibres are tightly woven the skin is tight and stretchable (for example, on the butt). Where the pattern is more random

Fig. 6.59. Cross cut section of mammalian skin. A. Epidermis. B. Dermis (Corium). C. Apidose layer. Drawing by G. Hangay.

and loosely woven, the skin is more elastic (for example, in the crotch section). It is what happens to these fibres during tanning which gives the final result.

The apidose layer is mostly fat and some flesh. It has no bearing on the tanning process, except that it must be removed (with part of the dermis) before tanning begins. The fresh skin is made up of the following components: 60%–70% water by weight; 30%–35% proteins; 2% fats; 0.5% carbohydrates; 1% mineral salts; and 0.5%–1% miscellaneous (pigments and so on). Most of the solid matter (90%–95%) is protein found in the dermis in the form of collagen. The main aim of tanning is to introduce chemicals to the skin which will form a stable and permanent bond with the fibres of collagen.

Most other proteins, such as the soluble albumins, globulins, mucins and glycoproteins which form approximately 5%–10% of the solid matters in the skin, are removed during the tanning process.

The natural fat, which can be present in much higher proportions than indicated above, is generally found in the apidose layer, but it can be integrated in the fibrous structure of the dermis. Fat cannot be preserved properly by tanning. All natural fat must be removed from the skin, first by physical, and then by chemical, means.

Proteins begin to decompose immediately after death. Soluble proteins decompose very rapidly. Since they are present around the hair, follicles are rich with them. This is where the first sign of deterioration occurs. The body heat of the freshly killed animal assists bacteria growth and, under warm climatic conditions, patches of the epidermis, together with the hair, come loose. This is called 'slipping' (see slip cast, above); it is a process which can be halted, but certainly not reversed. A skin which is missing large patches of epidermis is not a desirable specimen for either scientific or display purposes. However, the prevention of hair slip is not the only aim of the preparator. The skin, after proper preparatorial work, which is tanning in this regard, should retain its natural appearance, be decay free, chemically stable and insect-proofed. In addition, the hair should retain its original colour, lustre and fluffiness. The specimen should have retained its original shape and size. Where a specimen has been designated for lifelike taxidermy, it must have even more good characteristics, such as suppleness, or even thickness and stretchiness.

In order to achieve this, undesirable components must be removed from the fresh skin and the remaining fibres of the dermis should be bonded with chemicals as permanently as possible. The natural appearance, fluffiness, and lustre are achieved mostly by physical means (drumming, polishing, and so on). The retention of size, suppleness and stretch are the results of the artificial lubrication of the fibres with stable lubricants and physical action (drumming, staking and so on).

Bacterial decay must be arrested at a very early stage of the tanning procedure by chemical treatment. Deterioration of the skin by chemical action (acid) can be prevented by employing properly formulated compounds. Also, the permanent bonding of chemicals to the proteins of the skin and hair can provide protection against insects.

Fur dressing

The manufacture of leather is an aspect of tanning of no relevance here. However, the other main objective in tanning is fur dressing, or the tanning of skins with the hair on. In this publication, fur and hair and tanning and dressing will be used as synonyms.

Regardless of the huge variety of agents which are used in the many different kinds of fur dressing formulae, the basic steps are always the same. In museum work, skins should be tanned in such a manner that, even if they are meant to be scientific specimens, they could be mounted at a later date. Scientific specimens do not have to look lifelike, but the skin must be complete, stable and supple, and, thus, suitable for display taxidermy.

The basic steps in fur dressing are: salt; soak; scour; pickle; shave; tan; oil; stake; and finish.

Salting: Salting, described earlier, is part of field preparation, and the best method of preserving most skins if they are to be tanned. The salt removes a great deal of moisture from the skin. However, if too much time elapses between skinning and the beginning of the tanning procedure, the skin will harden considerably. Hardened, stiff skins have to be soaked in order to render them pliable and, therefore, more workable.

Soaking: Soaking should be done in a bath (a float) of water, disinfectant and wetting agent. The purpose is to rehydrate the skin; therefore the skin should remain in the bath only until it softens up. The disinfectant will keep harmful microorganisms at bay and prevent decay, but only to a certain degree. The skin must not remain in the bath for too long. It is not formulated for storage. Hair slip will occur after a prolonged period. The wetting agent assists in the opening up of the fibre structure of the skin, permitting the water to enter easier and quicker. There are excellent wetting agents on the market, designed for industry, but ordinary liquid soap can also be used. Small amounts of carbolic acid can also be added as it will act as a disinfectant and wetting agent at the same time. If there is too much salt in the soaking bath it will retard rehydration. If the skin has been properly salted, it can be successfully rehydrated if there is no added salt in the bath at all. Alcohol pickled skins can also be rehydrated very successfully in a bath consisting of water and carbolic acid only.

The skin should be agitated occasionally to speed up the rehydration. Large skins which have been folded prior to transportation should be opened up in the bath as soon as possible. They must not be forced open before they have softened a little, because they can crack along the folding line.

Nonmetallic containers should be used for all tanning work. The presence of salt and acids corrodes metal.

After soaking, the skin should be removed from the bath and squeezed dry. In well equipped tanneries, a centrifuge is used to drive the water out of the hair. In a small workshop, a washing machine can be used for the soaking and the machine's centrifuge (spinner) can be employed for driving the water out. Although many washing machines are made of metal, the enamel coating protects them against corrosion (at least for a while).

Once the water has been removed from the hair the skin must be weighed. The weight should be carefully recorded as it is used to calculate the amount of chemicals used in the following baths.

Scouring: Scouring (washing with water and liquid soap) removes all dirt and blood from the hair and washes some of the soluble proteins from the skin. Many species of mammals store large amounts of fat under their skin. The fat integrates the adipose layer and sometimes even the dermis. Most of the heavy layers of fat must be removed by chemical means. Commercially

available scouring agents normally include degreasers. These can be added to the scouring bath and, in most cases, will give good results. Skins with a very high fat content (those of many aquatic species or bears) need an additional bath with pure degreaser. After scouring, which removes most water soluble dirt, the fatty skins should be immersed in a degreasing bath. The bath could consist of a range of chemicals: Genklene, trichloroethylene, white spirit, benzine, gasoline, or even kerosene.

After the skin has been degreased, it has to be scoured again to remove the degreaser; otherwise this would upset the effect of chemicals used later in the tanning process. Plain water can be used for this scouring. If the skin is on the verge of hair slip, scouring should be done quickly. If it is in need of additional degreasing as well, as mentioned above, this should be done after pickling and shaving. Some skins (for example, kangaroos or deer) need no degreasing at all as they seldom contain excess fat. Skins of this nature still benefit from being scoured with proper scouring agents. If these agents are not available ordinary household detergent can be used.

Pickling: Pickling is the next step in the process. The purpose of pickling is to acidify the skin. Through the effect of the acid the collagen fibres loosen up and the skin becomes pliable. At the same time the fibres are prepared for bonding with the tanning chemicals, the introduction of which is the next step.

The acid is harmful to the skin if it is in high concentration in the pickle, or if there is not enough salt present. Too much acid "blows" the skin; this means that the fibres swell (acid swelling). This is an irreversible, disastrous effect and considered the greatest danger to the skin during the tanning process. To prevent this, the acid level of the pickle bath must be monitored very strictly.

Although the principles of the pH scale and the methods of checking pH levels are part of elementary chemistry it may be useful for the reader to have a condensed description of them at hand: In simple terms, pH measures the acidity or alkalinity of a solution upon a scale which starts with 0 and ends with 14. A solution with pH7 is neutral; pure water should have such a reading. Acid lowers pH, alkaline raises it. Each increment on the pH scale indicates a 10 times difference in acidity or alkalinity. A solution with pH 4 has 10 times the strength of a solution with pH 5.0. A solution with pH 3.0 has 100 times the strength of a solution with pH 5.0. The most practical and economic method of checking the pH level of a pickle bath or tanning solution is to use coarse range and short range reaction papers. The reaction paper contains dye which is sensitive to a specific pH value. In contact with the solution, the dye changes colour and can be compared with the colours of a standard colour chart designed for the purpose. Each colour on the chart

indicates a specific pH value. By using the coarse range paper first, an approximate pH value can be established. A short range paper can then be used to identify the exact pH level within the range indicated by the coarse range paper. Accuracy will depend on the quality of the short range paper, but for average work a tolerance level of plus or minus 0.5 is acceptable. The employment of a pH meter is recommended for more accurate measurement.

The pH level can be regulated by adding either acid or alkali. With regard to tanning, these are called buffers (in general chemistry the word has a slightly different application). It is important that only those buffers which are compatible with the rest of the pickling or tanning solution should be used. This means that if the acidity is to be raised in a solution which already contains an acid, quantities of the same acid should be added to achieve the desired strength.

As the skin itself has a particular pH level, the pH value of a solution can change slightly when the skin has been submerged in it; pH levels must be checked right through the process and adjusted as needed.

As mentioned above, acid swelling starts to occur at approximately pH 5.5. The skin gradually becomes rubbery and slimy to the touch. If the pH level of the pickling solution is below 3, the skin will have been ruined. Acid swelling is irreversible. The only practical safeguard against acid swelling is the presence of a sufficient amount of salt in the pickle or tanning solution. The minimum amount of salt is 60 grams per litre of water, but, using the rule of thumb, most formulae prescribe 100 grams per litre. Kish (1978) points out that, if a skin has to be taken from the pickle to a fresh scouring bath (this could arise if a skin on the verge of hair slip cannot be scoured properly before pickling), this must also contain the appropriate quantities of salt. The pickled skin, which will have absorbed acid in the pickle, will begin to swell immediately in the washing or degreasing bath unless a sufficient quantity of salt is present.

The mechanics of the pickle bath are simple. The scoured and degreased (if it was degreased) skin should be submerged in the solution. Occasional agitation will be necessary to enable the solution to reach every part of the skin. The solution must penetrate the entire thickness of the dermis. Progress can be checked by cutting the skin from the flesh side. The dermis should achieve an even, off white, opaque colour right through. If the colour is not even, the pickle has not penetrated the entire thickness.

Shaving: The skin should be shaved during or after the pickling. The flesh side will turn opaque, off white or pale grey after a few days in the pickle. It can then be taken out and the excess solution removed from the hair, either in a centrifuge or, simply, by hanging it up and letting it "drip dry". The flesh side must not dry out. Once the skin has stopped dripping, it must be placed

on a beam (Fig. 6.60A,B) and carved thin on the flesh side. This operation is called shaving and best performed by a special, two handled knife to remove the bulk of the corium.

Large wild boars, buffaloes, and so on wear out the fine, turned edge of the currier's knife; therefore, their hide first must be reduced with the more robust fleshing knife (Fig. 6.60,C,D,E). Once the skin has been thinned it can be shaved further with the currier's knife (Fig. 6.60,F) As the roots of the hair start to show from the flesh side, the shaving stops. The skin of the face must be shaved very finely. Animals with prominent whiskers (such as cats) represent some difficulties. The roots of the whiskers are embedded deep into the dermis, and, in some cases, into the adipose layers. They must not be cut through with the currier's knife because this will cause them to fall out, thus spoiling the specimen. The attached muscles must be carefully carved away with a surgical scalpel without harming the follicles. The remaining tissue can be ground off with a circular wire brush mounted on an electric grinder (this is attached to a bench top or pedestal). Animals with quills (such as African porcupine or the echidna) can also be fleshed successfully on the grinder.

Shaving can be done in stages, especially if the entire thickness of the dermis has not pickled. Once pickled areas have been shaved, the skin should be returned to the pickle. It is difficult to shave the raw skin. Shaving should continue as the pickle works its way through the skin. Also, shaving should proceed from tail to head. The skin can remain in the pickle until it is properly cured. However, if the pickling is prolonged, the pH level of the solution must be checked periodically. Some acids, (such as formic acid) evaporate, thus raising the pH level of the solution. Fungi and bacteria can also damage the skins if they are not checked. Carbolic acid can be added to control these.

Tanning: Tanning can be carried out using a variety of chemicals. These can be grouped in three basic categories: vegetable tans; minerals; and synthetic agents (syntans). These chemicals are applied to the skin in a water solution. The volume of water should be kept to a minimum in order not to disperse the active tanning ingredients to such a degree that it would reduce the opportunity to contract a bond with the proteins of the skin.

Vegetable tanning agents are not suitable for fur dressing (especially for museum purposes), as they tend to shrink and discolour the skins. Minerals, especially the salts of aluminium and chromium, are practical and easy to use tanning agents. Their effect is desirable for taxidermy purposes, especially if formalin is included in the process. Syntans are tanning agents for general use. They form a permanent and stable bond with the fibres of the skin. They are sold under various trade names. However, they are not favoured by museum preparators and taxidermists.

Once the skin has been properly pickled, it is ready to be neutralized slightly. Normally, sodium bicarbonate is used to raise the pH level of the

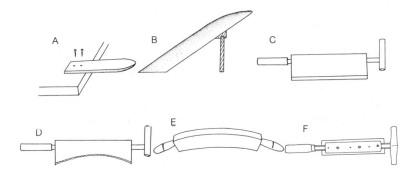

Fig. 6.60. A. A small bench top beam, suitable for fleshing small skins and the facial skin of larger animals. B. Side view of a large beam. C. Simple fleshing knife. D. Fleshing knife with a saw tooth edge. Suitable for removing large chunks of fat and flesh from big hides. E. Hollow ground fleshing knife, the best all-purpose design. F. Currier's knife with removable, turned edge blades. Used for shaving skins thin.

skin. Light skins, or those which have been thinly shaved, can be neutralized quickly by submersion in a neutralizing bath (40 L water, 500 g sodium bicarbonate) for one-and-a-half to two hours. Thicker skins should remain in the bath longer. If the skins are agitated, the neutralization is speeded up. The skin does not need to be neutralized literally (to pH 7), but the pH level should be raised to approximately 5.5 (equivalent to the natural pH of a fresh skin). Once this pH is reached, the skin should be thoroughly rinsed in fresh running water.

The tanning solution can be made up according to the formula recommended (there are thousands of tanning formulae), but certain points must be observed, no matter which system is followed. One of these is the pH factor. Every properly designed formula has an optimal pH level. This can be ascertained from the supplier or manufacturer of the particular tanning chemical. It is also important that the pH level is checked and adjusted once the skin has been placed in it. The buffering is carried out in the same way as described above for pickling.

The thickness of the skin, method of agitation, temperature of the solution and the nature of the tanning agents determine how long the skin must remain in the bath before it will be properly tanned.

After tanning, the pH level must be adjusted again to 4.5–5.0. A lower pH value means there will be too much acid in the skin. Most acids keep working, and so gradually "rot" the skin. Formic acid is an ideal chemical for tanning as it evaporates, thus "neutralizing" itself. Sulphuric acid is a very undesirable substance and, although it has been frequently recommended and used by tanners and taxidermists in the past, it must not be employed in museum work now.

The other substance which was once to be the all purpose preservative for tanners and taxidermists is alum (aluminium salts such as aluminium sulphate and potassium sulphate). Aluminium molecules do not form a stable bond with the collagen fibres in the dermis. The alum can be washed from the skin with water. Alum treated skin thus reverts to rawhide, and retains no properties of a tanned skin. The addition of aldehydes (such as formalin) can assist alum preservation greatly. The other great disadvantage of alum is that it is hygroscopic. This not only results in a damp skin on humid days, but also produces sulphuric acid through hydrolysis. This acid will eventually destroy the skin.

If the skin has been very thoroughly glued to a solid mannikin, the glue will hold it together for a long time, but not all tanned skins are glued to life size models of animals. In a scientific collection very few will be treated in this way. The skins of large mammals are usually tanned, then folded flat, and stored in that fashion. Sulphuric acid forming in alum tanned skins will destroy them. However, alum tanned skins can be saved from destruction by retanning them in a proper tanning formula.

Where a skin is suspected of being treated with alum it can be checked for acidity by the following method. A small section of the skin should be soaked in water. If it has not been rotted by the acid, it will not pull apart like wet paper. An incision should be made on the flesh side, deep enough to reach the epidermis, and a strip of pH reaction paper should be inserted into the cut. If the pH value of the skin is below 3.0, it contains too much acid; not much can be done to save it. If the pH level is between 4.0–3.0 retanning and sufficient neutralizing will perhaps save it from destruction.

At present, the best tanning agent is an aluminium chloride complex salt manufactured by BASF of Germany and available in many parts of the world (Luten F). A pale yellowish powder, it is soluble in lukewarm–warm water, then easily mixed with cold water. It is compatible with acids and salts and provides a very good, soft tan with plenty of "stretch" which is most desirable for taxidermists. The skins tanned with Luten F supposedly have an indefinite shelf life (this remains to be seen). It is a fact that Luten F has a stabilizing effect on the skin's structure and does not contain or produce sulphuric acid. Its water resistance is somewhat less than that of chrome tanning, but, if it is used with formalin, the resistance level is raised. Water resistance (not to be confused with waterproofing) is important for the taxidermist who has to keep tanned skins soaking while sculpting mannikins. Luten F is compatible with the various oils of the Lipoderm range, also manufactured by BASF.

Insectproofing can be considered as part of the tanning process. The method of treating bird skins with sulphonamide derivative Edolan U (Bayer) has been described in Volume 1 Chapter 5. The same technique can be applied to mammal skins also. Once the skin has been impregnated with the tanning

chemicals it is reasonably safe from insects. The epidermis and hair are not bonded by the chemicals; therefore they are more vulnerable to insect damage. Edolan U forms a permanent bond with the proteins of the epidermis and hair and therefore is an ideal agent to employ. It simply can be added to the last rinse or to the rinse water between the neutralizing and tanning processes.

Oiling: The next step in the tanning procedure is oiling. A good tanner's oil must be water soluble and must rinse free from the hair after the flesh side of the skin has been oiled. Most oils work best if the skin's pH level is between 4.0 and 7.0. They are applied hot, and either swabbed on the flesh side or by soaking the skin in a diluted solution. If no better oils are available, neatsfoot oil can be used.

Staking: Staking can be done by hand or machine. The purpose of this part of the procedure is to make the skin more pliable and soft. After the oiled skin has dried it feels stiff and semirigid. By working the skin between the hands, and pulling and stretching it, the fibres are loosened up again and the skin will soften. However, it is very physical work. Larger skins are best staked by two persons. Good results can be achieved by pulling the skin over the edge of a bench or the back of a chair. A special staking tool can be made from a metal disc cut in half and mounted on a pedestal (Fig. 6.61). It should be used as shown (Fig. 6.62). The physical work can be cut out if the skins are tumbled in a large drum partially filled with sawdust. The sawdust must be of light coloured hardwood.

Finishing: Finishing is not usually required with sawdust drummed skins, since the hardwood sawdust also polishes the hair. However, hand staked skins may need to be rubbed with a ball of old nylon stockings until the hair regains the lustre typical of the living animal. The flesh side should be lightly sanded to remove all uneven bits of skin, then sprinkled with talcum powder to give it a pleasant, smooth feel.

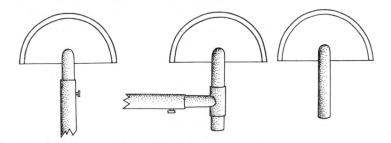

Fig. 6.61. Staking tool on various mountings.

Fig. 6.62. The method for using a staking tool.

Examples of tanning procedures

The quantities expressed in the following procedures are designed to be applied to 10 kilograms of raw skin.

Procedure 1: The soak consists of 100 L of water, 10 kg salt, and 500 g carbolic acid crystals. The skin should be agitated in this occasionally. When the skin has completely rehydrated and regained its original pliability it should be removed from the soak, drained and all flesh and fat cut from the flesh side. Do not try to shave the skin. The skin should now be washed in water (cold or lukewarm) with recommended amounts of detergent or scouring agent. When the hair is completely clean, rinse the skin in cold water. When submerged, the hair floats freely and appears "fluffy" if it is clean. If it clings in bunches and appears to be clogged, it is greasy and must be degreased. In this case, drain the skin, and submerse in the degreasing bath (25 L lukewarm water; 2 kg salt; 100 g liquid detergent [approximately]; 1 L kerosene). Agitate skins frequently for two hours then scour again in the same bath mixture as above. Rinse and drain, then submerse in the pickle bath (50 L water; 5 kg salt; 400 g formic acid). Agitate the skin at least twice a day. The skin should remain in the pickle until the dermis is evenly whitish and opaque. Remove the skin, drain and then shave evenly thin all over. Proceed from tail to head. Rinse in clear water, and drain. Submerse the skin in the neutralizing solution (40 L water; 500 g sodium bicarbonate). Leave the skin in the solution for approximately three hours, then rinse, drain, and immerse in the tanning solution (50 L water at 30° C; 5 kg salt; 150 g formalin; 100 g sodium

bicarbonate; and 250 g Lipoderm fur liquor). Leave the skin in the solution for approximately two hours. If the solution cannot be kept at a constant 30°C, the time should be extended proportionately. Agitate skins periodically. Remove the skin from the solution and add 600 g Luten F. Return the skin to the solution for 24 hours, and agitate periodically. Remove skins from solution, drain and neutralize if needed. Oiling can now proceed: one part Lipoderm fur liquor; one part hot water. Swab the liquid on the flesh side, let it soak in, then repeat. Fold the skin flesh side to flesh side for approximately 12 hours, then repeat. Hang the skin indoors, and let it dry naturally. Stake the skin when damp-dry, leave it for approximately 12 hours and break them again. If a sawdust drum is available, drum the skin while it is still soft and damp. Continue drumming until the skin is dry and soft. A skin to be used for taxidermy can be stored frozen without staking or tumbling. If the skin is to be used for lifelike taxidermy, finishing is not necessary at this stage. Skins prepared as flat skins are finished as described above. This method does not include insectproofing. However, Edolan U can be introduced to either the last rinse or the tanning solution. The tanning solution cannot be reused since the Luten F will be absorbed by the skins fibrous structure.

Procedure 2: The soaking, scouring, degreasing and pickling procedures are the same as in Procedure 1. After shaving, the skin is placed back into the pickle bath and the pH is buffered to 3.8–4.0 by adding 50 g–60 g sodium bicarbonate. Then add 600 g Luten F. Leave the skin in the bath for 24 hours, agitating periodically. Remove the skin, drain and rinse. Neutralize in 40 L water mixed with 500 g sodium bicarbonate. Oil, stake and finish as in Procedure I. This procedure is simpler than the first, but as formalin is not used, the finished skins are not water resistant. Flat skins (or study skins of smaller mammals) do not need this property. Therefore, this method can be easier and more practical for such skins.

Procedure 3: This method is based on the Chicago tanning process used by museum taxidermists in that city, and probably by many others all over the world. It is especially suitable for producing nice, soft leather with the fur on, and therefore is ideal for taxidermists. First, wash the freshly skinned hide in cold water. Then immerse in a solution of: 22.5 L water; 140 g carbolic acid; and 1125 g common salt. Leave the skin in the solution until it turns whitish. Flesh the skin as described above. Now, immerse it in the following solution: 18 L warm water; 1.8 kg salt; 100 g formic acid; and 50 g carbolic acid. Turn the skin three times on the first day, and twice each day for six days. Add 120 g Edolan U, leave the skin in the solution for one hour, then remove it and press out the surplus solution. Spread the skin on the floor and sponge it with: 10 L water; 28 g formic acid; and 84 g salt. Sprinkle the skin with

sawdust (flesh side) to hold the solution, then sponge it with more solution. Do not fold the skin for about six hours, but then fold it flesh side to flesh side and place it in a plastic bag for about 16 hours. Remove the skin from the bag, press out the solution, spread and sponge it with 4.5 L warm water mixed with 100 g sodium bicarbonate and allow it to cure for three–four hours. Rinse it in clear water, then press out solution and paint skin with one part sulphonated neatsfoot oil (or Lipoderm) mixed with one part hot water. Hang the skin up to let it dry. After three days, sponge it with 4.5 L water mixed with 28 g carbolic acid. Stake the skin as usual. Then place the skin in the fur drum and drum it with fine sawdust for two hours. Shave the flesh side of the skin with a currier's knife until it is very thin (proceeding from tail to head). Stake the skin again until it is the required softness.

There are many more tanning procedures, mostly invented for the manufacture of leather. Since the harmful effects of alum and sulphuric acid have been discovered, most museums turn to formulae based on Luten F.

Every preparator working with animal skins comes across many unexpected problems. The diversity of the mammal species often presents some seemingly insoluble puzzles for the taxidermist. In a museum which has seen many generations of preparators, the problems can be manifold. The various, often unrecorded, processes used create great difficulties. Therefore, it is essential to record every experiment, not only in the field of tanning, but also in general preparatorial work. These records can be studied later, and conservation of specimens, if needed, can be carried out in a more efficient and certain manner.

MAKING AN ARTIFICIAL BODY FOR A LARGE MAMMAL

Once all the information has been gathered from a dead animal, as well as from living individuals of the species, the work to recreate it all in artificial form can begin.

This process is an extremely difficult task, even for an accomplished sculptor. It is most important that a preparator undertaking such a task understands the whole nature of the work.

Taxidermy is an art form. Those who practice it on high levels possess more than just technical skills. A certain amount of talent, and a feel for three dimensional form, is absolutely necessary. Talent does not have to be on the level of Rodin or Michaelangelo, but it can be expanded with technical skill and by diligence. There is no scope for artistic licence in taxidermy. The taxidermist–sculptor must faithfully and honestly copy the reference information. The skin must fit the model. The dimensions and measurements recorded, and the shape, can be captured through the moulding of the carcass, and impressions gained through sketching and photography. All of

this can be recreated in the workshop. It is impossible to learn this work from a book and the authors have no intention of teaching the reader how to become a sculptor. However, the basic outlines of the sculpting procedure can be explained within the boundaries of this publication.

The sculpting method

According to American literature, the inventor of sculpted taxidermy is Carl E. Akeley. It is a statement of questionable validity since there is evidence that a number of German (and other European) taxidermists used sculpted hollow models to mount larger animals (for example, Karl Kusthard, Montegue Brown). However, Akeley's technique is best known today due to the numerous publications which describe it.

Akeley's technique

The essence of the technique is as follows: Once the specimen has been skinned and all records taken, the flesh is carved off the skeleton. The bones are dried (perhaps salted and dried) and retained, as they play an important part in the modelling.

The vertebral column (preferably with the rib cage attached) is placed on a sheet of plywood and arranged in a natural shape. The outlines of it are traced, in the same manner as contact drawings are made, on the plywood. Allowance needs to be made for the carved off flesh, viscera and so on, and the drawing corrected accordingly (Fig. 6.63). The drawing is reduced all around to allow for greater flexibility in modelling later on. The shape, called a centreboard, is cut out with a jigsaw, and a centre post is attached to it, which can later on be fastened to a flat base (Fig. 6.64). The base can be placed on a rotating sculptor's stand (turntable) or fitted with casters. It is best to make the centre post very strong to support the weight of the entire model, which can be very heavy once all the clay has been applied to it. This way there will be no dependence on the legs for support and they can be repositioned at will without risking the collapse of the model during sculpting.

Fig. 6.63. A. The fleshed torso and the drawing made of it. B. The modified drawing.

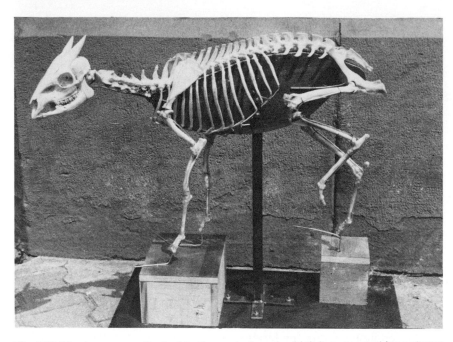

Fig. 6.64. The bones are attached to the centreboard, which is supported by a strong centre post. Photo by Dr R. Angst. Courtesy of the Landessammlungen für Naturkunde, Karlsruhe, Germany.

Next, the pelvic bone is attached to the plywood centreboard. The centreboard can be shaved a little and forced into the pelvis or the bone can be cut and attached to both sides of the board. The thickness of the board must be taken into consideration and the bone must be cut in such a way that the width of the pelvis is not altered. The pelvis is important in constructing the armature of the model as its width governs the correctness of the entire back section of the animal.

The bone may be attached to the board by wood screws or simply wired to it (Fig. 6.65). If the pelvis is not available, wooden blocks of an appropriate size and width (the measurements of the carcass should provide sufficient guidance) must be fastened in the correct location. The leg bones should be bound to heavy gauge wires, with sufficient lengths of wire protruding at the upper and lower ends of the legs. The upper ends are fastened to the pelvic and shoulder regions. If the pelvis is used, it is easy to locate the appropriate point where the hind legs join the rest of the armature (Fig. 6.64).

The position of the front legs should be determined by checking the measurements again. If necessary, wooden blocks can be used to space the heads of the humeri from the centreboard. Care should be taken to bind the

Fig. 6.65. A. Timber blocks attached to the centreboard may serve as sturdy supports and anchoring points for the leg rods. B. The leg rods may be fastened to the blocks by their threaded ends with nuts. C. Alternative fastening method for a lighter leg rod.

leg wires to the bones tightly and in such places where they will not interfere with the modelling. Although it is possible to model an animal without using the leg bones, their employment makes it more practical and easy. The bones, with their subtle bends and proportion, give much guidance to the sculptor.

The leg wires can be nailed or stapled to the centreboard. The bottom ends of the wires are not fastened to the base at this stage, thus allowing the legs to move back and forth freely.

Armatures: The cleaned skull will form a very accurate and practical armature for the head. The lower jaws should be wired or taped to the skull and two to three heavy gauge wires cemented into the skull cavity. The wires should be approximately twice the length of the neck and fastened in the cavity with either plaster or high density polyurethane foam. The lower ends of the neck wires are fastened to the centreboard either with staples or wire.

The above described technique is used to build the armature of mammals from the size of a fox to a medium sized domestic goat. For larger mammals, an armature of the torso is also necessary. This is built in strict accordance with the measurements and the armature is kept to a smaller size than that of the actual carcass. The armature of the torso can be made of wooden struts and hardware cloth, blocks of rigid foam carved to shape, and burlap dipped in plaster.

Armatures for smaller or larger animals need butterflies (Fig. 6.66). These are small pieces of timber tied in the shape of a cross and suspended in wires (Fig. 6.67). These are installed at areas where the sculptor anticipates the bulk application of clay. Clay, being pliant and heavy, tends to sag if applied in weighty quantities without any rigid support. The butterflies act as anchors and, since they are built in to the masses of clay, they support the weight. It is very frustrating when a nearly finished clay model (water-clay models are prone to do this) sheds large hunks of itself due to a lack of built in butterflies.

It is very important that the armature is built strong enough. Clay (either oil based modelling clay such as Plasticine, or water based potter's clay) can

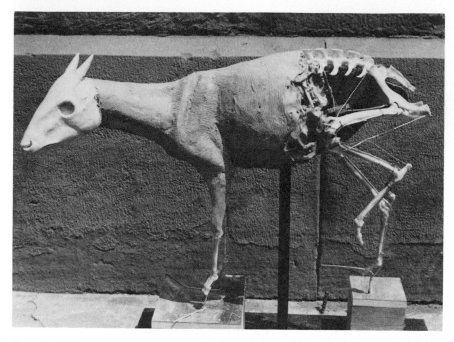

Fig. 6.66. Half completed model, showing a "butterfly" above the knee.

Fig. 6.67. A timber "butterfly".

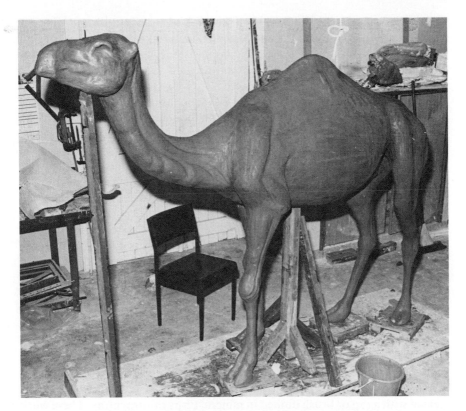

Fig. 6.68. A near finished clay model of a camel, prepared by Rolf Lossin and George Hangay. Photo by Gregory Millen. Courtesy of The Australian Museum.

be very heavy. A larger model can weigh a tonne or more and, if the armature is not constructed solidly enough (especially the centre post) disaster is the most likely result. The legs are best kept flexible, but still strong, in order to choose the final, most suitable position for them. Once this has been decided, the leg wires, or, in the case of large animals, the leg rods, can be fastened to the base. This will further strengthen the model. Sometimes it is necessary to install another supporting post under the neck. Animals with long, heavy necks and large heads (for example, a camel) most certainly require a prop under the neck or head (Fig. 6.68).

Clays: Although it is much more expensive than potter's clay, oil based modelling clay is a practical sculpting agent. It does not dry out, so the sculpting process can take any length of time. If water based clay is used, areas

which are not being worked on must be covered with a wet cloth and wrapped in plastic sheets to prevent drying. Still, this material also has advantages: it is easier to handle than oil based clay, its consistency can be regulated simply by adding water or letting it dry out a little, and water can be used for the final smoothing of the model's surface.

The clay is applied to the model as soon as the armature has been completed. Quantities of clay are worked on the armature in accordance with the data. It is often necessary to use a wooden mallet to pound the clay on the centreboard, and the thighs and buttocks section to ensure a good bond between timber, bones, the armature, and the clay. The butterflies must be firmly embedded in the clay. Measurements must be checked constantly during the building period. A good way to do this is to compare the shaping model with casts made of the carcass. Of course, the casts portray a dead body lacking muscle tone, blood pressure and, often, a lifelike stance. Copying a death cast does not result in a good model. The cast is simply a reference which gives the proper shape and measurements of a dead body. Talented sculptors use this information and add it to all the other recorded data to help them formulate a realistic impression of a living animal — the model itself.

Oil based clay can be manipulated to suit the sculptor. Plasticine can be softened with a heat lamp or in an oven on low temperature. It can be stiffened by placing it in a refrigerator or outdoors in the cold. The modelled surface can be flame polished with the use of a hand held gas torch moved swiftly across the surface. The flame melts the immediate surface and gives it a shiny smooth finish (see Volume 2, Chapter 12). The surface can also be treated with a rag or brush dipped in mineral turps or turpentine. These work as solvents. Brushmarks, small bumps and dimples can be rubbed from the surface with talc sprinkled on hands or fingers. The talc prevents sticking and allows the surface to be smoothed easily.

Water based clay can be finished, as mentioned earlier, with water. Containers of water clay must be closed or covered with wet rags to prevent drying out.

Trying on the skin: As the model is taking shape it is practical to fit the skin from time to time (Fig. 6.69). For this, the skin must be completely relaxed (wet) and free of sawdust. If it is not relaxed enough, it is very difficult to assess whether it fits the body or not. If it is full of sawdust (as it comes out of the sawdust drum) it will affect the surface of the model, making further modelling more difficult.

Often, the skin seems to be too small for the body. This can be caused by two things: either the skin is not relaxed enough, or the body is too big. Care must be taken to avoid this, especially at the legs and the neck. It is very easy to build the legs a little too heavy, and do the same at the neck; As well, the

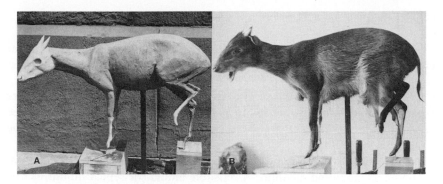

Fig. 6.69. A. An almost finished model (see Figs. 6.64, 6.66). B. The skin is tried on before the final details are modelled. Photos by Dr R. Angst. Courtesy of the Landessammlungen für Naturkunde, Karlsruhe, Germany.

skin tends to shrink in these sections more than anywhere else. Antelopes and deer always look better with heavy necks and many taxidermists like to cheat a little when modelling them.

Sometimes, the opposite can happen: the skin seems to be too big for the body. If the skeleton was used to build the armature this usually assures a correct body size, therefore the reason for this fault can lie in an unusual stretch of the skin. Some animals, for example, fat domestic dogs and wild pigs, can stretch a lot if the skin is shaved very thin. To remedy such an ill fit, the size of the body should not be increased. The skin can be tucked into wrinkles, and these will still look natural on the mount. In some extreme cases, especially when the specimen has long hair, sections of the skin can be cut out to make the skin fit. This should only be done when everything else has failed, as such action ruins the scientific value of the skin. However, it is up to the individual preparator or the institute to decide upon the importance of the specimen and establish which is more important — scientific value, or the appearance of the display specimen.

The final finish can be given to the model once the preparator is assured that the skin can be mounted on it successfully. Here again, recorded information is of paramount importance. The configuration of the surface veins, especially the facial veins, and external and internal saphena, should be modelled. A simple way of modelling veins is by half-embedding appropriate lengths of electrical conduits (or something similar; for example, smooth surfaced strings etc.) in the surface of the model, then smoothing them over with a little clay. Tapered ends can be modelled on with clay. The entire surface of the model can be smooth or embossed. The embossed effect can be achieved by working the surface with a serrated modelling tool or brush. A rough surface will ensure a better adhesion between mannikin and skin.

MOULDING THE MODEL

The completed model now has to be reproduced in a more permanent material than clay. First, a multipiece mould is made, then a cast is formed from that.

The mould is normally made of plaster of Paris or a polyester–glass fibre combination (commonly referred to as fibreglass). Plaster is cheaper and less harmful to the worker; fibreglass is more durable, and light, but may be dangerous to health.

It is advisable to make a reusable piece mould, regardless of which material is chosen as moulding medium. A reusable mould (or repeat mould) is one which can be used over and over again. It is constructed in such a way that the undercuts in the model are carefully sectioned and it is made in a sufficient number of pieces to prevent the undercuts locking the model in the mould.

First, the model is sectioned. A life size model of a four legged animal normally requires a five or six piece mould: a left and a right side piece, taken from the entire sides, including the head, body and legs, a piece (which is often cut into two pieces) taken from the inside of both legs; a similar piece (which also could be cut into two) of the inside of the back legs; and one piece from the root of the tail and the anal region. An additional piece is necessary if the cast is made of plaster or paper: a panel on one side to serve as an access entrance to the inside of the mould.

The division lines (Fig. 6.70) are marked on the model with a modelling tool or knife and metal shims are pressed in to form a fence. Instead of metal, celluloid film can also be used; this is a very handy material as it can be glued easily with a drop of acetone. It is important that the shims form an even, continuous line. If necessary, sticky tape can be used to hold the pieces together. On the lower legs, where the bones are close to the surface of the clay, it is impossible to sink shims into the model. Here, clay walls are used as dividers. The walls are made by rolling the clay into 30 mm–35 mm wide and 6 mm–8 mm thick "ribbons" of convenient lengths. These ribbons are placed on the dividing line. The clay falls from the legs unless it is stuck to them. This can be done with small lumps of clay and from the direction of the inside of the legs (since the outside is moulded first).

If plaster of Paris is used as a moulding medium, no release agent need be applied to the model. The plaster is applied in the regular manner (as described in Volume 1, Chapter 4) and, on the second and third coats burlap is incorporated to strengthen the mould (Fig. 6.71). Metal rods can also be incorporated to reinforce the legs. The other side is moulded in the same manner.

As both sides are completed, the clay dividers are peeled off from the insides of the legs. At these places, the exposed plaster surface is painted with

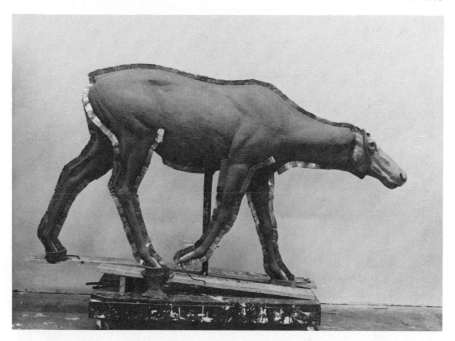

Fig. 6.70. Division of the model prior to moulding. Model and photo by J. Kish.

a release agent (oil, floor wax or clay slip) and more plaster is applied to the inside of the legs. Finally, the last piece is made by building up layers of plaster in the tail section.

After a sufficient setting period, the pieces are pried apart carefully and the model is demoulded (Fig. 6.72). The clay model is usually destroyed in the process. If oil based clay was used, it can be salvaged and reused if proper care is taken to avoid mixing plaster crumbs and other debris into it. If that happens and the dirt cannot be removed by simply picking it out of the clay, the clay can be heated until it melts, then strained through a fine wire mesh. However, the properties of the clay can change after such treatment. It is often necessary to add some oils or wax to the molten clay compound to restore its original characteristics.

Water clay is easier to recycle. Lumpy or dirty clay is placed in a large container and covered with water. This will turn the clay into a very thin, sloshy emulsion. The light debris floats to the top where it can be skimmed off and the thin, muddy clay scooped out and air dried until its consistency once again becomes suitable for modelling.

After demoulding, the mould must be cleaned of all crumbs of plaster, remnants of clay, shims, and so on, and the pieces put together again. It is

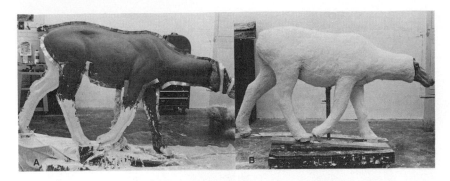

Fig. 6.71. A. Applying plaster to the model. B. The completed model. From the face a separate, rubber mould is made. Model and photo by J. Kish.

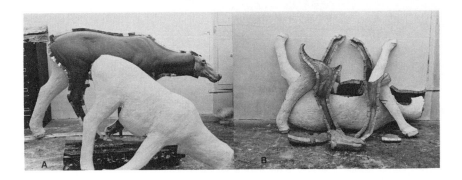

Fig. 6.72. A. The mould is removed piece by piece. B. The dismantled mould's inside surface is painted with shellac. Model and photo by J. Kish.

necessary to fasten the pieces together to prevent them warping. This can be done by tying them with wire or rope, which is tightened with a torniquet. It is best to use large G-clamps. To prevent fungus growth inside a damp plaster mould, a wad of cotton wool soaked in formalin or phenol solution should be placed inside before assembly.

A plaster mould of a large animal can be very weighty and may cause physical difficulties for the preparators working on it. It is best to use polyester resin and glass fibre cloth as moulding material on large models.

To make a fibreglass mould of a four legged animal model, the following procedure can be adopted: The model is divided into parts as described earlier and the entire surface, including the moulding fences or walls, should be covered with a release agent suitable for polyester. A thickened gel coat

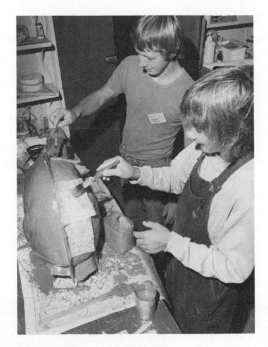

Fig. 6.73. Students prepare a fibreglass mould from a clay model of a wombat. Photo by John Field. Courtesy of The Australian Museum.

mixture can be prepared by mixing polyester resin with a filler (whiting, talc, or cotton fibre) and this is painted first on one side of the model, then on the other side. After the first coat has set, another layer can be painted on, using a similar mix. While the second layer is still tacky, pieces of chopped, strained mat are laid on it and quickly dabbed with unthickened, catalysed resin (Fig. 6.73). This is best done by two persons; one laying the mat, as the other immediately applies the resin. The mat must be thoroughly saturated with resin, and the preparators must make sure that there are no air bubbles captured between the mat and the gel coat. It is best to work continuously and cover the entire surface of both pieces, working the mats into the sharp edges where the fences were built. The mats have to come up on both sides of the fences, forming a flange all along the dividing line. If the mats project over the edge of the fence and join with the mats laminated on the other side, it does not matter. Seemingly this would bond both sides together, making separation impossible. However, when the mould is completed the edges are trimmed with a hacksaw back to the width of the fences. This assures an easy opening of the mould.

Normally two layers of material are laminated on the model, providing the appropriate thickness of cloth is used. If thinner cloth is used, three layers are applied.

After the two larger pieces (the sides) have been finished, the clay fences are removed from the legs and the exposed surface is painted with a release agent. The pieces are finished the same way as the others.

Once the resin has set all over the mould, holes are drilled into the flanges every 50 mm (Fig. 6.74). The edges are trimmed as mentioned above. A power jigsaw with a hacksaw blade is ideal for the work, although only a hand held hacksaw blade can be used in some tight corners. The purpose of the trimming is to ensure an even, neat edge, and that the sections where the mats are not separated by the fence are cut off. After trimming, the model can be demoulded. The clay can be salvaged as described above. The pieces of the mould should then be fastened together by short bolts and nuts through the holes drilled into the flanges (Fig. 6.74). This is a very neat way of holding the mould together.

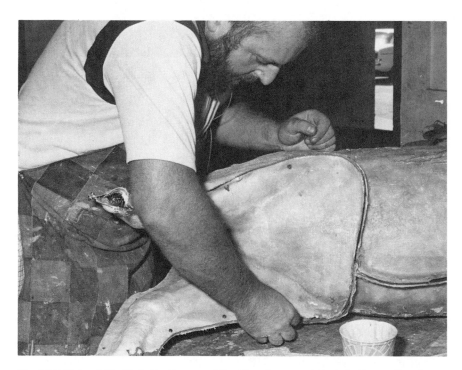

Fig. 6.74. Holes drilled into the flanges of the fibreglass mould help to line up the pieces. Bolts and nuts can be used to hold the pieces together. Photo by Heather McLennan. Courtesy of The Australian Museum.

Resin and fibreglass are unpleasant materials to work with, but the finished article compensates the preparator for all the trouble he/she experiences while making a fibreglass mould.

Moulding the face

Sometimes the face of a model is so intricate, and has so many undercuts, that it is impractical to prepare a two piece mould using rigid moulding materials such as plaster or polyester. The choice is either to fill these undercuts on the model and mould the head as described above and carve the filled in undercuts into the cast which is made from the mould, or section off this intricately modelled part and prepare a flexible mould of it. The flexible material can be rubber latex, silicone rubber or some other flexible moulding material.

The mould of the whole model is prepared in the above described manner except that the face is sectioned off (Fig. 6.75) and this part is not covered with the rigid moulding material (that is, plaster or resin). The face can then be painted with the flexible moulding material reinforced with cloth (Fig. 6.76A) and, finally, a rigid one or two piece (depending on the nature of the undercuts) jacket or mother mould can be prepared on top of it. The flexible moulding compound will fill all undercuts on the face and, perhaps, a one piece, cap like mother mould could be constructed on top which also can be removed in one piece when the model is demoulded (Fig. 6.76B).

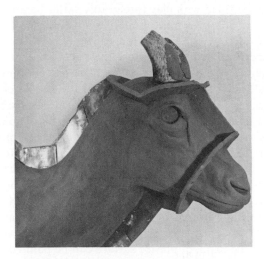

Fig. 6.75. The section of the face with the most undercuts is walled off with a clay ribbon. Model and photo by J. Kish.

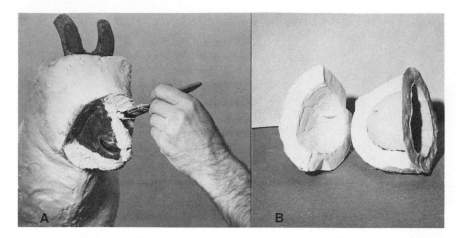

Fig. 6.76. A. After the plaster moulding of the body has been completed, rubber latex is applied to the face. B. After the rubber has cured, a plaster mother mould, or jacket, is made over it. This photograph shows the removed rubber mould and its two piece plaster jacket. Model and photo by J. Kish.

Earliners

The cartilages skinned from the ears have to be moulded in order to produce an artificial cartilage, called an earliner. The cartilage needs to be soaked in water until it regains its original flexibility and shape. The inside of the cartilage should be filled with clay (preferably water based clay). The shape may be altered a little to achieve a lifelike appearance. The ears are then placed on a bed of clay with the opening down (Fig. 6.77) and the edges of the cartilage are gently pressed against the clay. Four marbles should be pressed into the bed of clay, exactly half way, to serve as keys in the mould. A retaining wall must be constructed around the bed of clay. This can be made of timber, clay or even a strip of linoleum. Plaster and water should be mixed to the consistency of thick cream and a splash coat applied to the whole area within the retaining wall. As the first coat sets, more plaster must be laid on, and pieces of either burlap or sisal used as reinforcing material.

Once the plaster has hardened, the whole object should be turned over. The clay must be peeled away carefully without disturbing the cartilages. The marbles can be removed and the clay carefully scooped away from the cartilages. Some clay can remain in the butt section, thus allowing this area to retain its natural appearance. A retaining wall should be erected around the plaster; then the exposed plaster surface can be painted with oil. Plaster and water are mixed again and this side moulded in the same way as the first. After the plaster has hardened the two halves of the mould can be carefully pried open and the cartilages removed. The two halves, after being painted

Fig. 6.77. Ears prepared to be moulded.

with a small amount of diluted phenol, can be stored, clamped tightly together.

There are alternative methods of preparing ear moulds, some more complicated and perhaps providing better final results than the one described above. Kish (1978) gives a very good description of a moulding technique, as well as several alternatives for making the actual earliners from the mould.

The earliners can be made of a variety of materials using either or both of the moulds described above. For easy reference, we shall call the mould made over the back of the ear A, and the mould made over the inside of the ear B.

Before use, the moulds must be thoroughly dry. Once dry they should be painted with two layers of shellac (the first coat must be dry before the next one is painted on), and a release wax can then be painted on the dry shellac. After the wax has dried (and, if recommended by the manufacturer, has been polished with a rag), the preparation of an ear cast or earliner can begin.

If paper is to be the casting material, unsized paper of average card thickness no. 20 (100 gsm) weight (called rosin or building paper in the United States) is the best to use. The paper should be briefly soaked in a dextrin–flour paste and strips of it laid into the A mould. The strips should extend over the edges of the ear moulds. Then another three layers of paper strips can be laid in. More strips should be pasted in the midsection of the ear as reinforcement, and the overhanging edges folded and pasted in. No creases or lumps should show on the surface of the paper. These, if they occur, can be smoothed out by working paste over them with the fingers. The paper ear can be carefully removed from the mould, trimmed, and dried on a wire rack. After drying the earliners should be dipped in shellac or oil paint for waterproofing.

Sheet lead can also be used to make earliners. The perforated sheet is first cut to size, using the cartilage as a pattern. The edges should be tapered by gently beating with a small hammer and the shape trimmed again according to the cartilage. The shape is placed on the B mould and gently tapped with a small hammer until it follows all its contours. It is not worthwhile trying to duplicate the ear butts in lead, as the intricate shape is difficult to imitate in the sheet metal. The butts can be modelled during the mounting process, using modelling compound. Lead, being a heavy metal, is accumulative and can cause poisoning. Use barrier cream or surgical rubber gloves when working with it.

A very good earliner making material is Celastic. This industrial, cloth like material can be softened if saturated with acetone. Both A and B moulds, shellacked, but not waxed, are used to produce a Celastic earliner. Acetone will dissolve waxy compounds as well as shellac; therefore, the moulds must be lined with aluminium foil. A sheet of aluminium foil should be pressed into A mould, creasing it all around the edges. When the foil is removed, the crease will indicate the exact shape of the cartilage. The shapes are carefully cut out to be used as patterns which are traced on a sheet of Celastic (unsoaked).

The shapes are cut out of the Celastic and soaked in acetone until they become limp. The softened pieces are laid into the A mould and, before the acetone can evaporate, the B mould is clamped on it. Earliners for large ears need two to three, or even more, layers of Celastic. These must all be cut out in advance, soaked, and laid in the mould quickly. Acetone evaporates rapidly and, as soon as that happens, the celastic becomes stiff again. It is emphasized that the moulds must be clamped together before evaporation occurs. The acetone evaporates even from the closed moulds after time; then they can be opened and the earliners demoulded (Fig. 6.78). Celastic earliners should be waterproofed in shellac, as the material is not completely water resistant.

Ears are of great importance on a mounted animal; therefore, a great deal of time and care should be given to their reproduction.

Fig. 6.78. Earliners with formed ear butts.

CASTING THE MANNIKIN

The mannikin is made from the mould, and a number of materials and methods can be employed. The goal is to cast an exact replica of the model from which the mould was made. This cast is designated to accommodate the prepared skin of the animal. Therefore, it has to be made of a strong and stable material, and, in most cases it has to incorporate a metal armature.

Casting methods

Plaster: The cheapest and most accessible casting material is plaster. A plaster cast can be made from a plaster or fibreglass mould, providing the mould has no undercuts. As plaster is very rigid once it has set, a cast made of it should not come out of a mould with undercuts, which would lock the cast in the mould, and any forceful manipulation would lead to breakages. Undercuts in a mould can be eliminated by filling them with clay before casting. This, of course, causes loss of detail and accuracy in the cast, but, as an emergency measure, it still can serve a practical purpose. The lost detail can be remodelled on the cast itself once it has been demoulded.

In order to prepare a plaster cast from the mould of a four legged model, the inner surface of the mould must be thoroughly released. Olive oil or motor oil can be used, even on the surface of an untreated plaster mould.

Light weight burlap should then be cut to various sizes of squares and strips (for a mould of a medium sized antelope, ranging from 50 mm × 250 mm to 300 mm × 400 mm). Enough pieces have to be cut to enable the preparator to cover the entire surface of the mould three or four times. Once all these pieces have been cut, they can be piled next to the mould; a piece can now be cut for each piece of the mould large enough to cover the entire surface. One piece of the mould at a time, the large pieces of burlap are painted with a stiff body paste (see Formulae) on one side, then placed into the mould with the dry side to the moulding surface (Fig. 6.79). The cloth should be worked into the details of the mould, using a brush and fingers if necessary. It is important that the burlap is worked in very thoroughly, and no air bubbles captured between the cloth and the surface of the mould. The burlap should overhang at the sides at least 30 mm all round.

Next, a thin mix of plaster and water can be prepared. The strips of burlap can be dipped in it, but ensuring that the mixture saturates the weave. Excess plaster should be squeezed out before the piece of cloth is laid into the mould. The next piece, treated the same way, can be laid over the edge of the first, then the entire interior is covered from one end to the other (Fig. 6.80A). The plastered pieces of burlap should overhang a little at the edges. Two more layers of burlap should be plastered into the mould in the same way. All pieces of the mould must be treated the same way.

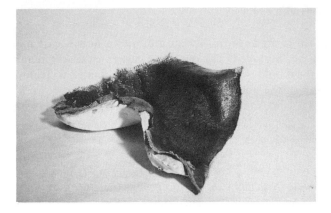

Fig. 6.79. Burlap and paste applied in the mould. Model and photo by J. Kish.

Once the plaster has set, the edges should be trimmed with a sharp knife. This must be done very neatly and accurately. The trimmed burlap must be flush with the rim of the mould (Fig. 6.80A). Now, the pieces can be put together. If the mould was prepared with keys, these can be used for guidance; if there are no keys, the pieces will have to be fitted together with a little more work and care (Fig. 6.80B). If the mould was made with a separately moulded access panel on one side, the pieces can be plastered together from the inside with more pieces of burlap dipped in plaster. If the mould lacks an access hole, the joining can be done through the rear before the tail section is placed in. Finally, a little plaster should be poured in and sloshed around the closed mould.

As the plaster sets, it heats up, then it cools. Once the cast is cold again, it can be demoulded. The body paste is still wet at this time, which makes demoulding easy. However, care should be taken to avoid handling the cast too roughly, as the first layer of burlap can easily delaminate from the rest. If the body paste has been applied too thickly it will now form a soft, malleable layer under the burlap (Fig. 6.81A). This must not be disturbed, but any imperfections should be corrected immediately. The cast should then be put on a stand with the legs positioned in the correct points to prevent warping. Another coat of body paste should be painted on the entire surface of the cast. Once the cast is thoroughly dry, it can be painted with three coats of shellac or oil paint (Fig. 6.81B).

An alternative to the above method is not to fit the tail section to the mould at all; a cast of it can be prepared and demoulded separately. The rest of the cast should be demoulded and set up on the stand as described above. The whole of the rear section then serves as an access entrance. An electric light can be placed inside the mould, the heat of which will speed up drying. A wad

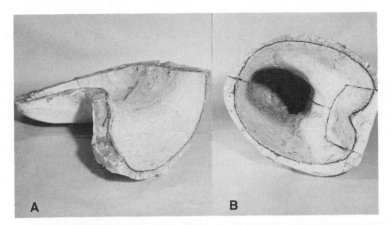

Fig. 6.80. A. Plaster applied to the burlap and after setting the cast is trimmed flush with the edges of the mould. B. The pieces are fitted together. Small pieces of burlap and plaster are applied to the seams to join the pieces. Model and photos by J. Kish.

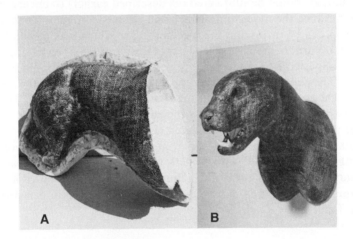

Fig. 6.81. A. The cast is demoulded. B. The finished cast with artificial jaws installed. Model and photos by J. Kish.

of cotton wool soaked in formalin should be placed inside the case to prevent fungus growth. After sufficient drying, the tail piece section can be glued in position. The mannikin should be shellacked as described above.

Paper: Another frequently used casting material is paper. Red rosin paper, construction paper or building paper are the common trade names for the paper used in the United States and Canada. This paper is not readily

available in many other countries; however, in most places a similar cheap, unsized paper is available. It will have a weight range of 100 gsm to 150 gsm (no. 20 or no. 30). It is possible to use thinner or thicker paper, but for best results paper of 100 gsm weight is the most suitable. The results for small mannikins are better if lighter paper is used. However, thicker paper can be made pliable enough even for small moulds if suitably moistened. If the moistening agent (water, or the paste described below) is hot, the required limpness of the paper can be achieved more quickly.

The paper should be torn into approximately 30 mm = 30 mm pieces; enough to cover the entire moulding surfaces seven or eight times. It is better to have more than enough paper torn to finish the job than not enough, or it will be necessary to stop the procedure half way to prepare more paper. If too much paper is torn, it can be stored and used at a later date.

The pieces of paper should be stacked on the work bench. First, one piece is painted with body paste (*see* Formulae), then another piece is laid on top of it. This piece is also painted with the paste, and the procedure is repeated until all the paper has been pasted.

The mould should be lubricated (as described earlier) to ensure sufficient release between the moulding surface and the pasted paper. Then, a 50 mm wide strip can be torn from the piece of paper which was pasted first (it is practical to turn the stack of pasted paper upside down, thus having the piece which was pasted first on top). This strip is laid into the mould, starting at its edge. The paper should extend approximately 25 mm over the edge of the mould. The next piece is laid on the first, slightly overlapping. The section of the paper which is overhanging the edge of the mould should be torn at regular points to allow better flanging (Fig. 6.82). The entire surface of the mould should be covered with paper, and the pieces should be worked into the details of the mould with fingers and brush, using more paste where necessary. However, the use of too much paste must be avoided as it makes the paper too soggy, and demoulding of the wet mannikin can prove to be very difficult.

Fig. 6.82. Pieces of paper are laid in the mould.

Once the first layer has been put down, another layer should be pasted in a similar manner. A small batch of plaster should be mixed, and smeared all over the second layer of paper. The strips now torn from the pasted paper should be wider than the ones used in the first two layers in the mould. These strips are pasted into the mould on top of the layer of plaster. Another layer of plaster is added, followed by another layer of paper.

The layers of paper should be pressed into the mould as firmly as possible to avoid pockets of paste and plaster forming. These not only make the skin too soft and soggy but also create problems in the finished product. Such spots dry "hollow", causing the paper to warp or "drum", or they form crumbly lumps between the layers.

Six to seven layers of 150 gsm (no. 30) paper should provide a strong enough mannikin. Once all the paper has been pasted in the mould, the edges are folded back into it. All pieces of the mould are worked the same way.

If the mannikin is to be fitted with horns, a piece of timber should be set into the skull section with strips of pasted paper. Later, this will serve to accommodate the screws holding the skull plate, with horns attached (Fig. 6.83).

Rods with threaded ends should be fitted into each leg. The rods reinforce the usually thin, and therefore weak, legs and the threaded ends which protrude at the phalanges serve as firm fixings when the mannikin is bolted to the base. The rods are pasted into the mannikin with strips of burlap soaked in plaster. The tail wire is pasted in in the same way.

Animals which typically support themselves on their tails (for example, kangaroos) need strong rods in the tail section as well.

Mannikins made for large animals (over the size of large antelopes) need metal or timber struts in the body. A method for attaching legs to the mannikin, using a "roman joint", to facilitate placing a skin prepared according to Akeley's method is shown in Fig. 6.84.

Finally, the pieces of the mould can be joined. The pieces must fit perfectly. If a perfect fit is not achieved, the edges of the paper must either be trimmed

Fig. 6.83. A piece timber pasted into the head of a mannikin. Antlers or horns are attached to the timber prior to mounting.

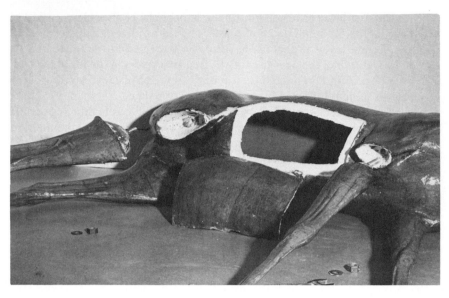

Fig. 6.84. The demoulded paper and plaster cast, showing a large service hole. Note the Roman joints of the legs. Model and photo by J. Kish.

or refolded further into the mould until they are not preventing the closure of the mould. Through the side panel of the access hole or the tail section, the pieces should be jointed together with strips of pasted paper or burlap and plaster. The latter is more practical, as it sets quicker. Once the pieces have been securely fastened together, the mannikin can be carefully demoulded and set on its base.

All imperfections can be corrected now on the still wet mannikin. Where pieces of paper have become loose during demoulding they can be pasted back and the whole surface painted with a thin coat of paste. The mannikin is now ready to be dried. Natural drying in a well ventilated room is the best method, as too rapid drying can cause shrinkage and warping (Fig. 6.85).

There are many variations on the above technique. Some of the variations are minor, invented to suit available materials or speed up the process in commercial taxidermy.

One particularly useful variation practised in the Denver Museum of Natural History (and presumably in many other places) combines the use of paper and burlap. Initially, the mannikin is made in paper, but once three or four layers have been applied it is backed with layers of burlap and plaster. This makes a strong mannikin which is relatively easy to remove from the mould. The plaster sets more quickly than the paste and, while the hard interior of the mannikin prevents sagging, the still moist paper surface is

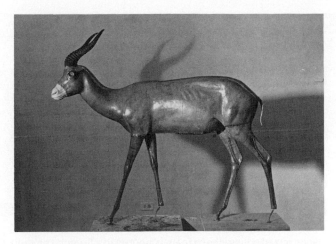

Fig. 6.85. A finished mannikin. Model and photo by J. Kish.

pliable enough to come out of the mould without any major difficulties. The thoroughly dry mannikin is shellacked in the same position as those made of burlap and plaster.

Foam: Another excellent mannikin making material is rigid polyurethane foam. Polyurethane foam vigorously expands during the foaming process. In using it, it is advisable to use fibreglass moulds which are strongly made and can be held together by bolts and clamps. Plaster moulds can also be used, but they, especially the larger ones, are difficult to tie or clamp together strongly enough to withstand the expanding foam's pressure.

The mould surfaces are released with a suitable release agent (recommended for polyurethane foam), and metal rods, tail wire and head block (if required) are placed in the mould. To prevent accidental shifting of the rods or wires, it is best to tie them together (with wire) in such a way that they keep their required position. The mould is then closed, leaving the tail section off to be used as a pouring hole (Fig. 6.86). Moulds designed for polyurethane foam could have a specially made pouring hole.

The measured foam is mixed in two or three batches, then poured in the mould. It is best to wait until the first batch has foamed, then pour the next one on top while the first batch is still flexible. This way, the bond between batches is perfect. Once the head and torso are full, the legs can be poured through the small openings of the feet.

Polyurethane foam is formulated in varying density and flexibility. While the bulk of the body can be poured of 64 kg m^{-3} dense foam, the legs should be made of 96 kg m^{-3} density foam. Small mannikins (or at least the legs) can

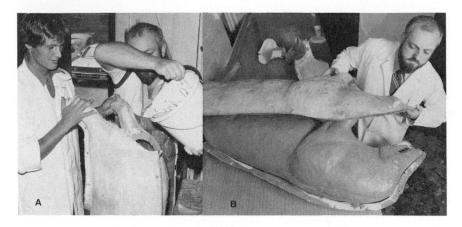

Fig. 6.86. A. Hand mixed polyurethane foam is poured in a fibreglass mould. B. The cast is demoulded. Photo John Field. Courtesy of The Australian Museum.

Fig. 6.87. Zebra group mounted on sculpted mannikins. Courtesy of the Naturhistorisk Museum, Arhus, Denmark.

be made of flexible foam, and this is usually so of commercially made small mammal mannikins. These are very practical as the flexible material can be manipulated to give the mount the required pose.

Here, again, a number of variations have been invented to counteract various shortcomings in the moulds, the quality of the foam, and methods of production.

In some cases, the moulding surfaces are lined with pasted paper, metal fittings are positioned and the mould assembled, then a low density (therefore, cheaper) foam is poured in. This technique provides a light and reasonably cheap mannikin which has a good, strong surface, and releases from the mould without any difficulty.

Commercially made mannikins are made under proper factory conditions using aluminium moulds which can be preheated to assure an optimal temperature. The foam is dispersed from elaborate equipment, out of the reach of most museums. Fig. 6.87 shows the results which can be finally achieved.

Mounting with the mouth open

If the animal is to be mounted with mouth open, and the teeth, tongue and interior of the mouth clearly visible, the procedure is as follows:

The skull is macerated in any of the methods described earlier. The teeth are removed and cleaned, but not bleached. The larger canines or tusks, which are often hollow, or at least partially hollow, are filled with epoxy to prevent future cracking, then all the teeth are glued back into the jaws with epoxy. The jaws are cut on a bandsaw, or by hand with a bone saw, as shown in Fig. 6.88. The bones are set into the head of the mannikin with epoxy putty or some similar material. Ensure that the jaws are set in the correct angle and depth; otherwise the skin will not fit properly on the mannikin, and the mouth will not look natural.

Fig. 6.88. A bandsaw is used to cut the skull in the places indicated.

Gaps between the material of the mannikin and the bones are filled with modelling compound and, if necessary, the lips are remodelled. The interior of the mouth is modelled with modelling compound. The throat and the roof of the mouth are formed from modelling compound, using modelling tools. Epoxy putty (*see* Formulae) is ideal for this work since it sets in a few hours, does not shrink, and can be smoothed with water. A small paintbrush dipped in water can be used to finish the surface of the mouth's interior.

The tongue can be modelled from the same compound, and inserted in the mouth while still wet. The final finish can be modelled with modelling tools and a fine wet brush. Once the putty has set the colours can be airbrushed on. A high gloss top coat on the entire surface of the interior gives a "wet look" to the specimen.

Commercially made plastic dentures with modelled gums and roof of the mouth, as well as flexible tongues, are available from taxidermist suppliers in many countries.

Making a replica of the jaws

If the specimen's skull is to be retained for the study collection, and is not to be used on the mounted specimen, a plastic replica can be made of it. The gums, the roof of the mouth, and the tongue, are modelled into the skull, using an oil based modelling clay (Plasticine). The modelling is done in two sections, the lower jaw being separated from the skull. A silicone rubber mould is taken from each piece, and, from these moulds, epoxy casts are made. The casts are installed and finished as described above.

Making the tail

The tail wire should be wrapped with cotton wool or fine excelsior to build up the thickness of the tail. It is finally wrapped with thread until it tapers smoothly (Fig. 6.89).

Modelling the face

If the initial model of the mannikin was not sculpted in every detail of the face (to eliminate moulding problems of the undercuts), these details should be modelled now with modelling compound. The nostrils must be deepened and the mouth slot will need to be cut into the mannikin. This slot is important as it is designed to hold the tucked in edges of the lips. Once the additional modelling has been completed the mannikin must be set aside to dry. After drying, the freshly modelled section should be waterproofed with two or three coats of shellac or oil paint.

Fig. 6.89. Wood wool is wrapped on wire to form the tail. Courtesy of the Naturhistorisk Museum Arhus, Denmark.

PRESS PLATES

Once the mannikin has been completed the press plates can be made. These are used to hold the skin tight against certain parts of the mannikin during the mounting process. The drying skin tends to drum across depressions and, to prevent this, the taxidermist has to use small nails, pins and glue as well as the press plates.

Press plates are used usually on the hocks of short haired animals, and sometimes on the face of large, short haired antelopes and so on where the facial veins are prominent.

To make a press plate, the part of the mannikin to be plated is painted with oil. One piece of burlap should be cut to act as a template; three or four pieces should be cut using the template. The burlap can now be dipped in a thin mix of plaster, then placed on the mannikin. The other pieces should be laminated on top of it once they have been dipped in plaster. Once the plaster has set, the press plate is removed and the surface of the mannikin cleaned. If some time is to elapse before the actual mounting of the specimen, the press plate should be clamped back on the mannikin and left to dry there. If the mannikin is to be mounted right away, the press plate can dry naturally in a well ventilated place.

Once the specimen has been mounted, and before the skin dries, the press plate should be placed in position, and held with a few nonrusting nails. If press plates are prepared from both sides of the hocks, they can be clamped on.

PREPARING THE SKIN FOR MOUNTING

The preserved (tanned or pickled) skin now has to be prepared for the actual work of taxidermy work (referred to here as mounting).

If the skin was pickled (either in alcohol or in any of the pickle solutions described earlier), it should be kept wet or frozen until the beginning of the mounting.

Tanned skins are much easier to work with if they are mounted before they have dried. The tanned, finished, but not completely dried, skins can be kept without risk for a long time if they have been frozen, or, at least, refrigerated. Dry, tanned skins, such as flat study skins or skins for the garment industry, must be wetted before mounting. The wetting can be done in different ways. The simplest and most practical methods are as follows:

Wetting dry skins

The entire surface of the flesh side can be wiped with a rag soaked in relaxing solution (*see* Formulae). This process should be repeated until the skin is thoroughly wet, then the skin can be rolled up and placed in a plastic bag until it has completely relaxed. It should be checked every few hours and, if necessary, worked over on the fleshing beam with a blunt or wooden knife, then wet again. If the skin has been fleshed, shaved and tanned properly, it should soften quickly (within hours) and its flexibility ("stretch") should be restored.

Very dry skins which have not been oiled properly and were not staked before drying can be immersed in the relaxing solution. This can only be done if the skin was tanned with a proper tanning technique and no natural fat or acid remains in it. Otherwise rapid deterioration may result.

Skins which have been preserved and stored in alcohol should also be soaked in the relaxing solution until they have rehydrated.

After soaking, skins have to be oiled again. Oils used in tanning are water soluble and the relaxing solution washes them out. After reoiling, the skins can be briefly drummed in the sawdust drum, or, if no drum is available, the flesh side can be rubbed with sawdust to pick up surplus oil and moisture. Ideally, before mounting, the skin should have dry hair while the flesh side should be dry to the touch, but wet, and therefore soft and "stretchy" in its tissues. If no sawdust drum is available, smaller furs can be fluffed with compressed air or even with a hand held hair dryer.

Repairing the skin

All tears and holes should be stitched up now. Even small holes must be mended properly. Bald patches where hair slip has occurred, if not too big,

Fig. 6.90. Simple method of mending a small hole (A — hole in skin; B — cut along dotted line and stitch edges together). Drawing by G. Hangay.

Fig. 6.91. Larger holes are mended with this method (A — hole in skin; B — cut along dotted line; C — throw away damaged section and slide triangle to the left. Join edges; D — stitch edges together). Drawing by G. Hangay.

can be cut out of the skin and the edges of the holes brought together and sewn up.

A very small hole can be stitched with two or three stitches. If the hole is a little larger (10 mm–20 mm diameter) and has irregular edges which cannot be sewn together neatly, it should be cut a little larger. The cut out section resembles a "boat" shape (Fig. 6.90). The edges of a hole cut to this shape can be sewn together neatly.

Larger holes can be mended with the square and triangle or the triangular tongue method (Fig. 6.91). If the skin has been tanned and oiled properly, these alternations should not reduce its size so that a little stretching will not compensate. Needless to say, the shorter the hair on the specimen, the smaller and neater the stitching must be.

If the skin is a flat skin, the ventral incision can be sewn up, and the incision on the legs can also be stitched partially, leaving the sections below the metacarpus open. A dorsal incision can now be made. The incision on the tail can also be sewn now.

Sewing some of the incisions prior to mounting is an alternative sometimes employed by taxidermists who prefer to mount skins which were skinned through a dorsal incision. Trying to sew the incisions of a flat skin when it has been mounted on the mannikin is difficult; it is often more practical to use the method described above.

Inserting the earliners

The earliners are inserted next. While this is being done, the rest of the skin should be placed in a plastic bag, so that only the head skin is left free. The thin skin of the ears tends to dry more quickly; therefore, it is sometimes necessary to keep it moist with a little relaxing solution.

The prepared liners should be fitted into the ear skins so that they fill the interior perfectly. Unless the earliner is an absolute copy of the ear cartilage, it has to be trimmed to fit. If the earliner is a little too big, the ear skin will drum across it; the earliner should be trimmed a little. Often, it is very difficult to achieve a perfect fit at the point of the ear. It is possible to overcome this difficulty by placing a small amount of modelling compound (epoxy putty is excellent for this application) into the tip of the ear, then pushing in the earliner. The amount of compound must be small, and it has to be squeezed flat once in the skin to avoid a lumpy, unnatural look.

Once the earliner has been trimmed to fit, it should be coated with paste (epoxy can be used very successfully here) before the final insertion. The paste or epoxy helps the earliner to slide in easily, and adheres the ear skin to the earliner during the drying period.

The ear butts are then filled with modelling compound (*see* Formulae) and their shape formed from the outside. Final shaping is carried out later when the skin has been mounted on the mannikin.

SETTING THE EYES

There are two methods for setting the eyes. The first method is as follows:

Method 1

The eyes are set in the mannikin's eye sockets prior to mounting of the skin. A modelling compound is made of body paste (*see* Formulae), dry, powdered potter's clay, and cotton flock, or dry, powdered paper. The dry ingredients are added in even parts to the body paste until they form a stiff compound which is no longer sticky to the touch. A small amount can be placed in the

eye sockets, into which the glass eyes are then pushed. The angle and the depth of the eyes must be checked against the measurements and sketches of the animal. The death masks are of invaluable help at this stage of the work. Using the death mask as reference, the eye surrounds can be modelled using the compound mentioned above. If the mannikin has been fitted with horns, and the upper section of the eye orbit was not reproduced originally, it has to be modelled now. The brow should be built up from the same modelling compound. The freshly modelled section must dry for 12 hours before being shellacked, and having the skin mounted on it.

Method 2

The second method of setting the eyes is somewhat simpler, but requires more experience for its successful execution. The eye sockets are filled with modelling compound, and the surrounding area and brow, if necessary, are covered with the necessary amount of compound. However, the modelling is not completed. Once the skin has been mounted on the mannikin the eyes should be fitted and the fine detail modelled through the skin. Where the skin has been pressed in to form wrinkles and folds (for example, tear ducts) fine pins must be used to hold it in position. Epoxy putty (*see* Formulae) is especially useful for this work as it sets hard before the skin is completely dry. The hardened compound, which also adheres to the moist skin, holds the skin securely. The advantage of this method is that the worker can see the final result immediately. However, the mount must be observed closely for the next few days and any distortion due to drying must be corrected immediately.

MOUNTING THE FEET

A small amount of stiff modelling compound should be pressed into the skin of the toes. This filling helps to form the feet correctly as the skin is sewn on the mannikin. Any excess filling can be squeezed out while the incisions of the feet are being served.

MOUNTING THE SKIN ON THE MANNIKIN

The first step in mounting is to coat the mannikin with body paste (*see* Formulae). The skin, which must be moist on the flesh side but dry to the touch, is then slipped over the mannikin. The edges of the skin are worked together, the wrinkles smoothed out and, once the skin lies naturally everywhere on the mannikin, the skin can be tacked at a few spots. The whole mount should be wrapped in a sheet of plastic to prevent it drying. It can be taken off the base and placed on a table or a specially constructed sewing stand (Fig. 6.92).

Fig. 6.92. A sewing stretcher or stand. Drawing by G. Hangay.

The best method is to start sewing the legs first, then the ventral or dorsal incision, and finally the back of the neck and head (in the case of horned animals) (Fig. 6.93). As soon as practicable, the mount should be placed back on its stand and sewing finished in this position.

Detailing the lips and nose

Once the incisions are sewn up, the head can be unwrapped from the plastic and the details of the face finished. Using a blunt knife as a modelling tool, the skin of the lips can be tucked into the mouth slot. Great care should be taken with this work and frequent reference to the death mask should be made all through the process.

The lower lip is always positioned first. The skin is tucked in, but no more than it would be naturally. The naked part of the front fleshy lower lip shows in most species. The top lips are arranged more or less in the same manner, although the fleshy parts do not show in most species. Adequate amounts of body paste or other glue (epoxy is excellent for glueing lips permanently in position) should be applied to the lips. A few pins can be inserted at strategic points to hold the skin securely in position. The nostrils are modelled by pushing the skin deep into the holes. Then the cavity can be stuffed with cotton wool or tissue paper. This will keep the skin pressed hard against the inner walls of the nostrils. Again, a few pins inserted here and there help to keep the skin in position. If the initial modelling of the nose is inadequate, the skin of the nose can be filled with modelling compound and the shape is formed through the skin from the outside. However, take care not to overfill the nose with compound as this will lend an unnatural appearance to the mount.

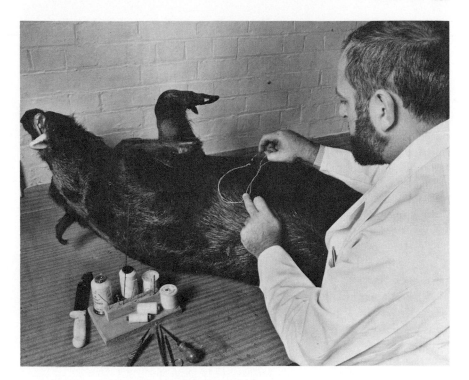

Fig. 6.93. The ventral incision is sewn. Wax thread is used. Photo John Fields. Taxidermy G. Hangay. Courtesy of The Australian Museum.

Treating the horns

If the specimen has horns, the skin should be glued and nailed to the base of the horns. The base consists of hard bone, and this will not take staples or nails easily. It is best to drill small holes at regular intervals all round the base of each horn, then, once the skin has been arranged, small tacks can be driven in. This will hold the skin very securely, hard against the bone. If it is not done, the skin will shrink away from the horns.

Positioning the ears

The ears should be positioned now. First, the ear butts should be pressed in the appropriate position (this should be checked against measurements, sketches and death mask). A strong, sharpened wire has to be driven into the mannikin through the ear hole to fasten the ear butt in position. The angle of the ear is set according to the attitude the specimen should reflect. Upright

ears, turned in the same direction as the eyes, suggest an alert, listening animal.

Adjusting the eyes

Finally, the eyes are set or adjusted. If glass eyes were set earlier, the skin should now be glued and pinned around them. If pliable modelling compound only was placed around and in the eye sockets, glass eyes should be inserted now. The compound is manipulated through the skin until it takes the required shape. Deep wrinkles, and other features, are pinned with fine stainless steel pins; insect pins are ideal for this work.

Detailing facial veins

The facial veins, if they are showing, are also pinned with fine pins. If the hair is long enough to hide the heads of the pins, they can be driven deep and left permanently.

All other prominent veins should be treated the same way, or pressure plates should be applied, as described earlier. The hair should be combed or brushed before the plates are fastened on the skin.

Brushing the hair

Finally, the hair is brushed to obtain a natural, lifelike flow (Fig. 6.94). If the hair will not lie in the proper manner, or if some special effect is required (for example, ruffled or erect hair on the neck), it can be wet with a special setting agent (either Aerosil or Cabosil mixed with water to a thick paste or water and powdered slippery elm mixed to a jelly-like state) then combed into the desired shape (*see* Formulae). Once the fur has dried, the remains of the setting formula should be brushed out of the hair.

Finishing the specimen

The specimen must be kept in a well ventilated, dry room away from direct heat until it is completely dry. The specimen must be monitored closely to check for shrinkage and warping; if these occur, they should be corrected as frequently as necessary.

When the specimen has dried completely, visible pins, pressure plates, strips of cardboard, leather, and so on, should be removed, and the hair combed again.

Pinholes and small gaps between the glass eyes and the skin, if they occur, must be filled with beeswax or petroleum wax. The wax can be coloured by

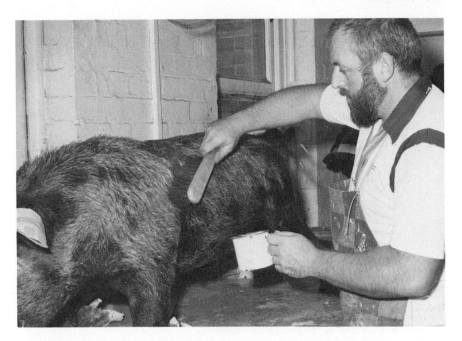

Fig. 6.94. If necessary, the hair is slicked down with a hair setting compound. Photo Heather McLennan. Taxidermy G. Hangay. Courtesy of The Australian Museum.

adding aniline dyes when it is molten. When the wax solidifies again, it can be made pliable with the fingers and be worked into the gaps and holes with a small modelling tool. Mineral turpentine, or turpentine oil, can be used to smooth the wax surface and a fine box wood tool can be used to put on the final finish.

The fleshy parts of the specimen normally need some recolouring (Fig. 6.95). This colouring must be carried out carefully and in strict accordance with the recorded colours of the live, or freshly killed, specimen. For best results an airbrush is employed, and the colours sprayed on. Thinned artist's oil paints, acrylic lacquers, or auto lacquers can be used, but always sparingly.

Some species require a complete colour restoration. These are normally sparsely haired animals, like wart-hogs, and various pigs. If possible the colour should be restored with dry paint dusted on the specimen. Once the required colour has been attained, surplus paint can be removed from the sparse hair with a wet sponge. The same effect can be achieved by spraying the entire specimen with auto lacquers (using pigmented undercoat to avoid gloss) and wiping the hair clean of paint with a sponge dipped in thinners.

It is not usual to paint or dye the fur of any species. This changes the natural appearance. It is necessary to bleach white hair if it has been stained in by

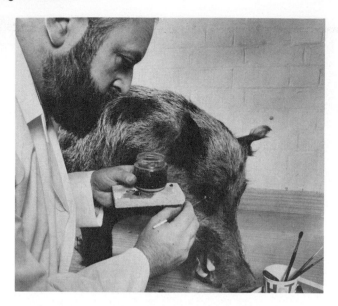

Fig. 6.95. Fleshy parts are coloured with artist's oil paints. Photo John Fields. Taxidermy G. Hangay. Courtesy of The Australian Museum.

vegetation or some other natural agent. Hydrogen peroxide at 35% strength is the bleaching agent most frequently used. It is mixed with a colourless or white filler such as Aerosil or Cabosil, whiting, or talc, to form a thin paste. This paste is painted on the hair, but preferably only on the top. It should not be rubbed into the roots. The bleaching must be carefully monitored; as soon as the required effect has been achieved, the paste must be removed and the hair quickly rinsed with clean cold water. Talcum powder or whiting can then be sprinkled on the hair before it is combed or brushed. This powder should be brushed out once it has dried.

It is advisable to test the bleach on a small amount of hair of the same species. Sometimes the bleach discolours white hair (for example, hydrogen peroxide turns white domestic goat hair yellow).

Once the animal has been finished, it can be placed on display. Fig. 6.96 shows, first, the cast awaiting assembly and the mounting of the skin, and, second, the finished specimen.

PREPARATION OF LARGE HAIRLESS MARINE MAMMALS FOR DISPLAY PURPOSES

The skins of these animals are far too great to be handled in the conventional taxidermic manner. Fat content and other undesirable characteristics of the

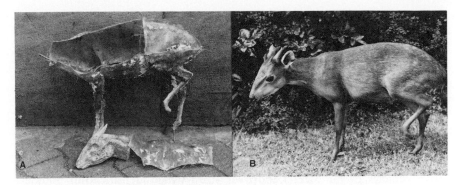

Fig. 6.96. A. Pieces of the fibreglass mannikin, prior to assembly. B. The finished mount. Photo Dr R. Angst. Taxidermy P. J. Gust. Courtesy of the Landessammlungen für Naturkunde, Karlsruhe, Germany.

skin render the animals unsuitable for the usual methods employed by taxidermists. However, good results can be achieved if the specimen is moulded and a lifelike plastic replica prepared. Specimens up to two to three metres in length can be moulded and cast as fishes of similar size (as described in Chapter 2). The handling of larger animals require a team of workers and a certain amount of experience and skill in the field. The following description was contributed by Mr P.J. PRETORIUS of the South African Museum, Capetown, South Africa:

CASTING A WHALE ON THE BEACH

"The South African Museum in Capetown is probably not the only museum in this country that occasionally attempts to cast large marine specimens. Those of you who in the past have attempted to do so probably soon realized how awkward and incredibly heavy these animals really are. Fate also rules that they normally wash up on a Friday afternoon on an inaccessible beach.

"For many years the South African Museum has been casting whales and dolphins for the new whale display we envisage. The casting of whales longer than three metres poses certain problems. The first and most serious problem we encountered was that their weight and streamlined shape often prevented the waves from pushing the carcasses above the high water mark. This makes casting impossible during high tide. Since the casting process may take up to six hours on a four or five metre whale, high tide will always interfere.

"Trying to pull a five metre whale weighing up to 3000 kg onto a dry beach with a Landrover proved impossible. The carcass normally imbeds itself into the wet sand. Suction of the very smooth bodies also does not improve matters. We once tried to pull a four or five metre whale shark out of the waves with three Landrovers. It remained exactly where it was. The only

result was that the police Landrover which was commandeered lost a wheel, and in turn had to be pulled out.

"The next problem was the need for fresh water to mix plaster of Paris. Large quantities are needed. Transport of the heavy and fragile plaster moulds proved a headache.

"The South African Museum has worked out a very workable solution to an otherwise awkward situation. The problem was overcome by good planning and equipment. No fancy equipment is needed. Nothing you will not find in the average museum or taxidermy workshop. The following list of tools and materials may be altered to suit yourself: One or two four-wheel drive vehicles of fair size (Landrover size); whale identification booklet; camera and film (slides [colour] and colour prints); notepaper and pencils; knives; tape measure; spades; gel coat (thickened polyester resin); polyester resin; fibreglass matting (42 g chopped strand mat); old tennon saw (to cut mould); broomstick with round end (to loosen mould from carcass); big curved needle (to sew up gashes and cuts in carcass); string (to sew with); disposable plastic gloves; brushes (for polyester work); acetone (to wash out brushes); tins (to mix polyester in); bucket (for water); rags; canvas (to cover work area in sun or rain; maybe an old tent); ropes (at least 10 metres); disinfectant, soap and fresh water to wash in and drink; towels; first-aid kit; paper to clean brushes before washing in acetone (old telephone directory); protective clothing; a couple of cases of beer (if the Director approves); and last, but not least important, three or four TAs. By the way that does not stand for tethered animals, as one sometimes gets the impression, it stands for technical assistant, that often overlooked object.

"When you arrive on the scene and find the animal with bits cut off and full of gashes and scratched, do not get discouraged. These problems are quite normal. Lots of beachbums carry knives which they use on anything that comes to hand. Fairly small pieces hacked off can easily be modelled in again. If it proves to be a rare specimen even larger pieces like a whole tail may be worth modelling with the aid of photographs and drawings.

"The first action to undertake is to pull the animal onto dry beach. If it is a fairly sizeable animal (four metres or more) do not try to pull it directly; it just won't work. Dig a small trench right through under the middle of the whale. Wrap the rope round the middle of the animal three or four times. The end of the rope to be pulled by the vehicle should come over the top of the whale while the other end should be hand held. When the rope is pulled by the vehicle, the rolling action will break the suction and the carcass should move quite easily.

"Roll the animal on its side, leaving the best side exposed. Never, but never, cast a whale or dolphin in a straight position. Always give it a tail up or a tail down curve.

"The next important step is to wash the animal and take photographs or slides from all angles, for later painting. Make colour notes and sketches as an insurance in case something goes wrong with your photographs.

"Cut the exposed pectoral fin off and keep it. Make two one centimetre deep cuts as far round the body as you can; one just behind the vent and one just behind the eye. These cuts serve as locating marks when you join the body, head and tail casts together later. Now make small lens shaped cuts fifty centimetres apart along the dorsal and ventral midlines between the two circumferential cuts. These serve to pinpoint the midlines in the cast.

"The carcass can now be dried and given a coat of gel coat, going ten centimetres over the circumferential cuts and as far down the sides as possible. Do not mould the head and tail; these can be cast at the museum.

"Wait until the gel coat has turned to a fairly hard jelly before putting on one layer of matting and resin. Before it has set brick hard it can be cut into manageable pieces from the carcass until it has set completely. After setting, it can be prised off with the aid of the broomstick.

"After the removal of the mould, the head and tail can be severed ten centimetres on the body side of the circumferential cuts.

"The head, tail, pectoral fins and dorsal fin can be removed to the museum and moulded in plaster in the conventional way. Fibreglass casts are taken from these moulds. At the museum the fibreglass mould pieces of the body can be tied together with wire staples and coated inside with floor wax and polyvinyl acetate release agent. Do not worry if the fibreglass mould seems slightly out of shape.

"Make the cast with one layer of matting and resin. Before removing the cast the wire staples can be pulled out and the mould removed in pieces.

"The cast will be very flexible and can be forced into the correct shape by putting in ribs as in the construction of a boat. At this stage you must consider the method you want to use to mount the cast; that is, on to a standing base or on to a wall. Brackets can be inserted and stuck on with fibreglass.

"The uncast part of the whale must now be modelled. Here the marks along the midlines come in very handy to establish the circumferential measurements.

"With the ribs in position they can be covered with wire mesh, fibreglass and then modelled smooth. The head and tail should be trimmed on the original circumferential cuts and joined onto the middle section, also on the original cuts.

"Any damage to the whale can now be repaired exactly as you would a motor car. The use of body filler has proved very effective. It can be put onto the cast and worked off before it has set brick hard. For the final filling, a cellulose body putty is used and allowed to set completely. Waterpaper, used through various grades to the finest, produces an excellent result.

"The painting is done like you would a motor car. Commercial spray paints may be used for basic colours but for subtle tints it is best to mix your own paint. This is done by thinning down artists' oil paints with cellulose thinners and adding a small amount of clear lacquer to bind the colour. The amount of lacquer can be varied to produce the desired sheen.

"To get the right amount of sheen on a cast of a whale is not easy. To me the skin of a whale looks like a wet black motor car tube, neither shiny nor matt either.

"I hope you have fun on the beach" (Pretorius, 1981).

MAINTENANCE OF TAXIDERMIC SPECIMENS

The following discussion was contributed by Mr GEZA MARTON, Assistant Curator of Conservation at the Applied Arts and Sciences (Powerhouse) Museum, Sydney, Australia:

"The maintenance of prepared mammals (and birds) should follow the general guidelines of the conservation of organic materials, and, within this wide concept, the proteinaceous substances, such as feathers, hair and prepared skin. This applies both to study and display specimens. However, environmental conditions for both differ; the study skin spends its life in the careful and studious environment of the scientific department. The display specimen, on the other hand, is kept under the exhibition lights, which are more often than not designed for the benefit of the visitors and not for the well being of the specimen.

"Once the specimen has been inexpertly handled, it is almost impossible to readjust it to its original state. Only the most skilful and experienced conservator or preparator should attempt to restore a valuable specimen to its 'original looks'. The appearance of the specimen changes from the moment it was killed. Fading of the colours cannot be arrested. Any chemical change will result in colour change, no matter how carefully the specimens are kept. The rate of change, however, can be slowed. This sometimes is sufficient when all considerations indicate that the life of the specimen is also limited.

STORAGE

"Adverse environmental conditions cause changes other than the fading of colours. The variation of heat and humidity, and high light levels accompanied with high or lower energy ultra violet radiation, are the most frequent problems encountered in the maintenance of taxidermic specimens.

"If high humidty persists, fungus will attack the objects; low humidity causes the material to dry out and thus become brittle. It is also possible that,

below the 40% relative humidity mark, there could be a chemical change in the keratin chain which would cause brittleness. As a general guideline, relative humidity should be as steady as possible between 50% and 60%. The change of relative humidity initiates a deteriorative process. Materials like feather and wool contain moisture depending on the relative humidity of the environment. A change in the relative humidity results in a change in the moisture content of the keratin and this creates heating and cooling within the fabric of the specimen. This change is expressed in differential or integral heat of absorption.

"Today, it is maintained that a temperature of 20°C ± 2°C and a relative humidity of 55% ± 2% will provide an adequate storage climate for feathers and skin. Lighting in the storage area should be limited to the lowest possible level (preferably nil). The objects should be stored in darkness and illuminated only when it is inevitably required.

DISPLAY CONDITIONS

"There are no safe display conditions, merely tolerable and intolerable ones. The specimens on display should be visible for the visiting public and thus are subjected to all sorts of abuse, such as high levels of lighting variation in great changes of relative humidity (it is more difficult and costly to maintain a steady climate in galleries than in small storage areas), air pollution, dust (on open displays), vandalism, and theft.

"The only guideline that can be given, apart from the ever-important good house keeping, is minimizing the light and ultraviolet radiation levels. Tungsten light emits low level ultraviolet radiation, but it is high in infrared content (in other words, in heat content). Fluorescent lighting is cold, but the ultraviolet radiation levels are high and filter systems have to be applied to protect the display from the low wavelength energies. The recommended light level is 50 Lux and the maximum exposure for ultraviolet radiation is 70 microwatts per lumen measured near the surface of the exhibit. Here the objects are in the hands of the designer of the display, and he or she should be very aware of the correct display conditions.

"Dust and pollutants can be taken care of with good house keeping. Vandalism and theft are the responsibility of the security department.

Fumigation

"When the objects have been exposed to contamination and soiling and need to be restored to an acceptable standard for storage, they have to be fumigated and cleaned.

"The fumigation of specimens is dependent upon the available facilities. These facilities range from a simple thymol tent fabricated from a plastic bag

and a light bulb to an elaborately designed, fully automatic vacuum and pressure controlled gas chamber. The efficiency of these facilities varies according to their design and the choice of gas. Fumigants which have been successfully used to eradicate insects and microorganism are hydrogene cyanide, and ethylene oxide. Methyl bromide should be avoided because it reacts with the sulphur containing components of the protein. Fumigant gases are highly toxic and must be used only by experts. The fumigation processes are usually controlled by legislation; laws are amended as fumigation technology develops".

REFERENCES

Anderson, S.: A new method of preparing lagomorph skins. *Journal of Mammalogy* 42/1961: 409–410

Anthony, H.E.: The capture and preservation of small mammals for study. American Museum of Natural History, New York. *Scientific Guide Leaflet* No. 61 1950.

Borell, A.E.: A new method of collecting bats. *Journal of Mammalogy* 18/1939: 478–480.

Ehman, H.: Innovative small animal taxidermy techniques. National Conference of Preparators and Technicians. Museum of Victoria, Melbourne 1980.

Ellenberger, Dittich and Baum: *Animal anatomy atlas for artists.* New York, 1949.

Howard, W.E. and E.M. Brock: A drift-fence pit trap that preserves captured rodents. *Journal of Mammalogy* 42/1961: 386–391.

Kish, J.: *The Jonas technique,* Vol. 2, Jonas Bros, Denver, 1978.

Klemmer, K.: Eine methode zum Fang fliegende Fledermause. *Saugefiekdl. Mitt.* 5/1957: 118–120.

Koshi, J.: A working safari. *Taxidermy Review* 6/5 1978.

Piechocki, R.: *Makroskopische Präparations technik: Wirbeltiere.* Akademische, Leipzig 1967.

Pretorius, P.J.: Measuring, casting and skinning medium and large mammals for taxidermy. *Sama* (South African Museum Association) 4/1981.

Siminovic, E.N. and L.P. Sviderskij: A mousetrap with the device for ectoparasik fixation. *Zool. Z.* (Moscow) 39/1960: 151–152.

Voronozov, N.N.: Application of sponge baits with carriers for catching small rodents. *Zool. Z.* (Moscow) 42/1963: 206–207

SOURCE MATERIAL

Anonymus: The Quebec fleshing machine. *Taxidermy Review* 9/2 1980.

Balciar, G.C.: Moulding a lifelike carcass. *Taxidermy Review* 5/6 1977.

Boone, P.: The story of the Bighorn ram Celebrity. *Taxidermy Review.* 7/1 1978.

———. Introduction to the anatomy of hoofed animals. *Taxidermy Review* 10/2 1981.

Carter, J.: Starting from scratch. *American Taxidermist* 12/6 1979.

Crandall, F.: Life size. *Taxidermy Review* 6/4 1978.

———. Observation on closed mouth predators. *Taxidermy Review* 9/5 1981.

Easterman, F.L.: A walrus for the St Roch. *Taxidermy Review* 6/3 1977.

Hangay, G.: Squeeze casting of carcasses. An aid for the sculptor-taxidermist. Conference of Museum Preparators. Sydney 1980.

Hohlfeld, E.: Detachable antlers. *American Taxidermist* 15/5 1982.

Kish, J.: Interpretation of veins. *Taxidermy Review* 5/3 1976.
——. Latex moulding compound. *Taxidermy Review* 5/6 1977.
——. Sculpting and moulding a game head. *Taxidermy Review* 1977.
——. Looking at eyes (Product evaluation). *Taxidermy Review* 6/6 1978.
——. The problem with tanning is ... *Taxidermy Review* 6/5 1978.
——. Studying animals. *Taxidermy Review*. 8/1 1979.
——. Celastic earliners. *Taxidermy Review* 9/1 1980.
——. The Wichers method. *Taxidermy Review* 9/6 1981.
Martinez, L.: The working study cast. *Taxidermy Review* 8/5 1980.
——. Backpack death mask. *Taxidermy Review* 8/4 1980.
——. Flexi forms. *Taxidermy Review* 8/5 1980.
Phillips, J.E.: On what should I mount. *American Taxidermist* 12/2 1978.
——. Do deer have flat necks. *American Taxidermist* 12/4 1978.
Pray, L.L.: *Taxidermy.* Macmillan, New York, 1943.
——. *Big game taxidermy.* Modern Taxidermist, Greenfield Center, NY 1951.
——. *Borax proofing for modern taxidermy.* Modern Taxidermist, Greenfield Center, NY 1956.
——. *The squirrel mounting book.* 3rd ed. Modern Taxidermist, Greenfield Center, NY 1956.
——. *American game head studies for the taxidermist.* Modern Taxidermist, Greenfield Center, NY 1960.
——. *Mammal studies for the taxidermist.* Modern Taxidermist, Greenfield Center, NY 1960.
——. *The mammal mounting book.* Modern Taxidermist, Greenfield Center, NY 1965.
——. *A taxidermist's sketchbook.* Joseph and Brucha, New York 1974.
——. *The whitetail deerhead book.* Modern Taxidermist, Greenfield Center, NY 1978.
——. *Modern taxidermy tips.* Modern Taxidermist, Greenfield Center, NY 1981.
Pretorius, P.J.: Design and construction of a degreasing plant. *Sama* (South African Museum Association) 6/1982.
Rittel, B.: Tanning with Luten F. *Taxidermy Review* 1978. 7/2
——. pH — the critical factor. *Taxidermy Review* 9/6 1981.
Thietje, W.C. and G.D. Schrimper: Laboratory techniques for mounting rabbits and other small mammals. *Taxidermy Review* 6/6 1978.

7
Embalming

THE EGYPTIANS are credited with being the first people to practise the art of embalming, albeit crudely. Part of their procedure was to immerse the body in sodium carbonate and sodium bicarbonate (Garner, 1979) for a certain period of time, after which it was cleansed and dried in the sun. Subsequently, other cultures have practised the art. Gaunches (the aboriginal inhabitants of the Canary Islands) and Ethiopians had similar methods to the Egyptians while the Babylonians, Syrians and Persians immersed their dead in honey to remove them from the air and thus prevent decomposition. Romans did not practise embalming and it was not until the late fifteenth century that embalming was performed in Europe and then only for scientific purposes.

William Harvey (1578–1657), who discovered the circulation of the blood in 1628, opened the door to the possibilities of vascular injection, although Leonardo Da Vinci (1452–1519) probably injected the arterial systems of his dead models to preserve them long enough for him to draw his wonderful art works.

In the early twentieth century, formaldehyde was used as the major constituent of embalming solutions, primarily because metallic poisons, which up until this time had been used to embalm cadavers, were prohibited for forensic reasons.

DEFINITION

Embalming is the thorough preservation and disinfection of a dead body to stop decomposition of the tissues due to bacteria and autolysis.

DISINFECTION

The body of an animal contains micro-organisms which must be destroyed to prevent decomposition occurring, as well as to prevent the possibility of bacteria transmitting disease to humans working in or near the preparation laboratories.

PRESERVATION

The protein component at the cellular level is chemically "fixed" so that it no longer provides food for bacteria to feed upon. The preservative must also stop autolysis (self-destruction of cells after death as a result of the action of their own enzymes).

 The embalming preservative used for vertebrates must have the following properties;

1. It should not coagulate blood immediately upon contact.
2. It should penetrate beyond the arterioles and hence into all tissues.
3. It must sterilize the tissues, thereby killing micro-organisms.
4. It should not alter the natural colour of tissues. Bleaching cannot be tolerated.

TYPES OF EMBALMING

CAVITY EMBALMING

This involves injection of preservative into the abdominal and thoracic cavities. Some diffusion of preservative is apparent after injecting, but not enough to prevent some decomposition occurring. The specimen should be immersed in a preservative as a storage medium.

ARTERIAL EMBALMING

This involves the injection of the preserving solution through the arteries, usually through a large and accessible artery such as the carotid, or femoral arteries in mammals, or the brachial artery in the wings of birds.

The principle behind arterial embalming is that the fluid should follow the route taken by the blood when the animal was alive. The embalming fluid enters the artery under pressure (normally in the direction of the trunk) and reticulates to the capillaries, pushing blood in front of it. Some fluid is forced into the tissue cells from the capillaries. Blood is then pushed into the venules and on into the veins, from which, for the sake of good preservation, it should be allowed to escape, usually at the vein which accompanies the injected artery such as the internal jugular vein near the common carotid artery, the femoral vein near the femoral artery, and the basilic vein near the brachial artery. Although the blood is allowed to escape from a vein in human cadavers, it is not always necessary for this to happen when embalming a small animal. Nevertheless, it is a good idea to allow the blood to escape.

Reasons for arterial embalming

There are two main reasons for arterial embalming in a zoological laboratory.

1. The preservation of whole animals for dissection by students so they can gain knowledge in technique and be able to identify anatomical structures.
2. The preservation of limbs, organs and associated structures so they may be prepared for teaching displays.

The primary difference between these two requirements is in the type of embalming fluid employed. When whole animals are embalmed, the fluid needs to be a preservative and a disinfectant so that specimens will remain free from decomposition and can be used as dissection specimens for long periods of time without the risk of infection to the dissector. When specimens are required for display needs, the fluid must preserve the tissues and retain a colour closely resembling the living tissue. This is of benefit in anatomical museums. As specimens are usually sealed in plastic containers and formalin is the preservative, additional disinfectants are not required.

Embalming is only practical if enough pressure is exerted on the fluid to force it into the tissues. By the time the fluid reaches the ends of the arterioles, much of the initial force has been lost so extra effort is necessary for diffusion to occur. The situation is satisfactory when the superficial veins become distended. To achieve this a force of around 210 g cm^{-2} is required for dogs, and around 140 g cm^{-2} for cats. More force is necessary for larger animals.

EMBALMING METHODS FOR STUDENT DISSECTION

LIVE SPECIMENS

Some workers who prepare large numbers of specimens and who have the services of a veterinarian prepare large animals by the following procedure. The veterinarian administers an injection of anaesthetic and blood anticoagulant via the femoral artery. The dosage should not kill the animal but be sufficient to allow the heart to keep just beating. The carotid artery is exposed and raised after cutting through the neck and blood circulation is stopped by clamping it with artery forceps. A small cut is made longitudinally on the artery on the head side of the forceps and a cannula inserted. This can be a syringe needle, but should not be of the slip-on type as pressure will build up during the embalming procedure and may cause the cannula to separate and bring about the loss of fluid. For cats, an 18 gauge needle will suffice, although a 16 gauge needle may fit just as well. Large animals require needles of greater diameter and, in general, the largest gauge possible should be used to facilitate bleeding and fluid transfer. The cannula must have the pointed end ground flat to prevent the piercing of the artery wall. It should be slipped into the artery facing towards the heart and can be held in position with half a reef knot made with strong but thin string. A complete knot should not be tied as this will make it difficult to remove the cannula when the injection has been completed (Fig. 7.1).

The animal can then be placed over a drainage hole and the artery forceps removed to allow as much blood as possible to drain via the cannula. If Luer-lock syringes are employed as cannulas, then the embalming tube should have a fitting attached to it to facilitate it joining onto the cannula. These stopcock fittings can be purchased with a tap which allows greater control over the rate of fluid flow.

Fig. 7.1. How a vessel is clamped and a cannula tied in position for blood letting. The clamp is removed to allow blood to escape. The same cannula is used for the passage of the embalming fluid into the vessels.

Fig. 7.2. The gravity feed bottle is supported on a tray which is hoisted to the required height so that a suitable pressure of fluid perfuses the arteries.

Any air trapped in the fluid tube should be expelled before the tube is attached to the cannula, for if air is permitted to enter the animal it will prevent the embalming fluid reaching all tissues. The embalming fluid can be injected after the bleeding has stopped; it is injected under pressure. If a bottle is suspended above the animal the contents will be fed in by gravity (Fig. 7.2). The bottle can be secured so that it can be raised and lowered; a height of one metre will increase the force to about 670 g cm^{-2}. Alternatively, a variable speed pump or compressed air chamber can be utilized (Fig. 7.3), but, whatever method is employed, it is necessary to have a means of regulation of the rate of flow of fluid into the specimen. A tap is effective for this purpose.

Fluid is allowed to enter slowly at first to prevent vasoconstriction, and, after a few seconds, the pressure can be increased. Twitching of the front legs followed by stretching of the limbs is evidence that the fluid is passing into the circulatory system. If this occurs too quickly, the pressure should be reduced a little until the movement is smooth. Different animals require different volumes of fluid, but the amount can be judged by the swelling of the blood vessels on the inside of the legs and the fact that the animal will become fatter and slightly turgid. In male dogs, the testicles become hard. Saturation is marked by frothing at the nose. When the animal is full of fluid, the saturation of the arteries can cease and the tube can be removed from the cannula. If the animal has been embalmed properly there will be a backflow

Fig. 7.3. An embalming or peristaltic pump is a useful addition for the rapid penetration of embalming fluid into the vessels.

of fluid. If the vessels are to be filled with coloured material later, the cannula should be left in position and a plug inserted into the end. If no coloured material is to be injected, the cannula should be withdrawn and the artery tied by converting the half reef knot into a full reef knot.

DEAD SPECIMENS

Laboratories which receive dead specimens have to follow another course to achieve good preservation. The following information applies primarily to small laboratory animals such as rats, guinea pigs and cats. Such small animals require much less embalming fluid injected at low pressure, so, for simplicity, mechanical pumps have been omitted from the discussion.

There are three methods. One is the use of the gravity feed bottle, as already mentioned. Then there is the use of a hand syringe; 50 mL capacity syringes are suitable and are used with a three way adaptor and two lengths of tubing. The adaptor is attached to the syringe and the tubes are attached to the open ends of the adaptor. The tubing which evolves at right angles to the syringe is placed into a container holding the preserving fluid and the other tube is inserted into an artery of the animal. The plunger of the syringe is withdrawn so that fluid is sucked up into the syringe. The adaptor control is changed so that when the plunger is depressed, fluid is forced into the animal (Fig. 7.4). The third method requires the use of the Higginson enema syringe. This is essentially a length of rubber tubing incorporating a rubber bulb which is situated between the two ends. The two tubes have within them one way valves so that, when the bulb is squeezed, a one way flow of fluid is achieved. One end of the tube is immersed in the fluid and the other end is attached to the specimen. All air within the apparatus must be extracted before it is secured to the animal (Fig. 7.5).

Fig. 7.4. This three-way hand syringe is useful for injecting embalming fluid into small animals.

Fig. 7.5. A Higginson enema syringe is also useful for embalming. A one way valve ensures a continuous supply of fluid.

EMBALMING FLUID

The embalming fluid should be viscous enough to penetrate into the smallest of arterioles and be able to perfuse through cell membranes. A good embalming fluid which uses commercial grade chemicals is composed of: carbolic acid 250 mL; formaldehyde (40%) 500 mL; glycerine 1 L; and tap water 3.25 L. Freshly drawn tap water contains dissolved air. Before use, it should be allowed to stand in a large container for 24 hours. If an animal is not to be injected with coloured material it can be sealed in a sealed plastic

bag. If it is a large animal, such as a dog, it should be placed in a large tank containing: formaldehyde (40%) 100 mL; and tap water 4.9 L. Prior to dissection by students, the animals must be removed from this fluid and allowed to drain. This makes the formaldehyde smell less pungent. If a cold room is available, large animals can be stored there before dissection. They may be returned to the cold room after each class and can be used over and over again for up to six months.

If the exposed areas appear to dry out during dissection, a spray bottle containing the embalming fluid, without the glycerine, can be used to dampen the affected area.

EMBALMING SPECIMENS FOR MUSEUM DISPLAY

Specimens required for museum display usually consist of organ systems and whole dissected organs. For example, to show the internal thoracic and abdominal features of a cat, the whole animal is first perfused with embalming solution, but an individual organ is injected once it has been removed from the animal. Since specimens for museum displays should maintain natural colour in the tissues, chemicals are used which act as buffering agents and colour restorers. All chemicals should be analytical reagent grade and, unless otherwise stated, distilled water must be used.

METHOD

The largest artery entering the specimen should be secured to a cannula and the fluid allowed to enter. Any method of forcing the fluid into the system is practical, but the gravity feed method is probably the best. Small alligator clips and artery forceps should be used to stop the fluid escaping through cut arteries; once the arteries have been secured they may be tied with strong cotton. Soft organs, such as the lungs, are injected via the trachea to expand them; they should be supported in a bath of preserving fluid. The fluid may be allowed to run in slowly over a period of several hours, then topped up with preservative every few hours for a week. Other organs and structures can be preserved via the arteries, but also placed in a bath of preserving fluid so as not to waste escaping fluid. The heart can be expanded, and kept that way, by inserting cotton wool into the cavities; however, this should not occur if the heart is to be dissected as the valves will be pushed out of alignment. Some specimens removed from a body which has been dead for some time may need a primary injection of formol saline to remove any blood clots. The tissues will also be fixed to a certain degree and the formol saline should be replaced with embalming fluid when it appears that there are no further obstructions

within the vessels. Formol saline is made up of: neutral formaldehyde (40%) 10 mL; sodium chloride 0.9 g; and distilled water 100 mL. A suitable embalming fluid is made up of: neutral formaldehyde (40%) 100 mL; sodium acetate 40 g; tap water 1 L. The fluid should be used as a bath for specimens, which may be left in it for two weeks, if the specimens are of kidney size, or several months, if the specimens are large and thick, such as liver or muscles.

STORAGE SOLUTIONS FOR CLEAR PLASTIC BOXES

Clear plastic boxes are made from acrylic plastic. Acrylics scratch easily, but they are sturdy and can be joined easily. However, they quickly succumb to certain chemicals, thereby restricting the use of certain liquids as preservatives and additives. Propylene phenoxytol, which preserves colour in a wide range of vertebrates and invertebrates, causes acrylic to swell and become soft after a few days, so that a box loses its shape. Alcohols cause acrylic to craze (leading to opacity), then to swell, and finally to disintegrate. Acetic acid used in formol-acetic-alcohol (FAA) preservatives swells acrylic after one day and glacial acetic acid completely dissolves it in three days. Carbolic acid dissolves acrylic after seven days. In an aqueous solution, formaldehyde has no effect upon acrylic. Many workers have formulated various preserving solutions, but only formulae from two workers are described here. Additional formulae can be found in the references listed at the end of the chapter.

Kaiserling's formulae

The following formulae are drawn from the Armed Forces *Manual of Macropathological Techniques*.

Kaiserling has put forward several preserving solution formulae and these are described here. Specimens are placed into solution A first, then transferred to solution B and then mounted in solution C.

July 1896 formula: Solution A consists of 3 g potassium acetate, 1 g potassium nitrate, 75 mL formalin and 100 mL water. Solution B consists of a 95% solution of alcohol. Solution C consists of 30 g potassium acetate, 60 mL glycerine and 100 mL water.

Undated formula: Solution A consists of 400 mL formaldehyde, 2 L water, 30 g potassium nitrate and 30 g potassium acetate. Solution B consists of an 80% solution of alcohol. Solution C consists of 2.72 kg potassium acetate, 5 L glycerine, 2 L water and 5 g phenol crystals.

1899 formula: Solution A consists of 85 g potassium acetate, 45 g potassium nitrate, 800 mL formalin and 4 L water. Solution B adds alcohol 95%.

Solution C consists of 30 g potassium acetate, 60 mL glycerine and 100 mL water.

Klotz–Kaiserling 1946 formula: The colour solution consists of 140 g sodium chloride, 80 g sodium bicarbonate, 625 g chloral hydrate, 512 mL formaldehyde, and 20 distilled water. The fixative solution consists of 600 g potassium acetate, 300 g potassium nitrate, 4 L formaldehyde, and 20 L water. The preservative solution consists of 2 kg potassium acetate, 4 L glycerine, 5 g thymol and 20 L water.

Wentworth's formulae

The following formula was first described in Wentworth (1947). Solution 1 consists of 80 mL–100 mL formaldehyde, 40 g sodium acetate, and 1 L water. Solution 2 consists of 20 mL formaldehyde, 40 g sodium acetate, 1 L water and sodium hydrosulphite (3 g/kg specimen).

The following formula was first described in Wentworth (1942). Solution 1 consists of 100 mL formaldehyde, 40 g sodium acetate and 1 L water. Solution 2 consists of 20 mL formaldehyde, 40 g sodium acetate, 1 g trisodium phosphate, 200 mL glycerine, 3 g sodium hydrosulphite and 1 L distilled water.

USING THE FORMULAE

These noted workers have formulated these various solutions and there are arguments for and against each of them. The authors have chosen to use a slight modification of Wentworth's 1942 hydrosulphite technique. The Klotz–Kaiserling method contains no fixative in the mounting solution C to harden the tissues. Specimens therefore tend to become friable and this can lead to cloudy solutions. The colours retained in the final solution show as brick reds rather than subdued reds. Colour can be controlled better using Wentworth's 1942 method. A modification of Wentworth's technique is to remove the sodium hydrosulphite from solution 2. Solutions 1 and 2 are primary fixatives and also media for dissection work. A third solution can be employed as the storage solution, made up by omitting the sodium hydrosulphite from solution 2, then adding 10 mL of the supernatant liquid from a saturated solution of camphor dissolved in alcohol. This solution should be left overnight, then filtered into a storage bottle. Acrylic boxes can then be filled with this solution when the specimen has been attached inside. The fluid should fill the box to the top. The box should be covered and left for a couple of days. During this period, cloudy solutions, loose ends of tissue and general bits of rubbish can be detected and rectified. Once the whole display is as good as it can be, add the top or base, which ever the case may

be. Just before the box is sealed add 3 g sodium hydrosulphite per kilogram of specimen. The sodium hydrosulphite can be dissolved by turning the box 90° every hour or so. Do not add more than the prescribed amount of sodium hydrosulphite, as this may colour the specimen too much, producing an unnatural appearance. If colour is not correct after two days a little more hydrosulphite can be added until the desired colour is attained. Once the last hydrosulphite has been added, the box must be completely filled to expel any air bubbles as these could lead to oxidation of the hydrosulphite, and cause irreversible colour loss. This technique is therefore unsuitable for specimens housed in glass containers which require an air space at the top of the jar so the fluid is able to expand and contract in hot and cold weather.

The Kaiserling and Wentworth techniques, which were designed for anatomical and pathological specimens, preserve the colour of the haemoglobin. Mahoney (1966) explains that the steps involve the conversion of oxyhaemoglobin into acid haematin during the preliminary fixation solution, then, when placed into the second solution, the acid haematin is changed to temporary alkaline haematin, while the third solution turns it into permanent alkaline haematin.

If damage occurs to the box, causing fluid to leak and air to enter, there is another fluid which can be used to retain the colour of a specimen. This should only be used as an absolutely final mounting medium for, if the specimen comes into contact with air after immersion in it, colour is lost forever. The quicker the specimen is transferred to this fluid the better the chance of colour retention. Therefore, a stock solution should be on hand all the time.

Final mounting solutions

Solution 1 (modified Romanyi): This consists of 100 mL formaldehyde, 16.6 mL pyridine, 33.3 g sodium hydrosulphite and 1 L distilled water. Let this stand for several days, then draw off 800 mL clear supernatant liquid and add it to 200 mL glycerine. After 24 hours, this should be filtered and placed in a stock bottle.

Solution 2: This consists of 234 g sodium acetate, 300 mL glycerine, 10 mL pyridine, 10 mL formaldehyde and 1 L distilled water. Leave specimens in this solution until another box can be made, ensuring that the transfer of the specimen to the box is quick.

REFERENCES

Armed Forces: *Manual of macropathological techniques.* Institute of Pathology, Medical Museum Laboratory, Walter Reed Medical Center, Washington, DC 1957.

Garner, R.: Experimental mummification. *The Manchester museum project* (ed. A. R. David). Manchester Museum, Manchester 1979:19.

Mahoney, R.: *Laboratory techniques in zoology.* Butterworths, London 1966.

Wentworth, J. E.: The preservation of museum specimens in war time. *Journal of Pathology and Bacteriology* 54/1942: 137–138.

———. The hydrosulphite method of preserving museum specimens. *Bulletin of the International Association of Medical Museums* 27/1947: 201–204.

SOURCE MATERIAL

Bruns, P.: Uber die Herstellung von Trocken-oder Mumien-Praparaten. *Beitr. Klin. Chir.* 17/1896: 205–206.

Cole, F. J.: The history of anatomical injections. *Studies in the history and method of science.* (Ed. C. Singer). Vol. 2. Arno Press, New York 1921: 285–343.

Farris, E. J.: Permanent preservation of the human body infiltration. *Science* 75/1932: 670–671.

Fischel, W.: Konservierung und Einbalsamierung von Tieren. *Ciba-Z.* 4/1937: 15002–1504.

Forster, B.: Uber die naturliche Konservierung menschlicher Leichen. *Der Präparator* 2/1956: 157–161.

Frenzel, J.: Verfahren zur Mumification von Vogeln und anderen zoologischen Objekten. *Journal of Ornithology* 39/1891: 74–86.

Gillmann, J.: Restoration of mummified tissues. *American Journal of Physical Anthropology* 18/1934: 363–370.

Gisel, A., and A. Spinka: Eine Pumpenspritze als neues Injektionsgeerat fur die Konservierung von Leichenteilen. *Anat. Anz.* 91/1941: 121–123.

Hinman, F., D. M. Morison, and R. Lee-Brown: Methods of demonstrating the circulation in general. *Journal of the American Medical Association* 81/3 1923: 177–184.

Hofmann, R. R.: Die Formalinfixierung ostafrikanischer Antilopen in stehender Korperhaltung. *Verh.. anat. Ges.* 115/1965: 547–550.

Inke, G., and G. Csanady: Use of Arbocoll H for the preparation of dry specimens (Preliminary Report). *Acta Morph.* 7/1956:237–238.

Keller, G.: Uber die Präparation kleinerer Wirbeltiere fur die Schau- und Arbeitssammlung in der Schule. *Naturforscher* 4/1928: 495–496.

Kirchroth, L.: *Die Mumifizierung von Vogeln und kleinen Saugetieren.* Klosterneuburg, Vienna 1923.

Polson, C. J., and T. K. Marshall: *The disposal of the dead.* English University Press, London 1975.

Projer, L. W., and H. W. Chambers: Colour preservation in pathological museum specimens. *Annals of the Royal College of Surgeons of England* 33/1963: 245–248.

Richins, C. A., E. C. Roberts, and J. A. Zeilmann: Improved fluids for anatomical embalming and storage. *Anatomical Records* 146/1963: 241–243.

Scudamore, E. F.: *Embalming, theoretical and practical.* (2nd ed.). British Institute of Embalmers, London 1966.

Shein, M.: Colour restoration and preservation of gross museum specimens. *Bulletin of the International Association of Medical Museums* 32/1950: 118–123.

Strub, C. G., and L. G. Frederick: *The principles and practice of embalming.* L. G. Frederick, Dallas n.d.

Turtox Service Leaflet No. 21: *Preparation and care of embalmed specimens,* n.d.

Waller, R. A., and W. N. Eschmeyer: A method of preserving color in biological specimens. *BioScience* May/1965: 361.

Woodburne, R. T., and C. A. Lawrence: An improved embalming fluid formula. *Anatomical Records* 114/1952: 507–514.

8

Anatomical preparation

THE following list of techniques describes the main methods of anatomical preparation. The second part of this chapter describes methods of preserving anatomical parts.

TECHNIQUES OF ANATOMICAL PREPARATION

COLOURED INJECTION

After embalming, vessels can be injected with a coloured medium which sets and then allows for dissection, X-ray analysis or corrosion techniques. Vessels which are filled for X-ray analysis or dissection can be filled with latex or gelatine, for small animals, or "glue", for larger animals such as dogs and sheep. Anatomical cavities that are to be filled to produce corrosion casts are normally filled using plastics.

Injection media

Gelatine: Because of its tendency to break easily, gelatine is more suitable for X-ray photography than for dissection. When used for X-ray photography, the gelatine should be mixed with a radio-opaque substance such as lead tetroxide or barium sulphate. Lum (1946) and Schlesinger (1957) describe

their methods with Schlesinger using potassium iodide to control the setting times of the gelatine. Mahoney (1966) details several methods for injecting gelatine using 10% sodium salicylate to retard setting times.

Latex: Animals are first embalmed (see Chapter 7) so that decomposition of tissues does not occur when the animals are dissected after the vessels have been injected with latex.

The latex should be purchased just before use, but its shelf life can be extended if it is stored in a cool place. It should be stirred and strained through cheese cloth or a fine sieve to remove any lumps which would impede the flow of the latex through the vessels.

Glue: When large numbers of dogs, sheep and cattle are to be injected, latex proves too expensive so this glue, used by the Department of Veterinary Anatomy in the University of Sydney, has the advantage of being both versatile and cheap.

To make the glue take 120 g of joiner's glue (Davis) and soak it in 1 L water overnight in an oven. When it has completely soaked in, add 50 mL glycerine and stir thoroughly; Irgalite red or blue pigment (Ciba Geigy) can then be added to achieve the desired hue. This glue should be injected when warm, as it is solid when cold.

Injection apparatus

1. Hypodermic syringe: Small animals such as frogs, earthworms and crayfish have a very small circulatory system and a syringe is the easiest and quickest tool to use. Disposable syringes are widely accepted for their cheapness and disposability, but some workers still prefer the glass syringes as they give a smoother release of the injection fluid, but they have to be cleaned thoroughly after each use. Whichever type of syringe is used, a 10 mL size is more than adequate for those animals listed above. In some cases, the needle should be attached to a short length of rubber tubing which can then be attached to the syringe. This allows the syringe to be held at different and possibly easier angles to that of the needle and specimen.

2. Compressed air: This method should be used when large animals are to be injected and quantities of between 400 mL and 4 L have to be injected smoothly and quickly.

3. Conical flask: Because of the need to inject large volumes of material into large animals, it is best to use compressed air. A conical flask holds the "glue" whilst injection is in progress. As the flask is made from glass it makes the

task of putting the right amount of "glue" into the specimen easier to observe. The flask should be graduated and enclosed in a wooden holder with a lid to prevent the stopper from becoming loose when the compressed air is forcing the "glue" out and into the animal.

INJECTION OF SMALL ANIMALS

Frogs are injected via the heart by inserting the needle into the conus arteriosus and injecting about 2 mL–3 mL of latex.

The cat requires about 30 mL of red latex and 30 mL–50 mL of blue; it is also injected using a hand syringe. The arterial system is injected via the carotid artery, and this should also have been the route for injection of the embalming solution. The venous system is filled via the external jugular vein which lies near the carotid artery. The vein is tied posteriorly and a loose knot is applied anteriorly. A longitudinal cut is made between the two knots and a cannula inserted. This is held in position by tightening of the anterior knot. The blue latex is injected, maintaining a firm and steady pressure, until the back pressure becomes too great. After this the cannula can be removed and the vein tied off. The portal system can be filled using yellow latex. The entry point should be through a branch of the mesenteric vein in the abdomen. After dissecting out the mesenteric vein, it can be cannulated and 12 mL–20 mL latex injected. It should be tied after withdrawal of the cannula. The abdomen can then be sewn up. The animal is ready for dissection once the latex has solidified.

INJECTION OF LARGE ANIMALS

Red glue is injected into the arterial system via a cannula tied into the carotid artery previously used to inject the embalming solution.

The conical flask should be filled with hot glue and held in position with the wooden holder. The apparatus should be placed where hot water can be poured over it to keep the glue liquid. The flask should sit on something that will absorb the hot water and keep the base hot.

A tube can be connected to an air line and turned on so that the glue is forced through the outlet tube until it reaches the end whence it is connected to the cannula and injection may proceed. Dogs the size of greyhounds require 400 mL–500 mL of glue and it should flow freely through the vessels. To check whether the vessels are being filled, a small cut can be made around the feet and ears, which will appear coloured. If the venous system has to be filled, the glue within the arterial system should be allowed to harden for 24 hours before injection of the blue glue. For injection of the venous system,

use the external jugular vein and inject using the same procedure as previously described, remembering to tie off the vessel once injection has been completed. Store the animals in a cool room or immerse them in baths containing formalin until they are to be used.

CORROSION CASTS

Anatomical museums usually display whole or bissected organs as well as parts of the body specifically dissected to show particular characteristics. These are displayed as "wet" specimens in varying types of storage containers.

An aesthetically pleasing form of museum display used in conjunction with the normal anatomical displays is the corrosion cast. Vessels such as arteries, veins, ducts and airways may be filled with various materials, such as polyester resins, and, once the injection mass has solidified, the original tissues can be corroded away using strong acids or alkalis. Plastics are the accepted injection medium as they are strong, light, durable and are able to be pigmented in order to depict certain characteristics. Tompsett (1970) favours polyester resins as they follow all conditions as well as being relatively cheap to buy. Another worker in this field (R. Bullock, Department of Veterinary Anatomy, University of Sydney, Australia) uses an acrylic cement called Tensol no. 7 (normally used to achieve quite outstanding results) made by ICI.

When polyester resins are used to make casts, a white bloom can sometimes appear on the surface. This can be overcome by spraying on a highly catalysed mix of resin later.

Apparatus

1. Glass cannulae: Various diameters and lengths are required. The ends should be softened using a Bunsen burner and then pressed down onto a sheet of heat resistant material to produce a flange so that, when the cannula is tied into a vessel, it does not slip out.

2. Injection apparatus: Tompsett (1970) uses a length of glass tube with an internal diameter of 2 cm and a length that can be between 5 cm and 60 cm or more depending on the volume of resin needed to be injected. The top end should have a rubber bung inserted to which a sphygmomanometer bulb can be attached. The lower end should be tapered, and a rubber tube can be connected for the glass cannula to slide into. This can also be clamped during refilling of the tube. The glass tube can also be graduated if necessary so that volumes injected can be easily observed.

PRESERVING ANATOMICAL PARTS

LUNGS

The bronchial tree is one of the easiest casts to make for it generally appears as a single coloured cast of the air passages.

The lungs and as much of the trachea as possible are removed from the thorax. Care should be taken to avoid cutting through the pleura. A glass cannula can then be tied into the upper part of the trachea and connected to a tube from the tap. The lungs should then be placed into a bowl containing water. The tap is turned on slowly so that the water inflates the lungs until they become turgid (Fig. 8.1). The flow of water into the lungs should be maintained until all blood has perfused out and the lung tissue has become somewhat pale. The water tap can then be turned off and the tube disconnected. The lungs should be gently squeezed to remove most of the water still in the airways, after which the lungs can be removed from the water and placed in a bowl containing a 70% solution of industrial spirits. The spirit should be poured into the trachea so that the lungs expand; this process should be repeated every hour for five or six hours. The lungs can be kept in the spirit for a week but they must be expanded several times each day.

Preparation for injection

A five litre gelatine solution can be made up the day before injection by adding no more than 12 g of gelatine to 100 mL of water.

The pigment can be mixed into 100 g of polyester resin and the recommended amount of catalyst stirred in. The time of mixing is recorded and, as soon as the resin begins to gel, the time is again recorded. This gives the pot life of the resin which will hold good for the same conditions of temperature and humidity. The filling of the lungs, or any cast, should commence within a few hours of the test.

The lungs can now be removed from the spirit and placed in water maintained at a temperature of 34°C. For dog (greyhound) lungs, about 15 L deaerated water should be run in through the trachea. Proportionately less water should be used for animal lungs that are much smaller in size.

The gelatine should be warmed to 34°–40°C and run into the trachea until the lungs become turgid and are slippery to the touch because of the gelatine coming through the pleura. The flow of gelatine should then be halted and it should be allowed to escape via the trachea until the lungs appear limp. A glass cannula should then be connected to the injection apparatus containing the coloured resin. The resin can be gently forced into the trachea where the resin will gel in about five minutes. Most lungs do not require much pressure;

Fig. 8.1. Washing the blood from a set of lungs. The lungs are supported in a bath of water.

gravity flow is usually sufficient. Once the lungs are filled, the cannula should be corked and the water in which the lungs have been floating should be cooled rapidly using icy water or crushed ice. This is to harden the gelatine; the lungs may need to be held in their correct position until the gelatine sets and resin polymerizes.

The lungs must be kept in the water for between one and five days to allow the tissues to expand and the resin to fully cure. They may then be placed in warm water to remelt the gelatine, but this step is not absolutely necessary. The specimen should then be placed in a tank containing concentrated hydrochloric acid to a depth that would totally immerse it. The lungs float at first, but slowly sink as maceration continues. The lungs of a dog require 24 to 48 hours in the acid. When maceration is thought to be complete, tap water should be run into the tank and the acid allowed to flow out until the solution is clear and judgment can be made as to whether the maceration is complete. If it is not complete, the water should be carefully siphoned off, replaced with fresh acid, and the specimen left for another 24 hours. There may be some tissue still adhering to parts of the cast which can be removed by directing a jet of water onto the affected area. This should be the procedure until the cast is clean, and free from tissue.

The cast can now be gently removed from the water and clamped via the trachea and allowed to dry. With most casts, too much resin may have been injected. This will have formed solid masses; also, some tissues become impregnated, causing the same problem. These solid masses conceal the

larger vessels and have to be removed using a dental burring tool which, when touched against the plastic, causes it to break off. This is termed pruning and may take several weeks on large casts. If small branches or important sections break off, these may be rejoined using pigmented resin.

When finished, the cast should be mounted on a stand using a length of brass rod tapped into the back of the trachea and glued in position. Back lighting produces nice effects to enhance the appearance of the finished cast.

PULMONARY VESSELS

A triple cast of the arteries, veins and bronchi may be attempted, but the resin must fill the cavities in the following order: veins; arteries; and bronchi. For a triple cast to be attempted at least 2 cm of the pulmonary trunk should be saved and cannulated, whilst the heart should be included for the veins. The heart should have the apical halves of the ventricles cut away and a purse string suture must be sewn in the ventricular wall close to the atrium, going right around the mitral valves. A large glass cannula with a flange should be passed into the left atrium so as not to alter the position of the mitral valve next to the aorta as this may allow resin to leak into the aorta. The suture should be tied around the glass cannula in a bow so that it can be tightened if required.

The lungs should be washed free of blood, and spirit run in as previously described. For the lungs of a greyhound, 350 mL of pigmented resin is required for the arteries, 500 mL is required to fill the veins, and 200 mL is required for the bronchi. These volumes allow for a generous oversupply.

A hole can then be made in the top of the arterial wall to allow water that may be inside to pass, and resin is poured into the veins by gravity flow until they are filled. The arteries should be filled about one hour afterwards. Gelatine should be poured into the bronchi as previously described and then the bronchi can be filled with resin.

Maceration will take twice as long as the time taken for just the bronchial tree; more care is needed in handling the cast due to the many vessels that have been cast.

KIDNEYS

As with the lungs, the kidneys may be cast with a single injection or with triple injections and one kidney may be filled or alternatively (and one which is more difficult to prepare) both kidneys can be injected. Single casts can be made by filling either the veins, arteries or ureters, but the triple casts must be poured in that order.

To prepare casts of both kidneys, they must be removed from the body keeping as much of the aorta, vena cava and ureters with them so that the glass cannulae can be inserted and tied. Fat adhering to the organs and vessels

must be removed and any cut vessels should be tied. Glass cannulae should be inserted into both ends of the aorta and vena cava, whilst the ureters should contain the largest diameter cannula that will fit it.

The kidneys can be placed on a flat tray and they and the vessels should be oriented in their natural positions. The vessels are then perfused with 3% solution of formalin by gravity feed until the kidneys become turgid. They then should be transferred to a container filled with water and left for 24 hours.

The kidneys should now be transferred to water maintained at 30‡C and then compressed to remove water from within. Blue resin (300 mL) should be made up for dog kidneys (perform a gel time test first) and allowed to flow into the vena cava. The kidneys are allowed to hang down and, when the resin is seen in it, the other glass cannula should be tied off. Resin is allowed to flow until it gels, making sure that the veins remain turgid.

Red resin (200 mL) should be prepared for the arteries, which can be filled in the same manner as the veins, except that moderate pressure may be applied until red spots appear on the under surface of the kidneys.

Allow the red resin to gel, and leave it for one hour before filling the ureters. A needle hole should be made into the highest part of each pelvis to allow water to escape and, when this happens, it is clear that they are filled.

Allow the resin to cure for at least 24 hours before placing the specimen into hydrochloric acid. Maceration usually takes from two to four days. A fine jet of water can be used to remove tiny branches and pieces of tissue.

LIVER

When the liver is removed from the body, the vena cava should be severed with part of the right atrium, and as much as possible of the hepatic artery, portal vein and common bile duct should be included. Glass cannulae can then be tied into the vessels, as well as to both ends of the vena cava. The cut end of the artery leading to the stomach should be tied off. The gall bladder should be squeezed to remove the bile, then repeatedly filled and washed out using a 3% solution of formalin. The artery, veins and bile duct should be perfused with a 3% solution of formalin and the specimen can then be stored overnight in a 1% solution of formalin.

The bile duct and gall bladder must be emptied of fluid and 100 mL of resin prepared; two to three minutes before the resin reaches its gel point, it should be injected via the bile duct. A fine prick should be made at the uppermost end of the gall bladder to allow any water or air to escape. Pressure should be increased to distend the bile duct just as the resin begins to gel. Red resin (200 mL) should be prepared and injected, one minute before it gels, into the hepatic artery. Strong pressure should be applied as the resin gels, for this vessel cannot be overfilled.

The portal vein should be filled next and the resin is again injected just before the gel stage. It is imperative that only very slight pressure be applied so that overfilling does not occur.

The superior end of the vena cava can then be connected to the injection apparatus and the resin allowed to enter it by gravity. This will push water out through the other end and, when resin appears, the cannula should be clamped. The hepatic veins fill very easily and, as soon as the coloured resin is seen on the surface of the liver, the cannula should be tied.

When the resin polymerizes, the specimen is immersed in a bath of hydrochloric acid for six to eight days. A fine jet of water will be needed to wash out pieces of resin and tissues. Pruning is usually necessary and the artery and bile duct need to be glued to the portal vein for support.

HEART

Heart from adult animals of dog size and larger make good casts, but hearts from smaller animals produce very thin vessels that break easily.

The heart is freed of clots by using forceps or passing water tubes through the aorta and into the ventricles where the water flushes them out. Glass cannulae are tied into the ascending aorta and pulmonary trunk. The heart is placed in a bowl of water and 10 litres of a 3% formalin solution are run into both cannulae by gravity feed. This fixes the pulmonary and aortic valves, which may take a long time to fix, in a closed position. It may happen that only five litres of formalin will be used.

Place the heart into a bowl of water maintained at 30°C and squeeze the muscle firmly to reduce the amount of water in the tissues quite dramatically.

The arteries should be filled first and the apex of the ventricles should point downwards. A bent hypodermic needle should be inserted through the aortic wall close to the glass cannula so that any water can escape during the flow of resin. Moderate pressure should be applied just before the gel stage.

After one hour of setting, the veins may be filled and the heart positioned so that the cut end of the vena cava is uppermost. A needle prick can be made into the coronary sinus where it opens into the atrium to allow water to be displaced. The operator should place an index finger into the inferior vena cava so that the coronary sinus is closed off. At the same time the cannula from the injection apparatus must be inserted into the middle cardiac vein, facing towards the atrium. An assistant should now apply pressure to the resin to force it into the veins; pressure should be applied until the blue resin is seen to appear on the surface of the heart and escapes from the needle prick into the coronary sinus.

Sometimes, the filling of the anterior cardiac veins is not complete so, after the resin has set, a small amount should be injected again. Maceration takes two to four days in fresh acid. The cast should be washed thoroughly to remove any acid residue.

AIR DRYING HOLLOW VISCERA

Anatomical parts such as lungs, stomach, intestines and bladders make excellent teaching aids if they are dried in the air. Comparative anatomy between different species, showing gross morphology, is in many instances superior to that shown by wet preserved specimens.

Dried preparations are very much lighter than when first removed from the dead animal. Stomachs and intestines become very similar to parchment. Lungs feels like polystyrene foam, but provide the student with good material for study. The lungs can be painted with different coloured paints to highlight individual lobes, or the names of the lobes can be painted on. All specimens can be sprayed with a lacquer to prevent the specimen absorbing moisture.

LUNGS

Use fresh material for this procedure. Remove the lungs from the animal, making sure that the pleura and lobes are not cut in any way. Cut the trachea near the throat so as to leave a long length attached to the lungs. Select a cork that just fits into the trachea and bore a hole in it to take a short length of glass tube about 6.4 mm in diameter. The cork is inserted into the trachea and tied in position with string. A rubber tube from the cold tap is connected to the glass tube and the lungs are placed in a bowl of cold water for support (Fig. 8.1). The cold tap is turned on slowly, allowing the water to flow through the air passages. The lungs enlarge until they become quite firm. They will become noticeably pale in colour and the blood is forced out. When they become white, disconnect the tube from the tap and allow water to escape from the lungs until they become soft and floppy. They can then be placed into a tray and the tube connected to an air supply. Some laboratories have compressed air available, but a portable compressor can also be used with success. The compressor should have a cylinder on board so that the motor is not on all the time. The drying time can take up to five days for sheep lungs, during which time the noise of the motor would often be excessive. Lungs of a cat and smaller animals can be connected to a fish tank air pump of suitable capacity. If the lungs are heavy, they should be inflated slowly while resting on the tray. After 30 minutes they should be suspended in the air by tying the trachea to a hook mounted in the ceiling. The force needed for air at the start of the procedure for sheep lungs is about 140 g cm^{-2}. Make sure that the "natural" shape is maintained. The air, in time, will remove the water within the lung tissue and drying can be hastened by directing an air fan into the surface (Fig. 8.2). As the lungs dry out they may start to collapse a little so increase the air pressure accordingly. This process must be kept in operation day and night until the lungs have dried completely.

If the pleura begins to bubble, a tiny hole should be made using a pin to deflate it back to the contour shape of the lung surface. The hole prevents

Fig. 8.2. The lungs are suspended and air is blown across their surface using a household air fan. Air is pumped through the tube tied into the trachea.

the bubble becoming too large. If the bubble is noticeable after drying, stick it down using a small amount of water soluble glue. If the heart is still attached to the lungs, it can be removed by careful cutting and manoeuvring through the lobes. It may have been removed after washing and before drying, or it could be removed half way through the drying process.

STOMACH

A good length of the oesophagus and duodenum accompanies the stomach when it is removed from the body. If the stomach is full of food, most of the contents can be squeezed out through the duodenum. As much of the organic matter as possible should be removed before washing. Corks which have had short lengths of glass tubing inserted through them can be placed in the oesophagus and duodenum and tied with string. A rubber tube should be connected to the oesophagus and attached to the cold water tap; this should be turned on to allow the water to pass through the stomach and flush out organic matter until it remains clear. Remove the tube from the tap and squeeze the stomach to expel the water. Attach a short length of rubber tube to the duodenum. The oesophageal tube is connected to the air line and pressure is released to inflate the stomach (Fig. 8.3). If the air passes through the duodenum too quickly, preventing inflation of the stomach, a tubing

Fig. 8.3. This shows the method by which a stomach is dried. Air is passed into the stomach via the cardiac sphincter. The tube which is tied into the pyloric sphincter acts as a regulating valve so as to keep the stomach wall inflated.

clamp should be applied which will then regulate the outflow of air and keep the stomach inflated and firm. The stomach should be suspended to try and keep its shape.

INTESTINES

The length of intestine required is removed from the specimens and organic matter is squeezed from it. The same method is employed as for stomachs, but pressure should be kept to a minimum to avoid altering the contours of the wall. The intestine may be sprayed with lacquer when it is dry and a window may be cut out of the wall to show the internal features. If the specimen is fatty, it should be immersed in trichloroethane or carbon tetrachloride to remove the fat, otherwise deterioration of the tissues will occur.

All dried specimens may be placed in the museum or passed around a class of students, especially if more than one set has been produced.

PRESERVATION BY IMPREGNATION

Tissues and organs may be preserved by replacing water within the cells with a plastic, paraffin, or polyethylene glycol (PEG). Specimens can therefore be handled and examined at close range without the problems associated with wet specimens. Unfortunately, small features such as blood vessels and nerves do not preserve very well *in situ* and, for this type of preservation, whole or bissected organs, whole body sections and muscle and bone preparations are suitable. The methods outlined below were mostly in existence before the introduction of freeze drying procedures and are almost obsolete except where freeze drying equipment is not available.

Paraffin impregnation was the first technique formulated and requires the specimen to be dehydrated in various grades of alcohol followed by the uptake of paraffin to replace the water. The specimen should be cleaned and dissected until the structures required for study have been properly exposed. It is then set and fixed in 10% formalin. The time for fixation varies from specimen to specimen and their thickness, but, as a rough guide, a dog heart bissected requires two to three days fixation. Specimens can be left for longer periods if the need arises. After fixation, the specimen should be washed in tap water and placed into a 50% solution of ethyl alcohol for one day. It should then be transferred through successive baths of 60%, 70%, 80%, 95% and 100% ethyl alcohol for a period of one day in each. The specimen may be soaked in a second bath of 100% alcohol to ensure complete dehydration. The specimen can then be transferred into a bath containing equal volumes of 100% alcohol and toluene for one day after which it should be placed into straight toluene for two to three days, changing the toluene each day. The next bath should consist of equal volumes of toluene and paraffin held at 40° C for half to one day, followed by several changes of low melting point paraffin at 50° C. Once the specimen has been fully impregnated it should be blotted dry and hardened in cold water. After hardening, any excess paraffin can be removed using a knife (if the amounts are excessive) or a brush dipped in toluene. Blair *et al.* (1932) found that adding two parts of naphthalene to three parts of paraffin enhanced the colour of some tissues.

Mittleman (1940) substituted diethylene dioxide (dioxane) for the dehydrating baths of alcohol for cold blooded vertebrates. Specimens were fixed in a 4%–8% solution of formalin for two to three days. Longer times result in a loss of colour. After fixation, the specimen should be blotted dry and placed into an airtight jar containing the dioxane. The dioxane should be changed each day for two days and on the third day the specimens can be placed into equal volumes of dioxane and paraffin (melting point about 45° C) which has been heated to just above the melting point of the paraffin in an oven. The container should be airtight. The length of time required for

complete impregnation depends upon the size of the specimen and its porosity. Soft skinned animals such as frogs, toads and salamanders will be ready in about 24 hours; thicker skinned specimens will take 36 hours or longer. At the end of this time the specimen can be removed from the mixture and placed into pure paraffin held at just above its melting point. It should stay in the paraffin for half the time that it was in the dioxane/paraffin mix. When ready, the specimen should be removed and submerged in cold water until it becomes quite hard. Excess paraffin is removed by scraping or by brushing with a brush dipped into xylene or toluene.

Olsen (1930) used melted beeswax (the temperature not to exceed 80°C) to infiltrate gorgonians (coral sea fans) so that they would be suitably preserved for display. Specimen colouration was restored by spraying suitable oil colours onto them then finishing them off by hand.

Impregnating tissues using polyethylene glycol (PEG) is claimed to reduce the shrinkage and colour loss. Fraser (1961) used PEG to examine, microscopically, plankton and some aquatic invertebrates. He added preserved specimens to a drop of 30% PEG 4000 in water on a microscope slide and allowed the slide to dry before examination. PEG is a liquid or solid depending on its molecular weight. PEG 400 is a liquid, as is PEG 600, whilst PEG 1500, 4000 and 6000 are white powders or flakes; all are soluble in water. To impregnate large specimens using PEG, fix the specimens in a 10% solution of formalin, making sure that they are expanded to normal shape for two to three days. Wash them in tap water and blot them dry before immersing them in a bath of PEG 600 for one week or more (freezing range, 20°C–25°C) at room temperature. Remove and place into PEG 1500 held at a temperature of 48°C for several days; then the specimen can be removed and cooled in the refrigerator (not in cold water as the PEG is water soluble). Remove excess PEG using a heat source such as a hair dryer and blot the specimen dry. To prevent the specimen sweating PEG on humid days or after prolonged handling, a coat of waterproof varnish can be applied, followed by a coat of clear lacquer.

The Armed Forces *Manual of macropathological techniques* (1957) describes a method by which a plastic, in this case a methacrylate, is used to impregnate specimens such as hollow organs. Specimens are first fixed in a 10% solution of formalin and soaked in PEG 600 for a week at room temperature. By then, all water should have been soaked up by the PEG. The next step is to sweat out the PEG from the specimen by placing it in an oven set at 50°C–60°C for one day to one week. The specimen should be blotted each day. After all of the PEG has been removed, the specimen should be placed briefly into a bath of acetone, xylene or toluene, after which it can be soaked for one week or longer in the liquid plastic. The plastic is made up by adding 200 g of powdered polymerized methacrylate to 400 mL of xylene.

After complete impregnation the specimen should be removed and suspended to dry. Hollow organs, which are likely to collapse, are kept inflated with controlled amounts of air until the plastic has dried completely.

Von Hagens (1979) describes methods that impregnate anatomical specimens such as kidneys, brain, lung, heart and intestines using a variety of plastics, including epoxies, clear silicone rubber, polyurethanes, polyesters, and acrylics. He has divided the methods into two categories: complete, and incomplete, impregnation.

REFERENCES

Armed Forces: *Manual of macropathological techniques.* Institute of Pathology, Medical Museum Laboratory, Walter Reed Medical Centre, Washington 1957.

Blair, D. M., F. Davies and E. W. McClelland: Preparation of dry specimens by paraffin naphthalene impregnation. *Journal of Anatomy* 66/1932: 486–487.

Fraser, J. H.: Use of polyethylene glycol in biology. *Nature* 189/1961: 241–242.

Hildebrand, M.: *Anatomical preparations.* University of California Press, Berkeley 1968.

Lum, R.: Notes on an elastic radio-opaque injection. *Massachusetts Anatomical Records* 96/1946: 165–181.

Mahoney, R.: *Laboratory techniques in zoology.* Buterworths, London 1966.

Mittleman, M. B.: Paraffin infiltration of museum specimens by the dioxan method. *Museum News* 18/8 1940: 11.

Olsen, C. E.: Wax infiltration of gorgonians. *Museum News* 8/9 1930: 12.

Romero-Sierra, C., W. Lyons, J. Driscoll, P. Lane and J. C. Webb: Techniques for the preparation of whole brain specimens. *Syllogeus* 44/1983: 53–56.

Schlesinger, M. J.: New radio-opaque mass for vascular injection. *Laboratory Investigations* 6/1957: 1–11.

Tompsett, D. H.: *Anatomical techniques.* (2nd ed.). E. & S. Livingstone, Edinburgh 1970.

Von Hagens, G.: Impregnation of soft biological specimens with thermosetting resins and elastomers. *Anatomical Records* 194/1979: 247–256.

9
Freeze drying

O F ALL compounds in plant and animal tissue, water is the most abundant. When preparing dry preserved specimens the primary concern is to remove this water with the least amount of degradation of the specimen.

During the process of freeze drying, the tissues become dehydrated while they are in a frozen state. Specimens handled this way retain their original appearance without much shrinking and deformation. An additional advantage is that the dehydrated organism is not subject to decay.

Since Meryman (1960) published the first comprehensive paper on the subject of freeze drying entire vertebrate animals and plants,* freeze drying technology has begun to develop in earnest. Hower, who pioneered freeze drying specimen preparations for museum purposes, wrote an informative leaflet in 1962 for the United States National Museum. In this article the general outlines of specimen preparation are described.

During the past 25 years several types of freeze drying apparatus have been constructed by many institutes all over the world. The first commercial model, the Edwards EF2 (Fig. 9.1), was developed in England in 1966 and, since it was designed to be used for preserving biological specimens, it was wholeheartedly welcomed by museums and other scientific institutes.

* The freeze drying of plants and invertebrate animals is discussed in Volume 2.

Fig. 9.1. The Edwards specimen freeze dryer. Note the condenser coil within the specimen chamber. Photo John Fields. Courtesy of The Australian Museum.

A freeze dryer consists of the following main components: a refrigerated specimen chamber; a condenser; and a vacuum pump.

The specimen designated to be freeze dried must be thoroughly frozen before it is placed into the specimen chamber. By sealing the chamber, a vacuum can be created by the vacuum pump and sublimation of the specimen begins immediately. It begins at the outer surface of the specimen and continues at the boundary between the frozen and the dried tissue. This boundary recedes towards the centre of the specimen as drying proceeds. As water molecules continue to escape from the icy crystals on the boundary, they move about at high velocity, colliding constantly with other molecules and with the structure of the dried tissue surrounding them. Since the chamber water vapour level is lower than it is inside the frozen specimen, the

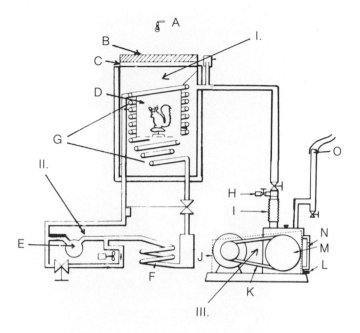

Fig. 9.2. Schematic drawing of an Edwards freeze dryer. I. Vacuum chamber. II. Refrigerator. III. Vacuum pump. A. 60 watt lamp supplements room heat when insulating cover is removed. B. Insulating cover. C. Transparent lid. D. Specimen chamber. E. Compressor. F. Refrigerant condenser. G. Coils, also acting as condensors for ice crystals. H. Air inlet to pump. I. Flexible connection to reduce noise and vibration. J. Belt guard. K. Belt. L. Oil drainage. M. Pump. N. Oil level. O. Exhaust.

molecules will sooner or later leave the higher water vapour space and enter the atmosphere of the chamber. Some of them will ricochet about, and some will return to the ice crystals. As the concentration of the vapour formed by these free molecules reaches a specific point, the rate at which molecules return to ice will become equal to the rate at which they depart; the water vapour is then said to be in a state of equilibrium. This would prevent further dehydration. To upset the equilibrium a lower water vapour area must be provided, near or within the specimen chamber. The most effective method of removing water vapour molecules from the specimen chamber is to provide a colder surface where water vapour can diffuse; thus, the free molecules can form new ice crystals. In the EF2 freeze dryer this problem was solved by constructing the specimen chamber and condenser in one (Fig. 9.2).

This apparatus provides good results but it has its limitations. Hower (1979) described various systems in detail. The best available commercial models are based on his research (Figs. 9.3 and 9.4).

Fig. 9.3. Large specimen freeze dryer with two condensers, made by Dynavac, Sydney. Courtesy of Dynavac Pty Ltd, Sydney.

The general procedure for the freeze drying of entire specimens is as follows. The specimen is posed after death and then thoroughly frozen for at least 12 hours. After this it is placed into the specimen chamber. The chamber has to be prechilled to maintain the specimen's low temperature. The vacuum pump should be switched on and the chamber evacuated. After a few days or weeks the specimen becomes dry and achieves a constant weight. Although the theory of freeze drying is completely sound and in most cases works very well, it is not at all easy to achieve complete success in this field.

Fig. 9.4. Schematic drawing of a large specimen freeze dryer, with one condenser unit. Courtesy of Dynavac Pty Ltd, Sydney.

Antagonists of freeze drying for vertebrate specimen preparation claim that, for a variety of reasons, the results are inferior compared with the results achieved by conventional taxidermy. The converse opinion is that such critics are motivated by professional jealousy and short-sightedness. It is true, however, that freeze drying is not the answer to all the problems which preparators face in many aspects of their work. It should be considered only a technique or a collection of techniques which, if learned and further developed, can help to achieve excellent results. It would be foolish to presume that a freeze drying machine can simply replace a skilled taxidermist. Talent, dexterity and the ability to think rationally are just as necessary for successful freeze drying results as the machine itself!

Not all species of plants or animals can be freeze dried with equal success. As a general rule, those with exoskeletons, hard leathery skin or thick fur, and low fat content are the best media. Many species of snakes and fishes are difficult to freeze dry; some delicate flowers and other fine plant material can quickly rehydrate after the process. Therefore, these are unsuitable subjects.

Before the freeze drying of individual groups of biological specimens can be discussed, a few problems should be mentioned which are considered the main obstacles in the course of successful preparation.

PROBLEMS

FAT

It is practically impossible to preserve fat in a dry preparation. Fat is not preserved in freeze dried specimens and can create problems during long term storage. The fat can seep through the skin, soiling the surface of the specimen. The fatty acids can also damage the tissues of the specimen and cause its complete deterioration. Oxidized fat can also attract insect and rodent pests.

The problem can be combated with a number of methods. Visceral fat of vertebrates can be removed when the animal is eviscerated. Layers of fat can be removed by partially skinning the specimen. Since heavy deposits of fat are often found on the abdomen, their removal is relatively simple. Layers of subcutaneous fat are simply scraped off the flesh side of the skin or carved off the body once the skin has been lifted. The surface of the flesh side of the skin and the body can then be rubbed with powdered borax and cornmeal to absorb the liquid remnants of the fat. This process should be repeated until the powder does not remove any more fat. Fresh powdered borax can be rubbed on the surface and the mass of the removed fat is replaced with a filling material, such as cotton wool, or modelling compound.

In some instances, fat can be removed by soaking the specimen in a liquid degreaser such as trichloroethylene, benzine, or white spirit. Invertebrates and vertebrates can be treated, with varying success, this way. To dissolve and wash the fat from the specimen through the skin is very time consuming. Vertebrates, especially amphibians, reptiles and mammals, sometimes deform so much during the process that their natural shape cannot be restored. Some soft bodied invertebrates (for example, coleoptera larvae) can shrink as a result of the removal of fat. It is almost always necessary to fill specimens degreased in such way. Solid fillers, such as cotton or dacron wool, or modelling paste, can be applied through an incision, and liquid fillers, such as thickened water, through injection. Thickened water can be made by adding a filler, such as Cabosil or Aerosil, to water until a running cream like substance is formed.

The removal of fat integrated in the muscle tissue is practically impossible. Norton (1980; 1983) mentions the use of butylated hydroxytoluene and butylated hydroxyanisole as antioxidants. However, Norton has stated that fat preservation does not seem to be a problem at his institute (Norton, personal communication). Some very fat specimens (domestic dog) were prepared five or six years ago; their fat was not treated in any way, yet neither leakage or discolouration has occurred. The authors have had similar experiences in the Australian Museum with specimens. However, there is still much to be done in order to perfect a technique which guarantees either the removal or the complete preservation of fat in a freeze dried specimen.

INSECTPROOFING

Since a freeze dried specimen, especially a vertebrate, can contain a large amount of desiccated flesh, it is extremely attractive to insects and other pests.

While a taxidermic specimen can have arsenical soap or borax applied to the entire flesh side of the skin, a freeze dried animal cannot be so treated.

ᶦThe best insectproofing agent seems to be the aromatic sulphonamide derivative, Edolan U (or Eulan U33). There are various methods employed to inhibit the specimen with this chemical.

One is to weigh the eviscerated (but not filled or wired) specimen and calculate 2% of its body weight. A quantity of Edolan U similar to that weight is measured and mixed into as much water as is needed to cover the specimen. The animal is soaked in this solution for approximately 30 minutes. Most of the Edolan U is absorbed by the specimen's protein and the solution becomes exhausted. Fur or feathers can be dried in the usual manner after the soaking. Invertebrates can also be treated in the same manner, as well as pathological specimens. Edolan (or Eulan) is unsuitable for the treatment of plants.

Various workers in the field recommend a higher proportion of Edolan in the solution and an additional bath of 1% acetic acid and water solution. The necessity for these can be disputed, since the specimen's proteins cannot absorb more than 1.5%–2% Edolan U (calculated on the body weight of the specimen) and since the average pH of an animal's skin or muscle tissue is 5.5; this should ensure an adequately affinitive environment for the chemical. However, soaking a higher concentration of Edolan U will not harm the specimen, although the appearance of a mammal or bird could suffer through clogged fur or plumage. Excess Edolan U can be removed from fur or plumage by a rinse in water or alcohol (ethanol). The 1% acetic acid bath can assist the absorption of Edolan in the epidermis, fur, feathers, and so on.

Hower (1979) also recommends that a 1.5% Edolan U and water solution be injected into the specimen before freezing; alternatively, the specimen may be injected after freeze drying with 1% Edolan and alcohol, then air dried.

Norton (1980) has described a technique for insectproofing and rodent-proofing freeze dried specimens using approximately 1% (based on the specimen's weight) glacial acetic acid added to the Edolan U bath and a second bath of four litres of 50% ethyl alcohol, 85 g carbolic acid and 4% full strength formalin. The specimen should be soaked in this solution for a further 30 minutes. The same solution can also be injected into the fleshy parts of the animal for greater effectiveness. Needless to say, this area requires more work. Experiments should be conducted in order to establish the proper proportions of chemicals employed in freeze dried specimen conservation.

TIME

The third major problem associated with the freeze drying technique is the relatively time-consuming nature of the process. The lower the temperature in the specimen chamber the longer it takes for the ice crystals to sublimate. The solution seems to be simple: raise the temperature, thus speeding up the process. Unfortunately it does not work in all cases.

Specimens with exoskeletons, such as crabs or beetles, can be dried without any apparatus, well above freezing point; some others, with less sturdy external cladding (for example, locusts) can be freeze dried at a relatively high temperature (just below freezing point). However, for soft bodied animals (or parts of) and most plants, it is essential that their temperature is kept below -10° C at least, and, in many cases, much lower. Specimens of this nature may distort, crack, shrink, or puff up at a higher temperature in the vacuum.

In the food processing industry, where the time factor has even greater importance, the temperature of the vacuum chamber is variable and during processing the temperature is periodically raised or lowered. This speeds up the process, but, of course, it changes the object's appearance.

The later and more complex commercially made, biological specimen freeze dryer apparatuses are constructed so that the temperature of the specimen chamber can be lowered or raised at will. Freeze drying exhibition quality material at a varied temperature is difficult, to say the least. As a rule of thumb, the temperature should be kept low at the beginning of the process. Once the outermost areas of the specimen have dried, thus forming a hard shell on most parts of its surface, the temperature can be slowly raised in order to speed up sublimation. It often happens that the specimen's surface does not dry evenly; therefore, a hard shell is not formed. As the temperature rises, such specimens can distort.

Another method for speeding up the process is to raise the temperature in the chamber for a short while, then quickly lower it again. This process should be repeated several times, with the higher temperature periods gradually increasing until the specimen is completely dehydrated.

Drying can also be assisted by perforating the specimen's skin. As the frozen water molecules try to find their way from the inner sections of the specimen towards its surface, their progress is greatly hindered by the dense tissues of the skin. The water can leave the specimen more quickly through the perforations.

As a rule, one must consider that the greater the volume and density of the specimen the longer it will take to freeze dry. There are exceptions, of course, but the majority of biological specimens can be treated on this basis. If a specimen is prepared for display purposes only, the viscera and some of the muscle tissues can be removed in order to reduce the amount which is to be freeze dried. In the case of large animals, often the entire body must be

removed and the raw skin mounted on an artificial body before freeze drying can take place.

RECONSTITUTION

After freeze drying, specimens are completely free of water, but in most cases contain some salts which are hygroscopic to a certain extent. In warm, humid climates this can cause serious problems as water can be readily absorbed by the dried tissues, thus causing a certain amount of water to be reconstituted into the specimen. The presence of formalin lessens the harmful effects of this process. Specimens with fur or feathers can be protected from reconstitution only be injecting them with formalin before freeze drying. Specimens with exoskeletons, or without fur and feathers, can be treated after they have been freeze dried by immersing them in thinned nitrocellulose or acrylic lacquers (25% lacquer; 75% thinners). Once the specimen is submerged in it, the lacquer takes up the space formerly occupied by water. This soaking is more successful if carried out in a vacuum. The lacquer also provides added protection against insects. If a high gloss surface is undesirable on the specimen, it should be soaked in semi gloss or matt lacquer.

FORMALIN

It is often necessary to freeze dry specimens which have been preserved in formalin. It is well known that formalin, although an excellent and widely used preservative, can also cause the destruction of the specimen by decalcifying ossified matter. The formalin (formaldehyde) absorbs oxygen from the atmosphere, oxidizes, and produces formic acid. This causes a number of complex chemical changes in the specimen which can lead to its destruction. The harmful effects of formalin can be counteracted by neutralization. The most frequently used neutralizers are borax, magnesium carbonate, calcium carbonate and sodium bicarbonate.

According to Hower (1979), carbonates and bicarbonates have proven unsatisfactory chiefly because they involve the continuous production of carbon dioxide. Hower also objects to the use of borax neutralized formalin as it leaves a deposit on freeze dried specimens as well as promoting the self-condensation of formaldehyde.

However, a deposit of borax on the surface of a freeze dried specimen can be considered a bonus. The amount of borax in neutralized formalin is approximately 0.5%–1% by weight; therefore, it is scarcely visible on most plant or animal specimens. Where it becomes visible it can be brushed or washed off, or simply sprayed over with clear lacquer. The method of soaking in lacquer, described above, would also take care of this cosmetic problem.

Where the specimen's appearance does not suffer from the presence of

borax on its surface, the film of borax provides extra protection against insects. Study specimens, especially pathology specimens and those which are to be examined under the microscope, or prepared further for the scanning electron microscope, would be greatly disadvantaged by a surface deposit of borax.

To eliminate this problem, Hower (1979) recommends hexamethylenamine (methenamine or hexamine) which is produced by chemical reaction between formaldehyde and dilute ammonium hydroxide. Hexamine, and also dilute ammonium hydroxide, can be added to specimens prepared with formalin. Ammonium hydroxide should not be added to strong formalin. The formalin should be diluted and the ammonium hydroxide added slowly and stirred constantly. Specimens which have been stored in unneutralized formalin should be treated in a neutralized solution for at least 24 hours.

FREEZE DRYING DIFFERENT TYPES OF SPECIMEN

FISHES

Many species of fish do not freeze dry well. The skin of those without scales seems to shrink and wrinkle during the process and most larger marine specimens leak fat through the skin after the process has been completed.

The best method has proved to be a combination of taxidermy and freeze drying. The surface of the fish should be thoroughly cleaned with alum water (5 L water; 300 g alum) applied with a sponge. The fish should always be sponged from head to tail.

Once the fish has been cleaned of mucus, it is eviscerated. Display specimens, which are shown from one side only, can be easily eviscerated through a cut on one side of the abdomen. Specimens with large mouths can be eviscerated through the mouth and, with the help of long forceps, the maximum amount of fat and flesh should be removed from the body and head. The roof of the mouth can be broken through with bonecutters allowing most of the interior of the head to be cleaned out. The eyes should also be removed. The specimen can then be fixed in a 7% solution of formalin and insectproofed in an Edolan–water solution and rinsed. The viscera and removed tissue should be replaced with tightly packed cotton wool; then the fish can be posed and frozen. After it has frozen right through it must be placed in the freeze dryer and processed. A temperature range from -30°C to -25°C is practical for fish drying.

Many species of fish can be treated this way with success; however, the majority of those with scales cannot be turned into perfect specimens using this method alone. The most common problem which occurs is curling of the

scales. To prevent this, the following method is recommended: after the specimen has been put through the preliminary preparation process and posed, it should be painted with (or dipped in) freshly mixed plaster of Paris mixed to the consistency of running cream. This plaster coating should be allowed to set, then the fish is frozen. After a suitable freezing period, the specimen can be placed in the freeze dryer and dried in the usual manner. The plaster forms a hard shell on the surface of the fish which prevents curling of the scales. After the specimen has completely dried the crust can be broken off and all the traces of plaster carefully removed.

Most fishes lose their colour during this process, although most darker markings remain. In many cases, it is possible to restore colour by the careful application of stains and transparent or translucent lacquers. Whatever process used for the restoration of colour, a soaking in thinned lacquer provides a good base for the colour build-up.

Once this has been completed the packing can be removed from the interior and replaced either by a carefully estimated quantity of freshly mixed polyurethane foam or polyester resin filled with chopped strained fibreglass or whiting. This is not absolutely necessary if the filling was packed tightly in the first place and can be judged to be solid enough to permanently retain the shape of the specimen. The eyes, removed at the beginning of the process, can be replaced with appropriately coloured artificial eyes. Polyester or epoxy paste should be used to cement the eyes in position. The interior of the mouth (if it was damaged during the evisceration process) can be remodelled with modelling compound or epoxy putty, and coloured suitably.

AMPHIBIANS

Most amphibians freeze dry and preparation of them is relatively simple. The method of killing is important: the animals must be killed in a relaxed state to prevent disfiguration (Volume 1, Chapter 3). The evisceration of small and medium size specimens is not necessary; perforation with a fine needle is enough to speed up the drying. Large frogs and toads, however, should be eviscerated through the mouth. The removed viscera can be replaced with cotton wool. Fixing is not absolutely essential, but is desirable for the longevity of the prepared specimen. A 5% solution of formalin is suitable for fixing and, if followed by an Edolan–water bath (described earlier), protection against insects is assured.

Posing the animals is also easy since most of them can be shown sitting or walking. A setting board of porous material can be used as a base and the animal arranged on it in a lifelike pose. If the specimen has been kept in captivity for some time and shows loss of weight, it can be corrected by injecting water filled with expanding agents into the collapsed sections. Care

must be taken to fasten each toe to the base, otherwise they may warp and curl up during the drying process. Toes are not fixed by pinning them to the base, but are held in position with two pins crossed over them.

Eyes for amphibians are often not available from commercial suppliers. Therefore, they must be made "in house". Polyester embedding resin is a suitable material to reproduce these eyes. A detailed description of the technique of making artificial eyes can be found in Chapter 2.

The detail around the eyes of most amphibians is very intricate and, in order to preserve this, it is best to set the artificial eyes before the specimen has been freeze dried. This is not an easy task. The best method is perhaps that described by Mr HARRY EHMAN, School of Biological Sciences, Sydney Technical College, Sydney, Australia:

"Artificial eyes can be inserted: (i) while the specimen is still soft prior to setting and freezing; (ii) after freeze drying; or (iii) after freezing but before freeze drying as described here. This method is recommended because: (i) much of the fur/feather/skin fluid and blood contamination that can occur with prefreeze insertion is eliminated; (ii) the brittleness of freeze dried periocular tissue is not encountered; and (iii) it is much easier to control the placement of brows, eyelids, wrinkles, and other periocular details.

"The specimen is first set up and frozen in the usual manner without removing the eyes. When the specimen is completely frozen and at minimum temperature throughout (that is, –20° C or less), the artificial eyes are quickly inserted as follows:

"1. Using a Pasteur pipette part-filled with water at between 15° C and 30° C, 'minithaw' the eyelids and other periocular tissue by rapidly expressing and sucking back a small pool of water that just covers the region to be thawed. Prodding the tissue with the tip of the pipette will indicate thawing.

"2. Once thawed, quickly remove the eye with the fine forceps between the eye and eyelid and then immediately further 'minithaw' the eyeless orbit. This also cleans the lid edges of eye tissue fragments. Thaw and pick out as much orbital tissue as is necessary for a snug fit of the chosen artificial eye. Ensure the lids are thawed then suck out excess fluid from the orbits.

"3. Quickly insert the artificial eye past the thawed periocular tissue and ensure its depth is correct.

"4. With a fine beaded probe or hook, lift and place the periocular tissue onto the artificial eye.

"5. Insert the Pasteur pipette into the corner of the eye under the lid margin and introduce enough water to just wet the edges of the lids all round (water also flows behind the eye allowing some attached thawed tissue there to 'float' across to the back of the eye).

"6. Arrange the periocular tissue as desired with fine instruments starting

in the proximal regions, and working out to the lid margins. If refreezing occurs too soon, 'minithaw' the area still to be arranged.

"If the above steps are carried out quickly and the specimen is handled so as to minimize general thawing (the holding and steadying hand can be insulated), the periocular tissue will refreeze within three or four minutes due to the relatively massive heat sinking capacity of the frozen head and neck. In any case, the specimen should be returned to the freezer until it is again at a uniform minimum temperature. It can then be transferred to the freeze dryer and dried as usual. Amphibians are freeze dried at or below -30° C".

Colour retention in freeze dried amphibians is usually good. At first sight the dried specimen could look dull and faded, but, after soaking in thinned lacquers, most colours and patterns reappear. Colours which do disappear during the process can be painted or airbrushed on in the usual manner. Here again, auto lacquers can be used with success. Naturally, photographic colour references of the live animal are of paramount importance.

REPTILES

Reptile specimens should be killed in the same way as other specimens. It is important that the animals die in a relaxed manner. However, larger lizards and turtles can be manipulated even if they were shot, poisoned or freeze killed. With small skinks, and especially snakes, it is absolutely important that they are killed in a way that their bodies do not deform. It is almost impossible to pose a snake in a lifelike manner if its body has been distorted when rigor mortis sets in.

Reptiles are perhaps the best subjects for freeze drying. Specimens longer than 150 mm are usually eviscerated. Those with large deposits of fat are treated further, first by removing the fat deposits through incisions and then, if necessary, by chemical degreasing. After eviscerating and defatting, the specimen should be thoroughly rinsed and fixed in a 5% solution of formalin, followed by Edolan–water insectproofing. The removed viscera and fat should be replaced with cotton wool and the incisions sewn up with fine, taxidermist stitches. Eyes should be set as described above and, with the exception of the snakes, posing is more or less done as with amphibians.

If a snake is to be posed with its head raised, wire of a suitable gauge and length must be inserted through the mouth, into the body and anchored to the mounting board (Fig. 9.5). The wire can be bent to conform to the desired position. The mouth can be propped open with a small piece of rigid foam. Care must be taken with the fangs of venomous snakes; the venom remains potent after the death of the animal!

Fig. 9.5. The method of wiring a snake, with its head lifted.

The freeze dried specimens are finished as described in Volume 1, Chapter 3. If mounted on bases, in a diorama or panels, larger animals need wires placed in their feet. These can be installed easily once the specimens have been prepared. Holes can be drilled into the soles of the feet, and wires, cut to appropriate sizes, can be glued in the holes with epoxy resin. Corresponding holes should be drilled into the base on which the specimen is to be mounted. The wires will fit in these holes. Most reptiles can be dried successfully at temperatures of -25° C, but the smaller, smooth skinned species, such as small skinks, are best treated at a temperature of -30° C or less.

Scale curling can occur with snakes also. This is almost certain to happen if the specimen was killed as it was nearing moulting time. The epidermis tends to curl, or even lift, during the freeze drying process. Often, it is possible to simply brush or peel this layer off, exposing the fresh, colourful skin underneath. Freshly moulted snakes can be treated in the same way as scaly fishes (see above). The crust of plaster will hold the scales and prevent curling.

Small and medium sized reptiles

The following technique, suitable also for small and medium sized fishes and amphibians, has been described by Mr HARRY EHMAN, school of Biological Sciences, Sydney Technical College, Sydney, Australia:

"The mucous coatings and/or scales of these animals are a major barrier to water vapour diffusion. Also, the mucus, some proteins and other polysaccharides tend to form eutectics on and in the specimen. The combined effect is to cause mild to severe buckling or even blistering of the specimen surface during freeze drying. This is because the vesicles of eutectics are in fact still in the liquid state and these disrupt the frozen, dried tissues.

"These problems can be minimized or eliminated by:

1. Setting the specimen in fresh water (that is, pinning, or propping fins) and freezing the specimen and water in one block of ice ('iced-in' specimen). The amount of water should be just enough to surround the specimen completely. Pinning boards and so on can be removed after freezing by careful chipping of encrusting ice. An extra layer of ice can be added by floating the block of ice in water at $1°C$ and then immediately freezing the lot together (for example, when the pinning board has been in direct contact with the specimen). Icing-in is useful for the following reason. As the specimen and surrounding water freeze, there is a growth of crystalline ice. Many of these crystals grow into the specimen skin and actually pierce the skin at the microscopic level. When the entire iced-in specimen has been freeze dried, these ice crystals are sublimed out of the holes, leaving pores through which subdermal and dermal ice can also be sublimed. If the specimen is simply frozen as set without being surrounded by water, there is very little piercing of the skin by ice crystals. Also, a coating of eutectics is formed on the skin of fish. When a fish specimen is 'iced-in', crystals can grow through the surface — the eutectic coating is made 'leaky' due to the ice crystal puncturing. This situation probably also applies to worms, molluscs and other animals with a 'wet', mucus covered skin.

2. Lowering the specimen temperature to between $-20°C$ and $-40°C$ during freeze drying to freeze more or most of the eutectics. Of course, the condenser temperature must be less than the specimen temperature to ensure water vapour molecules are preferentially frozen on the condenser.

3. Slowing the drying rate (vacuum strength) right down to minimize the rate of vibration of the free water molecules in the eutectic vesicles (that is minimize boil bumping of the vesicles). This can be easily done in practice by 'freeze burning' specimens and not using a vacuum at all. (However, the process can take months; but it may be preferable to having a more rapidly prepared, but poorer, specimen.) Large chest deep-freeze units that operate at $-20°C$ are ideal for this purpose. The specimen can be set in water as previously outlined, then 'iced-in' specimens can be placed in the upper part of the freezer. Because of the small temperature differential between the specimen, the freezer walls and the base, the water vapour molecules are preferentially frozen there as ice, that is, the freezer walls and base (or wherever the refrigerator coils are) act as the condenser. To date, small and medium sized fish and scincid lizards have been freeze dried in this fashion at Sydney Technical College, Sydney, Australia".

BIRDS

Although birds are also suitable subjects for freeze drying, they present a few problems. Their preparation requires the skill of a taxidermist. It is important that the whole process should be carried out with great neatness and that the feathers are not spoilt by blood, fat or body juices. To avoid the plumage being soiled, liberal amounts or powdered borax or woodflour should be used when eviscerating the specimen.

Birds less than the size of a crow are eviscerated, and the brain can be removed through the roof of the mouth. The best tool for brain extraction is a small vacuum pump.

If the plumage becomes dirty or bloody the specimen must be washed, at least partially. The technique is described in Volume 1, Chapter 5. If the bird has to be washed, it is best to insectproof it in the usual Edolan–water bath (a specimen which does not need washing saves a lot of work for the preparator). Those which can remain dry should not be immersed in an Edolan bath, but should be carefully injected with the solution, making sure that the liquid is properly dispersed throughout the tissues. This is not easy to achieve. Unfortunately, the protective qualities of this technique cannot be depended upon. If the solution does not disperse properly, the specimen will have some unprotected parts and these can be attacked by insects. The plumage and the epidermis will also be unprotected. After the specimen has been freeze dried it can be injected again, this time with an Edolan–alcohol solution (1% Edolan in ethanol) and dusted externally with bidimethylthio-carbamyl disulphide. The substance is also called tetramethylthiuram disulphide. It is dangerous for the user, since it is harmful if swallowed or inhaled, but it is a good rodent repellent, insecticide, and fungicide.

The body cavity should be swabbed clean and filled with dry granulated borax. Excess borax can be shaken out of the cavity, then replaced with fresh borax. This process can be repeated until most of the moisture has been taken up by the borax. A small perch should be made (Fig. 9.6) with three holes drilled into it. A wire with a sharpened end can then be installed in the hole in the middle. The specimen's legs should also be wired: two wires approximately three times the length of the leg, and with sharpened ends, are inserted through the soles of the feet and into the body. The ends of the wires should come right up to the shoulderblades, but not protrude from the body. The body cavity can be filled with cotton or dacron wool, then the incision can be stitched up. The wire mounted on the perch can be inserted in the bird through the vent and pushed along the spine (carefully bypassing the wool filling in the body cavity) into the neck and finally into the skull. The sharp end should be pushed through the skull and the skin of the head. The legwires can be fed through the other holes drilled into the perch and fastened to it.

Fig. 9.6. Bird specimen with temporary wire supports.

Now the bird can be posed, first by adjusting its height. The height can be regulated by gently pushing the bird up or down on the centre wire. Once the height has been decided upon the wire protruding through the top of the head should be cut off flush. The head must be lifted approximately 1 mm so that the end of the wire cannot be seen. The feathers of the head should be arranged so that they look natural. The angle of the legs and feet can then be adjusted by bending the wired limbs into the appropriate pose. Toes should curl around the perch; they can be fastened with small pieces of adhesive tape or string. The wings can now be pinned in position with long pins or pieces of wire with tapered points. If the wings should be open, they also must be wired, in a similar manner to the legs. Sagging skin and plumage is held in position with a fine layer of cotton wool wrapped around the bird in a similar fashion as taxidermic specimens are prepared. The feathers of the tail are cardboarded and if necessary, the tail itself is reinforced with a long pin driven through its base and into the spinal region of the bird. Now the bird can be frozen. Once the specimen has frozen solid the eyes can be replaced with artificial ones, following the above described Ehman method, and the bird is freeze dried.

Birds bigger than a crow should be partially skinned. The flesh of the neck and wings can be left in the skin, but the body and the thigh muscles should be removed. The bird can then be mounted on an artificial body following the principles of conventional taxidermy. There is practically no advantage in this technique compared with the usual taxidermic process. However, in some cases (for example, species with naked, fleshy heads) the results can be outstanding, and far better than those achievable with conventional taxidermy.

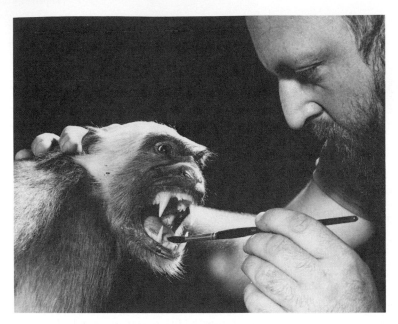

Fig. 9.7. The face of this large Entellus monkey was freeze-dried separately. After preparation, it was installed on the taxidermied specimen. Taxidermy by G. Hangay. Photograph G. Millen. Courtesy of The Australian Museum.

Large birds are usually not freeze dried. Their size means it is impractical to place them in the apparatus. Large birds with fleshy heads, such as turkeys, can be freeze dried partially. The head should be separated from the body and skinned, and the skull cleaned and insectproofed in the usual way. The skull should be fastened to an artificial neck, and the eye sockets can be filled with modelling compound and artificial eyes set. The fleshy skin should be turned back on the skull once the removed muscles of the head have been replaced by modelling compound. The skin should be arranged on the head in a natural manner, the eyelids fastened by fine insect pins, and the specimen freeze dried. In the meantime, the rest of the specimen should be stored in a freezer.

When the head has been freeze dried, it is consolidated by immersion in thinned matt lacquer. The rest of the specimen can then be thawed and mounted in a conventional taxidermic manner. When the artificial body is being made, the freeze dried head and the artificial neck can be incorporated; when the skin is mounted it should be glued and stitched at the neck to the head. Fleshy feet can also be prepared and incorporated in taxidermic specimens in this way. Feet must be well perforated to reduce the drying time. Birds should be freeze dried at a temperature between -20°C and -25°C.

MAMMALS

Mammal specimens up to the size of a fox can be successfully freeze dried, especially if the technique is combined with taxidermy (Fig. 9.7). If the animal is eviscerated, the best method is to remove the brain and insectproof the specimen by immersion in and injection of Edolan–water solution. Large deposits of fat should also be removed whenever possible. The limbs can be wired in the following way: five wires of even length should be cut (approximately the length of the body without the tail) and their ends sharpened. These wires are then inserted, one at each limb, through the soles of the feet, into the abdominal cavity. Another wire should then be cut, a little heavier than the other five, and one end sharpened. This end is inserted into the anus and pushed into the muscles of the back, all along the spine until it reaches the shoulder region. The body cavity can now be rubbed with granulated borax (as described for birds) and filled with cotton wool or dacron; the incision should be sewn up with small taxidermy stitches.

REFERENCES

Ehman, H.: Innovative small animal taxidermy techniques. National Conference of preparators and technicians. Museum of Victoria, Melbourne 1983.

Hower, R. O.: Freeze-drying biological specimens. *Smithsonian Institution Information Leaflet* no. 324 1962.

———. *Freeze-drying biological specimens.* U.S. National Musuem, Washington 1979.

Meryman, H. T.: In *Recent research in freezing and drying.* (ed. A. S. Parks and A. U. Smith). Blackwell, Oxford 1960.

Norton, I.: Freeze-drying as a method of preparation at the Queen Victoria Museum Conference of Museum Preparators. Sydney 1980.

———. Freeze-drying techniques. National Conference of preparators and technicians, Melbourne 1983.

SOURCE MATERIAL

Bensley, R. R.: Studies on cell structure by the freeze drying method. IV. The structure of the interkinetic and resting nuclei. *Anatomical Record* 58/1933: 1–15.

———. and I. Gersh: Studies on cell structure by the freeze-drying method. I. Introduction. II. The nature of mitochondriae in the hepatic cell of Amblystomae. *Anatomical Record* 57/1933: 205–237.

———. and N. L. Hoerr: Studies on cell structures by the freeze-drying method. V. The chemical basis of the organization of cells. *Anatomical Record* 60/1934: 251–266.

Bird, K.: The freeze-drying industry: Projections of capital and labor requirements. *U.S. Department of Agriculture Marketing Economics Division Report.* 70/1968.

Blum, M. S., and J. P. Woodring: Preservation of insect larvae by vacuum dehydration. *Journal of the Kansas Entomology Society* 36/1963: 96–101.

Corridon, C. A.: Freeze-drying of foods. A list of selected references. *Library list No. 77 National Agricultural Library.* U.S. Department of Agriculture 1962.

Davies, D. A. L.: On preservation of insects by drying in vacuo at low temperature. *Entomologist* 87/1954: 34.
——. The preservation of larger fungi. *Freeze-drying transcript of the British Mycology Society* 45/1963: 424–428.
——. and V. S. G. Baugh: Preservation of animals and plants by drying in frozen state. *Nature* 77/1956: 657–658.
Diekamp, G. F.: Die Anwendbarkeit der Gefriertrockung für die biologische Präparation. *Der Präparator* 28/2 1982.
Ehman, H.: Innovative small animal taxidermy techniques. National Conference of preparators and technicians. Melbourne 1983.
Fisher, F. R. (ed.): *Freeze drying of foods.* National Academy of Science, Washington 147/1962.
Flosdorf, E. W.: *Freeze-drying.* Reinhold, New York 1949.
——. F. J. Stokes and S. Mudd: Desivac process for drying from frozen state. *Journal of the American Medical Association* 115/1940: 1095.
Gersh, I.: The Altmann technique for fixation by drying when freezing. *Anatomical Record* 53/1932: 1–5.
——. and J. L. Stephenson: Freezing and drying of tissues for morphological and histochemical studies. *Annals of the New York Academy of Science* 85/1954: 329–384.
Harris, R. C. J. (ed.): *Freezing and drying.* England Institute (Biology), London 1951.
—— (ed.): *Biological application of freezing and drying.* Academic Press, New York 1954.
Harris, R. H.: Vacuum dehydration and freeze-drying of entire biological specimens. *Annals and Magazine, Natural History* (series 13) 7/1964: 65–74.
——. Vakuum- und Gefriertrocknung ganzer biologischer Objekte. *Der Präparator* 11/1965: 244–252.
Haskings, R. H.: Freeze-drying of macro fungi for display. *Mycologia* 50/1960: 161–164.
Hower, R. O.: Freeze-drying biological specimens. *Museum News (Technical Supplement)* 1/1 1964.
——. The freeze-dry preservation of biological specimens. *Proceedings of the U.S. National Museum* 119/3549 1967.
——. Freeze-dry preservation of biological museum specimens. *American Taxidermist* 2/2 1969.
——. Advances in freeze-dry preservation of biological specimens. *Curator* 13/2 1971: 135–152.
Kulis, G. F.: Freeze-dry taxidermy. *American Taxidermist* 11/1 1977.
Leihfeld, O. P.: Wirtschaftliche Anwendung der Eulan-Methode durch ein neues Trockenverfahren. *Der Präparator* 27/2 1981.
Mercie, F. L.: Preparation des collections vegetables sous vide (nouvelles observations). *Bulletin du Societe de la Botanie de la France* 95/1948: 38–43.
Meryman, H. T.: The preparation of biological museum specimens by freeze-drying. *Curator* 1/3 1960: 5–19.
——. *The preparation of biological museum specimens.* Naval Medical Research Institute, Bethseda Md 1961.
——. The preparation of biological museum specimens by freeze-drying. II. Instrumentation. *Curator* 4/2 1962: 153–174.
—— (ed.): *Cryobiology.* Academic Press, New York: 1966.
——. and W. T. Platt: the distribution and growth of ice in frozen mammalian tissue. *Naval Medical Research Institute Project Report* NM000-18.01.08 12/1955: 1–3.
Muller, H. R.: Gefriertrocknung als fixierungsmethode an phlanzellen. *Journal of Ultrastructural Research* 1/1957: 109–137.
Oster, G. and W. W. Polister (eds): *Physical techniques in biological research.* Academic Press, New York 1956.
Parks, A. S., and A. U. Smith (eds): *Recent research on freezing and drying.* Blackwell, Oxford 1959.
Passie, O. X., and V. T. Haider: Die Bedeutung der Gewebevorbehandlung (Gefriertrocknung und Fixation) zur Darstellung der Enzyme. *Der Präparator* 26/4 1980.
Phillips, A.: Getting the bugs out. *Taxidermy Review* 8/5 1980: 37.
——. *The art of freeze dry taxidermy.* 1982.
Reshetniak, B. M.: Lyophilization in your future. *Taxidermy Review* 7/2 1978.

Rey, L. (ed.): *Progres en lyophilisation*. Herman, Paris 1962.
—— (ed.): *Lyophilisation freeze-drying*. Herman, Paris 1964.
Rowe, T.: The theory and practice of freeze-drying. *Annals of the New York Academy of Science* 85/1960: 679–681.
——. and Snowman, A. F.: *Edwards freeze-drying handbook*. G. B. Selby's, Rochester, NY 1976.
Scott, W. J.: Recent research in freezing and drying. *Annals of the New York Academy of Science* 85/1960: 188.
Simpson, W. L.: An experimental analysis of the Altmann technique of freeze-drying. *Anatomical Record* 80/1941: 173–186.
Stadelman, E. J.: The use of Mercie's method of freeze-drying for the preparation of fungi for demonstration. *Proceedings of the IXth International Congress of Botany*, Montreal 11/1959: 376.

10
Skeletal Preparation

T HE PREPARATION of skeletons, or parts of them, requires a great deal of time and patience. Prepared bones form integral parts of vertebrate animal collections and assembled skeletons are most beneficial for study or display purposes. A well presented, comprehensive collection of mounted skeletons can prove to be the most popular exhibition in a museum.

RECORDING INFORMATION

Skeleton specimens are often difficult or impossible to identify once their preparation has been completed. Therefore, it is very important that all appropriate data are recorded before preparation begins. The data which are to be recorded are described in the appropriate chapters for each class of vertebrate. Species and sex identification is important! Specimens designated for exhibition purposes should be photographed in various stages of preparation; sketches and notes should be taken in order to assist the reassembly of the prepared skeleton. A contact drawing can be very handy when adjusting the pose of the assembled skeleton. The best possible guidance, of course, will be provided by an X-ray photograph of the live specimen.

Tagging of the specimens is also very important. If the skin has been prepared (for example, with birds and mammals) the number given to the skin should correspond with the number shown on the skeletal specimen. It

is also necessary that the existence of a skeletal specimen is clearly indicated on the data sheet of the skin specimen. If no skin specimen has been prepared, a complete data sheet should be made out for the skeletal specimen. The recording system of each institute will vary; therefore, it could be misleading to describe one particular method in detail. However, the main principle is always the same: the maximum amount of information should be recorded for each specimen and, if a separate preparation exists of the same animal, this should be clearly indicated. Tags attached to specimens should be made of chemically resistant plastic or wood, with engraved numbers.

FIELD PREPARATION

FISHES

The preparation of a fish skeleton is time consuming work of the most tedious nature. Therefore, it is not common to undertake such a task in the field. The specimen is usually preserved whole, or kept frozen, until the preparation of the skeleton can begin under more convenient circumstances. Still, it is sometimes necessary to prepare fish skeletal material in the field. First, the fish should be eviscerated and the flesh carefully removed from both sides of the body. Great care must be taken not to damage any of the fine bones. Since most fish dry easily and quickly, it is often more practical to leave a considerable amount of flesh attached to the bones rather than damage the skeleton by vigorous carving and scraping. If drying is not practical (because of, for example, wet weather) the fleshed skeleton can be preserved in a 50% solution of ethanol or a 15% salt solution. Cartilaginous fish skeletons should always be wet preserved (in the above solutions) until proper preparation can begin.

The anatomy of fishes is varied and complex in most cases. It is very easy to misplace bones, or to mix them with bones belonging to another fish, or to simply lose them. To overcome confusion, the best method is to take an X-ray photograph of the fish before work begins. If X-ray equipment is not available, precise sketches and notes must be taken right through the fleshing process. If a part becomes detached from the main skeleton (such as the anal fin) it must be properly marked with a tag, which, of course, should correspond with the tag of the skeleton.

AMPHIBIANS

Skeletons of this class are seldom prepared in the field since the usual field preparation method preserves the entire animal, from which a skeletal

preparation can be made later in the laboratory. However, if it becomes necessary to dry preserve some specimens, the procedure is as follows. The animal must be carefully skinned and eviscerated. The feet of small specimens are not skinned. As much flesh as possible is removed from the skeleton, but the cartilages and tendons should not be damaged. The specimen should be sprayed with a household insecticide and placed in a cardboard box to dry. When dry, the skeleton can become extremely fragile, therefore it should be stored and transported in the same cardboard box. Fine wood wool or crumpled newspaper should be used to pack the surplus space in the box. The box, with the thoroughly dried specimen within, can then be sealed in a plastic bag. Naphthalene flakes, camphor or a "pest strip" should also be enclosed in the bag to prevent any insect damage.

REPTILES

Smaller species of reptiles, like amphibians, are preserved whole; therefore their skeletons usually are not prepared in the field. The scarcity of liquid preservatives or some other reason could demand the necessity to prepare the skeletons dry. In such cases the method described above is recommended.

Large reptile skeletons are field preserved, since the specimen's size often prohibits the wet preservation of the entire animal. These specimens are skinned first (the head usually cannot be skinned on a reptile) and eviscerated. The head and tail are separated from the rest of the carcass. All flesh which can be removed without damaging the bones, cartilages and tendons should then be carved off. The head must also be cleaned of as much flesh as possible and the brain removed through the foramen magnum, either with a curette or with a strong jet of water. The bones should then be soaked in salty water (approximately one handful of salt to 10 litres of water) for approximately 10–12 hours to remove the blood. Reptiles decompose more quickly than birds or animals; therefore, the skeleton must be observed in the water and removed before it starts to fall apart. After soaking, the skeleton should be air dried. Before it becomes completely dry and rigid, the skull and tail are placed in the rib cage, the limbs folded across or to the spine and the whole skeleton bound with string to form a compact parcel. It is dried completely in this formation. To prevent insect damage it should be sprayed or dusted with insecticide. The dry skeleton can be transported in a strong, plastic bag (with added naphthalene flakes) packed in a sturdy, rigid box.

Special care must be taken not to overlook small, often solitary bones. These (for example, the small bones in the eyelids of crocodiles) can be removed with the skin during the skinning operation and lost if not noticed in time. Others can be carved off and discarded accidentally with the flesh. Thorough anatomical knowledge is a must for the preparator when working with skeletal material.

BIRDS

When collecting birds, most collectors are mainly concerned with the skin. This is an old-fashioned, inappropriate attitude which has caused many museums around the world to lack a good ornithological skeleton collection. Even if the skin is prepared in the traditional manner (with skull and limb bones attached) the rest of the body, which in most cases is discarded, could still be skeletonized and kept as reference material, together with the skin.

The skinned body should be eviscerated, fleshed and treated as described above. If the bird is designated for skeletal preparation only, the procedure is as follows: the specimen is skinned and, since the primary concern is to prepare the skeleton, no attempt is made to secure a perfect skin. The bird is eviscerated and the flesh carved off the bones. Here again, great care must be taken not to damage the delicate bones during the fleshing operation. A good anatomical knowledge is essential. The head can be left attached to the body with the smaller species, but the skulls of large birds must be cleaned out properly. The brain should be removed through the foramen magnum. Sometimes it is practical to detach extremities during the skinning. These, together with the separated skull, should be placed in the rib cage, the neck bent over it, and the whole "parcel" tied securely together with string (Fig. 10.1). The skeleton can then be soaked in salt water, as described above, and dried. To avoid accidental loss of bones which may become loose, the specimen should be stored in a strong, plastic bag (with naphthalene flakes or other insecticides included) and transported in a strong box.

Fig. 10.1. Bird skeleton packaged in the field.

MAMMALS

Collecting mammal skeletons is of paramount importance. Unfortunately, this aspect of collecting work is again often neglected, since the collector's main interest seems to focus on the skin and skull of the specimen. However, once the skin has been secured, the carcass still can be skeletonized, even if it does not yield a complete skeleton. The prepared bones can be attached to the skin preparation, thus providing a complete specimen, even if not in one piece.

A specimen can be skinned out so that a good skin and a good skeleton can be made of it. If each toe is skinned carefully right down to the nails, or hooves, the skin can be removed without damaging the skeleton. Such skins can still be used for study purposes, or even for display. In the latter case, hooves or nails must be reproduced and incorporated in the mount. Quite a number of exhibits (for example, dioramas) allow positioning of the specimen in such a way that its feet are not fully visible; therefore, the reproduction of nails and hooves may not even be necessary.

After skinning, the animal should be eviscerated and fleshed. In the case of smaller specimens, the limbs and the skull are best left attached to the main skeleton. Mammals over the size of a fox can be dismantled for easier handling. The importance of anatomical knowledge cannot be overemphasized, since mammal skeletons are diverse and small, unattached or very fragile bones can be damaged or lost by unskilled dissecting and fleshing. The fleshed skeleton should then be tied together with strong string and soaked to remove the blood. After this, the specimen should be dried, treated with insecticides, and packaged for transport. The smaller specimens can be stored in strong, plastic bags with insecticides; the larger ones can be stored in burlap sacks and strong crates.

The bones of small specimens and those of immature animals require special attention. After fleshing and a brief (one to two hours) period of soaking they should be immersed in a 70% solution of ethanol for approximately six to 24 hours (depending on their size). The alcohol fixes the cartilages; later, when the specimen is macerated, the bones will not fall apart as easily as they otherwise would.

The skulls of horned species require a different technique. These skulls usually should be boiled in the field in order to remove the horns from their bony cores. It is ideal to use an aluminium or stainless steel pot large enough to receive the skull with horns attached (Fig. 10.2).

Since such large pots are not always available on collecting trips, any other vessel will do so long as the skull and at least one of the horns can be fitted into it. The vessel should be filled with water, and then brought to the boil. The skull should be cooked until the flesh falls away from it. At this time the

Fig. 10.2. Horns are boiled in the field in order to remove them from their bony cores. Photo G. Hangay.

horn can be pulled or twisted off the bony core without much difficulty. Once one horn has been removed, the other can be cooked and removed the same way.

Some large species, such as the Greater Kudu, require a certain amount of strength, and, preferable, two people, for the removal of the horns. If a vice is available, the horn, wrapped in burlap, can be held by it and the bony core slowly twisted and pulled from it. The core, once pulled out, should be scraped clean and trimmed short. The part which is cut off should be kept to maintain a complete specimen. The horn's interior should also be scraped clean, sprinkled with powdered borax, and placed back on the trimmed bony core. The trimming of the core is necessary for easy removal of the horns at further stages of preparation. Antlered skulls also are usually cooked in the field, but the antlers should never be immersed in the boiling water.

Species with large tusks should also receive some extra attention. The skulls of these animals should also be boiled in the field and the tusks removed as soon as the flesh is cooked. This is best achieved by wrapping some cloth around the tusk, and firmly grasping it. After repeated twisting and pulling, the tusk should come out undamaged. Sometimes it is impossible to pull the tusk out, as the roots of it are thicker than the crown. In such cases the

alveolus should be chiselled around, and the tusk removed through the enlarged hole. If possible, the bone chips should be kept and glued back later. The interior of the tusk should be cleaned, all soft tissue removed, and the tusk itself slowly dried. If drying occurs too quickly, cracking or splintering will result. Once the tusk is dry to the touch, the interior should be filled with epoxy. This will prevent cracking later, when the tusk has dried completely.

PREPARING THE BONES FOR MACERATION

LIGAMENT SKELETONS

Animals up to the size of a fox designated as display specimens are usually prepared as ligament skeletons regardless of which class they belong to. This means that most components of the skeletons are held together by the natural ligaments. Therefore, it is vital that the maceration process should be halted at the right moment before the ligament themselves macerate. The procedure is as follows: Skin the specimen through a ventral cut extended from the anus to 20 mm–30 mm below the chin. If the skin is removed carefully and without too many cuts and rips it can be used later for taxidermy or tanning practice. Special attention should be given to the toes. They should all stay intact and attached to the body — not to the skin. Once skinned the carcass can be divided into six sections: the head (only the head without any of the vertebrae); the four legs (front legs removed together with the scapulae, or shoulder blades — the hind legs separated from the body at the pelvis); and the torso. Next, the specimen should be eviscerated. As much flesh and tissue as possible should be removed by carefully cutting close to the bones without damaging them. Be careful not to dismember the specimen further. As the flesh is removed, the skeleton becomes more and more recognisable. At this stage it is advisable to prepare an accurate sketch, recording the position of the bones. This sketch will be very handy when the skeleton is being assembled. During the fleshing process, rinse the skeleton from time to time to remove blood. Special attention should be given to the soft cartilages that attach the ribs to the breastbone. These should not be damaged. Work around them very carefully with a knife, scissors, or scalpel. The remaining flesh can be removed by careful scraping. Scrape with the knife towards the joints and cut off the excess. Throughout this process, the specimen should be kept moistened with water. Damp flesh is easier to remove and the colour of blood will not dry into the bones. Make sure that the ligaments are not damaged by being scraped too hard or by being accidentally cut. Flesh and scrape the limb bones in the same way and prepare the skull as described earlier (Fig. 10.3). Look for the small, unattached bones. A chart which shows

Fig. 10.3. The bones are scraped clean of flesh.

detailed diagrams of the animal's skeleton will be of great help. Many inexperienced workers forget to cut out and keep the hyoid apparatus. If the work is carried out slowly and thoughtfully no bones should be lost.

If this preliminary preparation is carried out in the field, the specimen should be soaked to remove the blood and then dried and packaged as described earlier. If the work is being done in the laboratory the skeleton can be prepared further as described later.

DISARTICULATED SKELETONS

Incomplete skeletons, or those designated as reference material to complement skin preparations, are usually prepared as completely disarticulated material. Very little preliminary preparation is needed. The most important part of the preparation is to avoid confusion later on when the bones are macerated. In order to prevent bones being mixed up the skeleton should be divided into smaller sections. Each section can be tied in gauze or some durable, woven material, and macerated. It is important to mark the individual lots. The sections can vary in size depending on the complexity of the skeleton and the need to provide adequate reference material. Sometimes it is necessary to macerate each foot or toe of a mammal separately to avoid later confusion. Larger bones, such as the ribs or a larger animal, can be numbered with either engraved numbers or drill marks.

ARTICULATED SKELETONS

Large specimens, which cannot be prepared as ligament skeletons, should be macerated completely and later assembled and mounted in a natural pose.

It is of great importance that the bones are not jumbled. To keep the vertebrae in the right order, a stainless steel wire or rod can be pushed through the entire length of the vertebral column (although prepared vertebrae will fit together like a jig-saw puzzle for the knowledgable preparator). The ribs can be tied to similar wires. Limbs, or parts of them, should be bundled up separately in gauze, as described above, or pinned on sheets of rigid foam. If there is some cartilage or ligament which must be saved from maceration (for example, cartilaginous sternum), it should be separated and prepared separately or treated with formalin while still attached to the bones. This is achieved by packing the cartilage in formalin soaked cotton wool before maceration.

LARGE BONES

The long bones and the lower jaw of some mammals contain large amounts of fat. The presence of fat is undesirable in a prepared skeleton; therefore, it must be removed. The long bones should be drilled at each end and the marrow removed, either with a stream of compressed air or a strong jet of hot water. Other bones can be treated the same way, although it is sometimes necessary to drill a number of holes into each bone, to flush the fat out or, at a later stage of preparation, to allow the degreasing agents to penetrate the interior more readily.

MACERATION

COLD WATER MACERATION

This is the simplest maceration method. Excellent results can be achieved with it. It is especially suitable for the preparation of disarticulated skeletons, small skulls and the skeletons of large animals. Glass, plastic, concrete or stainless steel containers are suitable. The container should be filled with water and the specimen submerged in it. It remains in the water until all the flesh, ligaments and so on rot away. The disadvantage of the method is the unpleasant smell.

Hurlin (1918) has described the employment of agar agar as a means of reducing the undesirable odours during the process. Agar agar (1 g L⁻¹ hot water) is dissolved and allowed to cool down to approximately 43°C–45°C. The bones are immersed in the solution, then left at room temperature until the maceration process is completed (10 days or longer). The agar agar absorbs most of the unpleasant odours, and smaller vessels of macerating material can be left open in the laboratory without badly polluting the

environment. The process is recommended especially for the preparation of the cartilagenous skeletons of embryos.

After the flesh, ligaments, and so on have macerated away completely, the bones should be removed from the water, rinsed and dried.

Cold water maceration to prepare a ligament skeleton

The following technique is practised by WINSTON HEAD, senior preparator, South Australian Museum:

"If the skeleton is to be mounted, lay the specimen on a sheet of paper or card, position it in the required pose and draw around it, making an outline which will be a useful reference when mounting the bones. On the drawing mark the positions of the limbs, joints and scapulas. The sex of the animal should be noted at this stage if possible.

"Skin the specimen, taking care not to cut into the bones or the ligaments of the joints.

"When all skin has been removed, eviscerate the specimen by cutting around the abdominal muscle and removing the viscera, taking care not to cut or break the ribs, sternum or pelvis.

"With a scalpel or sharp blade remove the main bulk of flesh, again taking care not to cut bones or joint ligaments. Place the fleshed, skinned skeleton over the drawing of the whole animal, position limbs and so on and draw around each part within the original outline, particularly the spine as its shape is often hidden by fur, and note position of limb joints.

"With a blade remove the limbs and head. The hindlimbs are disarticulated at the pelvis. The forelimbs are disarticulated from the rib cage, but with the scapula attached to the limb, and the clavical (where present) attached to the scapula. The skull is disarticulated at the first cervical vertebrae (atlas bone), which remains on the spine.

"To facilitate the removal of the tissue from the interior of the main limb bones, holes must be drilled in the ends of them when possible (medium to large specimens only). Each limb should also be labelled left or right.

"With sharp blades, forceps and fine scissors, remove as much of the remaining flesh as possible from the trunk, tail (if present), limbs, and the costal cartilages, working carefully so as not to damage the bones around the eyes or to lose the hyoid bones at the base of the tongue.

"Insert a probe or similar instrument into the brain through the foramen magnum and pulp the brain; this can then be evacuated by flushing with a jet of water.

"Place the skeleton in a container of room temperature, clean water, and leave to soak. After several hours, blood from the flesh will discolour the

water. This should be changed and the process repeated until all the blood has been removed from the flesh and the water remains clear after one hour.

"To ensure that the vertebrae stay in order, a nylon cord or wire (all wire used in articulating skeletons must be noncorrosive) is threaded through the line of vertebral foramina and secured at both ends. When a tail is present, it may be left joined or cut from the trunk. Secure the ribs by looping wire around each one in turn. Joined thus they will be held in order and the shape of the rib cage preserved.

"Using short lengths of wire, pin each limb, the tail and hyoid bones to a sheet of rigid foam or cork. When the bones are secured immerse them in clean water. The spine and rib cage are best suspended horizontally in water (small specimen only). Preferably, each piece should be in a separate container, but particularly the skull.

"Care must be taken to exclude all sunlight from the containers. Sunlight will cause the growth of algae which will discolour the bones. If the temperature of the water is kept at 20°C, a medium sized specimen (a fox or a cat) will take one to two weeks.

"When macerating a medium sized specimen the water should be changed every two to three days. First, decant a small amount of the liquid and put this aside. Carefully (so as not to disturb the bones) fill and overflow each container with clean water. When the water is clear, return it to the original level by syphoning.

"If the flesh has decayed enough to be able to remove it, syphon all the water out and remove the foam sheet. Brush, scrape and cut as much loose tissue from the bone as possible, taking care not to disturb the ligaments which hold the joints together (unless a completely disarticulated skeleton is required, in which case all tissue may be removed). Replace the foam sheet and carefully fill the container. Finally, pour in the reserved original liquid. This contains bacteria and will hasten the process of flesh removal.

"After the final cleaning, the specimen is rinsed and dried. Soak each piece in a bath of white spirit for the removal of oils and grease held within the bone. If the white spirit discolours, repeat the process with fresh solvent until it remains clean. When complete, dry the specimen. (This degreasing process is only necessary when the bones are obviously greasy or yellowish.)

"If the bones need bleaching, they may be repinned to the foam and soaked in a 10% hydrogen peroxide (20% solution) to 90% water solution until white (approximately 30 minutes to one hour) and then rinsed and dried, or set aside for immediate mounting".

WARM WATER MACERATION

This method is more or less similar to that described above, except the vessel is equipped with a thermostat regulated heating element which keeps the

water temperature at an even 37° C. The warm water is more hospitable for the macerating bacteria than cold water; therefore, this process is quicker. A grill is fitted approximately 30 mm–40 mm above the bottom of the vessel to keep the bones away from the sediment which will collect below it. This sediment could cause the discolouration of the bones. The water can be changed from time to time; this may slow the procedure down, but it also lessens the pungent odour which, unfortunately, is characteristic of this method.

MACERATION BY COOKING

Cooking the bones is the quickest method of removing the flesh from them. The results are somewhat inferior as the blood haemoglobin cannot be removed completely by cooking and the remains discolour the bones permanently (soaking bones first in cold water will cause the blood to leave the bones). It is also a risky method as overcooking, which occcurs easily, can ruin the specimen. However, larger skulls and other bones used as taxidermists' reference material or in the construction of animal models can be quickly prepared with this method.

A large aluminium or stainless steel pot with a grill insert (as described above) is suitable. In an emergency, any metal pot will do. The container should be filled with water, 150 g sodium carbonate added for each five litres, and the bones boiled for approximately three hours (Fig. 10.4). The cooking time varies according to the size of the specimen: the larger it is, the longer it takes to cook. When the flesh starts to fall away from the bones, the specimen has been cooking long enough. If necessary, the bones can be cooked further until every bit of flesh can be removed. After thorough cleaning, the specimen is rinsed and dried.

DRY MACERATION

Scharff (1910) describes a method by which the bones are buried in beach sand in a brick enclosure. Individual skeletons are placed in flower pots and buried. Maceration took 10 months; after 18 months hair and ligaments were also macerated.

MACERATION WITH INVERTEBRATE ANIMALS

The carpet beetles (*Dermestes lardarius* L. and *D. vulpinus* f.) are most suited for this work. A well stocked, and controlled, *Dermestes* colony can macerate a small skeleton within a day or two and a larger one (up to the size of a fox) in a few days. The beetles remove the tiniest morsels of flesh from the bones, but their progress must be closely monitored because they eventually attack

Fig. 10.4. An autoclave is ideal for boiling large carcasses. Photo John Fields. Courtesy of The Australian Museum.

the bones as the supply of flesh runs out. If the specimen is to be prepared as a ligament skeleton it should be removed from the colony before the ligaments are attacked.

The beetles can pose a serious threat to a zoological collection which includes dry specimens; therefore, if a colony is to be used it must be housed in a room specifically designated for the purpose. The room should be treated as a quarantine area and outgoing material especially should be thoroughly checked.

Within the room, the beetles should be housed in glass containers (aquariums) with closely fitting, fly screen lids. On the bottom of the containers, place a few pieces or cork and dry skin to serve as a hiding place for the beetles. On top of these, place a shallow tray made of fly screen to receive the specimen.

The ideal temperature is 28°C with relatively high humidity (65%–75%). The beetles are active only in the dark.

The freshly skinned and fleshed specimen is dried but the remaining flesh on the bones should not be allowed to harden and dry completely. Small specimens are placed, one by one, in small, open cardboard boxes and put in the colony. Larger skeletons can simply be laid on the screen tray. The

process must be closely observed; at least once daily in the beginning, and perhaps hour by hour towards the end. Once the bones are cleaned they must be removed from the colony and soaked in water for 24 hours, then dried.

Another beetle, the meal worm (*Tenebrio molitor* L.) can also be used for the same purpose. This beetle is not a pest of zoological collections; therefore, the precautions outlined above are not necessary if they are used for maceration. The beetles may be kept in a wooden box with a lid (they also prefer the darkness). The specimens to be macerated are placed in the box and covered with unprocessed bran. To provide some moisture for the insects a few pieces of apples or potatoes are also added. Allen and Neill (1950) recommend this method for the maceration of small skulls.

There are numerous other methods which use various insects and marine invertebrates to macerate the flesh from skeletons, but the employment of *Dermestes* is the most widespread today, and the most practical for many different kinds of specimens.

Whenever live animals are used to macerate the bones, great care should be taken to remove all poisons or insecticides from the specimens before the process commences. Soaking and rinsing will usually remove most of these substances from the specimen.

CHEMICAL MACERATION

There is a great array of chemicals which can be used for maceration. Many techniques, employing various chemicals, have been described. Often it is practical to combine techniques in order to get good results. One of those combined techniques, which is especially suitable for the preparation of medium to large size skulls, is described below. The description is based on that of Doris M. Schmitt (1966), Senior Osteologist at Ward's Natural Science International, Inc. Biological Preparations Department, Rochester NY, U.S.A.

Ammonium and sodium hypochlorite

It is advisable to use only adult skulls. The skulls of young animals are more vulnerable and they can easily be damaged during the process. However, if it is necessary to prepare the skull of a juvenile animal, boiling time should be cut in half. All scraping, rinsing, and scrubbing must be done gently otherwise the skull could fall to pieces.

To prepare the skull of an adult animal, proceed as follows. First, remove all skin and fur. Place the skull in a pot (use a stainless steel or enamelled pot, or Pyrex jar) of cold water. The pot should be large enough to accommodate the skull and enough water to cover it. Add two tablespoons

Fig. 10.5. The flesh is removed from the skull.

of sodium bicarbonate to each litre of water. Bring this to the boil, and boil for 30–35 minutes. The bigger the skull the longer it should be boiled. It is necessary, though, to constantly check the flesh. The skull has been boiled sufficiently as soon as the flesh begins to fall away from the bone.

Cool the skull gradually by adding cold water to the pot and letting it run over. This is to prevent the teeth cracking. When the skull is cool enough to touch, take it out of the pot and scrape off the flesh with a knife, making sure the scraping is done gently and the surface of the bone is not marred with the knife (Fig. 10.5).

The lower jaw should be detached from the skull and also scraped clean. Special attention must be given to the teeth. If they are loose, it is best to remove them and, after marking, place them in a container. They can be glued in place once the skull is prepared.

Using curved forceps, remove as much brain as possible through the foramen magnum. The remaining bits of brain can be easily removed by a jet of water and by gentle shaking. Remove the larger pieces of cartilage from the nasal cavity, but one must be very careful not to damage the nasal bones. These delicate bones are important for studying; therfore they must be preserved. Once the larger and easily removable pieces of cartilage have been removed, leave the rest for the time being.

Tie the lower jaw to the skull and place the lot in a suitable container. Use only glass, wood or plastic containers. Cover the skull with cold water and add approximately 10% houschold ammonia or 5% concentrated ammonia. Cover the container. Allow the bones to remain in this solution for from two to seven days, depending on size. The larger the skull, the longer it should be left in the solution. During this time the remaining bits of flesh will swell and the blood colour will be bleached out.

Fig. 10.6. The bones are placed in ammonia.

At the end of the prescribed time, rinse the bones in cold water. After putting on rubber gloves, scrub off the remaining flesh (it will come away readily). Now immerse the bones in a 30% solution of sodium hypochlorite and water. If using sodium hypochlorite special safety precautions should be taken: rubber gloves should be worn as well as goggles and a rubber plastic apron. The work area must be well ventilated, or the work performed in a fume cabinet.

The nasal bones should now be cleaned by removing all cartilage and other soft tissues with forceps. Once the skull has been thoroughly cleaned, rinse it in cold water and again place it in a container. After this the bones can be degreased and bleached. The technique can be applied to whole skeletons as well.

It is best to use a fresh skeleton for the purpose, but if the specimen was field preserved and dried it can still be prepared successfully. The dried specimen must be allowed to soak in the ammonia solution a little longer.

After most flesh has been removed place the skeleton in a jar or plastic bucket. Fill the container with a 5% ammonia–water solution (Fig. 10.6). Let the skeleton soak in this solution for from two to seven days. During the soaking time, the remaining bits of flesh will swell up and the blood will soak out of the specimen. The smaller the specimen, the shorter the soaking time required. Too much soaking will cause deterioration of the ligaments; the skeleton could fall apart.

Once the little bits of flesh have been sufficiently swollen and softened by the ammonia–water, the skeleton should be removed from the solution,

Fig. 10.7. The bones are scrubbed with a stiff brush.

rinsed, and carefully scrubbed with a nailbrush and toothbrush until the bones are spotlessly clean. The ligaments should be kept intact. If using sodium hypochlorite, make sure rubber gloves and an apron are worn (Fig. 10.7). Avoid damage when working around the cartilages. Do not let the sodium hypochlorite penetrate into the bones and ligaments by leaving the solution on them too long.

After the bones have been cleaned, rinse off the sodium hypochlorite, then degrease and bleach the skeleton as described later.

The usage of sodium hypochlorite is very beneficial. The chemical works very fast, thus speeding up the process. It also works on skeletal material previously preserved in alcohol or formalin. It is also a disinfectant; therefore, it should always be employed if the specimen's cause of death was unknown, or if it died of a disease dangerous for humans.

Sodium perborate

Roche (1954) has described the maceration of bones with this chemical. Sodium perborate (60 g–70 g for smaller specimens; 70 g–100 g for larger specimens) is added to each litre of boiling water. The perborate is dissolved in the hot water and the bones are then immersed in it. The container is covered and allowed to cool. After this treatment, the soft tissues gel and can be removed with forceps or a stiff brush. The method is used in The Australian Museum, where the specimens are usually allowed to soak in the

solution overnight, and are then cleaned. Small, delicate skeletons must be watched closely and not allowed to soak too long, as the chemical can deteriorate them too.

Potassium hydroxide

Zander (1886) has described the method by which the fleshed bones are soaked in a 5% solution of potassium hydroxide and water at 35°C–40°C. The chemical macerates the soft parts and emulsifies the fat. As soon as this happens, the bones should be rinsed and the soft parts removed by scraping and brushing. Before drying, the bones are thoroughly rinsed in running water. The advantage of this technique is that the chemical not only macerates, but also degreases, the bones.

Sodium hydroxide

Skinner (1926) used this chemical to macerate specimens previously stored in carbolic acid solution. The subjects were immersed for 45 minutes in a 1% sodium hydroxide–water solution at 75°C. This was followed by thorough dehydration of the specimens and, after that, by immersion of the specimens in a physiological salt solution. The solution was kept at 37°C and the specimens were macerated in it for four to six weeks. If, after this period, the soft parts were not thoroughly macerated, the specimen was treated again in a sodium hydroxide solution. After maceration, the bones were scrubbed and dried.

Trypsin

Rowley (1925) described a formula by which two heaped teaspoons of trypsin and one heaped teaspoon of sodium sulphide are added to four litres of water. The solution should be kept at 35°C–40°C and the specimen soaked in it for two to three days. After this period, the solution should be discarded and replaced with a fresh batch of similar constitution. This process is repeated every two to three days until the soft parts are macerated. The water used to make up the solution should be slightly alkaline for the best results. Once the bones have been macerated, they should be placed in fresh water; a small amount of ammonia can then be added and simmered for one to two hours. The advantage of this method is that the trypsin not only macerates the flesh but also deteriorates the fat. If larger bones are drilled, or even sawn lengthwise, the trypsin penetrates them easier. Unfortunately, the process is rather smelly and bones retain unpleasant odours for some time, even after the preparation is completed.

Harris (1959) modified the process. In his modification, 1 g sodium sulphide and 2 g trypsin are added to one litre of physiological salt solution and the specimen is simmered in it (at 60°C–70°C) for approximately 30 minutes. Larger specimens require longer "cooking". After this period, the soft parts can be macerated and easily removed by brushing.

Pepsin

This enzyme is used more or less in the same manner as trypsin. According to Piechocki (1967) the best working temperature for the maceration liquid is approximately 40°C and 1.5–2.5 pH is recommended. The pH level is regulated with hydrochloric acid.

Papain

This substance is usually employed to macerate small specimens. The skinned and eviscerated animal is placed in a noncorrosive vessel filled with tap water. The temperature of the water is brought to 37°C–45°C and a small amount of papain powder is sprinkled on the surface. The vessel is covered with a close fitting lid (in order to keep in the unpleasant odours). Various batches of papain powder work at various speeds; some workers activate each batch with a few drops of filtered supernatant fluid from previous macerating jobs.

The maceration of a small skeleton (for example, a mouse) should be completed within one or two days. It is essential to monitor the process carefully since cartilage and very fine bones start to macerate away after a certain time.

Mahoney (1966) recommends the method described above as suitable for processing bird (owl) pellets containing the various bones of small mammals and other animals.

Fehér (1975) describes the following papain technique: the skinned and eviscerated mouse carcass is boiled for 10 minutes, then allowed to cool to 37°C. This temperature is maintained by a thermostat and 1% papain powder is added to the liquid. After 24 hours the specimen is removed, boiled for a few minutes and rinsed clean. The method is recommended for small to medium (cat size) specimens.

MACERATING PRESERVED SPECIMENS

It is often necessary to prepare the skeletons of specimens which have been preserved. The usual cold water macerating technique or simple boiling usually does not suffice since the preserved soft tissues of the specimen are thoroughly preserved and thus are more or less impervious to these methods. For alcohol preserved specimens the following technique is recommended.

Antiformin

A stock solution of antiformin is prepared by dissolving 150 g sodium carbonate in 250 mL water and 100 g calcium hypochlorite in 750 mL water. The two solutions are mixed and shaken every two to four hours. The solution is filtered and an equal volume of 15% aqueous sodium hydroxide solution is added. The stock solution, while not used, should be kept in the dark or, at least, in a dark container. The maceration liquid is made up by making a 2% antiformin stock solution in hot, but not boiling, water. The specimen is immersed in this liquid for approximately one hour. During this time the soft tissues of the specimen should disintegrate enough for easy removal. More stubborn sections can be brushed with a toothbrush dipped in calcium hypochlorite. This latter chemical is also a bleaching agent and, if the specimen is not too greasy, the bleaching may take place during the maceration process.

Schmorl (1931) described a method by which formalin and alcohol specimens can be successfully macerated. The fleshed and eviscerated preserved specimen is soaked in warm water for 24 to 48 hours. After this, it is transferred to a bleaching bath of 3%–5% hydrogen peroxide and kept at 50°C for another 25 hours. After bleaching, the bones are soaked in water for from 12 to 24 hours. The actual maceration process begins after this; the method followed is identical to that of Kaewel (1928).

An antiformin solution (5%–10%) is prepared and heated to 40°C–50°C or even 60°C. The bones are immersed in this liquid for six to 12 hours and afterwards cleaned with a jet of hot water in order to remove as much of the soft tissue as possible. If necessary, the bones can be immersed again and left in the solution for 12, 24 or 36 hours, depending on the stubbornness of the tissues. Once all the flesh can be moved by a jet of hot water the maceration process is completed. After a further 24 hours in hot water, the bones can be degreased, bleached (if necessary), and dried.

DEGREASING

Most skeletal material requires degreasing. Considerable amounts of fatty tissue can be removed from the bones before maceration, but it is impossible to remove all the fat from the bones by physical means. Most of the fat is extracted by treating the specimen with a suitable solvent.

DEGREASING WITH AN INSTRUMENT

The most efficient degreasing method is to place the clean and dried bones in a degreasing instrument. The instrument consists of a vapour chamber, in

Fig. 10.8. Degreasing instrument. A. Condenser. B. Droplets of degreasing agent. C. Grid to hold specimens. D. Sump, where the degreasing agent is heated. E. Control box. F. Sludge door and drain cock. G. Vapour compartment.

which the specimen is placed, with a solvent reservoir beneath it. The solvent is heated to boiling point by a thermostat controlled element: the rising vapour condensates on the ceiling (cooled) and forms droplets which continuously fall on the specimen, dissolving the fat. The fat is removed from the solvent after the process has been completed, by either distillation or simple physical separation.

There are a number of degreasing instruments on the market. Usually, the commercial models used in engineering are suitable, or they can be converted for the purpose with relatively small alteration (Fig. 10.8).

A variety of solvents can be used. Unfortunately, most of them are harmful for the user, especially if handled carelessly. Here again, some commercially used substances are easily obtainable, one of them is Genklene (1.1.1. trichloroethane), allegedly the least toxic of fat solvents.

Trichloroethylene is a widely used degreasing agent, but, because of its harmful characteristics, it is less used today. Benzene, chloroform and carbon tetrachloride are also dangerous substances. Although their fat dissolving qualities are excellent, they are rarely used today.

DEGREASING WITHOUT AN INSTRUMENT

It is possible to degrease bones without an instrument. The defatting may be carried out by immersing the specimens in any of the above solvents. The

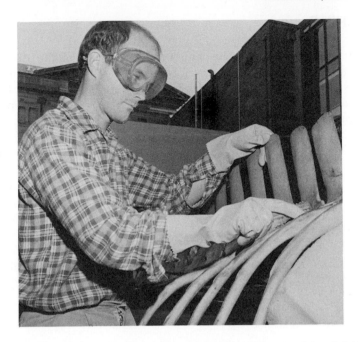

Fig. 10.9. A whale skeleton is scrubbed with soda solution, to remove fat and dirt from its surface. Photo John Fields. Courtesy of The Australian Museum.

effect of the solvents is increased at a higher temperature; therefore, when the nature of the material permits it, the liquid should be heated. Of course, flammable material must be handled with great care and an open flame must not be used for heating. During heating, vaporization is more intense; the user must be very cautious and avoid breathing the fumes. Skin contact must also be avoided.

Tetrachloroethylene can be used cold for degreasing with reasonable effectiveness. The bones are placed in a glass container and covered with tetrachloroethylene. Water is poured on top of this to form a sealing layer. The time for degreasing will depend on the size and fat content of the bones.

Sodium bicarbonate is the least dangerous substance suitable for degreasing. Bones with a high fat content cannot be degreased successfully with this material. However, the technique is simple: after maceration the bones are immersed in clean water and 5%–10% sodium bicarbonate is added. The water is brought to 80°C and kept at this temperature for 12 to 24 hours. Very small bones, or the bones of immature animals, must not be treated very long. Close monitoring is necessary during the process. As soon as softening of the bone surfaces occurs, the specimens must be removed from the solution, rinsed in clean water, and dried. Liquid detergent added to the hot water maceration process will also aid degreasing to a certain extent (Fig. 10.9).

BLEACHING

The appearance of skeletal specimens is enhanced by bleaching. Although it is not desirable to bleach the bones completely white, an even, creamy white colour is advantageous, not only from an aesthetic point of view, but also because a relatively uniform surface tone renders the specimen more practical for the purposes of study.

METHOD 1

The degreased, rinsed, and dried bones are immersed in lukewarm water to which approximately 10%–15% hydrogen peroxide and a few drops of strong ammonium hydroxide have been added. Bleaching, depending on the nature of the bone, can take place immediately, or within a few hours. It is handy if the temperature of the bleaching solution can be kept at 25°C–30°C, but, if this is not possible, it can be allowed to cool. Cooling slows the bleaching process down. As the bones acquire the desired degree of bleach they should be removed, rinsed thoroughly, and dried.

METHOD 2

The bones are immersed in a 6%–8% hydrogen peroxide solution with a few drops of ammonium hydroxide. The surface of the solution is covered with a thin layer of calcium hypochlorite powder which is allowed to dissolve slowly. The bones are moved about periodically to allow the solution to reach every surface. Bleaching should take place in approximately 24 hours, although smaller or very well degreased specimens should bleach sooner.

METHOD 3

The bones are immersed in a 5% hydrogen peroxide solution to which sodium bicarbonate has been added (25 g to each litre of solution). The solution is heated to 40°C and kept at this temperature. Bleaching should take place within a few hours.

METHOD 4

Full strength hydrogen peroxide is mixed with whiting to form a paste. The paste is painted on the bone's surface. Care should be taken to cover the entire surface of the specimen. After an hour or so, bleaching starts to take effect and the paste can be rinsed off. It is also possible to paint the paste on sparingly (but all over the surface) and allow it to dry. The dried compound

can be brushed off. Rinsing is always necessary in order to remove the hydrogen peroxide, which, if left on the bone for a long period of time, can damage the specimen. This method is especially suitable for very large specimens, such as whale skulls.

TEETH

The teeth of mammals are often not white but yellowish. In order to preserve this natural colour, the teeth should be protected during the bleaching process. Small pieces of celluloid can be dissolved in acetone and the compound painted on the teeth before bleaching. During the process the celluloid prevents contact with the bleaching solution and the colour of the teeth remains the same. After bleaching, the celluloid can be washed off with acetone.

DRYING

Once the specimen has been bleached it should be thoroughly rinsed and dried. Drying should not occur too rapidly. The bones must not be dried in a drying cabinet with the heating element turned on full, or in direct sunlight. Rapid drying can cause cracking of the bones.

After rinsing, the bones should be wiped dry with paper towels or clean rags and laid out on white, absorbent paper in a well ventilated dry room. During the drying process, the bones may be turned a few times to facilitate even drying.

FINISHING

Bones designated as display specimens may be impregnated with plastics. Epoxy resin (LC 261 + LC 249)* seems to be a suitable compound since it is especially formulated for impregnation (timber and concrete). The completely dried bone is painted with the catalysed resin. After a suitable setting time (depending on temperature), the plastic renders the bone extremely strong. This treatment is especially recommended for fragile bones or for juvenile specimens.

Fragile bones, which need extra reinforcing, could be placed in a container of the catalysed epoxy resin and vacuumed in a chamber to assist impregnation.

* CIBA-Geigy (Australia) Pty Ltd.

A glossy surface is not desirable in a bone specimen; therefore, if it develops due to the plastic impregnation, it can be counteracted by spraying the specimen with a matt lacquer (clear).

Broken or imperfect specimens can be repaired simply by glueing the broken pieces together with a fast setting, clear glue, such as epoxy, or even water based polyvinyl acetate carpenter's glue. Missing sections, if small, may be modelled with epoxy putty. The putty may be pigmented carefully to achieve the same colour effect as the real bone. Large missing sections are best carved out of wood then puttied in place. The carved section should be painted to match the bone.

In many cases, plastic impregnation is not necessary. However, a spray coat of clear matt lacquer not only enhances the appearance of the specimen but also prevents dust from settling into the pores of the bone surfaces. The dust that will accumulate with time can be removed by wiping or blowing.

Bone specimens should be kept in a dust free environment, preferably in tightly closed glass cabinets (display specimens) or in glass topped storage boxes (in a scientific collection).

ARTICULATING AND MOUNTING THE SKELETON

MOUNTING LIGAMENT OR PARTLY ARTICULATED SKELETONS

Small to medium size specimens are usually prepared as ligament skeletons, or parts of them remain attached with the ligaments. The following technique may be applied to a partially articulated skeleton, where the limbs were kept as ligament specimens, but the spinal column and skull were disarticulated during the maceration process.

It is important that the skeleton's posture closely resembles that of a live animal of the same species. This can be achieved if sufficient reference material is available for the worker. The best possible reference is an X-ray photograph of a living animal where the individual bones are distinguishable. If this is not available, a profile, life size sketch of the animal should be prepared. The bones can be arranged on this in the suitable position; the curvature of the spinal column can be established; and the height of the supports can be identified. The dimensions of the baseboard can also be determined.

First, the vertebral column should be assembled. A galvanized wire of suitable gauge should be sharpened at both ends and passed through the entire length of the neural canal. The wire should be long enough to support the skull by passing through the foramen magnum to the roof of the skull. The sharpened rear end of the wire should be firmly lodged in the last

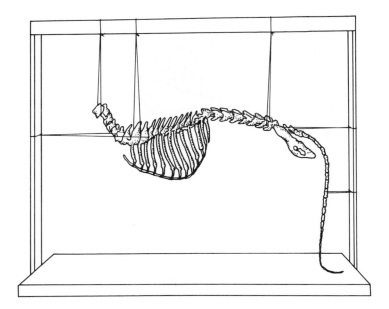

Fig. 10.10. The torso section of the skeleton is tied on a drying scaffold.

vertebra. Since the diameter of the neural canal is not even over the entire length it is inevitable that some of the vertebrae will spin around the wire. To prevent this, they should be glued to the wire with epoxy.

Alternatively, the wire protruding through the first vertebra can be speared through a cork that fits tightly into the foramen magnum, thus avoiding the need to put a hole through the top of the skull.

Spear a small cork on the protruding "top" end of the wire and force it into the spinal canal of the first vertebrae. If the canal is too narrow to take a cork, use a drop or two of polyvinyl acetate glue to cement the wire in the vertebrae. The skull can be fastened to the wire using the same method.

The skeleton can now be mounted directly onto its permanent base. A piece of timber is needed which is large enough to accommodate the skeleton in such a way that all feet sit comfortably on it. The skull must not overhang at the edge (Fig. 10.10). Next, erect the temporary "drying scaffold" as shown on Fig. 10.10. This can be made from any scrap timber, but it must be sturdy. Hang the spinal column on it, as shown.

Attach the forelegs as follows: with a small drill, make two holes about 20 mm–25 mm from the top of either side of both scapular spines (the ridge on the upper surface of the shoulder blade) (Fig. 10.11). Take a piece of soft,

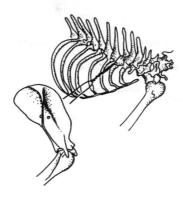

Fig. 10.11. The method of wiring the scapula on the skeleton.

fine wire, about 150 mm–200 mm long and feed both ends through the holes of one scapula. Twist together for 25 mm, then pass one end between the spines of the first and second thoracic vertebrae (those bearing the first and second ribs) and the other end into the space between the first and second vertebrae underneath the wire which was inserted in the vertebrae column. Twist both ends together for 25 mm and pass the ends through the holes in the right scapula. The purpose of the twist is to hold the scapula the correct distance form the body. Then twist the free ends of the wire together to make a firm bond.

Now attach the hindlegs. Follow the basic principles explained above. However, the twists between body and limbs are not necessary. The thigh bone should be set tight against the pelvis. Use same gauge wire as with the forelegs and secure the bones with a strong bond (Fig. 10.12).

Pin the feet in the correct position, and then the tail, if it is long enough (as in the case of a cat). The skull can be placed in position now. Allow the skeleton to dry until all the ligaments become hard and dry. If the skeleton is to remain in a humid environment it is advisable to paint the ligaments with full strength formaldehyde. Use a small brush to apply the chemical. The usual safety precautions should be observed when working with formaldehyde.

The formaldehyde will render the ligaments "rockhard" and they will not relax even in the most humid weather. It also insectproofs them to a certain degree.

When the specimen is intact, dried and secure, it is mounted on two vertical supports (Fig. 10.13). It may be glued or held in place by crimping the ends of the wires over the vertebrae (Fig. 10.14). Occasionally, the sternum may require drilling or modifyi..g to accommodate the front support.

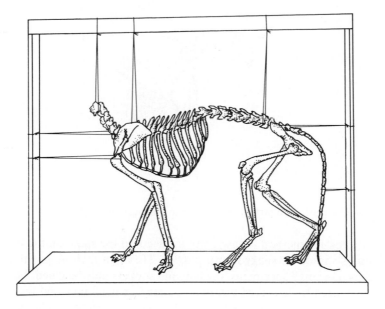

Fig. 10.12. The hindlegs are attached next.

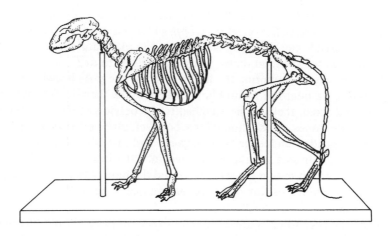

Fig. 10.13. The supports are installed and, after the skeleton has dried, the scaffolding can be removed.

Fig. 10.14. The method of fastening the neck to the support.

An alternative method follows. Having secured the spine on the stand the hind limbs should be soaked until pliable. They can then be positioned on the pelvis. On small specimens, the ball and sockets may be glued, but larger specimens need to be drilled through the head of the femur and the joint of the pelvis. The femur and pelvis are then bolted together. The limbs are positioned and held by supports from the overhead frame while drying. The bones of the feet should be positioned on foam blocks and held with pins while drying.

The fore limbs are resoaked and positioned on the rib cage. It may be necessary to use some removable packing between the scapula, humerus, and the ribs. The fore limbs can be held in place by two bolts or wire through the scapula — one above the vertebrae (if possible) and one joined to the nearest ribs. The clavicle can then be glued or wired in place and the limbs and toes positioned as for the hind limbs. These can be left to dry.

Another way of mounting the limbs is to use the pose drawing to mount each limb on a board of mannikin, and then allow them to dry. When they are dry and fixed, they can be attached to the pelvic section and rib cage.

The hyoid bones, which should have been set, glued or wired together, can now be suspended under the skull between and just behind the mandibles.

The spinal support should be inserted into the brain cavity through the foramen magnum so that the atlas bone and the base of the skull fit together. The skull is held in position by a wire joining a cervical vertebra and the back of the skull.

When the skeleton has dried, all temporary supports should be removed, the feet glued or pinned to the stand, and, if the rib cage is strong enough, the supporting wires removed (Fig. 10.15).

Fig. 10.15. Simple wire support for a small bird skeleton.

MOUNTING ARTICULATED SKELETONS

Large skeletons are usually not prepared as ligament specimens. These are completely disarticulated during the maceration process. To articulate and mount such a skeleton is a difficult task even for the most experienced preparator.

It is impossible to describe all aspects of skeleton articulation and mounting. However, a practical technique is given here by WINSTON HEAD, Senior Preparator, South Australian Museum, Adelaide, Australia:

"The bones should be clean, degreased and bleached at this stage. Each bone should have a label identifying its location in the skeleton (this information should be obtained during fleshing and maceration).

"In the case of a fresh specimen, a drawn outline of the animal may be used to shape a spinal support, but, in the case of found skeletons, photographs and sketches must be used for shape, and the length obtained from the bones of the specimen.

"Lay all the vertebrae out in line and in order. The intervertebral disc must be replaced. The replacements may be made of felt, card, or thin foam. Join

each vertebra to its neighbour and make the flat ends of the vertebral bodies roughly parallel. The width of the gap is the thickness of the disc which must be made. Cut the disc to shape. The curvature of the spine causes some discs to be narrower at one end. These must be trimmed to shape.

"When the discs are cut each vertebra is joined to its neighbour with the disc in place. A hole to take a wire should be drilled through the centre of the body of the vertebra, through the disc, and into the next vertebra. This process should take place for each vertebra. A noncorrosive wire can then be threaded through these holes and fixed temporarily at each end."

It is best to proceed with a freshly prepared ligament skeleton before the ligaments dry up. However, if mounting is delayed and the ligaments have dried, the bones may be soaked in a 2% carbolic acid in water solution until the ligaments relax. An alternative to the above method is another described by WINSTON HEAD.

"Usually a flat piece of wood, slightly longer and wider than the specimen, will suffice for a stand although certain poses may necessitate the use of branches, rocks, and so on. The frame consists of two lengths of metal tube, metal rod or perspex rod to act as vertical supports, and a length of noncorrosive wire or rod or a spinal support.

"By using an outline drawing of the specimen the spinal support can be cut to length and shaped. To determine the length accurately, insert a straight wire through the line of vertebral foramina (vertebral spinal cord cavities) until it emerges from the last or smallest foramen; allow enough length to secure the wire at the tail end and to support the skull (by insertion into the brain cavity) at the other end.

"The drawing can also be used to determine the lengths and locations of the vertical support rods. Generally, one supports the pelvic area and the other the neck.

"The second frame consists of a spinal support on which the vertebrae rest. Wire claws attached to the supports can be securely fixed to the spinal support by bolts or welding (usually used for fossil specimens).

"The specimen should have been prepared by the method described earlier. The spinal support should be inserted through the line of vertebral foramina until it emerges from the pelvic–tail region where it should be crimped back carefully onto the vertebrae (to prevent it from slipping out). Care must be taken not to dislodge any of the ribs or parts of the sternum, for both will be connected with only the finest of tissues.

"Suspend the spine horizontally from an overhead frame. The tail and rib cage may now be positioned. The ribs should be held in place by fuse wire and the ends of the ribs should be joined to the spine and the sternum cartilage by tissue. If some have come loose at the vertebrae they must be held in place

Fig. 10.16. Wire reinforcement for the rib cage.

with wire until dry enough to glue. If the sternum cartilage has come away, it should be held in place with cotton and wire, and fabricated and glued when dry. Alternatively, it may be removed and replaced later with a prefabricated cartilage made from wire and a modelling material. It is important to note the shape of the sternum cartilage before it is removed. The tail may be positioned with the use of cotton suspended from the overhead framework; pinned to a suspended pinning board; or removed from the spine and dried separately to be glued or wired back later.

"The spine support should be inserted through the line of vertebral foramina and secured at the posterior end. To accomplish this it may be necessary to loosen the first wire and, when the support is secure, the wire can be fixed permanently at both ends. The spine can now be attached to the stand. To attach the ribs, glue may be used for small skeletons. This involves supporting each rib so that the vertebra and rib are together while glue applied to this area dries or sets. The ribs or large specimens must be wired to the vertebrae. Holes should be drilled through the head of the rib and the corresponding part of the vertebra; these can then be wired together. The process is repeated, if necessary, at the second facet of the rib (facet of tubercle). Each rib is secured in this manner (Fig. 10.16).

"The bones of the sternum must be joined by drilling and wire dowelling. The sternum must be shaped and supported in position under the rib cage. Holes are drilled into sides of the sternum bones (where the costal cartilage joins) to correspond with the hole in the sternum. The wires must be shaped and eventually covered with a modelling material (for example, papier mache) to reproduce the look of cartilage.

"To pose the limbs, use the drawing, photographs, or sketches as a guide. The limb bones of small skeletons may be glued together in prefabricated fashion and then glued to the pelvis and rib cage, but larger specimens will require wiring and bolting (Fig. 10.17).

Fig. 10.17. The knee joint of a large mammal should be bolted.

"The carpals, metacarpals, tarsals and metatarsals must all be wired together by drilling in each bone a hole corresponding with holes drilled in the neighbouring bones. The bones are threaded into wires or dowelled and secured, resulting in each metacarpal/metatarsal set being joined to each carpal/tarsal set (Figs 10.18 and 10.19).

"The fibula and tibia (bones of the lower leg) and ulna and radius (bones of lower forearm) should then be drilled and wired together as unobtrusively as possible. The tibia and the ulna should be drilled and wired or bolted to the femur and humerus respectively. A hole should exit through the inside face and at the neck of the scapula. The humeruses and scapulas are then wired or bolted together.

"To join the femurs to the pelvis, a hole must be drilled through the head of the femur into the pelvic socket or articular capsule, and the elements bolted together. The patella is wire dowelled to the tibia. The fore limb and scapula must be hung from the spine or the rib cage. If possible, a bolt or rod joining the two scapulas should pass over the spine, with the lower scapulas being supported by a bolt, or wired to a rib. Alternatively, the scapula may be bolted or wired directly to the ribs, but leaving a space between the scapula and rib cage. If a clavicle is present, it should be drilled and wired to the acromion of the scapula and the clavicular notch of the sternum.

"The metacarpals can be drilled and wired to the ulna and radius, and the metatarsals can be drilled and wired to the tibia and fibula. All four limbs should then be positioned and the carpals and tarsals secured to the stand by staples or wires.

Fig. 10.18. Wiring the bones of a horse's foot.

Fig. 10.19. Wiring small bones together.

"If desired, the whole skeleton may be supported by the limbs, thus doing away with the vertical supports. (This method requires quite a bit of planning and the use of a metalwork shop.) The limb bones must be supported by strong rods bent to shape. The rod usually goes through the humerus and femur and to the rear of the tibia–fibula and ulna–radius connections, which are wired to it. The metacarpals and metatarsals are secured to the spinal support. The fore limb supports continue along the rear of the scapula, which is wired to the rod and also secured to the spine support. This mounting

method requires that, for each limb support, a connecting lug be included in the manufacture of the spine support to enable the limbs to be bolted to the spine.

"The hyoid bones should now be drilled and wired together and modelling paste used to replace the cartilage. The bones can then be hung under the skull between and just behind the mandibles.

"The spine support can now be inserted into the brain cavity through the foramen magnum so that the atlas bone and the base of the skull fit together. The skull is held in position by a wire joining a cervical vertebra and the back of the skull."

STAINING

STAINING SKELETAL MATERIAL

Embryonic material and animals as large as a mouse are suitable for staining. Animals as large as laboratory rats have been cleaned and stained successfully, although they are of no real value, as skeletons can be made after maceration of the flesh. The real advantage of clearing and staining is to observe those very small and delicate parts which would be difficult to see if they were unstained; this would include the hyoid bone and the sclerotic ring in the eyes of chicks and lizards. Cartilage normally shrinks and distorts if it is allowed to dry, so staining the cartilage and storing the specimen in glycerine keeps the correct shape and form.

The bones are stained red with alizarin red S, which selectively stains the calcium. Cartilage is stained with toluidine blue, alcian blue or methylene blue. Most specimens are stained with alizarin red S to show only the red bones, but a good contrast can be achieved if they are also stained with a cartilage stain. A good example of this is to be found when a series of animals of different ages are double stained so that the formation of bone from cartilage can be seen clearly. If specimens are to be examined closely, they are stored in glycerine, or they can be successfully embedded in clear plastic for display purposes (see Volume 2, Chapter 11).

The following techniques have been known to work, but they should be treated only as a guide. For specific techniques on particular animals, readers should consult the special reference list.

Alizarin red S

Alizarin red S is a yellow powder which, when placed into an alkaline solution, changes to red. To make up a stock solution of alizarin red S, add enough powder to distilled water to make a saturated solution.

Potassium hydroxide method

In this method, specimens are fixed in 80% alcohol for a minimum of a week after which they are skinned and eviscerated (reptiles, amphibians, and birds), or just eviscerated (fish). When skinning, leave the skin around the hands and feet and at the ends of the very small tail vertebrae.

After fixation, the specimen is washed in tap water for one hour and placed into a 1%–2% solution of potassium hydroxide. The specimen may be left in this solution for between two and five days; the tissues will turn brown and any fat present will stand out as white patches. During the time in the potassium hydroxide, the fat can be carefully removed using forceps and a scalpel. Alternatively, fat can be removed by placing the specimen in acetone for several days, after fixation and before placement in the potassium hydroxide. If the potassium hydroxide discolours, a fresh solution must be prepared and the specimen immersed in it. The specimen will become quite soft and jelly like; movement may cause it to disintegrate, so all steps should take place in the container in which it is to be stored. Therefore, solutions are sucked out and fresh solutions added very slowly and carefully.

The staining solution is prepared by adding to a 1% solution potassium hydroxide enough of the supernatant liquid from the stock solution of alizarin red S to impart a burgundy colour. The volume of the staining solution should be 10 times the mass of the specimen. The specimen should stay in this solution for one to two days, after which the solution should be replaced with fresh 1% solution of potassium hydroxide. The tissues as well as the bones will become red in colour; immersion in potassium hydroxide will destain the tissues. Immersion in several solutions of potassium hydroxide may be necessary before only the bones appear red. When this has been achieved, 50% of the potassium hydroxide can be removed and an equal volume of glycerine added. The specimen may float, so the jar should continue to be inverted until the specimen remains at the bottom of the container. After one day in this mix, remove 50% of the solution and replace it with the same volume of fresh glycerine, repeating this procedure three or four times before adding 100% glycerine. To prevent the growth of mould, add a crystal or two or thymol. This technique is excellent for birds and mammals as it produces clean, crisp looking specimens, yet is also cheap and easy to perform.

Enzyme method

Reptiles, amphibians, and fish do not clear and stain well using the potassium hydroxide method and so specimens may be cleared using an enzyme called trypsin instead of potassium hydroxide. Specimens should be injected with 10% neutral formalin, then left to soak for 12 to 24 hours. The animal should

then be eviscerated and soaked in acetone to remove fat deposits; if the deposits are large, they may be removed using forceps and scalpel. Small animals should not be skinned as they are liable to fragment. Large specimens need skinning; in some cases large muscle regions require removal prior to clearing. Bleaching melanin and dark areas is carried out by placing the animal into a solution of 0.5%–1% hydrogen peroxide. If bubbles form within the tissues, remove the specimen and wash it in tap water, or place it in a vacuum chamber to expel the bubbles.

The specimen is then placed into a trypsin solution made up by adding together 125 mL saturated sodium borate, 375 mL distilled water and 1 g trypsin powder. Leave the specimen in this solution until the tissues begin to clear. Then put it in a fresh solution. Supernatant liquid from the stock alizarin red S can now be added until a pale straw colour is reached. Leave the specimen until three quarters of the tissues are transparent. The specimen can then be washed in tap water and placed into a bath containing a 1% solution of potassium hydroxide which will cause the characteristic colour of the alizarin to appear in the bones and tissues. When the potassium hydroxide becomes stained, replace with fresh potassium hydroxide until the destaining is complete; bathing in a mixture of potassium hydroxide and glycerine can now take place until final storage in 100% glycerine.

STAINING CARTILAGE

Cartilage staining takes place much less frequently than bone staining but when both are stained the result is a more usable specimen for research or display.

Alcian blue

For this method (Wassersug, 1976), fix the specimen in 10% neutral formalin for three to five days. Skin and eviscerate and wash in running tap water for one hour. Place the specimen in a staining solution made up by adding 9 mg alcian blue 8GX, 60 mL absolute alcohol, and 40 mL glacial acetic acid and leave it until it is stained deep blue. The specimen should be removed from the staining solution every day to observe the staining progress. When staining is complete, the specimen should be blotted dry and placed in absolute alcohol. The alcohol should be changed every day for several days. If required, the specimen can then be stained using alizarin red S using the potassium hydroxide method, and later stored in glycerine.

Methylene blue

For this method (Noback, 1916) fix the specimens in alcohol or formalin. Once they are fixed, place them in 67% alcohol and 1% hydrochloric acid for

several days. Then place them in a batch of the same solution to which has been added 0.25% methylene blue. Leave them for two to three weeks or until the specimen has stained thoroughly. After staining, transfer them to acid alcohol changing solutions and leave until the tissue has been destained but the cartilage remains blue. The specimen can then be washed in 85% alcohol for several days and then dehydrated by being passed through successive baths of 90%, 97% and 100% alcohol.

Toluidine blue

In this method, fix the specimen in 10% neutral formalin for three to five days. Wash in running water for one hour. Skin, eviscerate and remove any fat deposits. Place the specimen into the staining solution consisting of 0.25 g toluidine blue, 100 mL 75% alcohol and 2% hydrochloric acid for two to four days. The cartilage should be stained blue; the tissues can be destained by being placed in several changes of 80% alcohol over a period of 48 hours. It is then placed into 90% alcohol for five to six hours, 95% alcohol for three to four hours and finally into 100% alcohol for 12 hours or until the tissues have destained. The specimen is cleared, hardened and stored in three parts oil of wintergreen and one part benzyl benzoate. If the specimen is to be stained using alizarin, do not clear and harden, but transfer from the 100% alcohol into the alizarin staining solution as described for potassium hydroxide.

REFERENCES

Allen, E. R. and W. T. Neill: Cleaning mammal skeletons with meal worms. *Journal of Mammalogy* 31/1950: 464.
Fehér, G: *Állatpreparátumok Készitése*. Mezőgazdasági Kiadó, Budapest 1975 (3rd addition)
Harris, R. H.: Small vertebrate skeletons. *Museum Journal* 58/1959: 223–224.
Hurlin, R. G.: A note on the preparation of skeletons by bacterial digestion. *Science* 47/1918: 22–23.
Kaewel, —: Mazeration von Knochenpräparation mittels Antiformin. *2b1. Path. Jena* 41/1928: 385–388.
Mahoney, R.: *Laboratory techniques in zoology*. Butterworths, London 1966.
Noback, C. J.: The use of the Von Wijhe method for the staining of the cartilaginous skeleton. *Anatomical Records* 7/1916: 292–293.
Piechocki, R.: *Makroskopische Präparationstechnik*. Akademische Verlagsgessellschaft Geest u. Portig, Leipzig 1967.
Roche, J.: Preparation des pieces osteologiques. *Mammalia* 18/1954: 420–422.
Rowley, J.: *Taxidermy and museum exhibition*. New York and London 1925.
Scharff, R. F.: On a dry system of macerating bones. *Musuem Journal* 10/1910: 198.
Schmitt, D. M.: How to prepare skeletons — a Wards Curriculum aid. Ward's Natural Science Establishment, Inc., P.O. Box 1712 Rochester, NY 14603. 1966
Schmorl, G.: Zur Technik der Knochenuntersuchung. *Beitr. path. Anat.* 87/1931: 585–598.
Skinner, H. R.: A method for the preparation of skeletons from cadavers preserved by phenol. *Anatomical Record* 33/1926: 327–330.

Wassersug, R. J.: A procedure for differential staining of cartilage and bone in whole formalin fixed vertebrates. *Stain Technology* 51/2 1976: 131–134.
Zander, R.: Die Knochenmazeration mittels Kalilauge. *Anat. Anz.* 1/1886: 25–28.

SOURCE MATERIAL FOR STAINING

Batson, O. V.: The differential staining of bone. I. The staining of preserved specimens. *Anatomical record* 22/1921: 1959 162–163.
Bertin, L.: Methodes de coloration a l'alizarine et d'eclaircissement de petit animaux pour l'etude anatomique. *Bull. Soc. Zool. France* 66/1941: 132–133.
Cerveny, C.: On the technique of making macroscopic sections of thin flat bones and their differential staining with the aid of alizarin red S. *Anat. Anz.* 116/1965: 196/201.
Cumley, R. U., J. F. Crow, and A. B. Griffen: Clearing specimens for the demonstration of bone. *Stain Technology* 14/1939: 7–11.
Davis, D. E., and U. R. Gore: Clearing and staining skeletons of small vertebrates. *Field Museum of Natural History Chicago* Collector's Guide 4/1936: 1–15.
Dawson, A. B.: A note on the straining of the skeleton of cleared specimens with alizarin red S. *Stain Technology* 1/1926: 123–124.
Drury, H. F.: Amyl acetate as a clearing agent for embryonic material. *Stain Technology* 16/1941: 21–22.
Evans, H. E.: Clearing and staining small vertebrates in toto for demonstrating ossification. *Turtox News* 26/1948: 1–6.
Gamble, J. P.: A combination of bleaching-clearing agent and its use in the processing of Spalteholz preparations. *Stain Technology* 20/1945: 127–128.
Gloxhuber, C.: Enzymhaltige Waschmittel. *Medizinische Welt* 23/1972: 244.
Gray, P.: The preparation of alizarin transparencies. *Musuem Journal* 28/1929: 341–344.
Green, M. C.: A rapid method of clearing and staining specimens for the demonstration of bone. *Ohio Journal of Science* 52/1952: 31–33.
Harris, H.: Alizarine transparencies. *Museum Journal* 60/1960: 99–101.
Hollister, G.: Clearing and dyeing fish for bone study. *Zoology* 12/1934: 89–101.
Hood, R. C. W. S., and W. N. Neill: A modification of alizarin red S technique for demonstrating bone formation. *Z. mikrosk. Forsch.* 6/1951: 264.
Klein, S. A., and T. Weinberg: The Spalteholz clearing method applied to the determination of carcinomatous metastases in regional lymph nodes. *Archives of Pathology* 26/1938: 1063.
Lipman, H. H.: Staining the skeleton of cleared embryos with alizarine red S. *Stain Technology* 10/1935: 61–64.
Mall, F. P.: On ossification centers in human embryos less than 100 days old *American Journal of Anatomy* 5/1906: 433–458.
Miller, C. M.: Demonstration of the cartilaginous skeleton in mammalian fetuses. *Anatomical Record* 20/1921: 415–419.
Moran, J. F.: Differential staining of bone and cartilage in toto of fish. *Proceedings of the Indiana Academy of Science* 65/1956: 234–236.
Nichols, C.: A note on the use of synthetic glycerol (Shell) in the clearing of embryos in toto. *Stain Technology* 16/1941: 37–38.
Noback, C. J., and Noback, E.: Demonstrating the osseous skeleton of human embryos and fetuses. *Stain Technology* 19/1944: 511–54.
Reagan, F. P.: A useful modification of a clearing fluid formulated by Spalteholz. *University of California Publications in Zoology* 28/1926: 357–360.
Reichert, F.L.: The value of Spalteholz' clearing method in the study of surgical and pathological specimens. *Annals of Surgery* 91/1934: 473.
Richmond, D. W., and L. Bennet: Clearing and staining embryoos for demonstrating ossification. *Stain Technology* 13/1938: 77–81.
Rocha, J. M., da: Staining of adult cartilage by Lundwall's methods. *Anatomical Record* 13/1917: 447–449.
Ruth, F. S.: Demonstration of ossification centers in the human embryo. *Philippine Journal of Science* 12/1977: 294.

Sedra, S. N.: Decreasing the time required for making an alizarin skeleton preparation. *Stain Technology* 25/1915: 223.

Sills, B., and S. Couzyn: The embedding of cleared biologic specimens. *Curator* 1/5 1958: 87–91.

Staples, R. E., and B. L. Schnell: Refinements in rapid clearing technique in the KOH-alizarin red S method for fetal bone. *Stain Technology* 39/1964: 61–63.

Taning, A.: Directions for staining fish with a view to racial investigations. *J. Cons. Int. Expl. Mer.* 2/1927: 50–52.

Taylor, W. R.: Outline of a method of clearing tissues with pancreatic enzymes and staining bones of small vertebrates. *Turtox News* 45/12 1967.

True, R. M.: Staining of embryonic and small mammalian skeletal system. *Stain Technology* 22/1947: 107–108.

Webber, P.: Alizarin staining techniques with special reference to reptiles and amphibians. *Herpeto fauna* 19/2 1978: 2–7.

Williams, T. W.: The use of sodium alizarin monosulfate and toluidine blue for the differential staining of bone and cartilage in toto. *Anatomical record* 76/1940 (Supp. 2): 96.

———. Alizarin red S and toludine blue for differentiating adult or embryonic bone and cartilage. *Stain Technology* 16/1944: 23–25.

Formulae

The following formulae are used by preparators and commercial taxidermists all over the world. However, many of them are often modified to suit the needs of an individual worker. These modifications are sometimes published, sometimes not. In this selection, the authors have endeavoured to collate a number of formulae which suit most purposes.

FORMULA 1: BODY PASTE

dextrin	2000 g
plain flour	2000 g
glycerine	400 g
carbolic acid	100 g
sodium arsenite	50 g (optional)
water	20 L (approximately)

Mix dry ingredients, and add little water to form a thick paste. Boil the water in a large vessel, and add the paste slowly while stirring the water. Avoid making lumps. Use a paint mixer, if possible. Boil until the mix thickens to the consistency of running cream. Allow it to cool before use. Store in a sealed crock or jar.

FORMULA 2: MODELLING COMPOUND

Using Formula 1, add a filler to the paste until it thickens to the consistency of potter's clay. The filler may be whiting, talc, kaolin, powdered clay, cotton fibre or dry paper pulp. Plaster can also be added. Plaster helps to harden the compound before it dries. The more plaster that is added, the faster the compound hardens.

FORMULA 3: EPOXY COMPOUND

Select a slow curing (two to 24 hours) epoxy, which is formulated so that it can be mixed with the hardener in a 50/50 ratio. Fill the epoxy with a measured amount of filler (as in Formula 2) to form a thick, putty-like substance. Fill the hardener with the same amount of filler. When ready to use, mix equal amounts of the two compounds. Similarly formulated compounds can be purchased from various suppliers, although most products need additional fillers to form a putty suitable for modelling.

FORMULA 4: RELAXING SOLUTION

water	5 L
carbolic acid	50 g
salt	100 g (only for mammal or reptile skins)

Add carbolic acid crystals to the water and agitate until completely dissolved.

FORMULA 5: ARSENICAL SOAP

white soap flakes	100 g
potash	400 g
sodium arsenite	200 g
camphor	25 g
alcohol	25 mL (approximately)
water	0.5 Litre

Mix the potash, soap and arsenic, then add the water and bring it to the boil. Allow it to cool then mix in the camphor and alcohol and store the mixture in a sealed jar. Do not breathe fumes while the formula is being heated, and avoid skin contact. Bear in mind that arsenic is an accumulative, lethal poison. Label the jar clearly and keep it locked away when not in use.

When ready for use, the arsenical soap is mixed with more water to the consistency of running cream. This brushable compound is applied to the flesh side of the specimen's skin.

FORMULA 6: PAPIER MACHE (QUICK)

dextrin	1000 g
water	1.5 L (approximately)
carbolic acid	25 g
paper pulp	
plaster of Paris	

Mix dry dextrin into the water and bring it to the boil while stirring to prevent lumps forming. Add paper pulp (either dry or wet) until a thick, mushy compound is formed. Add carbolic acid. When ready for use, mix a small amount of the compound with dry plaster to form a stiff putty. The more plaster that is added, the faster the mixture will set. See index for other papier mache formulas.

FORMULA 7: PRESERVING MIXTURE

alcohol	250 mL
carbolic acid	25 g
formalin	25 mL
glycerine	25 mL

The mixture is used to inject unskinned parts of taxidermic specimens.

FORMULA 8: NEUTRAL OR "BUFFERED" FORMALDEHYDE SOLUTION

hexamine	200 g
commercial formalin 40%	1 L

FORMULA 9: FORMALDEHYDE SOLUTION (NEUTRAL)

To 40% formaldehyde solution add calcium carbonate or magnesium carbonate to make a saturated solution. To make neutral formalin take the clear supernatant fluid and dilute it with water.

FORMULA 10: 10% FORMALIN SOLUTION

water	9 parts
commercial formalin	1 part (40%)

FORMULA 11: 10% FORMALDEHYDE SOLUTION

water	3.5 parts
commercial formalin (40%)	1 part

FORMULA 12: PHYSIOLOGICAL OR ISOTONIC SALINE SOLUTION

For frogs:

sodium chloride	0.65 g
distilled water	100 mL

For mammals:

sodium chloride	0.9 g
distilled water	100 mL

The salinity must be the same as that of the subject's blood. This can vary from one group of animals to another.

INDEX

5 6 7 8 9 0 1 2 3 4
A B C D E F G H I J